Manet and the Modern Tradition

MANET
AND THE
MODERN TRADITION

Anne Coffin Hanson

Yale University Press
New Haven and London
1977

Library of Congress catalog card number: 75–43319

International standard book number: 0–300–01954–8

Designed by John Nicoll and set in Monophoto Baskerville

Text set at Thomson Press (India) Limited, New Delhi and
printed in the United States of America
by the Murray Printing Company, Forge Village, Mass.

Plates printed in Great Britain by BAS Printers Limited, Wallop, Hampshire
and by the Westerham Press Limited, Westerham, Kent

Published in Great Britain, Europe, Africa, the Middle East, India
and South East by Yale University Press, Ltd., London.
Distributed in Latin America by Kaiman & Polon, Inc., New York
City; in Australasia by Book & Film Services, Artarmon, N.S.W.,
Australia; in Japan by John Weatherhill, Inc., Tokyo.

to
George Heard Hamilton
and
Joseph C. Sloane
to whom I am deeply indebted and
with whom I sometimes quarrel in
the pages of this book

progress and, simultaneously, fearful of its direction. This was Manet's uneasy world, the 'modern life' he chose to depict.

This book is about the dualities which involved the artist: his dependence on the past, his struggle to create an expression for the future. It attempts to put into perspective the strong critical and philosophical call for a new art, to place into that context Manet's adaptation of old and new imagery to his purposes, and to trace his technical development from traditional methods to a progressive approach. If Manet's career is to be understood, the old distortions which divided nineteenth-century art into rival teams of entrenched 'Academy' on one side, and enlightened (and suffering) rebels on the other, must be forgotten, and replaced by knowledge of the more complex interchanges which really occurred. The flowering of landscape painting, the constant increase in interest in genre, and ultimately the 'Realism' of Courbet, set the stage for a new art of modern life. The depiction of 'la vie moderne' can certainly be considered realism in the sense that it records the sights and peoples of nineteenth-century Paris, but in practice the term meant only a certain kind of imagery which showed its fashionable and progressive side. By contrast 'Realism', the term adopted by Courbet at the time of his strong social interests, carried with it concepts about the working classes and convictions about their fate. Manet's was not a social or political revolution, but the expansion of artistic means to embrace a new optimistic poetry dedicated to 'the spirit of modern life'.

In preparing this book I have been helped by many more writers and friends than I can mention: often the most provocative ideas have come from my students who teach me as I try to teach them. My debts to fellow scholars will be made clear when I repeatedly refer to their works, for even when I choose to disagree with them I am grateful for their prodding. My thinking about the period and the man has been particularly influenced by Albert Boime, Alain de Leiris, Jean Collins Harris, Theodore Reff, John Richardson, and Nils Gösta Sandblad. George Heard Hamilton's ideas on many subjects have taught me a great deal; his friendship has taught me even more. If from Joseph C. Sloane I learned how to use my mind so that I could argue with him, I find his constant confidence in me all the more rewarding. I owe this book to many people, but particularly to the two of them.

A number of museums and individuals have helped me obtain photographs and the permission to reproduce them. I wish particularly to thank Evan Turner, Director of the Philadelphia Museum of Art, and Alan Shestack, Director of the Yale University Art Gallery, for their generosity. Mlle Karen Hallberg of the Fondation Wildenstein has repeatedly helped me in many small ways. I am indebted to Nancy Walchli for her patient and efficient assistance in the preparation of the manuscript. Most of all I appreciate having had the opportunity to work with John Nicoll who combined a real understanding of my intentions with a sharp eye for the faults in the manuscript. For loving encouragement, I owe thanks to my husband and to many other friends.

Preface

EDOUARD Manet has long been recognized as a genius of the nineteenth century whose work has made a profound difference to the development of the art of our own age. His paintings have attracted the interest of many artists and historians, and books on his works run into the hundreds. There are several good catalogues of his entire *oeuvre*, and it is probable that few new facts are still to be discovered about the man. Then why still another book on Manet?

The questions of his 'originality' and his obvious borrowings from the masters, his desire for conventional success, and his choice of shocking subjects and styles—these have been confronted many times and in many ways. In recent years interest has turned to a search for the precise sources for his motifs. From the vast literature a picture of a strange man has emerged. Not himself well-read, a friend of the important literary figures of his day; politically naive in a period of political turmoil; hard working but playful; painfully sensitive but self-assured—a man of duality, of paradox, attempting to reconcile his love of tradition with his compulsion to create the new. John Richardson, in a sensitive account of his personality, describes him as a 'Janus-like figure', 'the forward looking rebel', 'the backward looking bourgeois'.[1] For Bataille, he was a 'compass needle thrown out of kilter'. With no choice but to make a clean break with the past he somehow lost confidence in himself.[2] While all these elements were present, we seem to lack a picture of a real man, integrated enough to have produced some of the most forceful works of art of his century. It is perhaps time to look elsewhere for the 'seemingly unreconcilable elements' which Richardson finds in Manet's character.[3] His society may well be responsible for many of the dualities long ascribed to the artist alone, and his art should be seen in that context. To discover what a man owes to his own culture, to his past and to his present, should in no way reduce the value of his achievements. Instead, it should make the man and his changing times into natural and believable phenomena.

The second half of the nineteenth century was a period of dualities. The French were proud of their heritage but placed their hopes in a new and different future. They knew they had changed, were changing, and that they would change still more; and they were naturally both pleased with their

[1]John Richardson, *Edouard Manet: Paintings and Drawings*, London/New York, 1958, 5–6.
[2]Georges Bataille, *Manet*, New York, 1955, 26.
[3]Richardson, 6.

This book was originally intended as an enlargement of the catalogue I wrote for the Manet exhibition held in Philadelphia and Chicago in 1966. I had hoped to rewrite and expand it almost immediately including paintings which were not obtainable for the exhibition and developing some of the ideas briefly stated in the introduction. Work was begun in 1967 thanks to a National Endowment for the Humanities Fellowship and a Junior Research Award from Bryn Mawr College which together freed me from a year of teaching. The book was put into its final form in the spring of 1974 which I spent as a Resident in the History of Art at the American Academy in Rome, and devoted to the beginnings of another project as well. I am deeply grateful for the opportunity for uninterrupted work in a hospitable and stimulating atmosphere. For several years prior to my stay in Rome work on the book had been set aside because of the demands of other responsibilities. The loss of time and the many new publications on Manet in those years shortened my work and undoubtedly made this book less ponderous. Most of all, rethinking many issues has helped me realize how vast the questions are and how inadequately mere facts can answer them.

I originally chose to work on Edouard Manet because I found his paintings full of provocation and delight. Years later, they are still a constant joy and an unyielding puzzle. I hope this book will answer some of the reader's questions about a great artist, but I am both pleased and concerned that the writing of it has not yet answered all of mine.

Contents

List of Plates xiii

Part I

1. The Turning Point 3

2. Predictions for the Future 18

3. Modern Life 36

4. Manet's Reactions 44

Part II

1. The Range of Manet's Subject Matter 51

2. Genre: The Parisian Type 58

3. Still Life 69

4. Portraits 74

5. Costume Pieces 79

6. The Nude 90

7. History Painting 103

8. Modern History: Scenes of 'La Vie
 Moderne' 128

Part III

1. The Critics' Views; The Historians'
 Sources; Definition of Terms 137

2. Traditional Picture Construction 143

3. Manet's Picture Construction 155

4. Composition 177

5. Japanese Art 185

6. Photography 193

7. Manet's 'Compositional Difficulties' 197

 Conclusion 206

 Selected Bibliography 210

 Index 217

 Plates at end

List of Plates

COLOR

I. *Concert in the Tuileries*. National Gallery, London.

II. *The Absinthe Drinker*. Ny Carlsberg Glyptotek, Copenhagen.

III. *Young Woman Reclining in Spanish Costume*. Yale University Art Gallery, New Haven, Connecticut.

IV. *The Painter Guillaudin on Horseback*. Collection of Mr Henry Ford II, Grosse Point Farms, Michigan.

V. *The Departure of the Folkestone Boat*. Philadelphia Museum of Art, Mr and Mrs Carroll S. Tyson Collection.

VI. *The Conservatory*. Nationalgalerie, Berlin.

VII. Detail of *The Conservatory*.

VIII. Detail of *Le journal illustré*.

IX. *The Bar at the Folies Bergère*. Courtauld Institute Galleries, University of London.

BLACK AND WHITE

1. *Le Linge*. The Barnes Foundation, Merion Station, Pennsylvania. Photograph copyright 1976 by The Barnes Foundation.

2. *Les Triomphateurs du salon*, cartoon by Gill, from *L'Eclipse*, 14 May 1876.

3. *The Urchin*, etching. George A. Lucas Collection, on indefinite loan from The Maryland Institute. Courtesy of The Baltimore Museum of Art.

4. *Le Petit Mendiant*, after Murillo, from *Les Français peints par eux-mêmes*, IV, 399.

5. *The Spanish Singer*. Metropolitan Museum of Art, New York. Gift of William Church Osborn, 1949.

6. *Gypsies*, etching. George A. Lucas Collection, on indefinite loan from The Maryland Institute. Courtesy of The Baltimore Museum of Art.

7. *Gypsy*. Location unknown.

8. *The Water Drinker*. The Art Institute of Chicago. Mrs Stanley McCormick Bequest.

9. *La Limosine*, by Jeanron, from *Les Français peints par eux-mêmes*, II, 249.

10. *L'Ouvrier de Paris*, by Pauquet, from *Les Français peints par eux-mêmes*, V, 361.

11. *The Old Musician*. National Gallery of Art, Washington. Chester Dale Collection.

12. *Rest of the Horsemen* by Louis Nain. Victoria and Albert Museum, London. Crown Copyright.

13. *L'Enfant volé*, engraving after a painting by Schlessinger, from *Magasin pittoresque*, XXVIII (1861), 293.

14. *Little Girl*, etching. Philadelphia

Museum of Art. The McIlhenny
Fund.

15. *La Petite Pologne*, by De Bar,
from *Les Français peints par eux-
mêmes*, IV, 25.

16. *Gilles*, engraving after Watteau,
from *Gazette des Beaux-Arts*,
VII (1860), 271.

17. *Le Chiffonnier*, from Pierre
Zaccone, *Les Rues de Paris*,
Paris, [1859], 205.

18. *The Milliner*. California Palace
of the Legion of Honor,
San Francisco.

19. *Portrait of Duret*. Musée du
Petit Palais, Paris.

20. *La Modiste*, by Lami, from *Les
Français peints par eux-mêmes*, IV,
349.

21. *L'Ami de L'artiste*, by Monnier,
from *Les Français peints par
eux-mêmes*, II, 157.

22. *The Balloon*, lithograph. Prints
Division, New York Public
Library. Astor, Lenox and
Tilden Foundations.

23. *Les Joueurs de L'hotel d'Angleterre*,
from Pierre Zaccone, *Les Rues
de Paris*, Paris, [1859], 216.

24. *At the Cafe*, drawing. Fogg Art
Museum, Cambridge,
Massachusetts. Bequest of Meta
and Paul J. Sachs.

25. *Le Café-concert*, from Emile de
Labébollière, *Le Nouveau Paris*,
Paris, [1860], 113.

26. *At the Cafe*. The Walters Art
Gallery, Baltimore.

27. *Still Life with Carp*. The Art
Institute of Chicago. Mr and
Mrs Lewis L. Coburn
Memorial Collection.

28. *Still Life with Salmon and Pike*.
Private Collection, U.S.A.

29. *Still Life with Melon and Peaches*,
National Gallery of Art,
Washington. Gift of Eugene
and Agnes Meyer.

30. *Still Life with a Hat*. Musée

Calvet, Avignon.

31. *Luncheon in the Studio*. Bayerische
Staatsgemäldesammlungen,
Munich.

32. *Frontispiece*, watercolor. Prints
Division, New York Public
Library. Astor, Lenox and
Tilden Foundations.

33. *Frontispiece*, etching. Prints
Division, New York Public
Library. Astor, Lenox and
Tilden Foundations.

34. *Letter with a Snail on a Leaf*, ink
and watercolor. Collection of
Mr and Mrs Alexander M.
Lewyt, New York.

35. *Letter with a Plum*, ink and
watercolor. Museum Boymans-
van Beuningen, Rotterdam.

36. *Stalk of Asparagus*. Musée du
Louvre, Paris.

37. *Portrait of Zola*. Musée du
Louvre, Paris.

38. *Portrait of Zacharie Astruc*.
Kunsthalle, Bremen.

39. Copy after Titian, *Venus of
Urbino*. Private Collection,
Paris.

40. *Portrait of the Artist's Parents*.
Private Collection, Paris.

41. *Portrait of the Artist's Parents*,
sanguine drawing. Private
Collection, Paris.

42. *Portrait of Victorine Meurand*.
Museum of Fine Arts, Boston.
Gift of Richard C. Paine in
memory of his father, Robert
Treat Paine II.

43. *Portrait of Berthe Morisot with a
Muff*. The Cleveland Museum
of Art. Leonard C. Hanna
Jr. Collect.

44. *Le Repos*. Museum of Art,
Rhode Island School of Design,
Providence. Bequest of the
estate of Mrs Edith S. Gerry.

45. *The Balcony*. Musée du Louvre,
Paris.

46. *Portrait of Pertuiset as a Lion*

Hunter. Museu de Arte, São Paolo.

47. *Le Tuer des lions,* from Pierre Dupont, *Chants et chansons,* Paris, 1855, IV, 125.

48. *The Boy with the Sword.* Metropolitan Museum of Art, New York. Gift of Erwin Davis, 1889.

49. *Mademoiselle Victorine as an Espada.* Metropolitan Museum of Art, New York. The H. O. Havemeyer Collection. Bequest of Mrs. H. O. Havemeyer, 1929.

50. *Tauromaquia,* no. 5., etching, by Goya.

51. *The Boy with a Tray,* etching. The Art Institute of Chicago. John H. Wrenn Memorial Collection.

52. *New Year Scene,* by Shunko I. Metropolitan Museum of Art, New York. The Henry L. Phillips Collection.

53. *The Sumada River,* by Harunobu. Metropolitan Museum of Art, New York. The Henry L. Phillips Collection.

54. *Amazon.* Collection of Mrs Henry Pearlman, New York.

55. *The Dead Toreador.* National Gallery of Art, Washington. Widener Collection, 1942.

56. Cartoon of *The Dead Toreador,* by Cham, from *Charivari,* 22 May 1864.

57. *Dead Soldier,* Italian School, Seventeenth Century. The National Gallery, London.

58. *The Death of Caesar,* by Gérôme. The Walters Art Gallery, Baltimore.

59. *Autumn.* Musée des Beaux-Arts, Nancy.

60. *Portrait of Nina de Callias: The Woman with the Fans.* Musée du Louvre, Paris.

61. *Odalisque,* etching. George A. Lucas Collection, on indefinite loan from The Maryland Institute. Courtesy of The Baltimore Museum of Art.

62. *Dejeuner sur l'herbe.* Musée du Louvre, Paris.

63. *Surprised Nymph.* Museo Nacional de Bellas Artes, Buenos Aires.

64. *La Rivière,* from Pierre Dupont, *Chants et chansons,* Paris, 1855, IV, 135.

65. *Fishing.* Metropolitan Museum of Art, New York. Purchase Mr and Mrs Richard Bernhard Fund, 1957.

66. Illustration by Gavarni from Paul Huart, *Physiologie de la grisette,* Paris [1841], 86.

67. *Le Sauvage,* from Pierre Dupont, *Chants et chansons,* Paris 1855, I, 101.

68. *Ma nacelle,* by A. Lemud, from P. J. Béranger, *Oeuvres complètes,* Paris, 1856, I, 250.

69. *Olympia.* Musée du Louvre, Paris.

70. *Sujet gracieux,* by Achille Devéria, from Maximilien Gauthier, *Achille et Eugène Devéria,* Paris, 1925, opp. p. 80.

71. *Cats Meeting,* lithograph. Prints Division, New York Public Library. Astor, Lenox and Tilden Foundations.

72. *The Cookoo's Verse,* by Shunshó, from Philip Stanley Rawson, *Erotic Art of the East,* G. P. Putnam, Sons, New York, 1968, Plate XXIV.

73. *Portrait of Laure.* Private Collection, Switzerland.

74. *Blonde Nude.* Musée du Louvre, Paris.

75. *Dead Christ with Angels.* Metropolitan Museum of Art, New York. H. O. Havemeyer Collection. Bequest of H. O. Havemeyer, 1929.

76. *Christ Mocked.* The Art Institute

of Chicago. Gift of James Deering.

77. *The Execution of the Emperor Maximilian*. Städtische Kunsthalle, Mannheim.

78. *The Execution of the Emperor Maximilian*. Museum of Fine Arts, Boston. Gift of Mr and Mrs Frank Gair Macomber.

79. Detail of *The Execution of the Emperor Maximilian*. Museum of Fine Arts, Boston.

80. *The Execution of the Emperor Maximilian*. Ny Carlsberg Glyptotek, Copenhagen.

81. Fragment from *The Execution of the Emperor Maximilian*, National Gallery, London.

82. *The Execution of the Emperor Maximilian*, lithograph. National Gallery of Art, Washington. Rosenwald Collection.

83. *The Barricade*, lithograph. The Art Institute of Chicago. Gift of The Print and Drawing Club.

84. *Civil War*, lithograph. Collection of Robert Walker, Swarthmore, Pennsylvania.

85. *The Battle of the Kearsarge and the Alabama*. The Philadelphia Museum of Art. John G. Johnson Collection.

86. *The Battle of the Kearsarge and the Alabama*, from *Almanach: Magasin pittoresque*, XV (1865), 55.

87. *The Escape of Rochefort*. Kunsthaus, Zurich.

88. *Portrait of Henri Rochefort*. Kunsthalle, Hamburg.

89. Cartoon by G. Darre, *Le Carillon*, 16 July 1881.

90. *Nana*. Kunsthalle, Hamburg.

91. *Skating*. The Fogg Art Museum, Cambridge, Massachusetts. Collection of Maurice Wertheim, Class of 1906.

92. *Les Patineurs de la glacière*, from Emile de Labédollière, *Le Nouveau Paris*, Paris [1860], 201.

93. Illustration for *Le Fleuve* by Charles Cros, etching. Library of Congress, Washington. Rosenwald Collection.

94. Illustrations for *L'Après midi d'un faune* by Stéphane Mallarmé, wood engraving. George A. Lucas Collection, on indefinite loan from The Maryland Institute. Courtesy of The Baltimore Museum of Art.

95. *The Raven on the Bust of Pallas*, illustration for *Le Corbeau*, translated by Stephane Mallarmé from Poe, *The Raven*, transfer lithograph. Philadelphia Museum of Art. The Print Club of Philadelphia, Permanent Collection.

96. *Little Gilles*, by Thomas Couture. The Philadelphia Museum of Art. The William L. Elkins Collection.

97. *Odalisque*, Anonymous, French Nineteenth Century. The Cleveland Museum of Art. Gift of Leonard C. Hanna, Jr.

98. *Study for The Romans of the Decadance*, by Thomas Couture. Museum of Art, Rhode Island School of Design, Providence. Mary B. Jackson Fund.

99. Copy after Delacroix, *Barque of Dante*. Metropolitan Museum of Art, New York. The H. O. Havemeyer Collection. Bequest of Mrs H. O. Havemeyer, 1929.

100. Copy after Velasquez, *Infanta Margarita*. artist unknown. Private Collection, United States.

101. *The Reader*. The St. Louis Art Museum.

102. *The Spanish Ballet*. The Phillips

Collection, Washington.

103. *Lilacs and Roses.* Collection of Edwin C. Vogel, New York.

104. *Portrait of Clemenceau.* Musée du Louvre, Paris.

105. *Portrait of Vigneau,* ink drawing. The Baltimore Museum of Art. The Cone Collection.

106. *Portrait of George Moore in a Cafe.* Metropolitan Museum of Art, New York. Gift of Mrs Ralph J. Hines, 1955.

107. *Young Woman.* The Art Institute of Chicago. The Joseph Winterbotham Collection.

108. *Claude Monet in his Floating Studio.* Staatsgalerie, Stuttgart.

109. *Boating.* Metropolitan Museum of Art, New York. The H. O. Havemeyer Collection, Bequest of Mrs H. O. Havemeyer, 1929.

110. *Le Bon Bock.* Philadelphia Museum of Art. The Mr and Mrs Carroll S. Tyson Collection.

111. *Portrait of Stéphane Mallarmé.* Musée du Louvre, Paris.

112. *On the Banks of the Seine at Argenteuil.* From the Collection of the late Samuel Courtauld, London.

113. *Le Journal illustré.* The Art Institute of Chicago. Mr and Mrs Lewis L. Coburn Memorial Collection.

114. *Lola de Valence.* Musée du Louvre, Paris.

115. *The Little Cavaliers,* etching. Bryn Mawr College, Pennsylvania.

116. Page of sketches from Hokusai, *Mangwa,* Volume I.

117. Page of sketches from Hokusai, *Mangwa,* Volume I.

118. *Salamander,* wash drawing. Cabinet des dessins, Musée du Louvre, Paris.

119. *Fishermen off the Coast of the Province of Nizan,* by Hiroshige II. Yale University Art Gallery, New Haven.

120. *The Railroad.* National Gallery of Art, Washington. Gift of Horace Havemeyer in memory of his mother Louisine W. Havemeyer.

121. *Snowy Morning in the Yoshiwara,* by Torii Kiyonaga. Honolulu Academy of Arts. The James A. Michener Collection.

122. *Portrait of Emilie Ambre as Carmen.* Philadelphia Museum of Art. Gift of Mr and Mrs Edgar Scott (Reserving life interest).

123. *On the Beach at Boulogne.* Collection of Mr and Mrs Paul Mellon, Upperville, Virginia.

124. *Boats.* The Cleveland Museum of Art. Gift of J. H. Wade.

125. *View of the Universal Exhibition of* 1867. Nasjanalgalleriet, Oslo.

126. *Blue Venice.* Provident Securities Company, San Francisco.

Part I

" a 'realist' painter who took for his subject-matter the ordinary life of his own day.

— doesn't fall into tidy categories & definitions.

If the art criticism of the period does not seem to follow clear policies, it must be remembered that the issues were hardly clear. Even the die-hards were aware that crucial changes had already occurred. Political events had played an important part[3] and economic changes had brought a new public to the Salons. The situation was no less affected by the historical accident of the coexistence of two great masters of opposing aims—Ingres and Delacroix. Ingres was securely within the official structure, a member of the Academy since 1825. Delacroix, although accepted into the Academy only at the end of a brilliant career, was, nonetheless, successful in terms of official commissions and public admiration. Each in his own way continued the great traditions of the past, but they chose different models and thus predicted different paths for the future. By mid-century the lesson of landscape painting and growing tendencies toward realism added still further dimensions to the conflicting directions.[4] The academician might encourage the young artist to emulate Raphael and the ancients, but tastes were hardly restricted to these worthy models. The Venetians, Spanish, Flemish and Dutch masters, and the seventeenth-century French realists, all were widely admired.

An almost inevitable result of such diversification is compromise, and it is only as such that one can understand the 'juste milieu,'[5] a style which conflated romantic and classic while borrowing enough of popular realism to appeal to public tastes. The 'juste milieu' artists might well have offered the answer for the conservatives as well as the public had the works not so often fallen below expected standards of quality. The very ease of story and sentiment of these 'amiable eclectics'[6] which might appeal to the bourgeois public did not make for masterworks, and the style was condemned from all sides.[7]

If there was one view held in common by conservatives and radicals alike, it was that art was in a bad state and in urgent need of change. Great art was simply not being produced. For the conservatives man must be shown as noble, depiction of him must serve a moral purpose, and this could only be achieved by the perfection of nature toward the ideal already established in the great works of the ancients and Raphael. 'Beware of the modern ... invoke the antique.'[8] Simply to encourage a return to the past was to hold an untenable position, and conservative critics were hardly fools. They recognized two important things, first, that little of what was being produced in the noble manner was of the same quality as the art of the past, and second that the old themes were losing their meaning. The public, now both more numerous and less educated, did not know the biblical and mythological stories of

[3]See Sloane, *French Painting*, 19.

[4]For a full study of the various trends of the period see Rosenthal, *Romanticisme*. See also Max Friedlaender, *David to Delacroix*, Cambridge, Mass., 1952, 84–5.

[5]Boime, 10–11.

[6]Ibid., 188, n. 33. And see Baudelaire *Oeuvres complètes*, 924, 929–30.

[7]For a discussion of the quality of art at mid-century see Sloane, *Journal of Aesthetics*, 9, n. 31, Sloane, *French Painting*, 37 and Rosenthal, *Romanticisme*, 368.

[8]Eugène Fromentin, Letter to Jacques-Fernand Humber, 6 September 1872 in Louis Gonse, *Eugène Fromentin: Painter and Writer*, translation by Mary Caroline Robbins, Boston, 1883, 74–9, quoted in Linda Nochlin, *Realism and Tradition in Art: 1848–1900*, Englewood Cliffs, New Jersey, 1966, 25.

1. The Turning Point

' A VIGOROUS taste for reality, modern reality',[1] that is what Charles Baudelaire admired in Manet's art. Emile Zola, sure that Manet was one of the masters of the future, nevertheless saw him clearly as a child of his own time.[2] In the many years since these critics wrote of Manet, he has generally been thought of as a 'realist' painter who took for his subject-matter the ordinary life of his own day. Such a view seems to leave little mystery as to his aims, but the 'ordinary life' of Manet's day does not itself fall into tidy categories and definitions. If Manet was, in fact, a 'child of his own time', then what was the climate of that time for a developing artist? What, in fact, was the 'modern reality' which so appealed to his taste?

While all periods comprise elements of the past and elements of the future, in France at mid-century there was a sharp consciousness of imminent change — of new challenges to be met for the glory of the country. For some the past presented the model for a new ideal and offered a guide for the moral rectitude necessary for the continuation of a higher civilization; for others, strongly committed to the idea that progress toward an improved life for all could be achieved by following the lures of the new, the future offered hope and excitement.

Such ideas ran through the entire fabric of French thinking and were strongly felt in the arts and particularly in the questions of the appropriate education for the French artist. Art had a role to play in the life of the average citizen: it had long served the country and it was expected to continue to do so. The artist could not simply ignore the issues, and it could be assumed that Manet, a Frenchman of pride and intelligence, would have found himself caught up in the opposed views of his day, often as little able to resolve their contradictions as the philosophers, the critics and the historians. Surely there was much to encourage him in an enthusiasm for 'modern life'. It must be remembered, however, that the modern world was as frightening to some as it was promising to others. To speak in terms of radicals and conservatives is to over-simplify a complex situation. Highly aware of both past glories and a need for a competitive position in the modern world, the thinking Frenchman often took an ambivalent position.

[1]'Peintres et Aquafortistes' originally appeared in Le Boulevard, 14 September 1862. It is reprinted in Oeuvres complètes, 1146, and here quoted from Art in Paris, 218.

[2]Mes haines, 219, originally published in L'Evénement, 20 May 1866 under the pseudonym, Claude; 260, originally published as Edouard Manet, Paris, 1867.

historic painting, and the long explanations in the entries of the Salon catalogues interested them far less than contemporary history, or, better still, anecdotal genre. Earlier subjects had so lost their relevance by 1856 that Gautier described some historical landscapes he had just seen as being like wallpapers in provincial inns.[9] The use of classical subjects later became so debased that George Moore complained that the Salon was like a library of Latin verses composed by Eton and Harrow masters and their pupils.[10] The public and the artist alike were blamed for lack of education, lack of religion, lack of interest in the past, and worst, lack of 'moral sense'.[11] As Henry de Raincy said in 1860, only craft was being taught, not *art*. For him, as for many, 'art' meant noble forms and moral messages, and craft was simply a means to those higher aims.[12] Artists and writers of all persuasions shared a concern for the state of art. Delacroix despaired of the tastes of his day,[13] and Castagnary complained that the Salon of 1857 contained many works of talent, but few worthy of serious examination.[14] Writing on the Salon of 1861, Maxime du Camp expressed hope that a painter would appear to found a French school in the second half of the century, 'for the first half has fallen into imbecility'.[15] And Zola decried those who believed that the dignity of art would be offended if one lively work were introduced into the great communal graveyard of the Salon.[16] But what could be done? Fromentin put the problem clearly, 'We revolve in a vicious circle. Public taste is injured; that of the painters is so no less; and we vainly seek to know which of the two should seek to elevate the other. Sometimes we say that opinion ought to act on the quality of the work, and elevate it; and again, according to a new idea, it must be the works themselves that should act upon opinion and convert it by good example'.[17]

Despite strong pessimism about the degeneracy of art, the conservatives were not reduced to despair, because they believed that art, in the larger sense, could be learned, and therefore could be taught,[18] and following that view, that the government, if it would, could both urge and enforce a new vitality in an art firmly based on the principles of the past. The familiar exhortation of M. Fould at the prize-giving ceremony opening the Salon of 1857, urging young artists to choose noble themes and to avoid the dangers of public taste, should be seen as a sincere effort to meet a very real problem.[19]

The traditionally accepted system for training the young French artist depended heavily on a series of prizes, allowing the more able to move step

[9]Théophile Gautier, *L'Art moderne*, Paris, 1856, 286. Years earlier, in 1837, he had complained that artists were ignorant of historical accessories. See *Fusains et eaux-fortes*, Paris, 1880, 159. On the decline of interest in earlier themes, see Sloane, *French Painting*, 38, n. 7.

[10]Moore, *Modern Painting*, 63.

[11]Sloane, *French Painting*, 40, offers a clear explanation of the conservative position.

[12]Henry de Raincy, 'Beaux-Arts', *Chronique universelle*, I (1860), 111–12. See also Sloane, *French Painting*, 105.

[13]*Journal de Eugène Delacroix* (3 vols.), Ed.

André Joubin, Paris, 1932, III, 60–62, 4 February 1867. Also see Rewald, 20–21.

[14]Jules Castagnary, *Salons* (2 vols.), Paris, 1892, I, 12.

[15]Sloane, *Journal of Aesthetics*, 9.

[16]*Mes haines*, 224, from *Mon salon*, 1866.

[17]Fromentin, 93–5, 98–100, 108–9, here quoted from Nochlin, *Realism*, 22.

[18]Sloane, *French Painting*, 37, n. 4.

[19]Speech printed in *Explication des ouvrages de Peinture, Sculpture, Gravure, Lithographie et Architecture des artistes vivants, exposés au Palais des Champs-Elysées, Paris*, 1859, pp. ix–x. See Hanson, *Manet*, 15.

by step to a securely recognized position. Official commissions, likewise, were frequently awarded on the basis of open contest.[20] Despite the fact that this system did not seem to be successful, the conservative belief in awards was not shaken. As late as 1869 the government, 'itself confessing this decadence, instituted the extraordinary prize of one hundred thousand francs to raise the level of art.'[21]

Such measures did little to reverse far stronger pressures for change. With the new public came a new patronage. Smaller works for individual owners were often purchased after their completion, rather than commissioned in advance. Ingres, despite his lifelong fight for 'the great' and 'the beautiful' saw the Salon become 'no more than a picture shop' with 'business rules instead of art'.[22] 'Alas, we have fallen low ... Art has become small and commercial' complained Manet's teacher, Thomas Couture.[23] Blaming the situation on the fact that the revolution had brought many foreign buyers to France, creating a market of collectors and speculators, and particularly for works of small dimensions,[24] he was concerned about the dire effects of the degeneracy of art. If art were for the purpose of serving the privileged alone, this might be less crucial, but 'art in our country has a direct effect on all French production. A lowering of the standards of art means a lowering of the standards in industry.'[25] More than one critic commented on the new commercialism. Writing on the Salon of 1857, About praised an artist who had submitted a history painting, an academic sketch, and a serious portrait in the midst of a flood of pretty things which made the Salon a 'great salesroom'.[26] Manet himself thought of larger works as 'white elephants', preferring to make smaller works which would sell.[27]

The Salons had, in fact, been transformed. Picture merchants had begun to develop in the 1830s and exhibitions became more and more important to commerce. Artists could hazard the exhibition of large and unsaleable works only if they had prior commissions or hoped to sell to the state.[28] The picture shop was hardly necessary for the artists already in demand, and more of the lowered quality of the Salons at mid-century can be attributed to the artists who withheld their works than to those who submitted them. About, in fact, began his review of the Salon of 1857 by listing the important men who did *not* exhibit, explaining that some were busy decorating public buildings, others simply resting on their laurels.[29] Zola thought the common man content with the insipid and the banal. 'They can't stand strong truths. It's

[20]Boime, 8, 11.

[21]Sloane, *French Painting*, 42–3. Sloane quotes and translates Charles Blanc, *Les Artistes de mon temps*, Paris, 1876, 191. 'Lorsque nous remarquions, lorsque nous disions que la peinture française tombait en décadence, parce que les progrès faits par nos artistes dans les genres inférieurs s'étaient accomplis aux dépens du grand art.'

[22]Rewald, 20.

[23]Couture, *Méthode*, 329.

[24]Ibid., 146–7.

[25]Ibid., 375.

[26]Edmond About, *Nos artistes au Salon de 1857*, Paris, 1858, 63–4.

[27]Letter from Manet to Fantin-Latour, 26 August 1868, Boulogne-sur-Mer, here cited from Courthion and Cailler, 16. For the original text of the letter see, Moreau-Nélaton, I, 103.

[28]Rosenthal, *Romanticisme*, 60.

[29]About, 1–2.

a simple matter of education. When they see a Delacroix, they hiss.'[30] 'There
is no one to guide the crowd, and what can they do in the great hubbub of
contemporary opinions? Art is fragmented. A great kingdom is broken up to
form a group of little republics. Each artist has drawn the crowd to himself,
flattered it, given it the playthings it loves, gilded and decorated with pink
ribbons. Art here has thus become a vast boutique of sweets, with candies for
all tastes.'[31] He thus signaled not only the lack of public respect for works of
real quality, but also that there existed no significant trend which might help
to guide their tastes.

As early as 1845 Thoré had complained that among the thousands of works
shown in the Salons, there were not six of them united in the same principle,
the same aim, or the same practice. 'Quelle diversité!' He had explained that
after the death of the heroic school of the Empire, and the birth of two new
schools, that of Géricault and Delacroix, and that of Ingres, French painting
was 'without system, without direction, and abandoned to individual
fantasy.'[32] Edmund About had much the same thing to say twelve years later:
'When you enter one of our exhibitions, it is not nature which jumps to your
eyes, but a conflict of ideas . . . A small minority groups itself around M. Ingres
while admiring out of the corner of the eye, the genius of M. Delacroix . . . The
rest is tumult and confusion.'[33]

For Thoré there was reason for hope. 'This is not bad, assuredly, because
originality is the first condition of art.'[34] Others did not see diversity as
originality. Théophile Silvestre complained that the critics don't know what
they want; their language is contradictory and obscure; everyone from the
butcher to the poet wants to be a connoisseur; and French art, 'deprived of
its originality, seems to have renounced the privilege of exercising any influence
in our epoch.'[35] If Thoré could see 'originality' in the Salons and Silvestre none
at all, it is because they were talking about different things, or, to be more
exact, they were looking for different qualities in a work of art.[36] If one believed
that art was a conveyor of moral truth, then the pursuit of a more visual kind
of truth in the transcription of nature might well seem to be an exercise devoid
of originality or thought. On the other hand the new subjects and styles,
deprived of formal or moral idealism might seem original in offering a new
base for the potential development of a meaningful direction for art. Thus,
while Thoré and others could find divergence or originality in the Salons,
Champfleury could complain of 'the mediocre art of our exhibitions in which a

[30]*Mes haines*, 279.

[31]Ibid., 277–8. Years later George Moore
still felt the same concerns. 'What an absence
of fixed principle! Curiosity, fever, impatience,
hurry, anxiety, desire touching on hysteria.
An enormous expenditure of forces, but spent
in so many different directions.' *Modern
Painting*, 59–60.

[32]Theophile Thoré [W. Bürger, pseudo-
nym], *Salons*, Paris, 1868, 114–15.

[33]About, 37. For original French see Han-
son in Finke, 134–5.

[34]Thoré, 1868, 114.

[35]'La critique d'art et l'école française',
La Chronique illustrée, I (1860), 217.

[36]Throughout his book, *French Painting*, Jo-
seph Sloane paints out the differences between
new formal developments and new attempts
to deal with historical subject matter. If
the latter direction was pursued by less gifted
artists, it was no less a real direction, and it
must be understood as such if the criticism
of the period is to be comprehensible.

universal cleverness of hand makes two thousand pictures look as if they have come from the same mould.'[37]

If there was some unity in the conservatives' plea for a return to old values, there was little unity in the positive appeals for a new art. The artist was bombarded on all sides with divergent opinions, many expressed with considerable passion. The critics, of course, saw their role as advisers to the public on the one hand and the artists on the other. Those who found talent in Manet's early works showed a growing irritation with what seemed to them his stubbornness in rejecting their advice—a stubbornness which seemed to them more than a personal affront, and a refusal to cooperate with the development of what they considered an appropriate art for France.[38] While some specific criticisms were repeated in more than one review, encouragement to try new subjects and new methods was vague and contradictory. Much was said of aims, but what the new art might actually look like remained largely the private visions of individual writers.

Joseph Sloane offers a useful simplification of the varying positive views toward a new art:

> The first general theory was that society, in some fashion, would automatically produce an art suitable to its nature, but that the form which this art would take could not as yet be determined. The second, rather closely allied to the first, was that the needs of the new order would specifically produce new ideals and a new effective symbolism to replace the ones which were no longer usable; the third was that art would become merely a frank exposition of the social scene as it was i.e. that art would shift to contemporary subjects and would adopt a rather bold and direct attitude toward them, leaving ideal beauty and morality to fend for themselves; and lastly, that modern art would mainly be the product of the artist's personality, in which subject-matter would be unimportant in the traditional sense and the painter's temperament decisive.[39]

With the advantage of hind-sight, we can see the correctness of all these predictions. At the time they represented different paths, but ideas shifted within these general frames, and crossed over their borders, creating highly complex patterns of thought most of which were entangled with positivistic philosophy and the firm belief in science as beneficial or even beneficent. These new positions brought with them new tastes for the arts of the past, particularly new respect for works which documented their own times and cultures. As examples of how an art reflects its age, they were considered good models to guide French artists to an effective style for the modern period. Their divergence was great. French, Spanish, and Dutch realist painting of the seventeenth century was admired, and Venetian painting was seen as

[37]Jules Champfleury, *Histoire de l'imagerie populaire*, Paris, 1869, xii, here quoted from Rewald, 20.

[38]This change in attitude on the part of the critics can be followed in Hamilton, particularly through pages 129–49.

[39]Sloane, *Journal of Aesthetics*, 11. These ideas are enlarged in Chapter V of *French Painting*.

direct realism, and not, as we know today, involved in covert and complex symbolism. Even the Japanese print could appeal on the grounds that it showed everyday life, albeit an everyday life far from that of western man.[40]

The changes were all under way for some time, but the years immediately after the Exhibition of 1855 seem to mark the turning point toward a commitment to a new art. Although Castagnary complains about the lack of outstanding work in the Salon of 1857, he says that it marks the precise point which separates a period already past and a period new-born. For him there is a 'profound and intimate solidarity between artistic evolution and changes in society itself. If progress exists for the latter ... it exists also for art and for the same reasons ... This progress is not yet manifest in the works produced ... but it shows itself in the inspired idea.'[41]

Thoré agreed with Castagnary about the moment of change. He explains that at the Exhibition of 1855 picturesque and literary romanticism triumphed, but 'what has won has died. It is an inflexible law. Vicit, ergo vixit.'[42] But romanticism was only a preparatory instrument for a new art, truly human, expressing a new society. 'There is now in France, and everywhere, a singular inquietude, an irrepressible aspiration toward a life essentially different from the life of the past.'[43] He agreed too on the nature of the new art. Castagnary's remark, 'A new period of art begins with a new object—man',[44] is similar to Thoré's well-known statement: 'Once art was made for gods and princes. Perhaps the time has come to make THE ART FOR MAN?'[45] Neither Thoré nor Castagnary thought that the new art had arrived, only that a new need was obvious, and that a new direction for meeting that need had begun.[46]

Ideas about this new art for modern man were frequent before the pregnant moment recognized by Thoré and Castagnary. Two concepts were essential to a positive outlook; the acceptance of the leveling of society through democracy; and the belief in progress to be achieved through science and industry. Nevertheless, within the views of a single man, one often found ideas working in contradiction or compromise. Thus Couture, who approved of the noble subjects of the past, could encourage his students to paint men on a scaffolding, or a locomotive, and to draw quick sketches of people in the streets.[47] He conveniently saw 'perfection' as much in a head of Rembrandt as in a fragment of Phidias, explaining that it is ourselves that we see in Rembrandt, while Phidias shows us what we ought to be.[48]

Essentially the 'new art', as it could be seen at mid-century, was largely demonstrated by an increased interest in genre paintings. More were shown in the Salons, more were purchased, and more were commented on by serious

[40]See below, Part II, 74–5, 80–82, 92; Part III, 186–7. Couture certainly looked on Venetian art as realistic. See *Couture par lui-même*, 125, 137.

[41]Castagnary, I, 12, 13.

[42]Thoré, 'Nouvelles tendences de l'Art,' (1857), xiii.

[43]Ibid., xiv.

[44]Castagnary, I, 15.

[45]Thoré, Introduction, ix.

[46]Castagnary, I, 13; Thoré, xiii–xliv. Baudelaire in his 'Salon of 1846' stated that a great tradition had been lost and that a new one had not yet been established. *Art in Paris*, 116.

[47]Couture, *Méthode*, 254–6, and see below Part I, 14 and Part II, 128.

[48]*Couture par lui-même*, 139.

critics. The proportion of landscape paintings in the Salons had markedly increased in the middle of the 1820s, history painting declined slowly at a fairly regular rate through the century, portrait and still life remained somewhat consistent, but genre paintings increased from approximately 6 per cent of the exhibited works in 1819 to about 18 per cent in 1861. These figures are far from accurate as they depend on titles many of which are deceptive. They nevertheless show a clear trend which reached a height soon after the revolution of 1848. A second change was the tendency for genre pictures to be less and less moralizing and narrative, and more and more records of typical activities and individuals, such as gypsies, peasants, fishermen, orphans, and beggars.[49] Such depictions are not unknown to earlier art. The seventeenth century produced many genre paintings of this kind, and in France the examples of Callot's drawings of representatives of various professions, or the remarkable genre paintings of the Le Nain brothers are outstanding examples. It is no accident that art historians and critics turned their interests to just these developments in past art at the same time. Champfleury's studies on the Le Nain of 1852 and 1860 were to make the works of these artists acceptable and available models for the aspiring modern genre painter. Despite earlier models in high art, however, the general trend toward the depiction of typical genre scenes and individuals seems to have received an even greater impetus from earlier illustrations in the French press.

A new and optimistic belief in democracy was certainly a strong force in the years just before the revolution of 1848, and although the socialist aspects of the concern with common man were repressed after the revolution, the general interest was not. The first years of the 1840s saw an explosion of illustrated literature on professions, family roles, urban and provincial types: the beggar, the doctor, the nun, the mother-in-law, the dandy, the *grisette*, the Breton peasant. While some narrative and anecdotal examples were to be seen, many of the illustrations of these types and the texts which accompanied them, were reportorial, depicting with dogged clarity both facts, and prejudices believed to be facts. Individual figures or small groups of figures were usually shown standing in front of the merest indication of typical landscape, their costumes, tools, and other appurtenances clearly depicted. Sometimes the poses would reflect the nature of the profession or role in life; more often, they were drawn from a small repertory, regardless of the age or profession of the person shown, much as fashion or travel illustrations sacrifice dramatic elements in favor of 'accuracy'. While often lacking in real accuracy, the aim and style of presentation was to join with the great advances of science toward the education, and therefore the elevation, of the average man.

Images of this type were widespread. Typical examples are the drawings and verbal sketches published in small pocket-size books under the titles

[49]For more extensive discussion of these changes see Hanson, *Museum Studies*, 64–5.

'Physiologie' and 'Physionomie' which began about 1840,[50] and in larger
format in *Les Français peints par eux-mêmes*, which called itself a study of public
and private customs. It was first published serially in 1839, and then in book
form in several editions between 1840 and 1876.[51] The texts, written in 1839
and 1840, mark an early period for the warm encouragement of an art for
modern life or as Jules Janin said in the introduction, 'a magic lantern show
of the new world'.[52] 'My dear contemporaries, that which you do today will
be history some day. In a hundred years one will speak of as extraordinary
your asphalt squares, your little steam boats, your railroads so badly made,
your gas so lacking in brilliance, your narrow exhibition halls, your modern
drama so moderate, your vaudeville so reserved and chaste.'[53] A chapter on
The Man of the People shows new hope for the worker. 'Serf in 1600, subject in
1789, citizen in 1793, the people were crowned emperor in 1804 ... The man
of the people will become manufacturer, artist, inventor. He will have fortune
and position.'[54] The middle class, too, was to play a new role. In the past art
had been for kings and princes, rare and expensive, now there were many
artists, and pictures in every house, the theater, the town hall. 'A bourgeois
art is thus created for the bourgeois, charming and commendable.'[55]

Many critics despaired of such popular tastes. For Charles Blanc, 'progress
made by artists in the inferior classes has been accomplished at the expense
of great art.'[56] Others felt the change inevitable. Edmond About, while an
admirer of Ingres, thought that it was as reasonable to paint a ragpicker as a
king, 'History painting, after having reigned sovereign, has left the field free
for genre painting.'[57] For George Moore, the inevitable was depressing indeed.
He complains that

> universal uniformity is the future of the world, the duke, the jockey boy, and
> the artist are exactly alike; they are dressed by the same tailor, they dine at
> the same clubs, they swear the same oaths, they speak equally bad English,
> they love the same women. Such a state of things is dreary enough, but
> what unimaginable dreariness there will be when there are neither rich
> nor poor, when all have been educated ... Universal Education, with
> which we are threatened, which has already eunuched the genius of the

[50] The popularity of these studies is attested
to through one of the characters in Flaubert's
Education sentimentale, Paris, 1869, the story
of which was set between 1840 and 1851.
M. de Cisy, who devoted his attention to
literature, was astonished at not seeing on
Frederick's table 'some of those new physio-
logical studies—the physiology of the smoker,
of the angler, or the employee at the barrier.'
Quoted from *Sentimental Education*, New York,
1957, 179.

[51] *Les Français peints par eux-mêmes*, Paris,
Curmer, in fascicules, 1 June 1839–6 August
1842. The same bound as a nine-volume work
1840–42. *Pictures of the French: A Series of
literary and graphic delineations of the French
Character*, abridged English translation in

one volume, London, Tegg, 1841. Abridged
French edition in two volumes, Paris, Furne
et Cie., 1853. Remainder sheets of Volume II,
1853 edition, reissued, Paris Delahays, [1858].
Combined 1855–8 edition, Paris, Blot, 1861.
Abridged edition with new format and new
illustrations added, in four volumes, Paris,
Philippart, [1876–8]. References below will
be to the last edition unless otherwise noted.

[52] *Les Français*, I, xvi.

[53] Ibid., I, vi.

[54] Ibid., I, 7–8.

[55] Ibid., I, 9.

[56] *Les Artistes de mon temps*, Paris, 1876, 191.
Here quoted from Sloane, *French Painting*,
42–3.

[57] About, 8.

last five and twenty years of the nineteenth century, and produced a limitless abortion in that of future time.[58]

Or elsewhere,

> Democratic art! Art is the direct antithesis to democracy ... The mass can only appreciate simple and naive emotions, puerile prettiness, above all conventionalities ... What was most admired at the International Exhibition?—*The Dirty Boy*. And if the medal of honor had been decided by a plebiscite, *The Dirty Boy* would have had an overwhelming majority ... If the people could understand Hamlet, the people would not read the *Petit Journal*.[59]

But the people *were* reading *Le Petit Journal* and a great many other similar periodicals, and even the critics were giving serious consideration to the illustrators and writers of popular literature. The works of Henri Monnier are a case in point. Monnier was well known for his *Scènes populaires*, dramatic skits on everyday life, and for his illustrations which accompanied them and were used in other publications such as *Les Francais peints par eux-mêmes*. While to our eyes today his work seems negligible, it was immensely popular and for most viewers seemed to have a ring of truth. Gautier writing for *Le Monde dramatique* in 1835 said 'I do not believe that there has ever been made anything more *natural*, in the strict meaning of the word, than the *Scènes* of Henri Monnier ... I admit that it is impossible for me to understand the way in which Henri Monnier proceeds, or the point of view from which he works. What he does is neither lyric, nor dramatic, nor even comic. It is the thing, nothing more, nothing less.'[60] In 1857 Monnier was still being discussed, this time by Edmond About, 'Those who see no reality in the tragedies of Racine, proclaim highly that M. Henri Monnier has captured nature.' About feels that Monnier has a 'certain finesse of observation', but that he catches only the surface aspects of his characters. 'His heroes have exactly the costume, the gesture and the language of their occupation.' One finds nothing of the eternal and immutable which great artists know how to represent. 'I don't doubt that M. Henri Monnier would prefer to do better if he could. This unpretentious realist has set out bravely in the pursuit of nature; he has seized one aspect of it, as a child who runs after a lizard and catches it by the tail.'[61] The tail comes off in his hand, and he mistakes it for the whole lizard. Although Taine predicts a new art for the new age,[62] in *De l'idéal dans l'art*, he speaks out firmly against reviews filled with modish illustrations which express only passing tastes. He places on the lowest rung of his moral heirarchy, works which

[58]Moore, *Confessions*, 142–3.
[59]Ibid., 100.
[60]Gautier, *Fusains*, 28–9.
[61]About, 22–3.
[62]'We have only to open our eyes to see the change going on in the condition of men, and consequently in their minds, so profound, so universal, and so rapid, that no other century has witnessed the like of it...What its forms will be and which of the five great arts will provide the vehicle of expression for future sentiment, we are not called upon to decide.' Hippolyte Adolphe Taine, *Philosophe de l'art* (2 vols.), Paris, 1917, I, 106, here quoted from *Lectures on Art* (2 vols.), New York, 1875, I, 162–4.

present ordinary life[63] of which, 'Nowhere can you find a more complete assembly than in the *Scènes de la vie bourgeoise* of Henri Monnier.'[64] He goes on to say that almost all great writers use secondary figures, and great artists show mediocre and ugly characters, but they use them to set the main figures into relief. Otherwise such figures, 'abortive in their character and distorted in their condition', simply produce repugnance in the spectator.[65]

Despite such views, there is every evidence that the bourgeois found such pictures fascinating indeed. Daumier, Gavarni, Eugène Lami, to name only a few in addition to Monnier, produced the images familiar to the average man, and were to play an important role in the transformation of both subject-matter and style in the new art to come.

The concept of 'modern life', however, was not just a concern for the customs and adventures of the average man. It held instead the far more exciting promise of a new and better material existence. A poem of 1859 from the first issue of an ephemeral magazine entitled *La Vie moderne*, pointedly captured this feeling:

> Time has doubled its course
> Humanity rushes headlong
> All the roads have become short
> The ocean no longer has any limits at all
>
> Life was long in the days of old
> On the slope it was dragged along
> We now live more in one month
> Than our ancestors lived in a year.[66]

Théophile Gautier was one of the first to write on the poetry of industrial progress. For him, the locomotive was the modern Pegasus, and as early as 1837 he wrote, 'the face of the world will be regenerated by this precious invention.'[67] For him the horse would soon become like the dinosaur; the ideal waiting room would be painted by the same artists who decorated the Opéra.[68] But he feared the enormous costs of railroad construction and

[63]'All things being equal otherwise, as the character brought to light by a painting or statue is more or less important, the painting or statue is more or less beautiful. That is why one finds on the lowest level those drawings, water-colors, pastels and statuettes which depict the man not as man, but as clothing, especially the clothing of the day.' Taine, *De l'idéal dans l'Art*, Paris, 1867, 71.

[64]Ibid., 96.
[65]Ibid., 97.
[66]Here quoted from Eugène Hatin, *Bibliographie historique et critique de la presse périodique française*, Paris, 1866, 540.

Oui, le temps a doublé son cours,
L'humanité se précipite.

Tous les chemins deviennent courts.
L'océan n'a plus de limites!

La vie était longue autrefois;
Sur la pente elle est entraînée;
Nous vivons plus en un seul mois
Que nos aieux dans une année!

[67]Gautier, *Fusains*, 187. The idea was certainly pervasive if Flaubert in *Sentimental Education*, can have his artist, Pellerin, paint a picture entitled *La République, ou le Progrès, ou la Civilization*, depicting Christ driving a locomotive through a virgin forest. *L'Education sentimentale*, Paris, 1922, 360. For Manet's view of railroads, see below, Part II, 128.
[68]Gautier, *Fusains*, 190–95.

embraced even more warmly the prospect of future travel by air. He saw the
balloon as far less damaging to the face of the earth; and once the balloon
could be directed in its course, he felt that man would become the master of
the planet, natural boundaries would fade away, and there would be no more
wars. It is interesting that although prizes could not spur on the young artists
of the age, Gautier should suggest that the government offer 25 million francs
to the man who could find a way to steer the balloon.[69] In his essay 'The
Republic of the Future', of 1848 he talks of other matters as well. The Republic
would break barriers, open all doors, offer facilities and training to everyone,
and then let social action take place. He sees a world of fine manners, 'elegance
and art go well with liberty', and believes that the absence of a court with its
king and palaces will result in the construction of great public buildings
needed for the new social life of the people. 'We firmly believe that the artists
will find as noble forms for these popular Versailles as were previously invented
for the fantasies of Louis XIV.'[70] This idea had already appeared in 1841 in
Jules Janin's introduction to *Les Français peints par eux-mêmes*.[71] It appears again
in Couture's advice to his students when, recognizing the changing world,
he says that the railroads and the great businesses will give important work to
the artist, and the state will no longer have to nourish monumental art alone.[72]
According to Gautier the machine would play an important role in this
fortuitous change. From slaves, to serfs, to workers, humanity would emanci-
pate itself. 'Then the iron arms [of the machine] will replace the frail arms of
man. Machines will hereafter perform all the toilsome, boring and repugnant
tasks ... The republican, thanks to his helots of steam will have the time to
cultivate his field and his spirit.'[73]

Such encouraging hopes passed quickly into popular imagery, both visual
and verbal. Pierre Dupont's collection of songs echoed public sentiment, and
Dupont's preface, written in 1851, almost uses Gautier's words: Dupont
predicts that there will not be one helot left in the modern republic. 'It is
necessary to break with false traditions and inaugurate in the world through
work, through science, and through love, the reign of truth.'[74] Gautier's ideas
are reflected not only in the preface but in the songs themselves. *Le Voyageur à
pied* meets a carter along the road:

> With a carter he took up company
> Laughing at the bitter scepticism of that old miscreant who denied
> The success of the railroad.
> He answered him: What will happen
> When balloons have cleared for themselves
> A new route in space
> Replacing the cart and the carter?[75]

[69]Gautier, *Fusains*, 'A propos de ballons'
(1848), 260–64.
[70]Ibid., 234–5.
[71]I, 9.
[72]Couture, *Méthode*, 148.

[73]Gautier, *Fusains*, 237–8.
[74]Pierre Dupont, *Chants et chansons* (4 vols.),
Paris, 1855, Preface, July 1851, 24.
[75]Ibid., IV, 25–8. For original French see
Hanson in Finke, 137.

A proliferation of books and articles on science attest to the public interest in new discoveries. Particularly popular were Guillaume Louis Figuier's *Histoires des merveilleux dans les temps modernes, Les Mystères de la science,* and *Les Nouvelles Conquêtes de la science*, all of which were published in numerous editions.[76] For the city dweller one of the most exciting of the inventions discussed was the electric light. According to an article in *La Vie moderne* in 1879 it was to bring progress to art, or more accurately to the appreciation of art by the average man. This 'sparkling light' revealed paintings in their true brilliant colors. The range of tints distorted by the heavy reddish glow of gas light could now be seen with all their nuances. 'These rays are identical to those of daylight!'[77]

While the people seem to have embraced science warmly, fears were voiced from several quarters. The increased doubt which accompanied scientific education brought 'eternal values' into question, and as Sloane has pointed out the heavy price of progress could be the 'surrender of moral certainty and the loneliness of spiritual individualism.'[78] George Moore liked progress no better than he liked democracy. By the time he wrote his *Confessions* in 1888, he mourned the bad taste of industrial production, 'The world is dying of machinery; that is the great disease, that is the plague which will sweep away and destroy civilization; man will have to rise against it sooner or later ...'[79] Couture urged the truly gifted artist to seek resources within himself, not in Science. 'One can even say, but on pain of being stoned, that science has become the original sin of civilized man, which, in its intricacy, destroys the only true guide of genius.'[80] Writing on the Exhibition of 1855, Baudelaire is most eloquent in his outcry against 'progress',

> that gloomy beacon ... Ask any good Frenchman what he understands by 'progress'. He will answer that it is steam, electricity, and gas—miracles unknown to the Romans—whose discovery bears full witness to our superiority over the ancients. Such a darkness has gathered in that unhappy brain, and so weird is the confusion of the material and the spiritual orders that prevails therein! ... I leave on the side the question of deciding whether, by continually refining humanity in proportion to the new enjoyments which it offers, indefinite progress would not be its most cruel and ingenious torture; whether, proceeding as it does by a stubborn negation of itself, it would not turn out to be a perpetually renewed form of suicide, and whether, shut up in the fiery circle of divine logic, it would not be like the scorpion which stings itself with its own terrible tail—progress, that eternal desideratum which is its own eternal despair.[81]

[76]Particularly popular were works like Louis Figuier's *Les Merveilles de l'industrie*, Paris [1875], *Les Merveilles de la science* (4 vols.) [1867–69], and *Les Grandes Inventions anciennes et modernes dans les sciences*, Paris, 1867, which attempted to discuss all aspects of human progress.

[77]Henry Vivarex, 'Chronique scientifique: La lumière électrique et de l'art', *La Vie moderne*, I, 8 (27 December 1879), 605–6.

[78]Sloane, *French Painting*, 41.

[79]Moore, *Confessions*, 101.

[80]*Couture par lui-même*, 110.

[81]Baudelaire, 'Exposition universelle, 1855', *Art in Paris*, 125–7.

One of the most exciting scientific developments of the period, and one which was to serve even the most traditional of artists was photography.[82] Baudelaire was 'convinced that the ill-applied developments of photography, like all other purely material developments of progress, have contributed to the impoverishment of the French artistic genius, which is already scarce.'[83] Ingres, possibly as early as 1841, used photographs of his sitters in painting portraits,[84] but his antipathy for science and mechanical processes led him to sign a petition to the government in 1862 protesting against a court decision which would have protected photography as if it were an art.[85] Turning the tables, Edmond About remarked, 'I don't blame the painters who are inspired by photography. Photography is good; it is of the school of M. Ingres; it excels in rendering details without breaking the masses.'[86] Generally popular with the middle classes, from which it developed much of its aesthetic, often attacked for its mechanical aspects and the lack of those very human qualities which give painting a spiritual influence on mankind, photography nevertheless was at times viewed in generous and grandiose terms. Philippe Burty wrote in the *Gazette des Beaux-Arts* in 1867 that photography has an immense influence on the human spirit since it educates the eyes to see new truths.[87] Burty's article is entitled 'La gravure et la photographie',[88] and it involves an aspect of the history of photography too often forgotten. The public had depended on engravings and lithographs for the many inexpensive pictures which decorated their ephemeral reading, as well as the illustrations in fine books, wherever an image needed to be repeated in large numbers. In the early years of photography it was difficult to make more than a few prints, some processes producing only one, and methods for reproducing photographs in printing processes suitable for large editions such as newspapers had yet to be developed. Photographs were often carefully copied by trained engravers for this purpose,[89] and Burty saw hope for the photograph if the image could be fixed 'at the printers, with the aid of flat inks'. He clearly saw the connections between engraving (speaking of the sun as the engraver of a photograph), and lithography which he referred to as 'photography prepared on a stone'.[90] The struggle to develop the new scientific method of securing images which could be produced in large enough numbers so that it could be used to inform the masses was as important at mid-century as the aesthetic effects which the photograph produced. The concern of the public, like that of many writers, was to record the age, and the photograph was eminently suited to that task. As a by-product, it exerted a profound influence on human vision, and thus on painting. Nature was now seen not only through the human eye but through the eye of the mechanical cyclops whose influence we still have not learned to ignore. We have, in fact, learned to live with it so amiably, that

[82]For a full discussion of the relationship between photography and painting see, Aaron Scharf, *Art and Photography*, Baltimore, 1969.

[83]'The Salon of 1859', *Art in Paris*, 153.

[84]Scharf, 26–7.

[85]Ibid., 116–17.

[86]About, 'Salon of 1857', 158.

[87]Burty, 271.

[88]Ibid., 252–71.

[89]Ibid., 268.

[90]Ibid., 270.

we are far less aware of the faults and limitations of photography than the nineteenth-century man for whom it was still a scientific marvel, and thus a symbol of a better life. In his day controversies over the various roles of the photograph, and over its value to art raged with considerable fire and lack of consistency, but regardless of philosophical standpoint, the general public embraced the photograph as warmly as the popular illustration — and often for the same reasons.

critics & friends influenced Manet's thinking

concert in The Tuileries 1862

↓ relation w/ friend

ture

rent forces. It is
riters whom he
his works. Their
present serious
he depiction of
e of encourage-
hat he accepted
ions, but a high
an be seen that
a new form of

p------ ---- --- ------, but developing gradually and logically through the combined forces of many influences, some of them the views of contemporary writers. It is therefore of value briefly to touch on the relevant ideas of those most likely to have influenced his thinking, while in no way attempting to sum up their philosophical and aesthetic positions.

Manet's painting, *Concert in the Tuileries* (Col. Pl. I), depicts a casual assembly of artists, musicians and writers, his friends and associates in the early years of his career. Among them is Charles Baudelaire whom Manet had met only a few years before the picture was painted in 1862,[91] just about the time when Baudelaire was committing to paper his essay, *The Painter of Modern Life*. While it was not published until 1863, there is evidence that it was written in 1859,[92] and some of the ideas it put forward would have already been available to Manet in Baudelaire's earlier writings, if not simply from the conversations they surely shared. In his *Salon of 1845* he had first written of the 'heroism of modern life', and had heralded the painter 'who will know how to wrest from actual life its epic side, and make us see and understand with color and with drawing how grand we are in our neckties and our varnished boots.'[93] A year later he devoted a section of his *Salon* to the subject, 'On the

[91]Sandblad (55–8) says that they met in the late 1850s. See also Hamilton, 28–37, for Manet's relationship with Baudelaire.

[92]*Le Peintre de la vie moderne* was first published in *Le Figaro* on 26 and 29 November and 3 December, 1863. It is believed from Baudelaire's correspondence that it must have been written in November 1859 to February 1860

(*Oeuvres complètes*, 1711, n. 1152). The painter of modern life was not identified as Constantin Guys until the re-publication of the work in 1869 in *L'Art romantique*.

[93]*Oeuvres complètes*, 866. For another translation see *Art in Paris*, 32. Translations are by the author except where English editions are cited.

Heroism of Modern Life'.[94] It is here that he defines his conception of beauty.

> Since all centuries and peoples have their own form of beauty, so inevitably
> we have ours. That is the order of things. All forms of beauty, like all possible
> phenomena, contain an element of the eternal and an element of the
> transitory ... Absolute and eternal beauty does not exist, or rather it is
> only an abstraction skimmed from the general surface of different beauties.
> The particular element in each manifestation comes from the emotions;
> and just as we have our own particular emotions, so we have our own beauty.

He goes on to talk of modern dark clothing, 'the outer husk of the modern
hero', as possessing a 'political beauty, which is an expression of the public
soul'.[95]

While many of Baudelaire's ideas change and develop over the years (for
example his views of the bourgeoisie), his later criticism is remarkably con-
sistant with the concept of beauty set out in the *Salon of 1846*.[96] In *The Painter
of Modern Life* he reiterates his theory of beauty, rejecting the absolute and
stating again the double nature of beauty, composed as it is of the variable
and the eternal. The variable or circumstantial elements of beauty are to be
found in the outward aspects of an age, 'its fashions, its morals, its emotions'.[97]
Thus when he spoke of the 'Heroism of Modern Life' in the *Salon of 1846* he
championed every day existence as appropriate subject matter for the artist.

> The majority of artists who have attacked modern life have contented
> themselves with public and official subjects—with our victories and our
> political heroism ... However there are private subjects which are more
> heroic than these ... The pageant of fashionable life and the thousands
> of floating existances—criminals and kept women—which drift about in
> the underworld of a great city; the *Gazette des Tribuneaux* and the *Moniteur*
> all prove to us that we have only to open our eyes to recognize our heroism.[98]

The later study deals at greater length with the 'pageant of fashionable life',
and ends with praise for the artist who 'sought after the fugitive, fleeting
beauty of present-day life the distinguishing character of that quality which,
with the reader's kind permission, we have called "modernity".'[99]

Baudelaire's article on the Exposition Universelle of 1855 applies these
principles world-wide. For him no single critical system could be adequate
to judge 'universal beauty',[100] for there is always the new and particular
element which eludes traditional analysis. *'The Beautiful is always strange.'*[101]
He asks how the infinitely varied strangeness which depends on environment,

[94]'Salon de 1846: De l'héroïsme de la vie
moderne', *Oeuvres complètes*, 949–52.

[95]Ibid., 950. *Art in Paris*, 117.

[96]Margaret Gilman (*Baudelaire the Critic*,
New York, 1971, 33–4) sees the first two
Salons as the 'cornerstone of Baudelaire's
criticism'. See also 143–4, 146, on Baude-
laire's formulation of the doctrine of *le beau*.

[97]*Oeuvres complètes*, 1154. *Painter of Modern*

Life, 3.

[98]*Oeuvres complètes*, 950–51. *Art in Paris*,
118–19.

[99]*Oeuvres complètes*, 1192. *Painter of Modern
Life*, 40.

[100]*Oeuvres complètes*, 954–5.

[101]Italics in the original. Ibid., 956. *Art in
Paris*, 124.

climate, customs, race, religion and temperament could ever be subjected to Utopian rules, and chooses to speak instead 'in the name of feeling, morality and pleasure.'[102]

The Painter of Modern Life both expands and elaborates ideas which Baudelaire had held and developed for some time. Its revived focus and enthusiasm seems to result from the fact that he had finally found a model for his 'painter of modern life' in the person of Constantin Guys. The article can be clearly seen as a combination of more general views which preceded his choice of Guys and sections discussing Guys' specific subjects and style. It is natural to ask why Baudelaire chose such an artist to personify his philosophical and aesthetic ideas. While Guys' works have facility and charm, he can hardly be regarded as an artist of first rank, especially if compared to artists like Delacroix, Daumier or Manet. Why not one of them?

In his *Salon of 1846* Baudelaire stated that 'Romanticism neither depends precisely on the choice of subjects nor in the exact truth, but in a mode of feeling,' and for him, 'To say Romanticism is to say modern art.'[103] He pointed out that Delacroix had long been considered by the majority of the public as the master of the modern school, and he clearly saw Delecroix as 'modern' in terms of his sensibility, his willingness to depict human passions, and his use of art as a vehicle for individual expression.[104] Later, in 1855, he still saw Delacroix in the same light, as having a 'quality all his own, a quality indefinable but itself defining the melancholy and passion of the century.'[105] He praised Delacroix's depiction of modern women. Yet while the shape of their figures and their 'air of reverie' correspond to the physical beauty of women of his own time, they still play the roles of romantic and historic story.[106] Delacroix may well have captured much of a modern sensibility, but he did not often concern himself with the *appearance* of modern life, the transitory elements of everyday existence. He might well have ranked as the greatest modern artist, but he was not the 'painter of modern life' in Baudelaire's new terms.

Then what of the many illustrators and caricaturists who recorded so fully the passing parade? In 1857 Baudelaire published an essay on French caricaturists[107] which amply showed his admiration for both Daumier and Gavarni.[108] He saw that 'trivial prints, sketches of the crowd and the street, and caricatures, often constitute the most faithful mirror of life', but he saw, as well, that caricatures, like fashion plates could quickly appear old-fashioned and thus more caricatural still.[109]

Baudelaire subjected the artists he discussed to the same standards which he used for Salon painting. Despite Charlet's popularity, he judged him too

[102]*Oeuvres complètes*, 956–7.
[103]Ibid., 879. *Art in Paris*, 46–7.
[104]*Oeuvres complètes*, 885–900.
[105]Ibid., 974.
[106]Ibid., 'Exposition universelle', 1855, 971–2.
[107]Ibid., 1006–13. 'Quelques caricaturistes

français', was first published in *L'Artiste* on 24 October 1858, then included in *Curiosités esthètiques* of 1868. It was originally planned to be part of a larger work on caricature.
[108]He definately saw Gavarni as the lesser of the two artists. *Oeuvres complètes*, 1009.
[109]Ibid., 994. *Painter of Modern Life*, 166.

petty, too topical, his draftsmanship rarely more than *chic*.[110] While admitting his gifts, he found Monnier preoccupied with detail yet insufficiently sharp in thought.[111] For Daumier alone he reserved his full approval. He admired his drawing, his gift of accurate observation, his memory, his direct clarity and moral force.[112] But more important, he saw in Daumier an ability to go beyond the immediate moment. Of his lithograph, *Rue Transnonain*, he said, 'It is not precisely caricature—it is history, reality, both trivial and terrible.'[113] If Charlet had 'no place among the eternal spirits—among the cosmopolitan geniuses',[114] then surely Daumier had.

Once, near the end of his essay on French caricature and again near the beginning of his *Painter of Modern Life*, Baudelaire spoke of Daumier and Gavarni as completing or complementing Balzac's *Comédie humaine*.[115] In doing so he observed that there was a strong literary element in their depiction of manners. While 'suggestions of eternity' are present in such works, the caricaturists, the illustrators, the 'historians', as he called them, more closely approached the role of novelist or moralist than artist or poet.[116] Baudelaire then turned to Constantin Guys, 'the man of the world', 'the man of the crowd'. There is a distinction here, though indeed a subtle one. Baudelaire immediately signaled his enthusiasm for Guys' soul.[117] He admired Guys' journalistic adventures, his extensive travel and knowledge of the world, but when he called him a 'man of the world' he meant it in yet a broader sense—a 'spiritual citizen of the universe'.[118] Next, he praised not simply Guy's powers of observation, but his ability like a convalescent or a child to see everything in a state of newness. 'Genius is nothing more nor less than *childhood recovered* at will.'[119] Rightly or wrongly Baudelaire felt that he had found a true 'lover of universal life',[120] and he could thus content himself with Guys' sharp perceptions and fresh facility of hand.[121]

In discussing Guys' aims Baudelaire once more made clear the basis of his critical stance. 'He is looking for that quality which you must allow me to call "modernity" for I know of no better word to express the idea I have in mind. He makes it his business to extract from fashion whatever element it may contain of poetry within history, to distill the eternal from the transitory.'[122]

Certainly Manet seems to qualify for this description. The cosmopolitan with his enthusiasm for life but a *flaneur* resistance to explosive emotion, equipped with dazzling technical facility might well have met Baudelaire's ideal. But the timing was wrong. When Baudelaire wrote *The Painter of Modern Life* in 1859 Manet had completed only some student works and perhaps *The Absinthe Drinker* (Pl. II). Even when the essay was finally pub-

[110] *Oeuvres complètes*, 995–8.
[111] Ibid., 1007–8.
[112] Ibid., 1006–7.
[113] Ibid., 1002. *Painter of Modern Life*, 174.
[114] *Oeuvres complètes*, 996. *Painter of Modern Life*, 168.
[115] *Oeuvres complètes*, 1010, 1155.
[116] Ibid., 1156.
[117] Ibid., 1156.
[118] Ibid., 1158.
[119] Ibid., 1159. *Painter of Modern Life*, 7–8.
[120] *Oeuvres complètes*, 1160.
[121] Ibid., 1168.
[122] Ibid., 1163. *Painter of Modern Life*, 12. Baudelaire's 'modernity' does not belong to one time period: it is the fugitive element of any period or place from which the mysterious beauty of life can be extracted.

lished four years later, Baudelaire could have seen relatively little of Manet's production, and, except for the *Concert in the Tuileries*, it was still heavily perfumed with references to the past. Had the order of things been different so might the results. Baudelaire certainly took an interest in Manet's paintings and offered his friendship and personal support. Nevertheless he wrote publicly on Manet only once on the occasion in 1862 of the publication of a portfolio of etchings by various artists which included Manet's *Gypsies*.[123] (Pl. 6) He used the opportunity to speak of more than that one work, however, promising for the next Salon several paintings, 'spiced with the strongest Spanish flavor.'[124] Despite the brevity of his remarks Baudelaire seems to have seen in Manet the potential to meet his aims for an artist of modern life. Manet not only had an interest in the world around him, but the necessary spiritual bent. He combined 'a vigorous taste for reality, modern reality with that lively and abundant imagination, both sensitive and bold without which, it must be emphasized, even the finest gifts are no more than servants without a master, agents without a government.'[125]

Baudelaire had much to keep him away from art criticism in the last years of his life. In 1864, dogged by financial difficulties, he had moved from Paris to Brussels, returning only when he was already paralyzed with his last illness. He died in 1867. Since some of the public shock at Manet's subject matter was related to the belief that the artist was, in a sense, illustrating the poet, it is perhaps fortunate for Manet that Baudelaire had no more to say of him in the public press.

In the *Concert in the Tuileries* Baudelaire is seen in conversation with yet another important literary figure of his day, Théophile Gautier. While the relationship between Gautier and Manet was certainly not as close as Manet's friendship with Baudelaire, there is every reason to believe that the inclusion of Gautier in the picture was a reflection of his importance in Manet's circle. He had already expressed admiration for the *Spanish Singer* (Pl. 5), which won an honorable mention in the Salon of 1861,[126] and it has been suggested that Manet may have made the picture expressly to please Gautier[127] who found it lifelike, and skillfully painted. Like other critics Gautier was later to become irritated when Manet did not fulfill his expectations. While still praising his strong color and vigorous brushwork, Gautier's *Salon of 1864* expressed disappointment that Manet 'has broken loose from rules accepted by centuries of logic'. In discussing *Dead Christ with Angels* (Pl. 75), he called Manet 'the frightful realist' and regretted that his very real talents had been misused. In Gautier's opinion, Spanish subjects like *The Incident in the Bull Ring* are 'better suited to the talent of a realist painter than the *Dead Christ with Angels*, a subject

[123]Guérin, no. 21.

[124]'Peintres et aqua-fortistes', *Oeuvres complètes*, 1146.

[125]Ibid., 1146. *Art in Paris*, 218.

[126]Hamilton, 25. *Moniteur universel*, 3 July 1861. Manet entitled the picture, 'Le Chanteur espagnol'; Gautier called it 'Le Guite-

rero'. In the Manet literature 'The Guitar Player' is more frequently used than 'The Spanish Singer'. However, following Hamilton's lead, we use the translation of the original title.

[127]Bowness, *PMA Bulletin*, 213.

which calls for some stylistic dignity and a certain idealising convention.'[128] In 1865 he was even more negative. 'Here there is nothing, we are sorry to say, but the desire to attract attention at any price.'[129] Gautier, still trying to understand 'modern painting' wrote on Manet in 1868 and again in 1868 at some length. He found considerable fault in Manet's work and yet he responded strongly to its vivacity. 'If he wanted to take the trouble, he could become a good painter. He has the temperament for it.'[130]

Throughout his criticism, Gautier stresses Manet's debt to the Spanish artists, Velasquez and Goya whom he admired. It has been suggested that Manet's interest in Spanish subjects might have resulted from Gautier's influence. However, this is hard to support, in view of the widespread taste for things Spanish at the time and the influence of other important Parisian figures. If we turn again to the *Concert in the Tuileries*, we find that the third man in the group with Baudelaire and Gautier is Baron Taylor, the contemporary expert on Spanish art.[131]

It is perhaps in other aspects of Gautier's writings which we could find ideas which may have interested the young painter, and which may better explain Gautier's inclusion in this casual and realistic homage to the influential men of the day.

We have already seen that Gautier welcomed 'progress' in the form of new inventions which might usher in a new age of comfort and fulfillment for the average man. Our knowledge, after the fact, of Gautier's regret that he could not understand the ideas of the men of the younger generation in no way negates his earlier enthusiasm for the new beauty which the modern world could bring. This new beauty, however, was a philosophic concern not attached to a particular style. The romanticism of the 1840s, which no doubt looked modern to Gautier's eye, was the mold in which he could cast his images of a new art. It is not infrequent for men to recognize an urgent need, but to find unacceptable the solutions proposed for it, and this is even less unusual in the field of art, where we are deeply conditioned to the appearances of the images of our time without recognizing our prejudices.

The doctrine of 'art for art's sake' is usually credited to Gautier. In its most superficial and popular interpretation it means simply that the value of art lies in its form and color and that art has no obligation to carry social political or religious messages. It is clear from Gautier's writings that this was not his meaning, and it is equally clear that the complex relationships between form and content in modern painting can never be strictly interpreted in such simplistic terms. Gautier explains the situation in *L'Art moderne*. The Swiss artist-philosopher Rodolphe Töpffer had described 'l'art pour l'art'

[128]Hamilton, 57–9. For *Incident in The Bull Ring* see below, II, 82–4.
[129]Hamilton, 75.
[130]Ibid., 120, 134–5.
[131]Isadore-Justin-Séverin Taylor (1789–1879) would have been generally recognized as an expert on Spanish art. He was one of three men sent to Spain in 1835–7 to select works of art for Louis Philippe's Galerie Espagnole. His *Voyage pittoresque en Espagne, au Portugal, et sur la côte d'Afrique,* (3 volumes) preoccupied him for many years, sections being published in Paris from 1826 to 1860.

as a complete occupation with the concept of the beautiful for itself alone; a complete disinterest in the allusions of subject matter. Simply form for form, means for means. But, says Gautier, 'The great error of the adversaries of the doctrine of art for art's sake, and of M. Töpffer in particular is to believe that form can be independent of the idea; form cannot be produced without idea, and the idea without the form. The soul has need of the body, the body has need of the soul.'[132] On the other hand he says a few lines later 'The forms of art are not wrapping papers destined to envelop the sugared almonds—more or less bitter—of morals and philosophy ... Is this to say that art must take an indifferent position, a glacial detachment from everything lively and contemporary to admire the ideal Narcissus, only its own reflection in the water and become its own lover? No, an artist is a man, he can reflect in his work ... the loves, the hates, the passions, the beliefs and the prejudices of his own times.' But without an execution which satisfies eternal laws of beauty it will not have value for the future. 'Art for art, is not to say form for form, but form for beauty.'[133]

Like Baudelaire, Gautier recognizes a variety of cultures and a variety of styles. He sees the subjects of great artists as exact representations of contemporary types. The differences between Teniers and Leonardo, Phidias and Puget, Boucher and Géricault are not capricious he says, they come from observed differences in 'climate, the times, costume, customs, and above all, the manner of seeing and the style of the artist: the more the imitation is faithful, the more the diversity is great ...'

> The ideal is not always preconceived. Often the meeting of a noble type, gracious, and rare, awakes the imagination and sustains works which, without this fortuitous event, would never have been born ... A great many painters and sculptors receive from the exterior their impression of beauty, and proceed from the material to the ideal ... Instead of giving a form to an ideal, they give an ideal to a form; it is no longer the soul which takes the body, it is the body which takes the soul; this last process seems to me the more simple.'[134]

Gautier's view of the ideal as reflected in the real, is certainly in keeping with Baudelaire's concepts of the eternal reflected in the transitory. No matter what Gautier may have liked or disliked in modern productions, his concept of starting with observation to find a new ideal, appropriate to the time and the place, can be seen as a strong invitation to any artist determined to express the quality of modern life.[135] And Manet could hardly have missed its appeal.

Zola also saw a duality in art, but one of a different kind. 'According to me,

[132]Gautier, *L'Art moderne*, 150–51. See also, Sloane, *French Painting*, 99, n. 63.

[133]Gautier, *L'Art moderne*, 152–3.

[134]Ibid., 154–5.

[135]In his long essay on Gautier in *L'Art romantique* (Paris, 1968, 255–6), Baudelaire explains that as a critic, Gautier, in his *Salons*, had explained 'Asiatic beauty, Greek beauty, Roman beauty, Flemish beauty, Spanish beauty, Dutch beauty, English beauty', and that through his innumerable articles on art and travel he had given the young a love of painting.

there are two elements in a work of art: the real element, which is nature, and the individual element, which is man.'[136] Reality is fixed;[137] the element of personal style comes through the artist. Thus, 'A work of art is a corner of creation seen through a temperament.'[138] Here the duality does not involve the ideal, but instead, the real world and the temperament of the real man. Zola rejects the idea of an 'absolute beauty', like the ideal perfection of Greek art held up as a model for the productions of various periods and cultures. Since all cultures start with the same reality and interpret it in different ways, for him beauty cannot be absolute. 'Beauty becomes life itself, the human element mixed with the element of reality, in giving birth to a creation which belongs to humanity. It is in us that beauty lies, not outside us.'[139]

Zola was one of the first critics to offer Manet enthusiastic support. In 1866 he announced that 'I am so sure that Manet will be one of the masters of tomorrow that I would think I had made a good bargain, if I had the money, in buying all his canvasses today.'[140] For him, 'Manet's talent is made up of correctness and simplicity ... I do not think that it would be possible to obtain a more powerful effect with less complicated means.'[141] This early criticism included little in the way of detailed analysis. It was largely a defence of Manet's right to work according to his personal bent. 'He puts himself courageously in front of a subject; he sees that subject in large spots; through vigorous contrasts; and he paints just what he sees.'[142] In response, Manet wrote Zola that he was pleased and grateful 'to be defended by a man of your talent'.[143]

In 1867 Zola published a long statement on Manet. It is divided into three parts: 'The Man and the Artist', which speaks of his life, his appearance, and his personality and offers some of Zola's views on art in general; 'The Works', which lists and discusses his production to date; and 'The Public', upbraiding the public for lack of discernment and understanding.[144] Zola presents Manet as a realist artist. He forcefully states that Manet rejected all reliance on past models and simply translated what he saw before him.[145] Recognizing the elegance of Manet's style, he claims that the artist assembles objects and figures solely according to his desire to create beautiful relationships, and he rejects the idea, then current, that Manet was attempting to illustrate Baudelaire's ideas. Zola glories in the thought that the *Dead Christ with Angels* is 'a cadaver, painted in full light with freshness and vigor',[146] or that *Olympia*

[136]*Mes haines*, 212.

[137]Ibid., 255.

[138]Ibid., 24. The Goncourts also thought that art should be the product of individual personality—realism transformed by the artist's sensibility, and they welcomed the portrayal of contemporary life. See Sloane, *French Painting*, 95–6.

[139]*Mes haines*, 254–5.

[140]Ibid., 219.

[141]Ibid., 222.

[142]Ibid., 221.

[143]Letter of 7 May 1866, in Wildenstein, 1975, I, 11.

[144]First published on 1 January in *La Revue du XIX siècle*, reprinted in pamphlet form in May, the month of Manet's private exhibition. The division of the article is interesting since Zola devotes twelve pages to his general arguments in Part I, nine to Manet's actual works, and six to scolding the public for its inability to accept the new.

[145]*Mes haines*, 253, 259, 260. See below Part II, 51.

[146]*Mes haines*, 268.

(Pl. 69) is 'that girl of our day, whom we have met on the sidewalks.'[147] He warns the public to look for no more than a literal translation in Manet's painting. 'He neither knows how to sing nor to philosophize. He knows how to paint, and that's all; he has the gift, and this is his true temperament, to seize the dominant tones precisely and to model in large layers both people and things.'[148]

This statement may well reflect what Zola wanted for the arts in 1867; it certainly does not adequately describe Manet's methods. His dependence on both present and past sources for his imagery was obvious to many critics of his day, and one can only conclude that Zola chose to ignore that facet of Manet's expression for reasons of his own. It has been suggested that Manet had a part in Zola's statements on his behalf,[149] but this seems unlikely in view of the subtle interrelationships of subject and style to be seen in the paintings themselves. Had Manet wished to obscure his intentions in order to obtain public approval it would have been more effective to blunt his blatant imagery than to construct a verbal apology for it. More reasonable is Faison's suggestion that while Manet's portrait of Zola is a visual record of the artist's interests, Zola's writings are statements of his personal theories rather than comments on Manet's art.[150]

Despite Zola's inability or unwillingness to see Manet's concern with his subjects, and his poetic transformation of nature, he showed sensitivity to the expressive qualities of Manet's color and form, and he sensed the modern vitality of Manet's approach. 'He is a man of our age. I see in him an analytical painter. All problems have again been put into question, science has had to have solid foundations, and it is based on exact observation of facts ... the artist is an interpreter of that which exists, and his works have for me the great merit of a precise description made in an original and humane language.'[151] Today it is hard to imagine Manet playing the role of scientist before his canvasses, but it is easy to understand the gratitude he might have felt toward a man like Zola for his impassioned and reasoned defense, even though it might in many ways have differed from his own ideas. There was much, of course, with which he could agree. Surely for him, as for Zola, beauty could be found in all manifestations of human genius, 'life, life in its thousand expressions, always changing, always new'.[152]

After 1868 Zola had no more to say about Manet until 1879 when he expressed his disappointment with his later works in a review published in a Russian journal.[153] The article suggested that Zola's earlier partial misunder-

[147]*Mes haines*, 270.
[148]Ibid., 260.
[149]Bowness, *PMA Bulletin*, 213. The question of Manet's intentions is complex. He certainly wanted his paintings to be seen and would not have blatantly announced aspects of them which could be criticized as immoral. Nevertheless Zola's views go so far in the direction of formalist interpretation to suggest that he was not fully aware of Manet's interest in the subject matter of modern life nor his attempts to find means to express the feelings of that life. For further discussion of these complexities see below, Part II.
[150]Faison, 162–8.
[151]*Mes haines*, 260.
[152]Ibid., 256.
[153]See Hamilton, 222–4. The article was in Russian and Manet probably never knew the precise words of criticism leveled against him.

standing of Manet's aims had made him unable to accept Manet's logical development. It was Zola, nevertheless, who wrote the introduction to the catalogue of the great posthumous exhibition in 1884. He expresses enthusiasm once again, but he says more of Manet's place in the hierarchy of great artists than of his works.[154] Remembering the adverse criticism of earlier years, Zola announces a victory for Manet's art, and in doing so, he seems also to proclaim a victory for his own early faith in Manet's eventual success.[155]

Another of Manet's defenders was Théophile Thoré, a gifted critic and able art historian.[156] He first mentioned Manet in his comments about the Salon des Refusés of 1863. His enthusiasm for Flemish and Dutch art had, perhaps attuned him to understand the new realism in France.

> French art, as it is seen in the rejected work seems to begin, or to begin all over again. It is odd and crude yet sometimes exactly right, even profound. The subjects are no longer the same as those in the official galleries: very little mythology or history; contemporary life, especially among the common people; very little refinement and no taste. Things are as they are, beautiful or ugly, distinguished or ordinary, and in a technique entirely different from those sanctioned by the long domination of Italian art ... The misfortune is that they have scarcely any imagination and they despise charm ... But let there appear some painters of genius, loving beauty and distinction in the same subjects and techniques, and the revolution will be quick.[157]

As for Manet, Thoré found him a true painter, capable of brilliant effects, but lacking in charm. To him, the *Déjeuner sur l'herbe* (Pl. 62) seemed simply absurd.[158] Thoré wrote a longer and more generous statement on Manet in 1864. He praised Manet's luminous effects, but felt that the artist was trying to exasperate the public with the very vitality of his canvasses. Nevertheless, he believed that 'these are eccentricities which conceal a real painter whose works some day perhaps will be admired.'[159] In both reviews Thoré stressed Manet's dependence on Velasquez and Goya. In response Baudelaire wrote to Thoré denying the possibility of the influence of Spanish art, and claiming instead that the similarities were 'mysterious coincidences'.[160] Thoré acknow-

[154]*Mes haines*, 309.

[155]Ibid., 304–9. Zola repeats his conviction that Manet's formula 'est toute naïve; il s'est mis simplement en face de la nature, et, pour tout idéal, il s'est efforcé de la rendre dans sa vérité et sa force', 307.

[156]Théophile Thoré wrote under the pseudonym Willem Bürger. After the revolution of 1848, he was exiled until the amnesty of 1860. He used those years profitably, spending time in Switzerland, England, and Holland, writing a series of catalogues of major collections in Holland and Belgium. After his return to France he continued to write criticism and history until his death in 1869. A pioneer Art Historian, he is particularly important for

his evaluation of Dutch art and notably for Vermeer, who was then little known. On Thoré see Fried, 73 n. 133; Hamilton, 48; Meltzoff, 'The Rediscovery of Vermeer', *Marsyas*, 1942, 145–66; Philippe Reyberol, 'Art Historians and Art Critics: Théophile Thoré', *Burlington Magazine*, XCIV (1952), 196–200.

[157]Quoted from Hamilton, 49. See Théophile Thoré, *Salons de W. Bürger: 1861 à 1869*, (2 vols.), Paris, 1870, I, 414, 416, 424–5.

[158]Hamilton, 50.

[159]Ibid., 60–62. Moreau-Nélaton, I, 57–8.

[160]Moreau-Nélaton, I, 58–9. See also Hamilton, 62–3.

ledged Baudelaire's letter in a second article in *L'Indépendence belge*, but reaffirmed his position. For him the guidance from the Spanish masters was hardly a fault. 'It is a pleasure to repeat that this young artist is a true painter. By himself he is more a painter than a whole regiment of Rome prize winners.'[161] Thoré wrote again on Manet in 1865, 1866 and 1868, strangely omitting comment on Manet's exhibition of 1867.[162] His remarks were more or less favorable, but even in 1868 he felt that the talented young man still had much to learn. 'His present fault is a kind of pantheism which thinks no more of a head than a slipper, which sometimes bestows even more importance on a bouquet of flowers than on a woman's face . . .'[163] Despite his appreciation of Manet's vitality and brusque new style, Thoré could not put aside his preconceptions about how subject matter should function. For him Manet's reportorial stance, his forceful frigidity, could be mistaken for a lack of interest in his subjects. His own deep concerns about the nature of society were not necessarily in accord with Manet's need to record life as it seemed to present itself to him.

Whether or not he fully understood Manet's aims, Thoré's sensitive statements on the art of his day surely blazed a path for Manet's direction. In 1857, while still in Brussels, Thoré had written an important essay, *Nouvelles Tendances de l'Art*. Like Taine, he believed that a new art would develop to express the new society,[164] and that 'the character of modern society, the society of the future, will be universality.'[165] He stated that the previous literary and artistic school, Romanticism, had voyaged voluntarily into the past, doing much to resuscitate history. It had also ventured into space in excursions to foriegn lands, but the artists, isolated from foriegn languages and customs, had preserved the prejudices of their national point of view.[166] Now, says Thoré, 'easy communications have put all people in contact with each other, and when countries open up and reciprocal influences can be felt, then, 'There will be only one race, one people, one religion, one symbol:— Humanity!'[167] He spoke of the complex symbolism of Pagan and Christian art, no more understandable to the Chinese than their dragons and fantastic monsters are to Western man,[168] explaining that the Pagan and Catholic allegories which are impenetrable to foreigners are 'equally indifferent to the modern spirit of the people which they still serve.'[169]

> To represent ideas we represent the gods, for abilities, the heroes, for
> accomplishments, the princes; and to represent nature itself, we still

[161]Hamilton, 62–4.
[162]Ibid., 77–8, 122–3, 123–4.
[163]Ibid., 124.
[164]Thoré, *Salons*, xiii–xiv, xliv.
[165]Ibid., xiv.
[166]Ibid., xv–xvii. I disagree with Michael Fried's use of passages from Thoré's writings to bolster the idea that Manet's choice of motifs sprung from strong feelings about the 'frenchness' of French art (*Artforum*, 48–52). No Frenchman can be denied a goodly share of patriotic feeling, but Fried's views cannot be sustained in the face of Thoré's tastes for non-French art, and his clear statements against French provincialism and in favor of an art which cut across national boundaries. They are further disproven by Manet's frequent non-French borrowings.
[167]Thoré, *Salons*, xvii–xviii.
[168]Ibid., xix–xxi.
[169]Ibid., xxii.

allegorize it both in place and time by the stereotyped veneer of mythical figures.'[170] In all this, 'Where is society represented—social, scientific and industrial, intelligent and hard-working? Where is man?'[171]

Thoré discussed the realism of Caravaggio, of Ribera, Salvator, Velasquez, and the Le Nain brothers, but he found that only the Netherlandish painters had escaped 'mythomania'.[172] For Rembrandt he had special praise,[173] 'It is painting which has written the history of the Low Countries, and even the history of humanity.'[174]

Finding universal thought in all cultures, and accepting the fact that major changes had already occurred, that the gods and heroes were forever gone,[175] Thoré rejected the concept of a fixed ideal for art, and offered instead the hope that some unknown artist was already struggling to express universal thought in a language intelligible to all.[176]

Manet was not caught up in Thoré's humanitarian spirit, but this does not mean that he could remain untouched by Thoré's call for an art which could speak of the essential nature of man and communicate across the boundaries of cultural differences. Thanks in part to Thoré's active interest in those artists whose work he thought reflected 'the history of humanity', they became more available to Manet and his contemporaries as models for the depiction of modern humanity. Their new 'art for man' may not have been what Thoré would have chosen, but it has succeeded, nevertheless, in recording and expressing basic characteristics of a society now past in still available terms.

In the same year of Thoré's essay on new tendencies in art, Castagnary published his *Salon of 1857*.[177] Despite the variety of the works in the exhibition, he stated that he could perceive a new unified tendency.

> Religious painting has disappeared ... history painting still occupies some place, but it appears, at a glance, since it tries to produce works too directly inspired by the events of our own time, that it has lost a clear notion of its domain and that it adventures on a terrain where it is a stranger.—The majority, and a compact majority, belongs to paintings of genre. Interior scenes, landscapes, portraits, almost all the Exposition is there; that is the human side of art which is substituted for the heroic and divine side, and which affirms itself at the same time with the power of numbers and the authority of talent.

Castagnary noted the absence from the exhibition of the great masters of contemporary art, Ingres, Delacroix and Ary Scheffer. 'They have left the field free for youth, a little turbulent, but a closer and more faithful echo of the new times.'[178]

For Castagnary, the value of a work was not related to the worthiness of

[170]Thoré, *Salons*, xxv.
[171]Ibid., xxvi.
[172]Ibid., xxx.
[173]Ibid., xxxi–xxxiii.
[174]Ibid., xxxiv.

[175]Ibid., xxxix.
[176]Ibid., xxxix, xliii.
[177]See above, 9.
[178]Castagnary, I, 3, (1857).

its subject, but to the grandeur of its passions, the profundity of its sentiment, the picturesqueness of its line. Thus 'a beggar under a ray of sunshine is in truer conditions of beauty than a king on a throne; a team on its way to work under the cold clear sky of morning has a value, like religious solemnity.'[179] He believed that past religious and heroic stories were no longer fruitful sources of inspiration, that 'the concept of beauty which has served painters of the past and which has furnished them with so many religious and historical masterworks, would not be appropriate for painters charged with the study of human life and with depicting on canvas a poetry still unperceived.'[180] Thus the Salon of 1857 was 'the cradle of the new art: *L'art humanitaire.*'[181]

After his introduction Castagnary turned to the works themselves, choosing to discuss a small number which seemed to have humanitarian tendencies in terms of a division which he felt was suggested by the aim of art itself: Nature, Man, and Human Life; or Landscape, Portrait and Genre.[182] The *Salon* ends with his call for a new humanitarian art: 'It is this new art that the present generation is called to establish. That is its imperative mission. In accomplishing it it will justify the logic of history and preserve its role in the communal work of progress; in deserting it, it abdicates itself and betrays humanity.'[183]

Castagnary set a hard task for the young artist. He was to adopt simple scenes of everyday life, and infuse them with the most potent and influential of human feelings. He was to glorify the very spirit of the new, democratic world in which progress offers the average man, as Gautier put it, 'the time to cultivate his field and his spirit.' Manet's painting certainly lacked the kind of overt passion which Castagnary seemed to demand, but it is to be remembered that Castagnary gave no specific directions as to how his ideal might be achieved, and that, in fact, he fully understood the artists' difficulty in trying to achieve it. 'It is not a question of accusing them of their weaknesses: they understand that easily, it is a question of encouraging them.'[184]

As one might expect, Castagnary's criticism of Manet is mixed. He immediately recognized the fresh excitement of the work, but he could understand neither the lack of traditional finish, which seemed to him a mark of lack of skill and lack of sincerity,[185] nor his 'whimsy' and 'fantasy'. Castagnary was one of the few critics who accused Manet of excessive imagination rather than a lack of it. 'He borrows his subjects from the poets or finds them in his imagination: he doesn't bother to discover them in everyday life.'[186] Since this remark was directed at Manet's *The Balcony* (Pl. 45) and *Luncheon in the Studio* (Pl. 31) with their contemporary figures and settings, Castagnary was obviously looking for more than a record of the appearance of contemporaneity. For him these arrangements were without reason or meaning.[187] What he

[179]Castagnary, I, 14, (1857).
[180]Ibid., I, 15–16, (1857).
[181]Ibid., I, 15, (1857).
[182]Ibid., I, 16, (1857).
[183]Ibid., I, 65, (1857).

[184]Ibid., I, 16, (1857).
[185]Ibid., I, 173–4, 'Salon des refusés', (1863).
[186]Ibid., I, 364, (1869).
[187]Ibid., I, 365, (1869).

saw as 'fantasy' or 'whimsy' was the lack of interpretative gesture or composi-
tion which might add to Manet's subjects some of the interior passion he
sought. It is as if Castagnary were asking new subjects to express their new
and modern passions with the gestures of the past. Open minded as he was,
he could not see the new dimension of man's own reactions to his passions—
the containment of the dandy, or even the growing callousness of modern man,
often exposed by more extensive communications to more bad news than he
could bear.

In 1870 Castagnary still felt that Manet 'possesses some of the qualities
necessary for making pictures. These qualities I do not deny, but I am waiting
for the pictures.'[188] He did not wait long. *Le Bon Bock* (Pl. 110) of 1873 was
much to his liking since 'it expresses through salient characteristics the customs
of the person depicted.' He believed that Manet should learn to finish things
properly, 'With the progress which contemporary taste is making I think
this is the only cause for dispute between Manet and the serious public.'[189]
Although Castagnary never ceased to chide Manet on his lack of finish,
the later criticism was generally favorable. He no longer demanded inter-
pretation, and restricted his comments largely to formal matters. Time had
clearly adjusted his eye to the new painting and perhaps also his ideas as to
how the new painting might best function.[190]

Whatever critical maturity he gained over the years, however, Castagnary
never abandoned the principles he set forth in the *Salon of 1857*. Ten years
later he stated again that it is man, individual or collective, his passions and
his customs, which must concern the painter.

> What is the use of tracing back into history, of taking refuge in legend, of
> looking through the registers of the imagination? Beauty is under the eyes,
> not in the brain; in the present, not in the past; in truth, not in a dream;
> in life, not in death. The universe which we have here before us is the very
> one which the painter must depict and translate. The poetry accessible to
> our spirits is made up of all the sensations which it sends to us. Hurry, do
> not delay an hour: forms and aspects will change tomorrow. Paint that
> which is, the moment you perceive it, it is not only to satisfy contemporary
> aesthetic exigencies, it is also to write history for the posterity to come;
> under this double heading, it is to fulfill exactly the aim of art.[191]

Castagnary's belief in the importance of recording the petty and passing
element of life, is not incompatible with the ideas of Baudelaire and Gautier.
For all of them, a precise observation of the real world might be used to reveal
much more. For Gautier and Baudelaire it was qualities of an eternal ideal;
for Castagnary it served to reveal larger truths about *L'Etre universelle*, human
nature, or the spirit of the times.

For the kind of art of which he approves, Castagnary adopted the term

[188]Ibid., I, 429, (1870).
[189]Ibid., II, 89–90, (1873).
[190]For later views see Hamilton: 1875,

191–4; 1876, 199; 1877, 202; 1879, 215.
[191]Castagnary, I, 241–2, (1867).

'naturalism'.[192] He praised great naturalists of the past, the artists of Venice, the Low Countries and Spain, and one finds again the growing appreciation of artists of genre, or supposedly genre subjects, and of styles often far different from the linear ideal of Raphael and Ingres. In 1868 he had been using the term naturalism for some years, and he stated that he had been mistaken in applying to it the status of a 'school'.

> A school is a body of doctrines, a particular system of expression, a conventional and arbitrary manner of seeing, feeling and practicing. Classicism, which thrived on mythology and allegory, arranging at the same time landscape and the human form, correcting one with Poussin, and the other with Raphael, is a school. Romanticism, which illustrates the poets, exhumes the middle ages, restores the bric-à-brac, mends the old armour and composes stews of artificial color, is a school. Naturalism, which accepts all the realities of the visible world, and at the same time all the means of understanding these realities, is precisely the opposite of a school.[193]

He had said earlier that 'The naturalist school re-established the broken rapports between man and nature.'[194] Later, by accepting naturalism not as a school, but as a way of life, he can say to the artist: 'be free!'[195]

When Castagnary speaks of the rapport between man and nature, he specifies that he means man of both city and country, but he says that naturalism already expresses the life of the fields with rustic power, but holds the life of the city in reserve.[196] This is an extremely important distinction. French painting which is to 'be made in its own image, and not in the image of dead peoples, which describes its own appearances and customs, and no longer the appearances and customs of vanished civilizations',[197] was largely successful only in one facet of its task. The reason was the slow demise of the picturesque, and the great reluctance of educated man to accept their most intimate surroundings as being beautiful at all. Despite Baudelaire's praise of the 'poetic beauty' of the 'evening suit and the frock-coat' as early as 1846[198] even he was hard put to discover the 'mysterious grace' he claimed for them in any actual works of art. More than one critic had demanded an 'art for man'—and about man—but what man? Despite changes in both subject and style as well as in numbers, genre paintings remained generally pictures of country people or the lower classes. This artistic preference was not without philosophical support. Champfleury, writing in 1857 under the title *Le Réalisme* stated clearly: 'Logically it would be more worthwhile to paint first the lower classes, in which the sincerity of feelings, actions and words is more in evidence than in high society.'[199] For him Courbet's *Burial at Ornans*

[192]For him, the character of most of the art of modern times is that of naturalism. 'Modern times', of course, begins with the Renaissance. See Castagnary, I, 290; Rewald, 148; and Sloane, *French painting*, 73–4.

[193]Castagnary, I, 290–91, (1868).

[194]Ibid., I, 105, (1863).

[195]Ibid., I, 291, (1868).

[196]Ibid., I, 105, (1863).

[197]Ibid., I, 106, (1863).

[198]*Oeuvres complètes*, 950–51.

[199]Jules Champfleury, *La Réalisme*, Paris, 1857, 10.

was full of poetry. Courbet's Ornan pictures, in fact, were much to his taste, and he gradually lost enthusiasm for Courbet's work as the artist produced fewer peasant pictures. A discussion of the degree to which Courbet's paintings and Champfleury's writings were motivated by political and social concerns is a separate study in itself.[200] While many of his best known works were devoted to peasants, or, as in *The Studio*, a contrast of various types, many of his paintings of still lifes, landscape and even contemporary figures can be regarded as almost classless.

Courbet had adopted the term 'Realism' for his rebellious private exhibition at the time of the universal exhibition of 1855, and had proclaimed his *Studio* 'a realist allegory'. In the introduction to the catalogue he claimed that the term had been thrust upon him. Nevertheless he used it again consciously in his 'Realist Manifesto' when he stated his aim 'to be in a position to translate the customs, the ideas, the appearance of my epoch, according to my own estimation; to be not only a painter but a man as well; in short, to create living art—that is my goal!'[201] Both Meyer Schapiro and Linda Nochlin have written perceptively on Courbet's use of popular imagery in creating a living art.[202] Instead of turning to the largely artificial and often sentimental genre models he could see in the Salons, Courbet had seen fit to translate the customs, and ideas and appearances of his epoch in part through the images which the average man already believed expressed just that. He presumably did not consider such sources as serious art, but if man, rather than gods and heroes, was to be celebrated by the modern artist, then man's own simple expressions would seem eminently suitable sources. Popular arts, and even the art of children, had become fascinating to many of the literary figures of the period, nor were these interests seen as incompatible with more traditional concerns for the fine arts. Champfleury's book on the brothers Le Nain, published between 1850 and 1852, served to set these French realist painters into the pantheon of the great and to make them more available as models to aspiring young artists at mid-century, but at the same time Champfleury was fascinated by *Commedia dell'Arte*, no longer an aristocratic form of theater but an influential and popular kind of public amusement, and by popular songs and caricatures.[203]

A great deal of popular literature and illustration dealt with regional and

[200]For a summary of Champfleury's life and an interpretation of his possible influences on Courbet and the eventual cessation of those influences, see Alan Bowness, 'Courbet's Early Subject-Matter', in Finke, 123–31.

[201]Gustave Courbet, *Exposition et vente de 40 tableaux et quatre dessins de l'oeuvre de M. Courbet*, Paris, 1855, here quoted from Nochlin, *Realism*, 33–4.

[202]Meyer Schapiro, 'Courbet and Popular Imagery', *Journal of the Warburg and Courtauld Institutes*, IV, (1940–41), 164–91. Linda Nochlin, 'Gustave Courbet's *Meeting*: A Portrait of an Artist as a Wandering Jew', *Art Bulletin*, XLIX (1967), 209–22.

[203]Jules François Felix Fleury, writing under the pseudonym Champfleury, published a book on popular songs, *Les Chansons populaires des provinces de France*, Paris, 1850; and a five-volume history of caricature, *Histoire de la caricature*, Paris, 1865–80, among many other works. Champfleury also wrote pantomimes and undoubtedly influenced the direction the Commedia dell'Arte was to take in the nineteenth century. On this subject see Francis Haskell, 'The Sad Clown: Some Notes on a Nineteenth-Century Myth', in Finke, 10–15.

provincial types, but it also described the city dweller in his many roles, from beggar to dandy. As the Salons began to exhibit more and more genre paintings, they began to be less and less moralizing and anecdotal and to resemble more and more the descriptive images of the popular press. However, while the bourgeois Parisian was a popular subject for more ephemeral illustrations the average Salon spectator was not likely to find his own class or profession as the subject of serious painting. He could feel uplifted and informed by pictures of Breton peasants, nuns, orphans or gypsies—even Parisian rag-pickers— but whatever the critics and philosophers had to say about an 'art for Man', he did not go to the Salon to find a mirror image of himself. Portraiture was an exception, of course, and it was normally confined to familiar modes. Modern man was not yet ready to accept his role as subject of paintings of the history of the modern age. Nevertheless, a turning point had been reached. Serious painting, with its technical skills and emotive power, was now to be used for the depiction of the artist's own intimate, particular, and specific life, devoid of narrative, devoid of romance, and cast in the same cool tenor of direct perception with which the sophisticated Parisian saw the world around him.

There is no denying that truly contemporary images had been made in paint before Edouard Manet. Courbet's *oeuvre* is frequently startling in its modernity. But with Manet the persistence and intensity of modern imagery— modern even when past models are obvious—is much more a dominant characteristic. The Impressionists quickly followed Manet's lead and were soon to express modern life as forceably in their own terms. Boudin wrote in 1868, 'The peasants have their painters ... that is fine, but between ourselves, those middle-class people strolling on the jetty at the hour of sunset, have they no right to be fixed on canvas?'[204]

Inasmuch as Courbet was an innovator, Manet's debt to him is very real. Their works, however, differ strongly in both spirit and craft and it seems singularly inappropriate to apply the term 'realist' to both artists in the same way—although the critics certainly did so on many occasions. Manet's first work to be accepted at the Salon, in 1861, was immediately seen in these terms. For Hector de Callias, 'The Spaniard Playing a Guitar recalls the palmy days of Courbet.' 'What a scourge to society is a realist painter', said Léon Lagrange.[205] Nevertheless, it is probably both more correct and more practical to agree with Sloane's decision that Courbet alone *was* the 'Realist Movement'. Sloane offers an excellent summary of the pitfalls presented by the terms 'naturalism' and 'realism'—pitfalls which result largely from the inconsistency of their use then and now. He chooses the more expanded term 'objective naturalism', directs it largely to Courbet, and concludes that 'realism, in its most provocative (or irritant) form, did not last long after 1857', bracketing

[204]Boudin to Martin, 3 September 1868, here quoted from Rewald, 44.
[205]Hector de Callias in *L'artiste*, 1 July 1861, and Léon Lagrange in *Gazette des Beaux-Arts*, July 1861, here quoted from Hamilton, 26.

in this way Courbet's major Ornans pictures, and leaving for a new title the more modern works which followed.[206]

In setting up his private exhibition near the World's Fair of 1867, Manet had mimicked Courbet. The 'Realist manifesto' which accompanied Courbet's exhibition in 1855 stated that he wanted to translate the customs, the ideas and appearance of his epoch. Certainly this is also what Manet wanted to do, but his exhibition was accompanied neither by title nor program. Courbet's second exhibition of 1867 was a success; Manet's was not. The public had adjusted to Courbet; Manet was still a cipher. Close as the two men might have been in many of their aims, Manet was a very different man and his naturalism was of a very different order. To use Zola's terms, it was nature seen through a very different temperament.

Even Champfleury saw Courbet more as prophet than messiah, 'the master, with his rehabilitation of the modern and the excellent means by which he recaptures the presentation of the modern will perhaps facilitate the arrival of a noble and great Velasquez, of a scoffing and satirical Goya.'[207] By 1860, when this statement was made, Manet had already discovered the fertile possibilities in imitation of those two great Spanish masters in his search for a means of expressing modern life, but he was to infuse his borrowings with a new quality unlike anything Champfleury expected.

[206]Sloane, *French Painting*, 73–80.
[207]*Grandes figures d'hier et d'aujourd'hui*, Paris, 1861, 252–3.

3. Modern Life

MANET's first major painting, the *Absinthe Drinker*, was a strangely Baudelairian work, but a genre picture of a low type nevertheless. *The Spanish Singer* of 1861 was again of a poor man, an itinerant performer, and the *Old Musician* of 1862, a fascinating assembly of types, each in one way or another rejected from society. The *Concert in the Tuileries* of the same year offers a radical contrast. Not that Manet did not continue to paint the poor—his beggar-philosophers were not created until 1865—but the *Concert* was the first of a series of important depictions of his own intimates and contemporaries, in the world which was immediately real to him. There is something essentially traditional about the clothing of regional types, and timeless about the clothing of the poor, but the participants in Manet's *Concert* are dressed *à la mode,* and one realizes that they will all be wearing new clothing for next season's concerts. Here is the essential difference between the realistic or naturalistic rendering of a contemporary scene and the depiction of modern life. Many 'contemporary' scenes might take place any where or any time, but this picture clearly reflects not just life as it was, but the magical connotations of a life committed to progress, improved by science, in which man has time and energy to fill his soul and replenish the arts. This is 'la vie moderne'.

Although clothing can echo the spirit of the wearer[208] and even the spirit of the age,[209] of the thousands of illustrations of modern life in books and magazines, many so similar to the *Concert in the Tuileries,* few captured more than a material record of exterior appearances. Emile Bernard was to say of Daumier and Manet, 'those two entered into the soul, the others painted only the clothing . . .'[210] While the Parisian public seemed to find great pleasure in the merest depictions of themselves in their habitat, real art demands much more. 'In short,' said Baudelaire, 'in order that any particular modernity may be worthy of eventually becoming antiquity, it is necessary that the mysterious beauty involuntarily lent to it by human life should be distilled from it.'[211]

The distillation or essence of human life! How can so much be inferred from an ordinary scene? The easy answer is to claim genius for the artist,

[208]*Couture par lui-même*, 128. Couture offered encouragement to his students to paint their own period. 'Soyez Parisiens comme on était Athéniens. Ayez confiance dans vos forces, ne vous suicidez pas dans le passé.' *Méthode,* 266.

[209]See discussion of Baudelaire, 18–22, above.

[210]Bernard, 102.

[211]Baudelaire, *Oeuvres complètes*, 1164.

and to turn to the potency of his formal arrangements. But the artist's craft arises from his spirit and his intentions, and the answers are far more difficult. The art historian, attuned to proving influences and connections by discovering treatises and documents must admit defeat before the wealth of material to be found in the nineteenth century. There is both too much repetition of ideas to establish single and clear connections and too little specific evidence to cement profound conclusions. The very confusion of the era will offer for each discovery an equally relevant contradiction. The only choice then is to follow the path of common sense and try to feel one's way to an understanding of that life itself.

In the *Concert in the Tuileries* there is nothing in the way of gesture or drama, no punctuation in the repetitious figures and trees, to lead us to the essential point of the picture. Is this then purely an exercise in form and color, practised perhaps in rebellion against the didactic art it overturns? Not at all. Just as the past artist's use of his subjects to express a moralizing or inspirational idea tells us much about the artist and his spirit so can Manet's direct clear gaze tell us much about himself and his associates. His way of looking at them under the trees in the garden, the band players out of sight, expresses as much of the spirit of his times as the drawing of their hats and canes. Manet moved in a society admirably described by Paul de Musset in *Paris et les Parisiens*, one of the many popular illustrated volumes on everyday life and particularly the life of the fashionable Parisian. In the midst of busy streets and the fascinating sights, Parisian men appear interested in nothing, while Parisian women know only two kinds of people, those who amuse them and those who annoy them.[212] Thus are described the distant attitudes of the sophisticates of the day. Not without feelings, perhaps, but caught in an external pose of condescending coolness.

The 'Dandy' had increasingly become a fascination for the French. In 1845 Barbey d'Aurevilly had published a book on Beau Brummell and 'dandyism'. In the early part of the century Brummell had established in London a dashing style of behavior and dress, and a personality both insolent and clever, amusing and cool. Brummell's fortunes fell toward the 1830s, but the concept of dandyism remained much alive, and in France it came to have a close connection with concepts concerning modern life.[213] Many of the illustrations in *Paris et les Parisiens* are by Lami and Gavarni, two artists mentioned by Baudelaire in his essay 'The Heroism of Modern Life' in the *Salon of 1846*. He speaks of the clothing of the modern hero. 'M. Eugene Lami and M. Gavarni, although they are not geniuses of the highest order, have understood all this very well—the former a poet of official dandyism, the latter the poet of raffish and hand-me-down dandyism! The reader who turns again to M. Jules Barbey d'Aurevilly's book on dandyism will see clearly that dandyism is a modern thing, resulting from causes entirely new.'[214] Fifteen years later, it was still

[212]Paul de Musset, 'Parisiens et parisiennes', in *Paris et les parisiens au XIXᵉ siècle: Moeurs, arts et monuments*, Paris, 1856, 403.

[213]Jules Barbey d'Aurevilly, *Du dandyisme et de Georges Brummell*, Paris, 1845.
[214]Baudelaire, *Oeuvres complètes*, 951.

considered 'a modern thing' and in 1860 *La Chronique universelle illustrée* published an article by Barbey d'Aurevilly entitled 'Du Dandysme et de Brummell' which repeats the essential message of his earlier book. 'The dandy is a bold man, but a bold man with tact, who stops in time and who finds, between originality and eccentricity, the famous point of intersection of Pascal.' Elegant, carefully dressed, 'He is neither handsome nor ugly, but he has in his person an expression of finesse and concentrated irony, and in his eyes an unbelievable penetration . . . a man who carries in himself something superior to the visible world.'[215] Vain, impertinent, indolent, Brummell was nevertheless a positive influence, 'That man, too superficially judged, was a power so intellectual that he reigned more by his airs than his words.'[216] Dandyism had become a part of the spirit of the times; the poets were impregnated with Brummell.[217]

In a society concerned with accumulating visible wealth, with the betterment of mankind in strongly material terms, the man of elegance was a symbol less of indolence than of success. While the typical descriptions, so popular at the time, never gave appropriate attention to individual traits, it is easy to see the concept of the dandy playing its role both in Manet's personal life and his art.

We have spoken already of the popularity of images of typical people of various professions, geographic areas, and roles in life. Similar records of typical places more and more captured the public interest through the 1860s and 1870s. Manet's *Concert in the Tuileries* derives from such pictures of sections of Paris—pictures so numerous that it is impossible to establish a single 'correct' source for Manet's painting.[218] Just as travel literature depicted and described typical scenes in far-away lands, so the magazines and books read by Manet's friends showed not only the exotic world far from Paris, but scenes of Paris itself. *Les Français peints par eux-mêmes* had recommended a serious look at the city. 'You want to know Paris? Run and look at her docks, her bridges, her promenades, her spectacles. Go visit her markets.'[219] Even a periodical as elevated as the *Gazette des Beaux-Arts* encouraged this interest. In 1859 it published a favorable review of *Paris qui s'en va*, a new work describing sections of Paris.[220] Books like Zaccone's *Rues de Paris* (1859) and *Le Tiroir du diable: Paris et les Parisiens* (1850) by Balzac, Sand and others read like contemporary guidebooks to the city and are filled with illustrations of life on the city streets. *L'Image, Paris-comique, La Vie parisienne, Diogène, La Chronique universelle, Magasin*

[215]*La Chronique universelle illustrée*, I (1860), 165–6.

[216]Ibid., I (1860), 167.

[217]Ibid., I (1860), 168. Interest in dandyism continued well after this date. An article on Barbey d'Aurevilly and his book *Du dandyisme* appeared in the 'Gazette du chic', *La Vie moderne*, II (12 June 1880), 384.

[218]Sandblad, Plate 1, 'Concert militaire dans le jardin du Palais des Tuileries', xylograph in *L'Illustration*, 17 July 1858. For another possible source see Hanson in Finke,

151 and Fig. 86, Ulysse Parent, 'Les enfants et les oiseaux au jardin des Tuileries', from *Les Français peints par eux-mêmes*, 1876, IV, 173.

[219]*Les Français peints par eux-mêmes*, IV, 275.

[220]'Livres d'art et publications d'estampes', *Gazette des Beaux-Arts*, IV (1859) 316–17. Anonymous review of *Paris qui s'en va*, Paris, Cadart, 1859, illustrations by Flameng. The book was again mentioned in 1860, Vol. VI, 184–5 and Vol. VII, 377–8.

pittoresque and many other magazines published articles of the same sort. *La Chronique universelle* ran a regular series called 'Aspect, Physionomie et Types des divers quartiers de Paris'. The *Magasin pittoresque* could offer a study of camels, views of Greek mountains, of the Gardens of Caserta, and of sights in Paris itself with equal aplomb. The constant rebuilding of the city invited illustrations of the new Gare du Nord, the new Place du Châtelet or the state of construction on the Champ de Mars as well as views of the older city. In the Almanach published by the *Magasin pittoresque* from 1852 to 1860 articles on each month were adorned with informative images depicting the customs, industries, crops, of peoples all over the world; natural phenomena, such as earthquakes, storms, comets, or the aurora borealis; information about famous men, and the important events of the year; views of world's fairs, of the new markets, of the races, of naval battles[221] and of the tragic fall of Nadar's great balloon, the Géant—all were recorded in reportorial style.

La Vie moderne had been the title of a magazine which appeared for a few issues in 1859. Twenty years later another periodical was published under the same name. The first issue included a poem by Théodore de Banville which offered an invitation to the artist:

> Artiste desormais, tu veux peindre la vie,
> Moderne, frémissante, avide, inassouvie.[222]

La Vie moderne helped support the artist of the trembling modern world with exhibitions of new work in its accompanying gallery. It is interesting that Flaubert had already described in *Sentimental Education,* a similar gallery attached to a modern periodical. His story takes place during the Revolution of 1848, and the title *L'Art industrielle* quite clearly reflects the concerns of that day with their greater emphasis toward social change. *La Vie moderne* by contrast could offer a view of the many benefits that democracy, industry— 'Progress', in fact—had brought to the average man.

La Vie moderne was under the editorship of Georges Charpentier, who had published Zola, Maupassant and Daudet and whose wife and daughters were so brilliantly painted by Renoir only a few years before the first issue.[223] Charpentier's brother Edmond was in charge of the gallery which was intended to give the curious as intimate a view of the art of the time as if he had been able to visit the artists' studios.[224]

The first issue made clear its aims: 'to allow the reader to be present at all the events of modern life: art, scientific discoveries, changes in customs', and 'to neglect in its universal exploration only the discordant world of politics.' It promised to offer the most celebrated and authoritative of authors, who would put on the family table each week the distractions of the spirit and the intellectual joys which civilized man needs as much as he needs his white

[221]See below, Part II, 121–2, for a discussion of popular imagery and Manet's *The Battle of the Kearsarge and the Alabama.*

[222]'Le Vie moderne', *La Vie moderne,* I

(1879), 6.

[223]1878. See Rewald, 419–20.

[224]Rewald, 430.

bread . . . 'joining the particular attraction of the journals of "actualité".'[225]
The articles, in fact, were written by a number of eminent men, their subjects
ranging widely from events in the world of art to electricity, underground
cables, the races, *japonaiseries*, balloons, Shakespeare, to mention only a few.
We read comments on Zola's *Nana*,[226] then being published in *Voltaire*; we
learn that Gambetta gave away 2,000 cigars an hour at the festivities on the
fourteenth of July at the Palais Bourbon;[227] and that it is difficult to get good
domestic servants.[228] Most of the art criticism was written by Armand Silvestre.
While it is hardly radical, it tends to support interest in new movements.
Silvestre felt that the Impressionists would someday occupy an important
place in art, 'I don't think that they have the last word, but perhaps the first
in a new art, and that is worth a hundred times more.'[229]

Manet was appropriately part of the world of *La Vie moderne*. In 1880 he was
represented in two curiously fashionable exhibitions in the gallery; one of
painted tambourines, the other of Easter eggs. His tambourine of flowers and
dancers' feet was illustrated in the January issue.[230] In March the painted
ostrich eggs brought more comment. Manet's contribution, decorated with
the 'divin Polichinelle' was probably similar to his complex color lithograph
of the *comedia dell'arte* character.[231]

After the close of the exhibition of eggs, twenty five works by Manet, ten
oils and fifteen pastels, were hung against sumptuous Japanese textiles
borrowed from M. Dalsème, a celebrated rug merchant. The exhibition, like
its predecessor, drew large crowds of literary and artistic celebrities and
'mondaines',[232] and was discussed in several issues of the magazine.[233] In the
longest of these, Gustave Goetschy reminded the reader that Manet had been
drawing public attention for twenty years. While this new exhibition had
again aroused old quarrels, people were getting wiser. If an artist is good,
there comes a time when he triumphs over ignorance and indifference, and
then Jean Bonhomme will proclaim him a great artist and say that his prices
are too high. 'You will see that it will become obvious one day that this Parisian,
who has been so often laughed at, is a true painter, and that he has recorded
his Paris with the spirit, talent and originality of a great artist.'[234]

[225]*La Vie moderne*, I, 2, 'Introduction'.
[226]Ibid., I, 434.
[227]Ibid., I, 242–4.
[228]Ibid., I, 3.
[229]Ibid., I, 5.
[230]Ibid., I, 4 (3 January 1880). Wildenstein, 1975, I, no. 324. Other tambourines probably exhibited are nos. 320, 321, 322, 323, 325. Tabarant does not catalogue the tambourines, but discusses them 372–3. Orienti does not show the illustrated tambourine but catalogues four other tambourines under the number 299.
[231]*La Vie moderne*, II, 13, 195. The Polichinelle is mentioned again in II, 14, 223. According to Tabarant, 375, Manet gave the egg to the singer Faure, after which it passed into the collection of Bernheim-Jeune. About 1908

it was badly broken and repaired. Its present location is unknown. The color lithograph is discussed in Hanson, *Manet*, 152–5, and is catalogued by Guérin, no. 79; and by Harris, *Graphic works*, no. 80. In *La Vie moderne* reference is made to a poem by Théodore de Banville which was printed below the image on the lithograph:
Féroce et rose avec du feu dans sa prunelle
Effronté saoul, divin, c'est lui Polichinelle
Polichinelle also appears in paintings of 1874.
[232]*La Vie moderne*, II, 16, (17 April 1880), 255.
[233]Ibid., II, 15, (10 April 1880), 239; 16 (17 April 1880), 247–50; 19 (8 May 1880), 303.
[234]Ibid., 'Edouard Manet', II, 16 (17 April 1880), 247–50.

Manet is mentioned in *La Vie moderne* many more times. In May Silvestre commented on his portrait of Antonin Proust, 'What vigorous modernity in the physiognomy and in the costume. What brilliant execution in the clear and correct tones!'[235] And finally, at his death in 1883, the magazine devoted a long article to his career—an article praising his sincerity, his love of truth, his invincible spirit, and the sense of modernity he brought to his work.[236]

In the latter part of 1873, Manet had met Stéphane Mallarmé, a man who shared his interests in modern life and who was to become his constant companion until his death. The poet was Manet's junior by several years and at the time of their meeting his work was in a period of quiescence. He had relied heavily on Baudelaire for much of his basic thought as a younger man, and was in the process of severing his dependencies and formulating a new outlook. Although there was no break in the quantity of Manet's production in those years, he too was at a turning point in his career. Influenced by the Impressionists *plein air* methods and broken brush work, as well as by the fresh shorthand techniques of Japanese artists, he was in the process of securing his remarkable technical facility and forming his later style.[237] It is hard to say which man might have influenced the other more. Most intimate relationships result in mutual sharing or even mutual invention of ideas. Mallarmé undoubtedly encouraged Manet's interest in modern life, but he admitted that he had learned much from Manet's ability to saturate himself in his own observations and to extract essential qualities from a world of multiple forms.[238] In his own work, Mallarmé tried to eliminate unnecessary words from his poetry and to depend on the evocative effect of precisely chosen images. In a letter of 1864 he had announced his aim, 'To paint not the thing, but the effect it produces. The truth must not therefore be made up of words, but of intentions, and all the words are effaced by sensations.'[239] Mallarmé's use of the word 'to paint' to describe his own approach to poetry shows how much he thought in terms of visual imagery and how much he related the two arts. When he wrote about his friend's work in 1874 and again in 1876 he showed remarkable understanding of Manet's aims and methods, and even of his earlier development.[240] He understood, as Zola had not, the importance of

[235]Ibid., II, 21 (22 May 1880), 327.

[236]Ibid., V, no. 19 (12 May 1883), 301–6. The cover illustration was a portrait of Manet by Desmoulins. The article by Gustave Goetschy repeats many statements in the earlier article. 'Ses personnages vivent et se meuvent dans un air ambiant qui leur est propre. Tout est vrai en eux et autour d'eux. Il a de plus le sens très pénétrant de la modernité et un sentiment particulièrement juste des gestes et des attitudes des personnages de son temps. Il sait les faire mouvoir et les vêtir suivant les habitudes et les modes de leur époch.'

[237]See below Part III, 171–3, 185–6.

[238]Henri Mondor, *La Vie de Mallarmé* (2 vols.), Paris, 1941, I, 355–6.

[239]Mondor, I, 145. Letter to Henri Cazalis, October, 1864. 'J'ai énfin commencé mon *Hérodiade*. Avec terreur, car j'invente une langue qui doit nécessairement jaillir d'une poétique très nouvelle, que je pourrais définir en ces deux mots: *Peindre non la chose, mais l'effet qu'elle produit.* Le vers ne donc pas, là, se composer de mots, mais d'intentions, et toutes les paroles s'effacer devant les sensations...'

[240]Stéphane Mallarmé, 'Le jury de Peinture pour 1874 et M. Manet', *La Renaissance artistique et littéraire*, 12 April 1874, reprinted in *Oeuvres complètes*, Paris, 1945, 695–700. 'The Impressionists and Edouard Manet', *Art Monthly Review*, I (1876), 117–21. There is apparently no original French version of

Manet's early borrowings from the masters. He saw the eclectic work of the early 1860s as Manet's 'first manner' when he sought 'friendly counsel' from Velasquez and the Flemish painters. He felt that Manet then sought eccentric and novel imagery like that of writers of the same years in such works as the *Olympia*; and that finally, in the middle of the 1870s he had developed a craft appropriate to express the palpitating life of his own era.[241] In his first essay he praised *Swallows* for the vast atmosphere surrounding the two figures, and the *Opera Ball* as a 'heroic attempt to capture, through the means peculiar to this art, a complete vision of contemporary life.'[242] He was even more enthusiastic two years later in his description of *Le Linge* (Pl. 1). He speaks of the costumes and the foliage: 'their contours consumed by the hidden sun and wasted by space, tremble, melt and evaporate into the surrounding atmosphere, which plunders reality from the figures, yet seems to do so in order to preserve their truthful aspect.'[243] Here Mallarmé connects outdoor painting and modernity, since painting objects as they appear in the open air offers the artist a new experience and requires of him new syntheses of form and new compositional devices.[244] Henri Guérard, who married Manet's pupil Eva Gonzales, had said that *plein air* painting was not just a matter of rendering a tree, 'it is life, it is the human figure, the modern figure, moving in the atmosphere with the effects, the intense values, the frank modeling, which the true light of the sun gives to beings and to things in simplifying them.'[245] The critics could now find some reason for Manet's brusque forms, and could realize that no other method could produce the same effects. In *La Vie moderne*, Goetschy had described Manet's process as simple: synthesis and simplification. 'He cared only for masses and attached little importance to details. In the symphony of his work, with a stroke of the brush he made each object sound its particular note.'[246] Mallarmé similarly defended Manet against the continued accusations that he did not finish his work. 'What is an 'unfinished' work, if all its elements are in accord, and if it possesses a charm which could easily be broken by an additional touch?'[247] This new view of the role of painting as a kind of visual poetry was years later stated again by one of

this article, although it has been translated into French in *La Nouvelle Revue française*, VII (1959), 375–85. It is not included in the *Oeuvres complètes*. The article is extensively and perceptively discussed by Harris, *AB* 1964, pp. 559–63. Many writers have found it difficult to understand the friendship between the poet and the artist since they see them, one as a 'symbolist', the other a 'realist'. Mallarmé lived much longer than Manet, developing both his craft and his ideas in such a way that he must be linked with the new movements of the twentieth century as well as those of the nineteenth. In the ten years before Manet's death, however, they shared many similar interests. Harris' article helps to clarify this relationship as does

Hamilton, 181–7, and Bowness, *PMA Bulletin*.

[241] Harris, *AB*, 1964, 560.

[242] Hamilton, 183.

[243] Harris, *AB*, 1964, 561.

[244] See below, Part III, 173.

[245] Bazire (66) states that the school of *plein air* began with Manet's *Garden*, and quotes M. Guérard.

[246] *La Vie moderne*, II, 16, (17 April 1880), 250.

[247] Mallarmé, *La Renaissance* (1874), here quoted from Hamilton, 183.

its greatest practitioners, Matisse, 'All that is not useful to a picture is detrimental. A work of art must be harmonious in its entirety; for superfluous details would, in the mind of the beholder, encroach upon the essential elements.'[248]

[248]Henri Matisse, *La Grande Revue*, 25 December 1908, here quoted from Alfred Barr, *Matisse*, New York, 1951, 119.

4. Manet's Reactions

DESPITE the endless proliferation of literature on Manet and his colleagues, we have no appropriate sources for his own views. Nothing remains but some letters of little interest and a few anecdotes told and retold. Antonin Proust's *Souvenirs*, published in 1913, long after Manet's death, is the most quoted source of what purport to be Manet's own words. It is obvious that Proust's memories were colored by Manet's eventual achievement, and also by the eventual justification of his faith in the artist. A certain degree of dramatic emphasis might be expected in his recounting of Manet's early struggles. With all its limitations, however, we must constantly turn to Proust's work, since we have so little else, reminding ourselves as we do so to try to find support for Manet's supposed remarks in the more tangible evidence of historical and artistic fact.

Proust recounts Manet's reaction to the urging of his friends to join them in the early Impressionist exhibitions. 'The Salon is the true field of battle—it is there that one must measure oneself. The little arenas bore me.'[249] In fact, Manet did not exhibit with Impressionists or any other dissident group, but this was perhaps as much because of his real differences of approach as because of his conviction that he must succeed within the establishment in order to succeed at all. In his own time Manet was universally recognized as a catalyst for the Impressionist outburst. His bluntly contemporary subjects and his boldly summary style were seen as directly connected with the scintillating Impressionist experiments. For a certain period in the 1860s valid connections can be made, and certainly Manet's friendship with Impressionist artists is firm fact. However, by the 1870s a great many differences of approach to both style and subject may have made the Salon a more appropriate battle ground for him than for his friends.[250]

Because of the tendency of many twentieth-century writers to summarize the Salon in terms of a few works such as Cabanal's famous *Birth of Venus* in the Salon of 1863, the wide range of Salon subjects in the early 1860s has been little understood. It has already been noted that changes had occurred toward a greater acceptance of genre painting, not only in terms of critical approval, but through the actual numbers of works displayed. While Manet's works were to produce profound reactions, his aims to combine the old and the new

[249]Proust, 43. [250]See below, Part III, 171–4.

seem less radical when compared to genre paintings of the period than when compared to the few 'history' paintings still being produced.[251]

The picture of Manet which the literature repeatedly thrusts on us is of a man crushed by constant rejection, sensitive to a point of painful vulnerability, yet doggedly (stupidly?) repeating again and again the very sins which the critics scorned. Whether described as stubbornness or ineptitude, Manet's persistence ultimately wins out over the hostile establishment. While this approach makes for a romantic story, it sheds little light on either Manet's development or the environment in which he worked. The facts suggest a far more complex situation. Manet's acceptance into Salon exhibitions is an alternation of success and failure, but perhaps, on the whole, a rather good record for bringing his works before the public in a traditionally accepted way. During his adult life from the time of his first submission of *The Absinthe Drinker* in 1859 until his death in April of 1883 twenty-one Salons were held. He twice sent no works; was completely rejected from four exhibitions; but succeeded in showing works in all the others. To these exhibitions he submitted thirty-seven paintings of which twenty-six were accepted.[252] These figures may compare poorly with the successes of a number of popular artists of the period, and they may seem radically unfair in view of Manet's later reputation. However, they were enough to constitute an encouragement to the artist not only to try again, but to confirm and develop his singular approach.

Acceptance in Salon exhibitions was one form of success; critical recognition was another. With more than 4,000 works in each Salon, to be singled out for comment, even negative, might have been seen as a form of acclaim. Even the fact that the Ecole des Beaux-Arts taught students to consider Manet absurd testifies to his importance.[253]

The criticism of Manet's work has been brought together in two places. Throughout his rambling account of Manet's life and works, Adolphe Tabarant offers excerpts from contemporary criticism. George Hamilton's admirable book, *Manet and his Critics*, translates and selects, offering interpretative commentary as well. In both these books the authors quote criticism concerning Manet, but not that directed to other artists. In both much of that criticism seems persistently hostile, but these remarks are taken out of context. What did the critics have to say about everyone else? In fact, not only notorious men like Courbet and Manet, but popularly accepted artists came in for their share of abuse.[254] Part of the pose of the intellectual elite was to make

[251]The question of lowered quality in the salons is discussed above, 4–6. Castagnary complained that only three of the fourteen members of the Institut showed their works in 1875, and of these two sent portraits. M. Cabanal showed *Thamar chez Absalon,* about which Castagnary remarked that 'if he were only twenty-five I would award him the Prix de Rome'—a harsh comment indeed. 'Si même il n'avait que vingt-cinq ans, je proposerais, sur le vu de Thamar chez

Absalon, de lui décerner le prix de Rome.' Castagnary, II, (1875), 144–5.

[252]There is no record of the smaller works such as prints and sketches which were often shown *hors catalogue.*

[253]Moore, *Modern Painting,* 38.

[254]Several French journals, particularly *Journal amusant,* devoted a considerable amount of space to graphic satires of each Salon. For a brief statement on the cartoonists and the journals in which they published,

light of serious issues. The Emperor may have liked Cabanal's *Venus,* but his taste did not protect the painting from attacks by both cartoonists and critics. Castagnary, for instance, exposed the ridiculousness of depicting so weighty a young woman lying gracefully on a wave.[255] His criticism of Manet is sober by contrast.

The cartoon was a favorite form of comment on each Salon. Few artists of note could escape such ridicule. Manet's *The Dead Toreador* is rendered as a doll-like toy, 'joujoux espagnols' in Bertell's 'Promenade au Salon du 1864' in the *Journal amusant.*[256] It shared the page with a cartoon of Gustave Moreau's *Oedipus and the Sphynx,* a work which was to suffer another attack by another cartoonist in the same magazine a week later.[257] In 1876 Manet's two submissions to the Salon were rejected, but he was considered an apt subject for the cartoonist nevertheless. In *Eclipse* Gill shows him bursting through a page of cartoons of nine paintings by other artists, entitled *Les Triomphateurs du Salon* (Pl. 2).[258] The characterization of Manet as the 'Triumph of Absence' seems hardly more cruel than that of Carolus Duran and Vibert as 'The Triumph of the Chic Staircase', or Bastien-Lepage as 'The Triumph of Sincerity'. Popular 'turquerie' comes in for its share of lampooning in the *Journal amusant* in the same year. Emile Ulm shows a woman approaching an artist, 'I would like to have my portrait painted, but I would like something simple and gracious, for example, lying in an horizontal pose on a divan, in the half light a ray of golden sunlight illuminating just my face, bringing out my attractions, and the smoke of a narghileh casting up a vague atmosphere provocative of dreams.'[259] In amusing the public on the pages of *Le Charivari, L'Eclipse* or the *Journal amusant* Manet seems to have been in good company.

During Manet's early career several critics saw promise in his work, and offered their advice in an apparently generous spirit, only later to loose hope that the artist could learn to 'behave'. Others, in spite of their adversary positions, found themselves unable to reject Manet's technical proficiency, and grudgingly admitted his importance. Since his great works remain in many ways puzzling to us today, Manet's critics deserve credit for their restraint in substituting querulous niggling for outright damnation.[260]

While Manet was accused of simply trying to draw attention with the

see Curtiss, 747–51. Mrs. Curtiss plans a larger work on Manet cartoons which are far too numerous to discuss in any detail here. It is interesting to note that the *Bon Bock,* which was generally favorably received, became almost a theme for cartoonists. In two cover illustrations they show him literally standing in a mug of beer: *Le Carillon,* 16 July 1881 (Pl. 89); *Le Sifflet,* 3 May 1874.

[255]Castagnary, I, (1863) 114. For a translation of this passage see Nochlin, *Realism,* 14–15.

[256]*Journal amusant,* 21 May 1864, 4. Cartoon by Bertell.

[257]Ibid., 28 May 1864, 4. Cartoon by

Grévin.

[258]*Éclipse,* 14 May 1876, cover. Cartoon by Gill.

[259]*Journal amusant,* 7 May 1864, 5.

[260]The contemporary criticism of Manet's work is thoroughly explored by Hamilton in *Manet and his Critics,* and there is little reason to review specific critical remarks here. In general, Hamilton interprets the criticism as extremely negative and depressing to the artist. However Hamilton's excerpts show that Manet was defended, albeit sometimes grudgingly, and that his works were noted and commented upon.

audacity of the work he submitted to the Salon[261] he seems actually to have chosen works to send which represented the full range of his approaches and a variety of subjects. The conservative *Le Bon Bock* was submitted with the more radical *Le Repos*; the religious *Christ Mocked* (Pl. 76) with the modern-pagan *Olympia*. Two medals, one at the beginning and one at the end of his career, seem poor recognition of his contribution,[262] but it should be remembered that Salon prizes, particularly at this moment in history, were intended to encourage the dying historical mode. Often prizes in no way indicated public reaction or tallied with the judgements of the critics. It should be remembered, too, that Couture did not prepare his students for the *Prix de Rome* contest, as many other teachers did.[263] While still giving lip service to old principles, Couture played down the importance of the exercises which trained prize winners in favor of a fresh approach before the model.

Prizes were only one form of compensation in the Salons. More important were opportunities to sell to collectors or to obtain comissions. Prize-winning and selling did not necessarily go hand in hand. As we have seen, the critics complained about the effects of the new commercial patronage on artistic quality, and more than one sought new patronage for the new art.[264] Couture himself speaks of the railroads, large companies, and the state itself, as such 'new patrons' for the arts, and reminds his students that their natural judges are the *amateurs*.[265]

Manet lived in a complex age, and like all great artists of all ages he was both sensitive and resilient. Baudelaire did not lack sympathy for Manet when he scolded him for complaining of the critics insults. Instead his letter in response to Manet's appeal for friendly support, classed him with other great figures who had suffered the jibes of little men.[266] He coupled irritation at Manet's despair with backhanded praise, and showed his concern for the artist through letters to his friends who might urge him on. More than a demonstration of Manet's weakness of spirit, this interchange with Baudelaire should be seen as testimony of the fraternity of writers, musicians and artists who recognize each others' trials and can offer each other the real understanding which comes from similar experience. Bazire recounts that people only had to look at Manet's signature and they would begin to laugh,[267] but he said at the end of the artist's life that he never weakened in the face of criticism.[268] Proust himself, although he undoubtedly added glamour and excitement to his stories of Manet's difficulties would have the artist say, 'I have suffered

[261]Maurice Chaumelin, *L'Independence belge*, 21 June 1869, here cited from Hamilton, 131.

[262]In 1881, when Manet was honoured for the second time, the artists themselves selected the jury, and the award was given against the wishes of the Academicians. Gervex and Roll particularly mustered support for Manet. See Boime, 17.

[263]Although heralded for his *Romans of the Decadence* of 1848, a History painting *par excellence*, his oeuvre is overbalanced by portrait and genre. Of 244 works catalogued by Jerome

Willard Howe, Jr. (*Thomas Couture: His Career and Artistic Development*, unpublished Masters thesis, University of Chicago, 1951) only about 70 can be called 'History' pictures, and of those many are preparatory sketches for larger works some of which were never finished.

[264]See Boime, 16.

[265]Couture, *Méthode*, 148–9.

[266]Moreau-Nélaton, I, 69–70.

[267]Bazire, 48.

[268]Ibid., 60.

cruelly, but it drives me on.' He goes on to quote Manet, 'Imbeciles! They don't stop saying I am uneven. They couldn't say anything more laudatory. It has always been my ambition not to equal myself, not to repeat tomorrow what I did yesterday, but to inspire myself constantly with new aspects, to search to make a new note heard.'[269] How like Picasso's statement, 'I have a horror of copying myself.'[270] Railing against the mediocrity of both classical and romantic art, Couture urges his reader to believe that 'true talent is restless, a searcher; he suffers, does what he can, and is never satisfied; while the plagiarist who is born of him, whether he be romanticist or realist, has no doubts; he calls himself legion, he radiates in his mediocrity, he has all the insolence of stupidity.'[271]

Blanche explains that the legend of Manet's failure was developed from little real evidence. True painters had recognized his merits early in his career. He said that Manet 'grieved and rejoiced by turns ... sorry that he was proving startling and causing scandal until suddenly, discovering that even scandal may be profitable, he allowed himself to be persuaded rather readily that he bore every sign of being an innovator, a thorough paced Revolutionary.'[272]

This very human side of Manet the man can perhaps best explain the vitality of his art, since it comes so directly from his involvement in all aspects of his own life. He can become very real to us through a letter of Berthe Morisot's to her sister describing her meeting with Manet in the galleries of the Salon of 1869. 'I found Manet with his hat over his eyes looking bewildered; he begged me to look for his painting since he did not dare himself. I have never seen such an expressive face. He laughed uneasily, declaring at one and the same time that his painting was very bad and that it would be very successful.'[273] As a friend and fellow artist she saw him clearly as a charming person with human frailties and superhuman strengths. The humor, grace, and at the same time the struggle, which underlie her description of this incident seem to make more real the tragedy of Manet's early death. He surely would not have stopped struggling, but the promise of his large late works, and even of his unfulfilled late ideas suggest that his inner strengths would have led him to leave for posterity even more inventive and provocative works.

[269]Proust, *Studio*, 75.

[270]'Statement by Picasso: 1935', in Alfred Barr, *Picasso: Fifty Years of his Art*, New York, 1946, 273.

[271]Couture, *Méthode*, 151.

[272]Blanche, 11–12.

[273]Morisot, 26. Letter of 2 May 1869, to her sister, Edma.

Part II

1. The Range of Manet's Subject Matter

SINCE he felt he was getting nowhere by copying the old masters, by painting nature seen through other eyes than his own, quite simply one fine morning he understood that it was up to him to try to see nature as it is without looking for it in the works and opinions of others. As soon as his idea occurred to him he took anything whatsoever, a person or an object, put it in his studio and began to reproduce it on canvas according to his own ability to see it and to understand it. He made an effort to forget everything he had studied in the museums; he tried not to recall the advice he had received or the paintings he had studied. He became no more than an individual intellect served by specially gifted organs, set down in front of nature, and interpreting it in his own manner.[1]

Zola's description of Manet as 'the sensitive eye' set the stage early for a purely formalist interpretation of his *oeuvre*. Other contemporary critics, puzzled by his curious handling of subject matter, found his deliciously painted still lifes acceptable. If they were positively disposed toward the artist, they avoided the problems of suggested meanings by claiming no meanings existed. If they were not, they accused him of lack of imagination, lack of feeling, lack of 'moral vitality,' and lack of knowledge.[2] 'The proof that Manet lacks knowledge is that when he paints a still life he executes a very beautiful painting, seeing that it is less difficult to do a casserole or a lobster than a nude woman.'[3] Despite their brilliant appearance to us today, Manet's figures

[1]Zola, *Mes haines*, 253. Here quoted from Hamilton, 91. Zola's statement was made in 1867, an early date to assume that Manet had completely rejected the masters. See also, Faison, 162–8. Bazire (6) was convinced that Manet worked directly from nature. 'Il regardait non dans sa mémoire, mais dans la réalité.' See also *Mes haines*, 259, 267–8, 270. Hamilton (93) believes that 'his whole artistic temperament consists in the way his vision is organized.'

[2]These ideas can be found repeated in various forms throughout the criticism quoted by Hamilton. A few examples are: Lack of imagination; Grangedor, 1868, 116, Wolff, 1869, 139, Gautier, 1869, 134; lack of feeling, Lagrange, 1861, 26, Chamelin, 1869, 132; lack of moral vitality, Redon, 1868, 128–9; lack of knowledge, Castagnary, 1863, 47–8,

1868, 123, Redon, 1868, 128, Haché, 1868, 125. It should be understood that the critics' charge that Manet lacked imagination referred not to style but to interpretation of subject. In a few instances the word is used in other ways, but the context makes clear that 'imagination' is usually connected to a belief in the need for dramatization of subject obviously lacking in Manet's work. Redon's judgement of Manet's work is based on just such an understanding of 'imagination'. (Although Redon admired Manet's facture.) 'Knowledge', by contrast, referred to conventional methods of drawing and composition. These subjects are discussed below in Part III.

[3]Gonzague Privat, *Places aux jeunes, causeries critiques sur le Salon de 1865*, here quoted from Hamilton, 65.

seemed to his contemporaries to lack vitality, and therefore to lack the potential for symbol or narrative. Veron, the editor of *Le Charivari*, thought Manet 'Such a clever painter of still life, that all his characters look as if they had risen from their graves.'[4] George Moore only gradually came to know and appreciate Manet's work, but he always saw it in terms of the seriously limited by its naturalism. 'People talk of Manet's originality; that is just what I can't see. What he has got, and what you can't take away from him is a magnificent execution. A piece of still life by Manet is the most wonderful thing in the world; vividness of color, breadth, simplicity, and directness of touch—marvellous!'[5] This view of Manet as a naturalist virtuoso was strengthened in the twentieth century during a wave of formalist criticism. Zervos, writing in *Cahiers d'art* in 1932 commented on Manet's detachment and even found his approach dead and dry. He saw Manet's work as poetry without lyricism, his subjects painted like still lifes from the outside only, and said that the artist 'took refuge in technique' because of a lack of originality and imagination.[6] The same views have been more recently repeated. Bataille, convinced that Manet lacked imagination believed that in painting the *Olympia* 'he had to reduce what he *saw* to the mute and utter simplicity of *what was there*.'[7] 'What Manet insisted on, uncompromisingly, was an end to rhetoric in painting. What he insisted on was painting that should rise in utter freedom, in natural silence, painting for its own sake, a song for the eyes of interwoven forms and colors.'[8] He discusses major works of Manet's in terms of the 'destruction of the subject',[9] and concludes about such a work as the *Olympia* that the 'subject, whose meaning was cancelled out, was no more than a pretext for the act—the *gamble*—of painting.'[10]

Sloane discusses both the *The Battle of the Kearsarge and the Alabama* (Pl. 85) and *The Execution of the Emperor Maximilian* (Pls. 77–82) and concludes that Manet was not interested in subject matter. Being so devoted to his own vision he was incapable of imaginative projection into the subject itself.[11] To be sure Manet declared in a letter to Duret that his lithograph of *The Execution* was an 'oeuvre absolumment artistique',[12] but his words were in protest against the authorities' refusal to grant permission for him to publish a depiction of an inflamatory event, and there is every reason to suspect his motives in such a claim.

[4] *Journal Amusant*, 27 May 1869, here quoted from Hamilton, 132.

[5] Moore, *Confessions*, 104. (First published in 1886). In this statement the word 'originality' is used in the same sense as the word 'imagination' in that it refers to treatment of subject.

[6] Christian Zervos, 'Manet est-il un grand créateur?' *Cahiers d'art*, Nos. 8–10 (1932), 295–6.

[7] Bataille, 31, 57. Italics in the original.

[8] Ibid., 36–7.

[9] Ibid., 50–55, 61–7.

[10] Ibid., 82.

[11] Sloane, *AQ*, 92–106. These ideas pervade the entire article. He found 'hardly a trace of feeling' in *The Battle of the Kearsarge and Alabama*, 94, and felt that in *The Execution of the Emperor Maximilian* 'of dramatic mood or feeling there is virtually none', 99. He believed that Manet 'paid no further attention to the historic meaning of the event itself', and 'that he was incapable of projecting himself imaginatively into such scenes as were required of a history painter', 100. For a discussion of Manet's history paintings see below, 103–27.

[12] Guérin, no. 73.

As recently as 1965, George Hamilton saw 'nothing whatever' to stir 'our sympathies' in *The Execution*,[13] reaffirming his position stated earlier in *Manet and his Critics* that the picture showed a 'total lack of drama'. For Hamilton, Manet's contribution lay in his invention of forms.[14] He stood 'Motionless, we might say even emotionless before the object, his eyes sought only to record the visual experience in the fewest material terms.'[15] Jamot believed that Manet had achieved more, but he saw his power in terms of some magical transformation rather than the working together of subject and style,

> Our Le Nain, our Corot, our Manet, one would believe that they had no other ambition than to observe nature without a preconception and to reproduce it with all possible exactitude; but by a sort of modest miracle, and precisely because they bring no preconceptions to their work, their submission to nature serves them better than any other apparently more noble means to translate with force or with charm the mystery, which, in ordinary times, hides itself impenetrably deep within them.[16]

A new approach to Manet studies has developed in recent years with a quest for the sources of Manet's motifs and a search for their layers of meaning. Some excellent work has been done to balance the earlier formalist interpretation, but a danger exists that the secrets below the surface of Manet's work will seem as consuming a lure as earlier scholars had found his vibrant brush. The ready trap for the investigator lies in reading Manet's painting in terms of twentieth-century social, religious, political, and even medical views, which would have been quite untenable in his own time. The best of recent research in this field has taken advantage of contemporary literature of all kinds to establish probable meanings relevant to Manet the man and to the society in which he lived. Such meanings can complement the obvious qualities of his facture, and often shed light on the curiosities of his composition and handling of form. There is no point here in repeating in any detail the excellent work which has been done toward the specific analysis of certain works. Precisely because such work has been done it is now possible to consider Manet's subject matter in more general terms; to explore what it owed to past approaches, and what it contributed which was essentially new.[17]

Although Manet's subjects are repeatedly characterized as scenes from every day life, their range is remarkably wide. Copies after the masters, still lifes and portraits could be expected of most aspiring artists of his day. His

[13]Hamilton, *Art News*, 111.

[14]Hamilton, 278, 281.

[15]Ibid., 279.

[16]Paul Jamot, Introduction in *Manet: 1832–1883*, catalogue of the exhibition at the Musée de l'Orangerie, 16 June–9 October 1932, Paris, 1932, XXI–XXII, XXV.

[17]While I do not always agree with their interpretations and conclusions, the following authors have made serious contributions to the direction of Manet studies: Wayne Anderson, D. G. Barskaya, Albert Boime, Alan Bowness, Beatrice Farwell, V. Gurevich. Jean Collins Harris, Werner Hofmann, Rosalind Kraus, Alain de Leiris, Gerald Needham, Theodore Reff. Works by these scholars are listed in the bibliography and will be cited at appropriate points in the following discussions.

forays into 'history painting', *The Execution of Maximilian, The Escape of Roche-fort* (Pl. 87), *The Battle of the Kearsarge and the Alabama,* all represent recent history, but by Manet's time Géricault, David and Ingres had all found acceptable themes in recent events. Manet's two religious paintings followed long tradition in story and even in their sources of imagery. In all these works, it was not the subject itself but the way it was presented which made it seem challenging. The same can be said of his nudes, no more nude nor less classical than many of Delacroix's or even of Ingres' figures, but startingly unlike the trivial repetitions of many of his contemporaries for reasons other than the choice of subject alone. Spanish subjects, and depictions of typical citizens of the provinces or members of the lower classes were warmly accepted by critics and public alike, and the variety of scenes of everyday life—sea scapes, races, gardens, parks, street and café scenes—were acceptable subjects if dealt with in acceptable modes. They may have seemed more appropriate to illustration than to serious Salon painting, but such subjects were universally enjoyed.

The very first story we are told of Manet's budding career involves the rejection of his *The Absinthe Drinker* (Col. Pl. II) from the Salon of 1859 and his conversation about the work with his former teacher Thomas Couture. Couture was supposedly shocked by the picture and accused Manet of lack of moral character for painting such a subject.[18] Nevertheless, one hesitates to accept the story at face value. The depiction of drinkers, even absinthe drinkers, was hardly unusual at the time. As a student, and presumably with Couture's blessing, Manet had made a copy of Adrian Brouwer's dramatic drinker already apparently mad from the effects of absinthe.[19] Couture surely knew Manet's model, Collardet, since he was often to be seen near the Louvre. By trade a rag-picker, he was hardly a noble subject, but rag-pickers were already seen in illustrated magazines and more than once appeared as subjects of paintings in the Salons.[20] Much of the technical structure of Manet's picture continues Couture's methods, a fact recognized early by Zola[21] and admitted by Manet himself.[22]

Although Couture might have found fault with the force of some of the less modulated areas of color, it is unlikely that he would have reacted so strongly to what he would deem simply another opportunity to give advice. If the story is true at all, the reasons for his intense feeling must be found neither in the subject of the painting nor its style, but rather in the associations it suggested to Couture—and would have suggested to the public—namely that it illustrated Baudelaire's already shocking *Fleurs du mal.* Hamilton finds that 'the tone—that elusive element which is more than merely the subject—of his

[18]Two versions of the story have come down to us: one told by Proust (33), the other, supposedly told by Degas to Moreau-Nélaton (I, 26). They differ slightly in wording but not in meaning.

[19]Private Collection, Rome.

[20]Hanson, *Museum Studies,* 68–80.

[21]*Mes haines,* 250 (1867).

[22]Proust, 33. 'J'ai préparé sottement mes dessous selon sa formule', Also see below Part III, 158–63.

early paintings, especially of *The Absinthe Drinker*, is Baudelarian.'[23]

The Absinthe Drinker as an early work, provides a dramatic example of the difficulties of discovering what Manet's pictures are 'about'. Problems of interpretation exist for many others as well, and if twentieth-century writers cannot agree the confusions of nineteenth-century critics are surely understandable.

To the standard saws about Manet's lack of interest in his subjects and the narrowing of those subjects to 'scenes from everyday life', can be added other oversimplifications and misunderstandings such as the proclamations that Manet ceased borrowing from the masters at a certain moment in his career, that his 'historical subjects' belong to only one period, or that he never painted a Spanish picture after his visit to Spain.[24] Zola's claim that 'one fine morning,' Manet put behind himself firmly and intentionally his dependence on earlier artists, simply cannot be supported.[25] It is obvious that early in Manet's *oeuvre* his borrowings were overt, both from the standpoint of the easy recognition of their sources as images and the styles of the artists quoted, but also from the standpoint of the disjunction of images within the pictures themselves. The pastiche-like appearance of *The Old Musician* (Pl. 11) is a case in point. Manet's dependence on quotations from other artists abated only very gradually during his career. It would be more correct to say that the borrowings became more and more hidden, more and more part of the elemental structure of his paintings than that he stopped borrowing. There was, at the same time, a shift in sources. From recognizable references to Raphael and Giorgione, to Velasquez and Goya, he turned to equally recognizable references to Hokusai and to contemporary Parisian illustrators. In saying 'equally recognizable' I refer to the French public, not to the present art historian, who finds such references more hidden because of his lack of familiarity with the world around Manet. A change in the intended meaning of his works required a change in source, and with that change a different aura or coloration which gave the works their modernism. Such sources can now be traced in a sufficient number of works to give us an adequate view of the importance of Manet's borrowings to the very content of his pictures.[26] They allow us to read the superficial subject matter in such a way as to understand what Manet's subjects really are, and to see the provocative and innovative way he made form and subject serve together to a content expressive of the very essence of 'la vie moderne'.

Manet's career can be summarized in terms of a series of developmental

[23]Hamilton, 30. He goes on to suggest a strong common feeling in Manet's work and Baudelaire's fourth *Spleen* in the *Fleurs du mal*, noting that Jan Thiis ('Manet and Baudelaire', *Etudes d'art*, I (Algiers, 1945), 9–23, saw a similarity between the painting and Baudelaire's *Le Vin de l'assassin*. I have more directly connected the work with *Le Vin de chiffonnier* in *Museum Studies*, 73. Since the model for *The Absinthe Drinker* was a rag-picker the poem is appropriately titled. The ideas expressed in it are similar to those to be found in less dramatic and poetic popular descriptions of rag-pickers.

[24]Léon Rosenthal, 'Manet et l'Espagne', *Gazette des Beaux-Arts*, XII (1925), 214.

[25]See above, 51.

[26]See Reff, *Artforum*, 40.

stages, each producing masterpieces. We see him early, as a budding profes-
sional, continuing with direct copies after the masters, then moving to modified
copies, such as his *Scene in a Spanish Studio*,[27] or *Fishing* (Pl. 65). While they
definitely refer to Manet's own role as artist, these paintings are at the same
time homages to the artists he paraphrases. Finally, in this early copying stage
are works which can only be described as pastiches. The greatest of these is,
of course, his *The Old Musician*, its blatant quotations drawn together into a
profound statement with a unified meaning which transcends the sum of its
loosely connected parts.

Works of the mid-60s to the very early 70s might be thought of as a second
group. Manet continued to use traditional sources with the witty intention
that they be recognized, but the growing force of his own facture often over-
shadows the borrowed meanings, and a kind of integration of form and subject
forces them to function on a deeper level. Quotations were less often recognized
by contemporary critics, and many have gone unnoticed until the recent
spotlight of art historical inquiry brought them to the surface in somewhat
clinical terms. The mere identification of such sources can too easily become
a profitless game if each identification is not tested against its effect in an
ultimate message.

A third phase begins in the early 1870s when Manet was in close contact
with his Impressionist colleagues and his work underwent a lightening of
palette, a loosening of brush stroke, and a further simplification of form. On
the surface, he seems to have turned more to the direct observation of every-
day life with the overt purpose of recording the world around him without
comment or judgement. However, the lessons of Japanese art played an
important role in the development of light-filled virtuoso shorthand notation
of his last years.

This brief and superficial summary may serve as an framework for the
discussion of Manet's subjects one by one. But first we have admitted that
Manet was a constant borrower through most of his career, and a word should
be said about the very nature of borrowing itself. In spite of the lessons to be
learned from Picasso's career, his constant use of art as subject for art, the
standard views of borrowing, already expressed by critics of the nineteenth
century, pervade twentieth-century thinking on the subject. When Manet
was accused of lack of imagination, it was in part because his subjects were
without narrative and symbolic overtones, and in part because he re-used
the motifs of other artists without expected adaptions. Ingres' paraphrases
of Raphael in the *Vow of Louis XIII*, while immediately recognizable to the
extent of being an overt homage to the Renaissance artist, were nevertheless
bathed in a nineteenth-century sentiment already expressed by other works
in Ingres' *oeuvre*, and very much available to the average spectator in terms of
respect for the past and the assumption that even modern man could be aroused

[27]Private Collection, Paris, 1860.

to noble religious feeling.[28] By contrast the equally overt borrowings in Manet's *The Old Musician* defy easy interpretation and certainly present no universally accepted moral message. The combination of a number of sources in high art with sources from recent Salon painting, current magazine illustration, and even Manet's own earlier works, makes clear the borrowings served not only to give status to the work in terms of both form and elevated idea, but were used to establish other more complex concepts as well. The artist of Manet's day quoted from other works of art for reasons quite different from Ingres'. One such reason is largely formal. The interest in the visual image itself, the effect of a pose, a combination of colors, a linear arabesque, can preoccupy his vision and he begins to see a motif in many places and many forms. If the traditional artist works from a pattern book, copying out an image from a standard guide, one image may suffice, but nineteenth—and twentieth-century artists, largely freed from such shop methods are more liable to collect and combine similar images from a variety of sources. Manet went further to pose live models after motifs he had found in other arts, as if to double check against nature the very essence of an artistic motif, and in doing so to deprive it of its artifice, and infuse it with new possibilities of form and meaning. It is therefore futile to search for one 'correct' source for a given motif in a picture by Manet. When a number of possibilities present themselves, they may all be 'correct' in the sense that they form a useful collection of images for further processing.

It is also important to remember that artists are often influenced by motifs in works which are inferior to their own in quality. Images can be attractive as raw material quite regardless of their artistic worth or even their expressive force if they offer formal or associative elements relevant to the artist's aim. Certainly Japanese prints were not regarded by their Parisian admirers as high art, yet they provided a rich source both for compositional devices and for specific motifs for a number of highly inventive artists. Manet, and Degas as well, used ordinary illustration and even popular verbal descriptions as source material. Such borrowings no longer served to underscore the noble forms in a work of art, or to enforce its high purpose, and unless we can accept the explanation sometimes offered that they were used simply as the result of a paucity of inventiveness, then we must find new reasons more appropriate to the new functions of art after the middle of the century in the expression of its own age.

[28]Jean Seznec ('*The Romans of the Decadence and their Historical Significance*', *Gazette des Beaux-Arts*, XXIV (1943), 221) points out that Couture's painting, *The Romans of the Decadence*, is an amalgamation of fragments from Tiepolo's *Last Supper*, Veronese's *Marriage at Cana*, a Rubens figure, a bit of Parthanon drapery, and an 'attitude' from Poussin, the central group having been drawn from *Virgil Reading the Aeneid* by Ingres. Manet may have learned his approach to combined borrowing from Couture.

2. Genre: The Parisian Type

IN discussing the nature of genre as a category, Max Friedländer makes the distinction that 'The historical picture says: *that* happened once; the genre picture says: *this* happened often ...' Genre, meaning genus or species, is thus anonymous; it has to do with the idea or type. 'Because we do not know the names and are not interested in them, the common human condition is revealed and, within that condition, class sex, age, mother, child, soldier, lady.'[29] Friedländer's remarks provide an introduction to a discussion of genre painting of the seventeenth century, the period he regards as the Golden Age of genre, and the period from which so many of Manet's motifs are drawn. They are equally fitting, however, for the popular illustrated literature of the nineteenth century which, like a vast encyclopaedia, provided information about 'typical' people of various ages, professions and origins. It is not difficult to amass considerable evidence that Manet looked at this kind of literature nor to assume that he saw in it an easy access to imagery which would document his paintings of modern life.[30]

While no one has pointed to a specific source for Manet's *The Reader* (Pl. 101) of 1861, a portrait for which the model is known, the image can be regarded as a type. It meets Friedländer's requirement of genre that it speak of the common human condition, and the acceptability of the subject seems proven by the fact that 'readers' are found in great numbers among the genre pictures in the Salon. Shown in Martinet's gallery in Paris, Manet's painting escaped critical notice, possibly because nothing offensive could be found in either the subject or the style, which to Moreau-Nélaton seems reminiscent of Velasquez.[31] The famous *Bon Bock* (Pl. 110) of many years later, like *The*

[29]Max Friedländer, *Landscape, Portrait, Still Life*, New York, 1963, 155.

[30]In a chapter entitled, 'Pictures of Humanity', Werner Hofmann, (*The Early Paradise: Art in the Nineteenth Century*, 1961, 135) suggests that such works as *Les Français peints par eux-mêmes* were sources for this type of painting. He does not offer specific examples. For bibliographical information on this work see above, Part I, note 51. All references below will be to the four-volume edition, Paris, [1876–8] unless otherwise noted. Hanson, *Museum Studies*, 65, shows direct connections between the illustrations in *Les Français*

peints par eux-mêmes and a number of Manet's paintings. Hanson, in Finke, 133–63, demonstrates similar borrowings from a variety of sources such as popular song illustrations and illustrations in books and magazines such as *Les Rues de Paris*, *Le Nouveau Paris*, the *Magasin pittoresque*, and the *Physiologies*. The first important study of the influence of popular imagery on nineteenth-century painting is Meyer Schapiro's 'Courbet and Popular Imagery', *Journal of the Warburg and Courtauld Institutes*, IV (1940–1), 164–91.

[31]Moreau-Nélaton, I, 33.

Reader, treats a common type like so many jovial smokers and drinkers which populated the Salons and the contemporary magazines.[32] Its debt to Frans Hals has frequently been mentioned, and it thus can be linked solidly to the Golden Age of Genre. While it received some negative comment it also won praise. The safe subject and the somewhat conservative handling of colors and values allowed some critics to admire the virtuosity in paint handling and the robustness of effect. Albert Wolff, a particularly harsh antagonist felt that Manet had 'put water in his beer'.[33] Manet's *gamins* such as the *Boy with the Cherries*[34] and *The Urchin* (Pl. 3), offer the same double reference to past and present, to seventeenth-century genre and to subjects in popular illustrations. The source for *The Urchin* is undoubtedly a reproduction of a Murillo painting in the Hermatage. *Les Français peints par eux-mêmes* includes a chapter entitled 'Le Gamin a Paris', and also an illustration called 'Le Petit Mendiant' (Pl. 4) which is an engraving after Murillo's painting.[35] Again a living model is also known—this time Léon Leenhoff. In all these instances Manet has apparently been inspired by a pictorial source and then posed a model following the motif in order to make that motif truly modern.

The best known of Manet's early works which thus combine overt references to past art and yet spoke strongly of its own day is *The Spanish Singer* (Pl. 5), which won for him an honorable mention in the Salon of 1861. The critics were immediately struck by its realism; they were divided as to whether this quality was good or bad. Guitar players had already populated the Salons and Gautier was to say with obvious relief 'Here is a *Guitarero* who hasn't stepped out of a comic opera ... How heartily he sings as he plucks away at his guitar! We can almost hear him.' While recognizing the figure's immediacy, Gautier also saw the painting's origins in earlier arts, 'But Velasquez would have given him a friendly wink, and Goya would have asked him for a light for his *papelito*.'[36] For both subject and pose one can find Dutch as well as Spanish sources. Surely Manet had looked at a number of paintings by Teniers which supply the singing figure, the bench, the ceramic jug, in various combinations.[37]

[32]Moore, *Modern Painting*, 36, says that 'Manet's *Bon Bock* is one of the eternal types, a permanent national conception as inherent in French life as Polichinelle, Pierrot, Monsieur Prud'homme, or the Baron Hulot.' See Hanson, *Museum Studies*, 64–5 for a discussion of such types.

[33]Hamilton, 166–7.

[34]Gulbenkian Foundation, Lisbon, 1859.

[35]Manet would also have known Murillo's painting *Le Jeune Mendiant* in the Louvre. While the composition is quite different, the painting does show a similar straw basket and Manet's figure resembles the young Murillo beggar both in age and facial features. Reff (*Burlington* 1970, 456–8.) points out that Murillo's *Little Beggar* in the Hermitage was illustrated in Charles Blanc's *Histoire des peintres*, and would also have been available to Manet from that source. The publication

dates of the various volumes of Blanc's history of painting postdate Manet's paintings, but Reff believes that the sources which Manet did use were published in fascicules during the 1850s before being republished in bound volumes. The number of motifs which seem to depend on illustrations in Blanc make his argument convincing. Since Blanc's illustrations are engraved copies of the works they had undergone an aesthetic transformation just as had copies used for illustrative material in volumes of a more popular nature.

[36]3 July, *Moniteur universel*, here quoted from Hamilton, 25.

[37]Manet's Dutch sources were recognized by his contemporaries. G. Randon noted Manet's debt to Teniers and Van Ostade in the sub-title of his cartoon of *The Smoker* (Minneapolis Institute of Arts, 1866) in the *Journal amusant*, 1867 during Manet's private

The temptation to look for a precise and accurate source is great and this might well be an appropriate approach for the art historian bent on unravelling the truths about some other artist, time and place. Here, we must again accept the multiplicity of Manet's borrowings as an element basic to his own thinking about the role of past art in the creation of a modern means of expression.

Gypsies cannot be considered as part of a repertoire of French types except that, being homeless, they were at home everywhere. Like Spaniards, gypsies were among the most popular subjects both for illustrations and for paintings. From 1857 gypsies were seen in all the Salons; numerous books and articles appeared which were concerned with precise details of gypsy language, dress and customs. Gypsies were the subject for plays, pantomimes, ballets and opera. Prosper Mérimée's *Carmen* of 1847 was largely based on George Borrows' standard work on gypsies, and in turn Bizet's *Carmen* produced in 1875 at the Opéra Comique depended on Meilhac and Halévy's version of Mérimée's story.[38] In an interesting parallel to the new convictions that primitive, childlike and popular arts could be appropriate sources for serious art, Franz Liszt's *Des bohemiens et de leur musique en Hongrie* of 1859, aroused interest in the study of gypsy music.

Manet painted a large picture of gypsies which was shown both in Martinet's gallery in 1863, and in his large exhibition on the Port de l'Alma in 1867.[39] After this exhibition Manet cut the painting into several fragments and our knowledge of its subject and composition comes from an etching (Pl. 6) which he made after the painting.[40] It depicts a gypsy family, a father (Pl. 7), a

exhibition at the Port de l'Alma. 'Il y a des gens qui préfèrent ceux de Teniers ou même de Van Ostade. ... ' Manet saw Dutch works on his trips to Holland, and illustrations were available to him in various publications including those of Blanc and Thoré. His friend, the American dentist, Dr. Thomas Evans, who bought some of his works, had a fine collection of paintings which was largely comprised of Dutch genre and included works of Teniers and his followers. A type-script of the inventory of Evans' collection at the time of his death is in the library of the Thomas W. Evans Dental Institute, University of Pennsylvania.

[38] A great many books on gypsies appear to base their information on H. M. G. Grellmann, *Histoire des bohémiens*, Paris, 1810, a work which describes their habits and dress with details concerning their filth, the unsavory things they eat, myths on cannibalism and child stealing. A study on the gradual changes in attitudes towards gypsies in the nineteenth century would reveal much about the century itself.

[39] *Catalogue des tableaux de M. Edouard Manet exposés Avenue de l'Alma en 1867*, Paris, 1867, no. 9. For more easily available list of works shown see Moreau-Nélaton, I, 43.

[40] The etching, Guérin, no. 21. Early catalogues of Manet's paintings err in listing the

three fragments of the painting as: *Buveur d'eau* (Orienti, no. 46; Tabarant, no. 47; Wildenstein, 1932, no. 59), *Bohémienne* (Orienti, no. 42; Tabarant, no. 48; Wildenstein, 1932, no. 61), and *Bohémien* (Orienti, no. 43; Tabarant, no. 49; Wildenstein, 1932, no. 60), since the picture of the female gypsy was destroyed in the cutting. Information given by all three cataloguers for *Bohémienne* belongs to another work, *Gitane à la cigarette* (Orienti, no. 41; Tabarant, no. 50; Wildenstein, 1932, no. 304). Wildenstein, 1975, still lists *Bohémienne* (no. 45), but correctly states that Manet destroyed it. For a full explanation see Hanson, *Burlington*, 158–66. As was mentioned in note 46 of this article, it is likely that a still life of a basket of onions, now in a private collection in Paris, is another fragment of the original picture. Unfortunately I have not been able to obtain permission to see the work. See Wildenstein, 1975, no. 44. I was able to unravel the mystery of the apparently incompatible fragments listed in the catalogues because of a belief that the etching was a correct copy of the original painting. Such copies were frequently made by nineteenth-century artists to advertise their works, and it was common for a 'canvasser' to take orders for prints after paintings in galleries during exhibitions. See Moore, *Modern Painting*, 177–80.

mother with a baby, and in the background a small boy (Pl. 8). The standing male figure, centrally placed, repeats a convention for the depiction of provincial types, already used and re-used in literature like *Les Français peints par eux-mêmes*. *La Limosine* (Pl. 9), by Jeanron shows a figure, albeit a woman, in an identical pose. This is not just a matter of Manet's finding a convenient way to order his model, but of his conscious continuation of a convention used for reporting information about various types of people. The convention, although having its roots in seventeenth-century genre, thrived in eighteenth-century travel literature, where plants, animals, and people are described not according to their particular features, but to the features common to them as a class. This organization of the unfamiliar into clear concepts as classes or types allows for an appropriately 'scientific' understanding of a great mass of disparate material. [41] With a growing concern about man's role in nineteenth-century society, descriptions of the Frenchman in his own habitat had become interesting to the Parisian, and narrative elements in illustration and literature often gave way to a deft combination of acute observation and preconceptions about the typical. Since the aim of travel books is to provide information, views and scenes are usually directly descriptive, often including human figures involved in typical tasks. Most common is the single standing figure set against the slightest indication of low lying landscape, wearing typical dress and holding tools or weapons which provide further information about their lives. Jeanron's *La Limosine*, like many other provincial figures in *Les Français peints par eux-mêmes* is depicted in just this fashion. It almost appears that Manet's *Gypsies* might have been originally planned to include only one figure, since the male gypsy is placed in front of a low-lying landscape almost at the center of the composition, and the other three figures are crowded into the space at his left. This curious arrangement suggests a compositional problem in the large oil. Certainly we have no other evidence of any kind to suggest why he decided to dismember the painting. However, the combination of the standing male type with other figures is not unknown either to travel illustration or to the illustrations of French types as can be shown by the insertion of other family members into an illustration of a family of negroes from Laongo in an eighteenth-century English travel book or the illustration of a Parisian worker in *Les Français peints par eux-mêmes* (Pl. 10). In any case Manet has cast his family of gypsies into a popular form of reportorial imagery, avoiding the rich possibilities of narrative and romantic episode in favor of a blunt view of things as they are.

The Old Musician (Pl. 11) is the largest, and the most complex of Manet's early paintings. On the one hand obviously a pastiche of disparate images; on the other, a work of haunting impact. Formalist explanations cannot overcome its disjunctions, nor explain its power. Of all Manet's works, it has aroused the most attention on the part of recent scholars looking for Manet's sources and hoping to explain the content of his work. Alain de

[41]A great many nineteenth-century travel books kept this tradition alive. One example, *La Turquie pittoresque: histoire, moeurs, descrip-* *tion* (William A. Duckett, preface by Théophile Gautier, Paris, 1885) includes descriptions of gypsies (190).

Leiris was one of the first to understand Manet's method of asking his models to take the poses he found in motifs in earlier arts. He successfully shows that the figure of the old musician while depending in part on the central figure in Velasquez' *Drinkers,* owes as much to a Roman replica of a Greek portrait of Chrysippos of which Manet had made a drawing in the Louvre. Manet would have known that the subject of the sculpture was an ancient philosopher, but, since in the nineteenth century the piece wore the wrong head, he would not have known precisely which.[42] Florisoone was the first to point to a very different kind of source in identifying the little boy dressed in white with Watteau's *Gilles,* and he suggested parenthetically that he might be one of the little peasants in 'la *Charette* de Le Nain', presumably referring to Louis Le Nain, *Les Moissonneurs* now in the Louvre.[43] Paintings by both Antoine and Louis Le Nain have since been suggested for the entire composition as well as for particular figures. Most recently Michael Fried has proposed no less than three paintings by Louis Le Nain as sources for *The Old Musician,* finding individual bits to choose from each.[44] In an article written in answer to Fried's, Theodore Reff suggests Antoine Le Nain's *Old Piper,* since he finds in it not only sources for the poses of some of the figures but spiritual connections in 'the very qualities of gravity and naive wisdom that contemporary writers considered characteristic of the street musician and urchins whom Manet represents.'[45] I have stated my preference for the *Rest of the Horsemen* (Pl. 12) and suggested that the writings of Champfleury and Blanc in the 1840s could have made the works of the Le Nain known to Manet.[46] I do not know how this picture might have been available to Manet, but Louis Le Nain's *Les Moissonneurs* and Antoine Le Nain's *The Piper* were both illustrated in the pages of the *Gazette des Beaux-Arts* during 1860 (Watteau's *Gilles* was illustrated in the same volume.)[47] Reff has since pointed out that a large number of the paintings which influenced Manet were illustrated in Charles Blanc's *Histoire des peintres,* a multi-volume work published over the years between 1849 and 1876, the volumes most important to Manet appearing before 1860.[48]

[42]De Leiris, *AB*, 1964, 401–4, and De Leiris, *Drawings*, 8, no. 4. Although De Leiris makes this important connection, he does not carry his discovery to the possible conclusion that the old musician *is*, in fact, a philosopher. Earlier, Michel Florisoone had proposed Velazquez's and Zubaran's paintings of philosophers as sources for Manet's *The Old Musician. Manet*, Monaco, 1947, xxxii.

[43]Florisoone, xvi–xvii.

[44]Fried, 30–31, 46. The paintings suggested are, *La Halte du cavalier,* in the Victoria and Albert Museum, London, *Les Moissonneurs,* and the *Repas de paysans,* both in the Louvre, Paris.

[45]Reff, *Artforum*, 43.

[46]Hanson, *Museum Studies*, 70. Reff has since proven such an assumption to be correct. See above note 35.

[47]Antoine Le Nain, *Old Piper, Gazette des Beaux-Arts,* VIII (1860), 176; Louis Le Nain, *Les Moissonneurs, Gazette des Beaux-Arts,* VIII (1860), 273; Watteau, *Gilles, Gazette des Beaux-Arts,* VII (1860), 261. Le Nain's, *La Nativité,* which may have served as a source for the seated figure in Manet's etching, *Gypsies* (and for the related oil painting of which this part is now destroyed), is to be found illustrated in *Gazette des Beaux-Arts,* VIII (1860), 327. Fried cites Louis Le Nain's *Forge* as a source for Manet's *Portrait of the Artist's Parents,* (44–5). Although there are some general stylistic connections, a specific connection here seems far fetched. However it is interesting to note that an engraving after the *Forge* was used to illustrate a chapter on workers in *Les Français peints par eux-mêmes,* 1876, IV, 37.

[48]See above, note 35.

Apparently Manet could choose from a large repertoire of motifs repeated by the brothers Le Nain in various combinations, just as he used the benches, jugs and musicians which were to be found reappearing in various forms in the work of David Teniers. All this suggests that Manet had a rather thorough knowledge of the arts of the past and a keen interest in reading the latest statements about them. He was apparently equally interested in the art of the present. Henri-Guillaume Schlesinger exhibited a painting of a family of gypsies in the Salon of 1861 which was illustrated in the *Magasin pittoresque* during the exhibition.[49] *L'Enfant volé* (Pl. 13) depicts a practice described in virtually all the literature on gypsies—the theft of a baby. The light-skinned child held by the man in the center of the picture attracts the attention of the other gypsies, except perhaps for the lookout seated on a rock. This presentation, both informative and anecdotal, is completely opposite in spirit to Manet's *The Old Musician*. To the left and slightly isolated from the main group stands a barefoot child holding a baby. An immediate source, she appears almost unchanged to the left of Manet's lonely wanderers. Despite the explicit reference to Schlessinger's painting, Manet may not have intended to identify the little girl specifically as a gypsy.

When he repeated the figure in an etching for his 1862 portfolio, it was printed on the same sheet with *The Urchin*, and simply entitled *The Little Girl*[50] (Pl. 14). Moreau-Nélaton says that some of the models for Manet's *Old Musician* were probably beggar children from 'Little Poland', a picturesque slum near Manet's studio[51] (Pl. 15). I have pointed out elsewhere that this quarter was illustrated in *Les Français peints par eux-mêmes*; that one of the children carrying a bundle or a baby in this illustration is reminiscent of the *Little Girl,* and that she is also similar to other depictions of beggars and orphans which appear in other chapters.[52]

In part the Le Nain's *Rest of the Horsemen* seems close to *The Old Musician* because of the broad expanse of landscape behind the figures which serves to separate them from each other. Manet has further enforced this sense of separation by the pastiche-like quality of the work. The quotations from several sources remain distinct, adding to the isolation afforded by the barren landscape. Although some figures look at others, none actually exchange glances, the only sense of human contact being afforded by the comradely embrace of the two small boys. The impact is similar to that of Picasso's *Saltimbanques* where a group of acrobats stand similarly psychologically separated in a kind of wasteland. Picasso was undoubtedly familiar with Manet's painting, which was shown at the Salon d'automne in 1905.[53] As lonely figures on the fringes of society, the actors of his Saltimbanque period could express for Picasso

[49] *L'Enfant volé, Magasin pittoresque,* XXVIII (1861), 293.

[50] *La Petite Fille.* Guérin, no. 25. Harris, *Graphic Works,* no. 19. For a list showing Manet's own titles, see Manet's trial etching for a frontispiece for a portfolio, Harris, *Graphic Works,* no. 39.

[51] Moreau-Nélaton, *Graveur,* no. 12.

[52] Hanson, *Museum Studies,* 70.

[53] National Gallery, Washington. Alfred Barr, *Picasso, Fifty Years of his Art,* New York, 1946, 36. My thanks to Edward Fort Fry for calling the Salon d'automne catalogue entry to my attention.

some of his own feelings of isolation. Daumier had many years earlier shown the plight of the wandering player in his cartoons of hollow-eyed and dejected *saltimbanque* families. Francis Haskell, in a penetrating article on 'The Sad Clown' even likens him to another legendary outcast, *The Wandering Jew*.[54] While Haskell does not mention Manet's painting, he does comment on one of its most obvious sources, Watteau's *Gilles* (Pl. 16). Elegantly dressed to perform before a luxury-loving society, *Gilles* nevertheless seems to be enveloped in a nostalgic sadness. As Dora Panofsky has pointed out, *Gilles* is shown performing the *parade* or free announcement before the actual performance begins, and that he wears the same costume and has the same character as Pierrot, a farcical figure, constantly mistreated and laughed at.[55] Since Watteau's day, the *Commedia dell'Arte* had become a less elegant and more popular form of entertainment, being revived by the intelligensia because of their interests in the entertainments of the common man, and their view of the *Commedia dell'Arte* as 'a microcosm of the human condition'.[56] We cannot so securely identify the boy in dark clothing whose hand rests on Pierrot's shoulder. He may be another member of the lonely group of wandering players, but unfortunately nothing in his anonymous costume allows us to suggest that he could be a Harlequin with whom Pierrot was then and later so often paired.

The old musician himself is clearly still another wandering entertainer, familiar to the readers of magazines and books about the types. Reff gives the musician the character of the type of street philosopher described by Victor Fournel and Champfleury, and he assumes that Manet's choice of the Chrysippos statue as a motif was intended to underline this relationship.[57] Since much of the popular literature of the period endows such street people with naive wisdom, this interpretation is reasonable.[58] More certainly a philosopher in Manet's mind is the figure of the absinthe drinker, copied directly from Manet's own painting of that title. If Manet was truly distressed by the negative reactions to his original *The Absinthe Drinker* (Col. Pl. II), it must have had special meaning for him or he would not have chosen to repeat it again in a larger work. In a priced record of works he had available for sale

[54]For the three Daumier cartoons, see figures nos. 9, 10 and 12 in Francis Haskell's article, 'The Sad Clown', in Finke, 2–16. Also see Linda Nochlin, 'Gustave Courbet's *Meeting*: A Portrait of the Artist as a Wandering Jew', *Art Bulletin*, XLIX (1967), 209.

[55]Dora Panofsky, 'Gilles or Pierrot', *Gazette des Beaux-Arts*, XXXIX (1952), 319.

[56]Haskell in Finke, 9, discussing Théophile Gautier's views.

[57]Reff, *Artforum*, 43, citing from Gloria Colton Feller, A Study of the Sources for Manet's *The Old Musician*, unpublished Master's thesis, Columbia University, 1966, 15–17.

[58]Rosenthal (*Aquafortiste*, 61) in speaking of the etching of *The Absinthe Drinker* suggests a connection with popular illustrations, 'Il avait

dans le tableau, un air doux et, somme toute, sympathique; c'était un bohème, un intellectuel dévoyé. Il a, à présent, une mine patibulaire comme certains héros de Gavarni ou d'Henri Monnier.' I go into some detail concerning the connections between Manet's 'philosophers' and popular literature in *Museum Studies*, 70–78 and Finke, 142–5. It is not known whether Manet would have concerned himself with the identity of the antique statue of Chrysippos. The use of the name 'Christophe' for the rag-picker philosopher in *Les Français peints par eux-mêmes* (IV, 23) suggests that there is more to be done on the study of nineteenth-century attitudes toward ancient philosophers as a continuing tradition.

in 1872, Manet listed four of his paintings as 'four philosophers': *The Absinthe Drinker, The Ragpicker,* and two paintings each entitled *Philosopher*.[59] These two philosophers, clearly beggars, have been traditionally connected with Velasquez' paintings of Aesop and Menippus. While other sources for Manet's paintings are to be found, the similarities are strong.[60] By the seventeenth century in Spain philosophers were frequently portrayed as beggars, a fact which Manet might have known.[61] He would have had other means of making such a connection, however, through both the texts and illustrations of popular literature on typical French professions.

It was known that the model for *The Absinthe Drinker* was a ragpicker who was a familiar figure around the Louvre. A chapter in *Les Français peints par eux-mêmes* is an early source for descriptions of ragpickers. It speaks of a rag-picker philosopher who gets carried away with the heady wine of his own words.[62] Manet could have read the descriptions of ragpickers in *Les Français peints par eux-mêmes*, and since many connections can be made with the illustrations in those volumes we may assume that he did. However, the attributes established there for various types seem to have become common currency through repetition in other journals, thus making precise sources difficult to ascribe, just as it is difficult to name precise visual sources for Manet's imagery. Pierre Zaccone's *Les Rues de Paris* (Pl. 17) for example, offers similar illustrations of ragpickers and a text which amounts to a summary paraphrase of the chapter in *Les Français peints par eux-mêmes*.[63]

It has already been suggested that Manet's *The Absinthe Drinker* was found offensive because of its inferred reference to Baudelaire's poetry. While the language is of a different order, the content of Baudelaire's *Le Vin de chiffonniers* seems almost to have been drawn from these popular sources.[64] Like his

[59]Moreau-Nélaton, I, 132. *The Absinthe Drinker*, Pl. II; *The Rag-Picker*, Norton Simon Foundation, Los Angeles, 1869; *The Philosopher*, both Chicago Art Institute, 1865. *The Rag-Picker* is entitled *Le Mendiant* by both Duret (1919, no. 95) and Wildenstein (1932, no. 153). In 1931, Tabarant gave it its correct title, *Le Chiffonier* (*Manet: Histoire catalographique*, Paris, 1931, no. 106) and in 1941 he explained the confusion which had arisen from the use of the title, *Le Mendiant* (115–16). It is worth noting that Manet grouped together a work of 1859 and two of 1865, and one of 1869. While stylistic differences are obvious between the earlier and the three later works, the type of subject and its presentation are much the same. Certainly the meanings of the four works are similar.

[60]See José López Rey, *Velàzquez: A catalogue raisonné of his oeuvre*, London, 1963, nos. 73 and 78. The meaning of the Philosopher painting may not have been generally known. In an article written in 1863 Charles Blanc stated that he did not know why Velazquez's paintings of Aesop and Moenippus are

so named, commenting that the figures could not have more Spanish faces. Blanc also said that the two paintings were known through Goya's etchings of them. (Blanc, 'Velazquez à Madrid', *Gazette des Beaux-Arts*, XV (1863), 65–74) Goya's etchings of the two philosophers are also mentioned by Valentin Carderera, 'François Goya', *Gazette des Beaux-Arts*, XV (1863), 245. For a full discussion of the philosopher paintings, see Hanson, *Museum Studies*, 74–8.

[61]Delphine Fitz Darby, 'Ribera and the Wise Men', *The Art Bulletin*, XLIV (1962), 297–307.

[62]Hanson, *Museum Studies*, 43–4, and Finke, 142–5.

[63]Pierre Zaccone, *Les Rues de Paris*, Paris 1859, 205–8. A review of *Paris qui s'en va et Paris qui vient* (Paris 1860) in the *Gazette des Beaux-Arts*, VI (1860), 184–5, mentions that the livraison on the 'Métier de chiffon' develops the idea of the rag-picker as practical philosopher. The rag-pickers' café, mentioned in other literature is illustrated here.

[64]Charles Baudelaire, *Les fleurs du mal*, Paris, 1941, 120–21.

earlier counterpart, Baudelaire's wretched figure also speaks of sublime laws and makes himself drunk on his own glorious words. Just as Manet recast the illustrations of rag-pickers to form his *The Absinthe Drinker*, Baudelaire created a moving poem capable of shocking the same public who took no offense at the same ideas more prosaicly expressed in popular *études des moeurs*.

Following descriptions in Fournel, Feller identifies the bearded figure to the far right in *The Old Musician*, as a quack doctor or hawker of remedies.[65] He might also be identified as the 'Wandering Jew', subject of many popular prints, Eugene Süe's book of the same title, and a song by Beranger with the catching refrain, 'Toujours, toujours, toujours, tourne la terre ou moi je cours.'[66] Whichever identification is correct, he takes his place among a group of wanderers, who live isolated on the fringes of society. The very quality of physical separateness which Manet achieves by piecing together his composition from various sources and by allowing the figures to remain essentially unrelated, is thus potently expressive of the subject it represents.

Max Freidländer says 'The painter who feels the universal human constant naturally inclines to the lower classes, whose doings and behaviour are not regulated by education and ceremonial.' 'Countrymen, the child, all creatures who are close to nature are less affected by change than the higher classes, than civilized society.'[67] Manet's philosopher beggars and wandering players while perpetually with us, had to depend for their modernism on references to contemporary illustrations, stores and songs. Manet also depicted types described in popular literature which could be immediately recognized as modern since, being upper class or at least Parisian, they wore fashionable clothes. Thus, his pretty *The Milliner* (Pl. 18) appears to derive directly from an illustration of a chapter on milliners in *Les Français peints par cux-mêmes* (Pl. 20); the portrait of his friend Duret (Pl. 19), on an illustration to a chapter entitled 'L'ami de l'artiste' (Pl. 21).[68] Other works such as *Nana*, *Le Journal illustré*, *La Parisienne*, and *The Amazon*, all depict fashionable young ladies, who are representative of specific types, and who therefore speak of the human condition in a new modern idiom.[69]

Sandblad believes that the summer of 1862 was the moment of a shift in

[65]Reff, *Artforum*, 43 and 48, n. 14.

[66]*Oeuvres complètes* de P.-J. de Béranger (2 vols.), Paris, 1856, II, 214–15. Champfleury devoted a large portion of his *L'Histoire de l'imagerie populaire* to the legend of the Wandering Jew, however, this work was published in 1869 after Manet's painting was completed.

[67]Friedländer, *Landscape, Portrait, Still Life*, 166.

[68]See Hanson, *Museum Studies*, 69, Figs. 7, 8, 9, 10. Even Manet's *Le Linge* does not represent the overworked lower classes, but a pretty, up-to-date young mother in her backyard. The painting was refused by the jury of the 1876 Salon, but shown to the public in Manet's own studio (see Hamilton, 194–200). The painting was not well received, and

Albert Wolff accused Manet of having an eye but no soul (*Petite presse*, 17 April 1876). According to Proust (81) Manet answered by saying 'Si au lieu de peindre Jeanne Lorgnon nettoyant ses hardes, j'avais fait l'impératrice Joséphine lavant son linge sale, quel succès, mes enfants.'

[69]See below 86–9, 129. A recent exhibition of imagery of Nana offers further explanation of Manet's paintings through graphic comparisons with other paintings and popular illustrations. *Nana— Mythos und Wirklichkeit*, Hamburger Kunsthalle, 19 January– 1 April 1973. The same material, differently organized, appears as a book under the same title by Werner Hofmann, Cologne, 1973. I did not use either source, since my text was completed when they appeared.

Manet's interests from the lower class genre of *The Old Musician* to the fashionable genre of *Concert in the Tuileries* (Pl. 1).[70] The latter painting has been dated as early as 1860, but Sandblad convincingly demonstrates that this date is untenable, and places the painting in the summer and fall of 1862,[71] *The Old Musician* having been painted in the first half of that year. As far as precise dating is concerned Sandblad is undoubtedly correct. However, Manet continued working with the subjects of *The Old Musician* in graphic works, and three of his 'philosophers' were not painted until 1865.[72] Rather than an abrupt change it seems that Manet gradually developed a preference for more fashionable subject matter during the 1860s.

While the *Concert in the Tuileries* is admittedly a modern scene depicting Manet himself with an assembly of artists, musicians and writers of his own circle, Sandblad has shown that, like the paintings of lower genre, it intentionally refers to the work of an earlier master.[73] Manet had copied a small painting in the Louvre which was then thought to be by Velasquez and made an etching after his copy (Pl. 115) In a catalogue of 1853, Frédéric Villot explained that it represents famous artists who were contemporaries of Velasquez and identified the two figures to the far left as Velasquez and Murillo.[74] Manet, then, would have seen this picture not only as a record of the manners and dress of seventeenth-century Spain, but a specific depiction of the world of the painters he so admired. Manet had already made a paraphrase of Rubens' landscape with a rainbow in the Louvre replacing the two foreground figures at the right with portraits of himself and Suzanne Leenhoff dressed in the manner of Rubens and his wife, from a print after another Rubens' landscape.[75] Instead of inserting himself into Velasquez' world in historical dress, Manet recast the assembly of artists into a Parisian park, following the model of contemporary illustrations of scenes of Paris. Sandblad offers as source an illustration of a military concert in the Tuileries garden from *L'Illustration*.[76] Similar pictures were available from other sources since many books on French types were organized by sections of the city.[77] Such illustrations often captured spirit as well as detail. The dejected figures in *La Petite Pologne* (Pl. 15), isolated against a barren cityscape are in sharp contrast with the gossiping crowds in the Tuileries, just as Manet's *The Old Musician* projects precisely the opposite feelings to those of the community

[70]Sandblad, 27–8.

[71]The catalogue of the retrospective exhibition held in 1884 after Manet's death lists the work as painted in 1860. As Sandblad points out the catalogue contains other demonstrable errors. Wildenstein, 1932, I (no. 36), Tabarant (no. 33) and Orienti (no. 32) all follow the catalogue and place the work in 1860, however in discussing Manet's works in chronological order in the catalogue preface Zola groups the *Concert in the Tuileries* after works made in 1862 and just before those of 1863. We agree with Sandblad's opinion that the painting belongs to the later date on the basis of style as well.

[72]See above, note 59.

[73]Sandblad, 36–45.

[74]Ibid., 38.

[75]Ibid., 44, and Figs. 2, 3, 4.

[76]Ibid., 19 and Fig. 1.

[77]See Hanson, *Museum Studies*, 148 for another similar illustration of the type which might have been a source for Manet's picture. Manet also painted a small picture called *Children in the Tuileries*, Rhode Island School of Design Museum, Providence. According to Proust (39) Baudelaire went with Manet when he painted this picture, and he may well have influenced Manet's choice of subject for the *Concert in the Tuileries*.

and activity of his *Concert in the Tuileries*. Even in its lack of compositional focus, Manet's painting, like its popular models, suggests an extension of the bustling crowd. Into his picture Manet has introduced his own portrait at the far left, standing with Albert de Balleroy, an artist with whom he had shared a studio. His brother Eugène, Baudelaire, Gautier, Offenbach, and perhaps Astruc, Fantin-Latour and Champfleury, are present in the seemingly anonymous crowd.[78] This casual assembly of influential and creative people appears to be a sort of answer to Courbet's *Studio*, according to Bowness, 'the modern artist's declaration of independence ... a work in which the artist and the activity of creating art becomes the subject.'[79] Its message is certainly propagandistic; its central focus on Courbet, himself. Manet has more wittily included himself on the fringe of the sparkling world of his family, friends and colleagues in the arts. Courbet's painting is a declaration of a modern concept; Manet's a depiction of a modern world. If the viewer were to recognize its source in the so-called Velasquez, the contrast between the two works could only function to stress the fashionable immediacy of Manet's record.

Manet's lithograph of a captive balloon (Pl. 22)[80] hovering over another crowd in another part of the garden in the same year, shows that his interest in typical scenes of Parisian life was well established. It was soon to be followed by pictures of the fashionable Spanish dancers at the Hippodrome.[81] His scenes of the racecourse, *The Exhibition of 1867* (Pl. 125), *The Departure of the Folkestone Boat* (Col. Pl. V), or his friends on the river at Argenteuil (Pl. 112),[82] all belong to the mode of popular scenes from everyday life, now disconnected, however, from the historical and personal references of his *Concert in the Tuileries*. This new kind of genre seems to have as its source the illustrations of everyday life so prevalent in the French press. Magazines like *L'Image*, *La Vie parisienne*, and *Magazin pittoresque*, and books like *Les Rues de Paris*, *Paris et les Parisiens*, *Le Nouveau Paris* provided ample information about the cafés and café-concerts of Paris. An illustration of cardplayers in a café in *Les Rues de Paris* (Pl. 23), might well have served Manet for his drawing, *At the Café* (Pl. 24), or the scene of a café concert from *Le Nouveau Paris* (Pl. 25) for his *Corner in the Café Concert* (Pl. 26) where the performer on a lighted stage is relegated to the background, and our focus is on the café-goer who ignores the show to play his own small drama or simply sink into sophisticated boredom.[83] It is with so mundane a subject, *The Bar at the Folies Bergère* (Col. Pl. IX), where the central figure ignores both spectators and performance, that Manet has captured the essential feelings of boredom and glitter, the inner and outer existence of his own age. It is with such paintings that Manet records modern 'history'—the spirit of modern life.

[78]Sandblad, 20–22.

[79]Alan Bowness, 'Courbet's Early Subject Matter', in Finke, 131.

[80]Guérin, no. 68.

[81]Sandblad, 29, 'Manet could paint his Spaniards from the autumn of 1862 because they actually formed an essential element in the Parisian milieu.'

[82]For Manet's racecourse paintings see Harris, *AB* 1966, 78–82. Popular books and magazines offer literally hundreds of illustrations of such scenes. For instance see *Les Français peints par eux-mêmes* (1840–42), I, last page (unnumbered) for a vignette of a steamboat called 'Parisienne' at a crowded dock.

[83]For illustrations and discussion see Hanson in Finke, 153–4 and Figs. 87, 88, 89.

3. Still Life

THE changes in Manet's still life paintings over the period of his career in some ways parallel his shift of interest from lower class genre to subjects expressing the spirit of modern life. The earlier still lifes also show a dependence on the works of artists of the past, Manet's borrowings being overt enough to suggest that he wanted such associations to be recognized. His obvious admiration for Dutch and Flemish art might tempt one to search in his still life paintings for some of the themes of luxury and its dangers to be found in seventeenth-century Dutch still life. If they exist, they have been much altered. Manet's paintings are usually modest in contrast to the cornucopian piles of fruit and vegetables or the rich displays of flowers, fish, elegant silver and glassware which characterize pictures he could have known by artists like Heda, Kalf or De Heem.[84] Further, they lack specific references to prudence or mortality, such as the mirror or the scull, later to reappear in Picasso's still life paintings. Manet's own obvious pleasure in the small luxuries of his bourgeois life suggest that he saw few dangers in self-indulgence and felt that no warning of future judgement was necessary.

Manet's facture, particularly in the later still life paintings seems to owe much to the glistening surfaces of Dutch and Venetian paintings, but his still life motifs cannot be traced to specific Dutch and Venetian sources. On the other hand, several of his early still life paintings are directly drawn from Chardin. They present a kind of kitchen plenty which has the same appeal as Chardin's depictions of mothers and children in the well run homes of the hard-working middle class. It has long been recognized that Manet's *Rabbit* of 1866 directly derives from Chardin.

In 1932 Bazin identified its source as *The Hare* in the Louvre,[85] but a survey of Chardin's work shows equally close dependence on several other paintings of the same subject.[86] Such precise sources cannot be found for Manet's

[84]Manet would have been familiar with works in the Louvre and works illustrated and discussed in such publications as Charles Blanc, *Histoire des peintres de toutes les écoles. Ecole hollandaise*, I, pages unnumbered, includes works in the Louvre by Willem-Klaesz Heda, David de Heem, and Willem Kalf, and adds others such as the De Heem paintings in Brussels and Amsterdam.

[85]Germain Bazin, 'Manet et la tradition',

L'amour de l'art, XIII (1932), 152, 155.

[86]*The Rabbit*, Private Collection, Paris, 1866. See Georges Wildenstein, *Chardin*, Paris, [1933], nos. 705, 709, 713. Jacques Mathey, 'Manet and Chardin', *Connoisseur* CLIV (1963), 92–7, rightfully paints out connections between works by Chardin and Manet. Specifically he cited *The Rabbit* as relating to Chardin's *The Hare* (as pointed out by Bazin in 1932), and the general dependence of Manet's

Still Life with Carp (Pl. 27), of 1864, but the robust tone of homely satisfaction certainly speaks of Chardin and the large copper pot with its tilted lid appears repeatedly on Chardin's kitchen tables. This work and the very beautiful *Still Life with Salmon and Pike* (Pl. 28) parallel Manet's interest in the representatives of the simpler Parisian types which preoccupied him in the early sixties. In the *Salmon*, which probably should be dated no earlier than 1869, and *Still Life with Melon and Peaches* of 1867 (Pl. 29), we move from kitchen to the dining room and thus into the casual elegance of Manet's own world. The coarse tables and rustic kitchen equipment are now replaced by sparkling glassware, fine damask and silver, and even a casually abandoned flower. There is, as well, a remarkably strong sense of the people who have left the table in such casual disarray, disdainful of the abundance spread out before them. The still glistening fish, the wet grapes, the perfumed lemon seem to speak of very real ease and pleasure in contrast to the more formal character of Dutch paintings with their bountiful display of sights and smells and promised tastes. A knife handle toward the spectator, a cut piece of fruit suggest some degree of participation, but never the intimate inclusion offered by Manet's far less opulent scenes where someone has just enjoyed the routine comforts of upper middle class life. These pictures speak of 'la vie moderne' as persuasively as some of the portraits or street scenes which record other forms of affluence and pleasure.

The comfortable table with its array of food in *Luncheon in the Studio* (Pl. 31) was immediately praised by some contemporary critics, but the figures were found puzzling at the time,[87] and they certainly have not yet been fully and satisfactorily explained. Perhaps there need be no further explanation than that the diners once present in the *Salmon* or the *Melon* have remained in the room to smoke or simply to muse while the maid slowly clears the table. Something of a deeper meaning is suggested however by the fact that the scene takes place in Manet's own studio. Even some aspects of the *vanitas* theme may have been present in his mind. He certainly would have known *vanitas* still lifes. The Dutch volume of Charles Blanc's *Histoire des peintres des toutes les écoles* which appeared in 1863 illustrates a picture by David Bailly entitled, *Vanitas, Vanitas, et Omnia Vanitas*. The text describes the subject as a young artist dressed in black, 'à la mode de son temps', seated next to things which symbolize the vanities of human life.[88] His palette hangs on the wall behind him, and near him are strewn a pipe, a book, beads, flowers and wine, while over all float soap bubbles, a symbol of the fragility of life itself. Manet does not include such an overt symbol of life's passing pleasures in his *Luncheon in the*

Boy with the Cherries and *Soap Bubbles* on works by Chardin. Manet may also have been influenced by Daumier's *Boy Blowing Bubbles*. See Eugène Boury, *Daumier, l'oeuvre gravé du maitre*, Paris, 1933, no. 415. Unfortunately other examples used by Mathey to support the idea of Manet's dependence on Chardin do not appear to be authentic. For further dis-

cussion see Hanson, *Manet*, 115–19.

[87]Hamilton, 129–40. Castagnary, in the 11 June issue of *Le Siècle* cannot understand what he sees as an assembly of unrelated objects, much less the people arranged without reason or meaning. Hamilton, 137–8.

[88]*Ecole hollandaise*, Paris, 1863, Appendix, 3, 4.

Studio, nor does he depict himself as artist. Yet the glints of color in the glass of wine and the fresh smell of the lemon peel are ephemeral enough, and his presence evident in numerous details. The picture seems deprived of the moralizing aspects of the *vanitas* theme while still preserving the transitory. It offers no warning of ever-present death, but instead it reasserts the role of daily pleasures as simple reflections of an eternal good. Again one feels how thoroughly Manet shared with Baudelaire convictions in the fugitive beauty of modern life. Again one sees Manet's ability to take a traditional model and turn it to his own purposes.

The personal dimensions of the *Luncheon in the Studio* are obvious. The central figure in the picture, the young boy in front of the table, is Léon Leenhoff, a member of Manet's family.[89] The flower pot and the hanging on the wall attest to Manet's taste for orientalia. The armor and swords on the chair are part of his collection of studio props; and his many charming sketches of cats suggest that there was one in his establishment. After the notoriety of the black cat in the *Olympia,* it would have been natural for Manet to regard it as his special symbol, and its inclusion in *Luncheon in the Studio* may have had considerably more meaning to him than simply the naturalistic record of his own environment.[90] The armour has less obvious connections, but the large sword may well refer to Manet's *Boy with the Sword,* Léon himself at an earlier age. A unique and curious still life painted by Manet some years earlier suggests that such interpretation of these objects is justified. The *Still Life with a Hat* in the Musée Calvet at Avignon (Pl. 30), originally intended to be hung over a doorway in Manet's studio, depicts several objects which Manet kept there during the period of his intense interest in Spanish subjects. A basket of Spanish costumes, a guitar and a sombrero are grouped in front of what appears to be an architectural detail or the decorated edge of a curtain. The fact that Manet re-used this motif in the frontispiece for a series of etchings (Pl. 32, 33) suggests that he saw these objects as representative of a number of the motifs he was using at that time.[91] Their clumped format is sharply reminiscent of vignettes frequently found in books, magazines and music pages either at the end or the beginning of a section. Comprised of objects which relate to the contents of chapter or article and often including articles of clothing, they served as shorthand summaries to arouse the reader's interest in the text.

[89]Whether Léon Leenhoff was Manet's wife Suzanne's younger brother, her son, and possibly Manet's son as well must be left to conjecture. There is little evidence to go on except for the facts that Suzanne was a part of Manet's father's establishment, that Manet did not marry her until after his father's death, and that Léon was generously provided for in Manet's will, with the cryptic statement that his brothers would understand. There have been various discussions of Léon's paternity, the most recent being Kovàcs, 196–202. More interesting is Reff, *Burlington*, 1962, 182–6, who discusses a vocabulary of personal symbolism applicable to other works by Manet as well.

[90]See below, 98. The cat in the *Luncheon in the Studio* seems to have been based on an etching of several cats which looks like a casual sketch-book page (Guérin, no. 52; Harris, no. 64; Hanson, *Manet*, no. 88, 109). This page in general terms seems patterned after the casual studies of animals in Hokusai's *Mangwa*. A drawing of similar studies of cats is catalogued by De Leiris, *Drawings*, no. 226. For comparisons of Manet's and Hokusai's works see Hanson, *AB*, 1971, 544–5.

[91]See Reff, *Bulletin NYP*, 143–8.

A brief glance at some of these vignettes, chosen almost at random, will confirm not only Manet's dependence on such sources, but Manet's intention that such a source be recognized.[92] A summary of his interests, the painting functions as a personal symbol. Although the etching after the Avignon painting was undoubtedly made to serve as a frontispiece for a portfolio of etchings produced in 1862, it was not, in fact, used at that time. The plan went through elaboration, then simplification, and was finally put to use as the cover of his 1874 portfolio.[93] The most complex of the frontispiece plans (Pl. 33) provides further support to the interpretation of the vignette motif as personal and even biographical. It depicts the still life at the bottom of the page (an appropriate location for a vignette). The decoration behind it is here clearly a curtain with a figured border. A sword and a picture of a balloon soaring over some Dutch windmills have been introduced above the still life to the left, while Polichinelle peeks through the curtain at the right, thus expanding the personal references. Harris has suggested that the Polichinelle represents a 'sort of self-portrait'.[94] (It predates Manet's own elaborate color lithograph of Polichinelle by a number of years, and is therefore not a reference to one of his works.) There is little physical resemblance to the handsome Manet in the shrunken chin and bulbous nose of the Polichinelle, but it is not impossible to assume that Manet could have seen the actor of the *Commedia dell'Arte* as a brother artist in a world little disposed to understand and accept the arts. Whatever the correctness of her proposal, certainly the work can be seen as autobiographical, in the sense that it represents a new self-consciousness of the artist living in the world of his motifs and his personal life, rather than filling the more traditional role as educator of the public, supporter of moral values, and creater of the eternal truths. In this sense, some of Manet's still life paintings, and some of the still life included in figure paintings, are intrinsically modern or present, whatever their precise interpretations might be.

The still life paintings of Manet's later *oeuvre* seem to provide less opportunity for interpretation and fewer references to earlier arts. Instead of showing a number of objects in the well stocked kitchen or on the well spread table, Manet has moved his focus closer to show us only a few pieces of fruit or a single crystal vase of flowers. This reduction in the number of objects displayed seems to increase the intimacy of the objects themselves and to allow them to function as single and private delights for the spectator, as they surely did for the artist. By 1880 Manet was already ill and less able to work on larger canvases. The increase in the number of small still life paintings in the last years of his life

[92]Hanson in Finke, 158–9, Figs. 101, 102.
[93]Harris, *Graphic Works*, commentaries on nos. 38 and 39, and Hanson, *Manet*, 145–7.
[94]Harris, *Graphic Works*, 117. See also Reff, *Artforum*, 44 for connections between Manet's Polichinelle and the frontispiece to Callot's *Balli di Sfassania*. Reff goes further in *Burlington* 1962, in offering a highly detailed and personal interpretation of all the elements of the trial frontispiece, finding in it a reference to Manet's virility, and his relationship both to Léon Leenhoff and to his wife Suzanne. I cannot fully accept Reff's interpretation without further evidence as to Léon's paternity.

may well result from the limitations of his poor health. A work as sensuously charming as the single lemon in the Jeu de Paume, however, shows that Manet was as able as he had ever been to respond to the delights of the material world which good fortune had provided him. The reduced size and extent of these later still life paintings surely do not result only from Manet's limitations. He had for a number of years developed the virtuoso elements of his style into a vivid shorthand which served him as well for other subjects, evoking a mood with the most restricted means. Small water-color sketches of fruit and flowers illustrated many of the letters Manet sent to his friends at the end of his life (Pl. 34, 35).[95] Much of their charm depends on the very fact that they were even more intimate than the paintings, small and personal tributes from the painter to those he loved. One of the most delightful still life paintings of his last years is the *Bunch of Asparagus,* bought by his friend Charles Ephrussi. It differs from the later elegant bouquets of flowers and baskets of perfumed fruit on the buffet or table. But the scintillating and sensuous treatment of the fresh stalks in Manet's late style give the mundane subject a kind of opulence. Ephrussi was apparently very pleased with his purchase and sent Manet two hundred francs more than the agreed price. With characteristic gentle humor, Manet made a very private painting for Ephrussi (Pl. 36), a single stalk of asparagus, which he sent to his friend with the message, 'There was one missing from your bunch.'

[95]See Hanson, *Manet,* nos. 185–90.

4. Portraits

As if to signal the demise of the traditional hierarchy of subject matter which placed portrait and landscape on a lower level than 'history' painting, Castagnary, in his review of 1867, announced that the portrait demanded the highest faculties of the painter, and represented the culmination of the art of painting. His reason was that 'With a single portrait of Clouet, Holbein, Van Dyck, Titian, Rigaud, David, you can reconstruct, with the person who served as model, the entire epoch when that person lived.'[96] In other words, he assigned to portraiture the task of recording social history. In the following year he praised Manet's *Portrait of Zola* (Pl. 37) as one of the best portraits in the Salon, although he found the figure too flatly treated and lacking in gradations of values. For him the image did not succeed in offering a view of society as a whole, only a fragment of it, but 'It is a beginning . . . We are still involved with little painting, the painting of private life . . . If we had a public life instead of an official life, wouldn't we have before long a grand manner of painting?'[97] But he presents no easy solution for recording modern life. Precisely what gives the grandeur to portraits by Clouet, Holbein, Titian and David is their historical distance, and therefore their lack of immediate familiarity. While for Castagnary the future of art lies in nature and mankind, the landscape, the portrait and the genre picture,[98] Manet's paintings lacked a kind of message which traditional painting had taught him to expect. Without exaggeration or idealization the picture of Zola was simply too private for Castagnary. It did not portray the man as writer so much as the friend of Manet in intimate surroundings set against objects with meanings for a limited few. Lane Faison has suggested that Zola's critical writing on Manet was more a self-portrait than a revelation about the artist, and that, likewise, Manet's portrait of Zola is more a portrait of Manet seen through his surroundings.[99] To be sure, the writer is seated in Manet's studio, his pamphlet on Manet visible on the desk, and framed above his head a photograph of the notorious *Olympia,* while a Japanese print[100] and an engraving by Goya after

[96]Castagnary, *Salons,* I, 245.
[97]Ibid., I, 314.
[98]Ibid., I, 11, 16, 65.
[99]Faison, 162–8.
[100]The Japanese print is a typical one and has been attributed to various artists as a result. Sandblad believes it to be by Utamaro (note to Figure 31). Reff *GBA* 1964, 121, n. 2) mentions a better source in Kuniaki II noted by Ellen Phoebe Weise in Source Problems in Manet's Early Painting, an unpublished thesis, Radcliff College, 1959. See also Reff, *Burlington,* 1975, 35–44 and Figs. 32, 33.

Velasquez' *Drinkers* constitute direct references to some of Manet's sources. Acutely exact as a specific record, the painting does not educate society by revealing the times in general terms. Inexplicable to the average man, and without comment on his state, it cannot meet Castagnary's requirements for a 'public art.'

It is interesting to note that Titian is among those in Castagnary's list of admirable portrait painters. Although Venetian artists were not praised as models for the highest in academic art; they were vastly admired by a wide spectrum of both artists and public. Manet's teacher, Couture had much to say not only about their effectiveness but their method as well. What is easily forgotten today is that the symbolism in Venetian paintings has only recently attracted the attention of scholarly detectives bent on ferreting out subtle, even secret, meanings and connections with contemporary literature and social customs. In Manet's day Venetian art was considered realistic.[101] This is a point of some importance when works like the *Olympia* and the *Déjeuner sur l'herbe* are considered, but it is not without relevance to Manet's portraiture. Manet's portrait of Zola is painted in the Venetian portrait mode with its planar space and its use of intimate detail for references to the sitter's role. Manet may even have been encouraged to keep these references on a private level by the obscurity of many of the objects in Venetian portraits.

If relationships to Venetian painting can be inferred in the Zola portrait they are overt in Manet's depiction of Zacharie Astruc (Pl. 38), painted four years earlier.[102] The placement of the figure against a dark wall with an opening into a light-filled space beyond is a Venetian device. As a student Manet had copied Titian's *Venus of Urbino* (Pl. 39) where this device is used. In his portrait of Astruc he paraphrases the scene in the background of the *Venus* changing the view into an adjoining room where two maids lean over a chest of clothing into a modern interior where a contemporary French woman, her back to ther viewer, is engaged in a similar domestic task. On the table next to Astruc in the front plane of the picture stands a glass, a peeled lemon and some books—a somewhat enigmatic group of objects. Astruc had early been a defender of Manet, during the Salon des Refusés of the previous year.[103] The books seem reasonable symbols, particularly since one bears Astruc's name. The water and the lemon with their references to smell, taste and sight remain mysterious. Appearing in the *Luncheon in The Studio* (Pl. 31), *The Woman with the Parrot*,[104] and again the *Portrait of Duret* (Pl. 19), the lemon

[101]There is a great deal of support for this view. For some examples see, Couture, *Méthode*, 125; Castagnary, Salons, I, 290; Joseph Péladan, in *L'Artiste*, February 1884, spoke of Veronese as 'uninhibited by any thought'. Here quoted from Courthion and Cailler, 186. In a *Journal* entry of 20 January 1857 under the heading 'Thought' Delacroix notes that Venetian scenes lack 'interest for the mind'.

[102]Manet again painted Astruc in *The*

Music Lesson, Museum of Fine Arts, Boston.

[103]Astruc wrote a poem for Manet's Olympia, which was printed in the Salon *livret* of 1865, and it may have been Astruc who was responsible for the name of the picture (Tabarant, 105). Manet designed the cover for Astruc's song *Lola de Valence* (Guérin, no. 69).

[104]Metropolitan Museum of Art, New York, 1866

seems to demand explanation as a private symbol for Manet rather than for his sitter.

The strangest of Manet's early portraits is the study of his mother and father (Pl. 40) which he sent to the Salon of 1861 with *The Spanish Singer*. A popular subject, robustly treated, the singer was warmly accepted. The portrait produced a shocked reaction, 'But what a scourge to society is a realist painter! To him nothing is sacred! Manet tramples underfoot even the most sacred ties. The *Artist's Parents* must more than once have cursed the day when a brush was put in the hands of this merciless portraitist.'[105] Such a subject clearly demanded the sentiment which Castagnary felt humanizing and uplifting. Fewer feelings of filial respect are suggested in this work than in the average daguerreotype. In fact it is just the photographic bluntness and the harsh extremes of lighting which give the *Portrait* its unyielding quality of dispensing the precisely observed truth. It is interesting that a drawing for the painting (Pl. 41)[106] shows Madame Manet standing further behind her husband, her head smaller and portrayed in a darker tone. This deepening of space and disjunction between the two figures as well as the more traditional chiaroscuro of redrawing seems to offer a greater sense of impending incident, and therefore of personal concern. Manet's *Portrait of Victorine Meurand* (Pl. 42) in the Boston Museum is painted in the same summary manner as the *Portrait of the Artist's Parents,* but the sober blacks and grays are replaced with scintillating touches of color which tend to make less obvious the photographic source of the style. Furthermore, no sentiment is needed for the portrait of a professional model, whom Manet clearly saw as an equivalent to the male dandy—knowing and serene.

Manet's friend Berthe Morisot was to provide an entirely different lure. Of Manet's own class, herself an able painter, and a person of engaging wit and charm, Berthe was pretty in an impish fashion. According to Moreau-Nélaton, she arrived at his studio one winter day, bundled up in furs with her dark hair awry, like the personalization of winter itself. In the portrait of *Berthe Morisot with a Muff* (Pl. 43) of the winter 1868–9[107], the brusque impasto of the portrait of Victorine is replaced by a more active virtuoso brushing which subdues the harsh contrasts of the earlier work. Berthe, more stylish, more agitated, represents not just a different woman but a different class and a different outlook. Her portrait is an early example of a series of extraordinarily winning pictures of dashing men and pretty women and children which Manet painted during the rest of his life. *Le Repos* (Pl. 44) of 1870–71 is also a portrait of Berthe Morisot. There is no reference here to Venetian painting nor to the art of other old masters. No allegorical meaning is intended by the title 'Repose' or 'Rest', although this popular title was undoubtedly used by other

[105]Léon Lagrange, July 1861, *Gazette des Beaux-Arts*, here quoted from Hamilton, 26.
[106]De Leiris, *Drawings*, no. 150. Reff, *Artforum*, 42, compares *The Portrait of the Artist's Parents* with Rembrandt's etching of "A Bearded Man in a Furred Oriental Cap',

noting that the man was thought to be Rembrandt's father. Harris, *Graphic Works*, 38, relates Manet's etching of his father to some of Rembrandt's portraits of his own father, particularly Hind, no. 92.
[107]Moreau-Nélaton, I, 109.

artists for such a purpose. Madame Morisot was concerned that it would be improper for a well-bred young lady to be seen in such an informal pose, and a neutral title was chosen to avoid embarrassment to her daughter by leaving the sitter unidentified. Many portraits went to the Salons labeled 'Portrait of Madame M.' or 'Portrait of Mademoiselle B.' out of respect for the sitter's privacy, but these works were conservative and dignified enough to be above the sort of reproach which greeted Manet's picture.[108] Cham's cartoon in *Charivari* proclaimed it 'A lady resting after having swept the chimney herself.' To others it represented seasickness or slovenliness or was simply a confusing image.[109] Berthe is shown in a daytime dress which, though simple, can be recognized as the latest casual summer fashion. The plum colored plush sofa is as modern as the large Japanese print which hangs on the wall. George Moore describes it as a scene in a 'prosaic French apartment' of a 'common white dress', but 'never did a white dress play so important or indeed so charming a part in a picture.'[110] Théodore de Banville found in it 'an intense character of modernity ... Baudelaire was indeed right to esteem Manet's painting, for this patient and sensitive artist is perhaps the only one in whose work one discovers that subtle feeling for modern life which was the exquisite originality of the *Fleurs du mal*.'[111] On the one hand an intimate view of a friend relaxing at home, on the other as much a record of the latest style, as a contemporary fashion print, the elegant naturalism of this lovely painting transforms the subject from portrait to a scene of everyday life—an answer to the persistent call for an art to reflect modern life.

The Balcony (Pl. 45) which depicts Berthe with a young violist Fanny Claus and the landscape painter Antoine Guillemet, should perhaps not be considered a portrait at all. Manet claims to have had the idea for the picture when he saw a group of people on a balcony at Boulogne, but the painting is also clearly a restatement of Goya's *Majas on the Balcony*. The obvious similarities function both as an homage to the earlier artist, and to point out the differences between the suggestive romance of Goyas mysterious group and the blunt obviousness of the Parisian picture. We do not know definitely who all the sitters were for Manet's *Boating* (Pl. 109), but their precise identity seems no more important than the identities of the models for the *Balcony*. Both these works, like *The Railroad* and *The Conservatory* (Pl. 120, Col. Pl. VI), are portraits in the sense that they fulfill Castagnary's aim and allow the spectator to use them to reconstruct an epoch. Scenes which might be more appropriately considered landscape like the *Departure of the Folkestone Boat* or *Argenteuil* (Col. Pl. V, Pl. 112) are, similarly, portraits of a period.

Manet left many brilliant portraits not only of now anonymous individuals, but of people whom he admired and who are still remembered today: Constantin Guys, Cabaner, Chabrier, Clémenceau (Pl. 104), the opera singer

[108]For a full discussion of the painting see Davidson, 5–9.
[109]23 May 1873. See Hamilton, 163, 166.
[110]Moore, *Modern Painting*, 42–4.
[111]15 May 1873. *National*. Here quoted from Hamilton, 172.

Jean-Baptiste Faure, and the Irish poet George Moore.[112] Perhaps the most curious of all Manet's portraits is *Pertuiset, The Lion Hunter* (Pl. 46). Pertuiset was a fascinating person, painter, big game hunter, and man about town. As if Manet intended to conflate his various roles, he shows Pertuiset like the city dandy safely posed in a Parisian park. The background, reminiscent of the rising ground in *Déjeuner sur l'herbe*, suggests the photographer's backdrop more than the mysterious jungle. The lion dead, and possibly even stuffed, serves more as iconographic symbol than narrative prop. Pertuiset's pose, gun ready, is no longer necessary since his prey has already been shot. No doubt a natural position for a hunter, it also appears in an illustration for a song popular of Manet's day (Pl. 47), *Le Tueur de lions* from Pierre Dupont's *Chants et Chansons*,[113] where the lion still stalks in a more romantic, and at the same time, more believable jungle. Despite its apparent naïvetés, Manet's painting has a surprising impact as a composite record of a man, his appearance, his life, and even his view of himself.

[112]*Constantin Guys*, Shelburne Museum, Shelburne, Vt., 1879; *Jean-Baptiste Faure as Hamlet*, Kunsthalle, Hamburg, 1877; *Portrait of George Moore*, Paul Mellon Collection, Upperville, Va., 1879; *Emmanuel Chabrier*, Ordrupgaardsamlingen, Copenhagen, 1880; *Jean Cabanes, called Cabaner*, Jeu de Paume, Louvre, 1880. A distinction should be made between the traditional portrait of Moore, which shows him half-length against a plain background, and *George Moore in a café* (Pl. 106), which, while a portrait, treats Moore as subject for a scene from modern life.

[113]Paris, 1855, IV, 125. For discussion and illustrations see Hanson in Finke, 159–60.

5. Costume Pieces

LIKE many a fellow Parisian, Manet enjoyed fancy dress and make-believe. Writing of a party in honor of Zola, George Moore remembered, 'Manet had persuaded me to go to the Bal de l'Assommoir dressed as a Parisian workman, for he enjoyed incongruities, and the blouse and the casquette, with my appearance and my accent, appealed to his imagination.'[114] Several of Manet's earlier paintings partake of this same pleasure in costumed role playing. For instance, his *The Boy with a Sword* (Pl. 48) shows young Léon Leenhoff dressed up in seventeenth-century costume like Spanish royalty. At once a portrait of a member of the family and an homage to the Spanish masters he revered, the painting admirably combines realism and fantasy. More curious is *Mademoiselle Victorine as an Espada* (Pl. 49), a picture of Manet's familiar model dressed in a bull fighter's costume which Manet had in his studio. The suggestive female dressed in male clothing is incongruous indeed set against the distant bull fight scene in the background. A necessary part of role playing, the costume is naturally appropriate for portraits of professional performers who fascinated Manet throughout his life. His portrait of Lola de Valence shows the dancer dressed to perform one of the Spanish ballets so popular in the Hippodrome in the summer of 1862. She stands behind stage scenery, a motif unusual in formal portraits but already familiar to the public through illustrations by Gavarni and Daumier, holding a pose both appropriate for her dance and typical for souvenir prints and posters of popular performers.[115] She is thus depicted both in her stage role and present in modern Paris. By contrast, Mademoiselle Victorine is neither actress nor athlete, and the bull fight behind her, while artificial, cannot be interpreted as a photographer's backdrop or a stage set, since no break appears between the distant fight scene and the ground on which Victorine stands. The distant figures

[114]Moore, *Confessions*, 247. The play *L'Assommoir* was then being performed at the Ambigu.

[115]For the back of the stage set Richardson (14) suggests a Daumier. A Gavarni illustration, 'Avant d'entrer en scène', from *Les Français peints par eux-mêmes*, from a chapter entitled *La Figurante*, IV, 332, would be an equally convincing source. Similar illustrations can be found in *Physiologie de l'homme à bonnes fortunes*, Paris, Aubert [1841], 28, and

Emile de Labédollière, *Le Nouveau Paris*, Paris, Barbu [1860], 22. I am indebted to Mollie Fairies' unpublished talk, 'Some Sources for Manet in Popular Imagery', at *A Symposium on the History of Art*, 16 April 1966, Institute of Fine Arts, New York, for information about typical souvenir ballet prints and posters of the period. For two of the illustrations she used, see Hanson, in Finke, 152–3.

engaged in the bull fight are taken directly from two etchings in Goya's *Tauromaquia* (Pl. 50).[116] Except for the costume, Victorine's figure seems to have no connection with Spanish art. Her pose repeats that of *The Boy with a Tray* (Pl. 51), earlier depicted as a single figure in an oil, watercolor and etching, and included in a painting of a group of *Spanish Cavaliers*. Other than for Manet's tendency to re-use his own motifs under different circumstances the connection seems slight. Other sources for the pose have been suggested. Reff believes *The Boy with the Tray*, and therefore Victorine, derives from Titian's *Girl with a Fruit Dish*, a work which would have been available to Manet through Blanc's *Histoire des Peintres*.[117] The problem here is that the girl is in three quarter view and therefore the twist of the pose is not shown in relation to her feet. Michael Fried's suggestion that a probable source was Rubens *Venus* or *Fortune* in the Galerie Suermondt is more convincing and the image would have been available to Manet in an illustration in the *Gazette des Beaux-Arts*.[118] If these sources were used (and it is possible that several were combined) they do not seem to have been chosen for the extra meaning they could add to the picture.

Another important source must be considered—the Japanese print. Zola, in 1867, answered the charge that Manet's painting recalled 'images d'Epinal' by saying 'It is much more interesting to compare this simplified painting with Japanese prints which resemble it through their strange elegance and their magnificent tonal areas.'[119] Both Hamilton and Sandblad have suggested Japanese prints as sources for *Mademoiselle Victorine as an Espada*. Hamilton felt that Manet 'looked to the Japanese print for his composition' in that painting and *The Incident in the Bull Ring*, while Sandblad, referring to *Mademoiselle Victorine* and *The Young Man in the Costume of a Majo*, says 'something of the Japanese actor portrait is discernable in them, and in both pictures the figures make complex but clear silhouettes against the background.'[120] Victorine's pose differs from that of the actor in the Japanese print which Manet carefully copied in the background of his *Portrait of Zola*,[121] but similarities exist nonetheless. Both figures depend on a dominant black silhouette with an irregular edge, the black played against delicate pale tones and whitish flesh. Manet's portrait compares more fully with a number of courtesan portraits

[116]Goya's bull-fight etching number 5 provides the exact motif for the bull and picador in the middle ground of Manet's painting. Even the shadows on the ground have been copied. The painting follows the spatial organization of number 27 of this series, where large figures appear in the foreground, a second fighting scene is placed in the middle ground, and the edge of the bull-ring can be seen in the background. The barricade appears in many of Goya's prints complete with spectators and even a small figure climbing ever the wall.

[117]Reff, *Artforum*, 41 and *Burlington*, 1970, 446–58.

[118]Fried (52–3) cites the oil as the source although he also knew that an engraving after it had been published. Beatrice Farwell makes the additional suggestion that Marcantonio Raimondi's Virtues would have been available to Manet. Both his Temperance and his Justice might have proven helpful sources. See *Museum Journal*, 197–207.

[119]*Mes haines*, 258–9.

[120]Hamilton, 53; Sandblad, 83. For a good general discussion of Manet and Japanese art, see Sandblad, 71–7. *Young Man in Costume of a Majo*, Metropolitan Museum of Art, N.Y., 1862.

[121]See above note 100.

which repeat a characteristic pose,[122] their weight carried on one foot, arms raised, and head turned (Pl. 52). So many examples exist that it is futile to search for one precise source. Manet's spatial composition also seems to derive from numerous Japanese models. One example, by Haronobu (Pl. 53), shows two women in a fishing boat set against a continuous plane of water and land. A second boat and a group of figures on the shore are shown very much smaller in size to indicate their distance from the foreground figures. In two-dimensional terms, however, they are at the level of the standing woman's head and shoulders, just as the bull-fight figures in Manet's painting lie on its two-dimensional surface close to the upper part of Mademoiselle Victorine's body.

The subject matter of Japanese prints which so fascinated French artists from the middle of the 1850s to the turn of the century were the Ukyoye, or scenes of everyday life. They parallel to a large extent the interests of the Barbizon painters, Courbet, Manet, Degas and the Impressionists in life as it could be observed around them. It would not be fair to say that the subjects of Japanese art influenced the subjects of French painting since each culture seems to have developed a naturalist school for its own reasons. Before Japan was opened for trade and its art known to Europe, the French were interested in information about the customs and dress of other peoples whom they found exotic, and even those of their own more isolated provinces. Their acquired knowledge functioned like a mirror held up to their own lives, and with a growing belief in the nobility of the savage and the purity of children, they could find admirable characteristics even in cultures which they felt inferior or 'primitive'. It was in such a fertile environment that the first examples of Japanese art arrived in France, and there can be little question that their appeal lay not only in their visual charms but also in the information they gave about the hitherto unknown life of a distant race.[123] Thoré had stressed the brotherhood of mankind—the underlying similarities among people of different nations—and the subsequent need for a universal art, and whether through such high ideals or merely curiosity, the French saw Japanese genre as paralleling their own new 'art for man'.[124] Specific borrowings of specific motifs are frequent in the works of Braquemond, Whistler, Degas, Manet and Van Gogh, some as overt as Manet's quotation in his portrait of Zola.

It could not have gone unnoticed in France that many of Japanese wood-block portraits were of famous courtesans. Courtesans had become very visible in nineteenth century France to such a point that George Moore

[122]For examples of courtesan figures see *Masterpieces of Japanese Prints*, Art Institute of Chicago, 10 March–17 April 1955, Nos. 12, 99; James Hillier, *Japanese Masters of the Colour Print*, London, 1954, Nos. 5, 15; Louis Gonse, *L'Art japonais* (2 vols. 1883, I, 42).

[123]Sandblad (73) points out that a traveler to Japan like Baron de Chassiron collected manuals of sciences, arts and professions and mentioned similar manuals produced in France for the education of the people. Even before the opening of Japan informative illustrations about that country were published in popular journals. Japanese beggars (after some work in the Siebold collection) appear in the *Magasin pittoresque*, XXIX (1861), 365.

[124]See above, Part I, 27–9.

complained, 'Nowadays everyone is respectable.'[125] Many of the most famous of the 'grandes horizontales' were highly educated women, accomplished in the arts, whose salons were meeting places for the creative men of the period. They also knew how to play and we know that they sometimes naughtily donned men's clothing as fancy dress—a practice which seemed daring and therefore sexually arousing.[126] One wonders if Manet might have been aware that Japanese courtesans occasionally dressed as men.[127] If the Japanese practice was known in France it would have served as still another example of compared customs which the prints offered to the curious Frenchman.

In any case, the subject of Manet's *Mademoiselle Victorine as an Espada* seems not to have been a depiction of a Spanish bull fight, but instead, to reflect the contemporary French taste for fancy dress—the imagined environment supplied by Goya's admired prints, and thus kept on the level of art, not life.

In its original form Manet's *The Incident in the Bull Ring* must have had strong similarities to the portrait of *Mademoiselle Victorine as an Espada*. The painting had received severe criticism when it was shown in the Salon of 1864, and some time between the end of that exhibition and the exhibition of Manet's works in the Martinet Gallery in 1865, Manet had cut it up. Two fragments remain: one a small bull fight group called *The Incident in the Bull Ring*, now in the Frick Museum, and the other, shown in 1865 at Martinet's, *The Dead Toreador* (Pl. 55), now in the National Gallery in Washington. The original composition can be reconstructed from these two fragments with the help of a contemporary cartoon (Pl. 56) and published verbal criticism, which although exaggerated and often hostile, offered descriptions of the general organization of the picture.[128]

If we compare the original *The Incident in the Bull Ring* with the portrait of *Mademoiselle Victorine as an Espada* again we see a distant bull fight scene being enacted on sharply rising ground; again a large figure dressed in Spanish costume occupies the foreground plane. This time, however, it is not the brash model in fancy dress, coyly looking over her shoulder at the viewer, but a magnificently painted figure of a toreador lying alone and bleeding in the ring. While the very nature of the tragedy seems to put aside the game element so strong in the *Mademoiselle Victorine*, there is nothing here to convince the spectator that he is viewing a real bull fight. The critics were clear in their disapproval of Manet's handling of the background figures where they saw no reasonable diminution in size in relation to the distance. George Hamilton states that 'Manet apparently thought there was some justice in the complaints about his perspective' and concludes that he cut up the painting as a result.[129]

[125]Moore, *Confessions*, 141.

[126]See below, 89.

[127]Apparently they performed skits for the annual celebration called *nikawa*. See Ichitaro Kondo, *Ktagawa Utamaro*, Portland, Vermont, Tokyo, 1956, commentary on Plate 2. For a print of a courtesan dressed as a man see, Sadao Kikuchi, *A Treasury of Japanese Wood-block Prints*, Fig. 176. Shigenaga, Tokyo National Museum. Although Manet's Olympia was not dressed at all, she was a courtesan, and was thought to look Japanese. See Sandblad, 79, and see below, 89.

[128]Hanson, *Burlington*, 158–61.

[129]Hamilton, 54.

This view had first been put forward by Bazire, writing in 1884, and is frequently repeated in the literature.[130] The curiosities of the composition will be further discussed below, but some investigation of Manet's borrowings in painting this picture may help to cast light on our present concern, its subject matter and meaning. In 1864, even before Manet cut up the larger painting, Thoré stated that the 'toreador, disemboweled for the amusement of several thousand frantic spectators, is a life-sized figure audaciously copied from a masterpiece in the Pourtalès collection, assuredly painted by Velasquez.'[131] The dead bull fighter, his elegantly pink cummerbund in place, is hardly disemboweled, nor is he depicted life-size. Errors in such details should be forgiven the critics whose task of seriously considering challenging works of art was made difficult by the crowded and confusing conditions of the Salon halls. It is of some interest in interpreting Manet's pictures however, to note that this otherwise serious and perceptive critic should have seen or imagined a more gruesome and dramatic death for the fighter than that which was actually portrayed. The perfection of the toreador's costume, marred only by a trickle of dark red blood; the orderly pose of the figure without the drama or distortion of violent death, freeze the scene in an iconic fashion, and give the figure an air of heroic nobility.[132] In the original picture, before its dismemberment, this effect might well have been diluted by the disinterested play of the small fighters in the background. Quite apart from 'compositional difficulties' Manet may have recognized that the original meaning of his larger work might have been less effective than the different meaning which could be realized by depicting the figure alone.

Thoré was quite right in identifying the source of the recumbent figure as the *Orlando Muerto* in the Pourtalès collection (Pl. 57).[133] Baudelaire, then in Brussels, immediately sent a letter to Thoré in defense of Manet's originality. After expressing his pleasure that Thoré had defended Manet in the general tone of his criticism, he declared that Manet had never seen the Pourtalès collection. He does not deny the visual connections, but refers to them as 'mysterious coincidences' parallel to the similarities between his own works and that of Poe. Thoré replied in the *Indépendance belge* of 26 June reaffirming his observation and maintaining that if Manet had never visited the Pourtalès collection he must have seen the painting 'through some intermediary or

[130]Bazire, 42; Tabarant, 86; Moreau-Nélaton, I, 57.

[131]*Indépendence Belge*, 15 June 1864, here quoted from Hamilton, 60.

[132]Fried suggests that Manet was influenced by Géricault's *The Raft of the Medusa* in conceiving *The Dead Toreador* (56), claiming that Manet's figure may be a 'kind of reworking' of a figure in Géricault's painting. The poses are entirely dissimilar as are the feelings of the two works. In making such comparisons Fried does not consider the ponderance or disposal of body weight. See

his comparison of *The Absinthe Drinker* with Wateau's *l'Indifferent* (32–33).

[133]In Manet's day the painting was thought to be by Velasquez. Now in the National Gallery, London, it is entitled *Dead Soldier* and attributed to Italian School, Seventeenth Century. Thoré suggests the influence of Goya in this painting, and finds the *Dead Christ with Angels*, which was exhibited in the same year to relate in some fashion to El Greco. He also mentions Rubens, Annibale Carracci as sources for the religious paintings, Hamilton, 61–2.

other'.[134] Since the Pourtalès collection was private, there could be a question as to whether Manet ever actually saw the picture before he painted *The Incident in the Bull Ring*. The collection was sold at auction during the winter of 1864–5, and the works were apparently put on view at that time,[135] so in all likelihood Manet saw the so-called Velasquez before he cut up his painting, if not before he originally painted it. It seems possible, but unlikely, that Manet visited the Baron Pourtalès before he died in 1859, or that his heirs permitted a visit after that date. The Baron collected Meissonier's works and though Meissonier was hardly a friend of Manet, some Parisian artists may have had access to the collection through some such connection. Apparently Gérôme did, since his *Ave Caesar,* which was shown in the Salon of 1859, includes details from the famous gladiatorial armour in the collections.[136] In any case it was not necessary for Manet to see the actual work to learn the subject and composition of the *Orlando Muerto,* and the old argument as to whether he did or did not see it can be stilled by the fact that photographs of the works in the Pourtalès collection are advertised for sale as early as February 1863.[137] Thus the picture was available to Manet in some unmysterious form. Bates Lowry has suggested another access to the *Orlando Muerto,* that is, through Gérôme's painting of the *Death of Caesar* (Pl. 58) in the Salon of 1859.[138] Gérôme's figure reverses the pose of the dead warrior (and of *The Dead Toreador*) but the frequency of engraved and etched illustrations after paintings which reverse poses, make this an unimportant point. Gérôme's painting depicts not just the dead Caesar, but a considerable amount of the architectural setting above and behind him. An overturned throne, the bottom part of a statue, a sacrificial flame, and a rotulus on the floor, all add specific detail, and thus conviction, to the recounting of the event. Ackerman's suggestion that Manet patterned his *The Incident in the Bull Ring* on this picture is convincing indeed.[139] The small bull-fighters in the distance at the edge of the ring, function as details to set the scene, just as Gérôme's details set the scene for the event in Roman history. Gérôme used his archaeological knowledge to make his references historically correct. Manet depended on what to him could have seemed as reliable a source, Goya's etching of incidents in the Spanish bull ring. In both works we are presented with a tragic hero. Gérôme's painting, in Ingresque

[134]He claimed also that Manet had never seen a Goya or an El Greco. Thoré's words here quoted from Hamilton, 62–3. For the original French see Tabarant, 85. 'par des intermédiares quelconques.'

[135]The February issue of the *Gazette des Beaux-Arts* of 1865 includes an engraving after the *Orlando Muerto* between pages 98 and 99, as part of an article, 'La Galerie Pourtalès', by Paul Mantz, Part IV, 97–117. Parts I and II appeared in November and December of 1864, Part III, in January 1865.

[136]Ackerman, 167 and note 16.

[137]'Souvenirs de la Galerie Pourtalès reproduits par la photographie', *Chronique des arts et de la curiosité,* I (Feb. 8, 1863), no. 11, in a supplement to the *Gazette des Beaux-Arts,* 120. Sixty plates in five portfolios of twelve each had begun to be produced in October 1862. By February, the first four were available for sale at Goupil's or at the *Gazette des Beaux-Arts* offices.

[138]Bates Lowry, *Muse and Ego: Salon and Independent Artists of the 1880s,* Pomona College Gallery, Claremont, California, 1963, 33. Ackerman who notes Lowry's discovery, also points out that Paul Dumesnil had noted the connection between Gérôme and the Pourtalès figure in his *Le Salon de 1859,* Paris, 1859 88–94 (Ackerman, 167 and note 21).

[139]We cannot, however, accept Ackerman's conclusions (172–4) concerning the two artists.

sharpness deals with a story which had the sanction of a long history of associa-
tions with moral rectitude: Manet's depicts no known story at all, no particular
individual, but the tragic result of a sport still popular in a neighboring country,
whose styles and customs had vividly caught the imagination of the modern
Frenchman. Manet's hero, then, is a modern man, part of 'the pageant of
fashionable life and the thousands of floating existences . . .' which Baudelaire
saw as 'modern heroism'.[140]

The Dead Toreador has been likened to Daumier's *Rue Transnonain* of 1834
where the vicitm of political oppression lies murdered on the floor of his own
bedroom.[141] While the almost comic figure, dead in nightdress and cap, can
be thought of as another type of modern hero, he bears no resemblance to
Manet's *Toreador*. Daumier's rendition is dramatic and episodic; Manet's
seems to negate specific event. It is exactly that quality which functions more
effectively in the present *The Dead Toreador* than it could have in the original
The Incident in the Bull Ring. Manet had apparently learned his motif from
Gérôme's *Death of Caesar*, but he reduced his composition by cutting the image
to the format of the *Orlando Muerto*. He thus strengthened its impact and
extended its references to heroism to a medieval story. Such references in
Manet's works tend both to tie his paintings to past tradition and, at the same
time, by contrast to their styles and intentions, to stress the newness of his own.
Devoid of either the specificity of the classic story or the dusky lights of the
romantic tale, Manet's hero is a modern man whose human tragedy speaks of
the eternal and the general. Although *The Dead Toreador* can be considered a
'costume piece' in the limited sense that it shows a posed figure in fancy dress
rather than a naturalistic scene, the painting goes far beyond this category
in its effect, and it becomes a potent 'history' painting in the new critical terms
which demanded of history no repeated tales, but a record of the sensibility
of modern man.

In discussing *Mademoiselle Victorine as an Espada* the subject of the role of
women in the nineteenth-century has been broached. Their situation is
neatly summarized for us by Arsène Houssaye, 'there were good women and
bad women; the good ones remained maidens until after marriage and confined
their attentions to their husbands thereafter; all the rest were bad. The rules
for men were entirely different from those for women, and the double standard
was as axiomatic as the official basic standards of good and bad.'[142] The
'good' and 'bad' mentioned here are purely moral judgements, for there was
much good in the lives of bad women of the period. Often more beautiful,
educated and wealthy than the devoted wives of their lovers, they reached
such a state of prominence that they became highly visible members of society,
setting styles of dress and conduct. The term courtesan is not a clear and
limiting designation.[143] It was assumed that any woman who was left without

[140]Baudelaire, *Art in Paris*, 118–19.
[141]Fried, 76, note, 167.
[142]*Man About Paris, Confessions*, New York,
1970, 73.
[143]Books on this subject tend to be written
for a popular audience and although often full
of facts, they are not well documented. The
best scholarly discussion of the types of courte-
san and their various designations can be
found in Sidney Braun, *The 'Courtesane' in the*

the protection of her family, or who chose to follow a professional career would be subject to the temptations of life. Dancers, actresses, women separated from their husbands, were thus all considered 'free'. In the lower classes, the loss of virtue too often became the inevitable end to a struggle against poverty and the little girls who worked as milliners, barmaids or laundresses might be expected to be willing to earn a good meal or a pleasant evening with their favors. Such social dangers help to explain the protective attitudes of Berthe Morisot's mother, although the Morisot family was intellectually highly liberated. Berthe herself in a letter to her sister Edna describes her embarassment when the Manets left her unchaperoned in the company of Puvis de Chavannes in the middle of the Salon.[144] Particularly for a young woman involved in painting and associating with some of the most advanced and creative men of her age, the formalities of propriety were needed to protect her name.

Writers disagree on Manet's involvement with women, some claiming him a faithful husband, others a man possessed by sexual desire. He painted a great many pretty young women, some of whom can be identified as women of easy virtue. But it must be remembered that he was involved with the scintillating immediacy and even triviality of modern life around him—the life in which they were involved—and that like other artists and literati of his generation, he could enjoy the company of women free to share in the excitement and creativity of the age.

Manet painted several pictures entitled *Amazon*, depicting pretty French women in strict dark riding costume.[145] Couture has suggested this elegant costume as a charming subject for the modern artist[146] and horsewomen were frequently illustrated and described in popular books and magazines which considered Parisian types. All Frenchwomen, good or bad, rode, and many courtesans were particularly proud of their horsemanship. 'Amazon' in fact, became one of the many euphemisms used to refer to women of easy virtue.[147] Manet may have intended a painting of a woman dressed in riding costume as one of a set of four paintings representing the four seasons. Two such works were completed: *Autumn* (Pl. 59), a portrait of Mery Laurent, and *Spring*,[148] a portrait of Jeanne de Marsy. Both paintings measure 72 × 51 cm., both show the figure half-length, and both were painted in 1881. In 1882 Manet painted three half-length studies called *Amazon*, the most finished of which is 74 × 52 cm., close enough in size to suggest that it might have been intended to be part of the same group. Tabarant assumes that Manet's

French Theatre from Hugo to Becque, Baltimore, 1947, 9–16. Of the types included it is interesting to note that *Les Français peints par eux-mêmes* includes chapters on La Grisette, La Mère d'actrice, La Figurante, La Modele, La Femme adultère, Le Rat.

[144]2 May 1869, *Correspondance*, Paris 1950, 27.

[145]*Portrait of Marie Lafébure on Horseback*, Museu de Arte Moderna, São Paolo, 1875;

Young Woman with a Round Hat, Pearlman Collection, New York, 1877; *Amazon*, on deposit Musée des Beaux-Arts, Basle, 1882; *Amazon*, Private Collection, Winterthur, 1882.

[146]Couture, *Méthode*, 258–9.

[147]Michael Harrison, *A Fanfare of Strumpets*, London, 1971, 16.

[148]*Spring*, Private Collection, New York. See also Tabarant, 414, 432–3.

worsening illness prevented the completion of his plans for a set of Seasons.[149]
The subject of Manet's *Amazon* (Pl. 54) has not been securely identified.
Tabarant interprets Manet's notebooks to show that she was the daughter of
a bookseller named Saguez. Blanche, who was present when Manet worked
on the painting, identifies the model as a Henriette Chabot. According to
Tabarant the costume was borrowed from a friend for the portrait, suggesting
that whichever young lady posed for the picture she was not in fact an
'Amazon'.[150] Since both Mery Laurent and Jeanne de Marsy were well
known members of an exciting intellectual and artistic demi-monde it would
be interesting to know more of the model for *Amazon,* and thus to know more
of Manet's intentions for his picture.

In 1874 Manet painted *The Woman with the Fans* (Pl. 60), a portrait of Nina
de Villard (Anne-Marie Gaillard), the estranged wife of Hector de Callias,
critic, author, and editor of *Le Figaro*. Nina is dressed in the costume of a
Spanish *maja*; she reclines on a pile of pillows against a wall covered with
Japanese panels and decorated with Japanese fans. The crane in the central
panel appears again in the background of Manet's portrait of the *cocotte*
Henriette Hauser as 'Nana' (Pl. 90). Its significance would have been obvious
since 'grue' or crane was a common term for courtesan at the time.[151] Nina
was an able musician, poet and woman of great charm and intelligence. Her
political stance put her in danger in the days after the Commune. Her Salons
were attended by writers, musicians, and artists of her day. Her lovers included
the poet Charles Cros, Bazire, and possibly even Manet for a time, and among
her friends were Mallarmé, Verlaine, Villiers de l'Isle-Adam, and Emmanuel
Chabrier, to mention only a few. Eccentric, 'a slightly demented muse'
according to Maurice Rollinat, she surrounded herself with animals and
orientalia, with music and poetry, with food, drink, and good company.[152]
The Woman with the Fans shows Nina in the kind of costume she actually wore
at her fashionable salons, thus reflecting both her personality and the general
world of the demi-monde. Manet also made some gouache studies of her in
street clothes. One of these illustrated Charles Cros' poem, 'La Parisienne,'
in the March 1874 issue of *Revue du monde nouveau*.[153] Her stylish French dress
thus makes her a representative for all the lively women of Paris, while the
costume portrait, unlike the make-believe of *Mademoiselle Victorine as an
Espada,* depicts her as the fascinating individual that she was.

Nina's pose is natural and relaxed, suggesting the conversational ease

[149]Tabarant, 459.

[150]Blanche, 56. Tabarant, 458.

[151]Braun, *The 'Courtesane'*, 15.

[152]See Tabarant, 227–30. Manet made
illustrations for Charles Cros' poem, *Le Fleuve*
(Guérin, no. 63, Harris, no. 81) which was
dedicated to the artist.

[153]See Harris, *Graphic Works,* nos. 76, 77,
78. Guérin, nos. 90, 91, 92. Cros was present
at the sittings for *Woman with the Fans*, and
wrote a poem about these occasions which

was published in the March 1874 issue of the
Revue du Monde Nouveau. Manet had made a
gouache after the oil portrait, and the poem
was illustrated with a woodblock based on
the gouache. According to Henri Mondor
(*La Vie de Mallarmé*, Paris, 1941, 442) Nina
was buried in a Japanese robe—the robe she
wore when she posed for Manet among the
fans. Although she may have worn one, she is
not wearing a Japanese robe in Manet's
picture.

undoubtedly enjoyed by the visitors to her Salons. It contrasts with the pose of a costumed woman in an earlier painting by Manet. *The Young Woman Reclining in a Spanish Costume* (Col. Pl. III). Here Manet again presents us with incongruities. A young woman wearing masculine Spanish clothing lies on a fashionable French plush divan attended only by a playful kitten of which she seems unaware. Unlike Nana, she holds a self-conscious pose easily recognized as deriving from seductive odalisque figures of Ingres or Delacroix.[154] Romanticism had made studies of far away places part of the French repertoire of subjects, and Ingres' own harem pictures, based on the writings of Lady Mary Wortley Montagu, might even have been seen as 'educational' since they gave information, otherwise unavailable, about the peoples of another culture. By mid-century paintings filled with near-eastern accoutrements had become a popular mode, one which many critics thought to be practised to excess. Manet himself used oriental costume only twice; once in 1862 for an etching called *Odalisque* (Pl. 61),[155] and later in a painting of about 1871 entitled either *La Sultane*, or *Young Woman in Oriental Costume*.[156] The model for the painting remains unidentified. She is depicted standing in front of an oriental couch, a water pipe at her side. No explanation has yet been proposed for her inclusion in Manet's *oeuvre* at a time when he was otherwise preoccupied with subjects involving his own daily life. The earlier *Odalisque* is easier to justify since it was made during the period when he borrowed more frequently and more overtly from the works of other artists. While the specific pose differs from that of the *Young Woman Reclining in Spanish Costume*, the general impression does not. (The reversal of the figure could be justified by the reversal of the etching of the printing process.) Farwell has pointed out that both may have been made from the same model,[157] and it seems probable that Manet had the odalisque theme in mind when composing his picture of the young woman in Spanish costume.

The painting is inscribed 'à mon ami Nadar.' Gaspard-Félix Tournachon, who called himself Nadar, was a portrait painter, a caricaturist, a leader in the development of photography, and a figure in Paris for his daring ascents

[154]See Ingres, *Odalisque with the Slave*, 1839, Fogg Art Museum, Cambridge Massachusetts, and Delacroix, *Odalisque*, 1857, Niarchos Collection, London. The small Delacroix painting was based on a photograph of about 1855 in his collection of a nude woman seated on a divan covered with turkish fabrics and pillows and set against a painted backdrop. See Aaron Scharf, *Art and Photography*, Baltimore, 1969, 94, figs. 81 and 82. While in this instance the painting surely followed the photograph, this entire class of photographs, to which this one belongs, while sometimes suggestive, nevertheless follow the conventions of painting. For another example see Scharf, fig. 79. The same Delacroix/photograph comparison is to be found in Van Deren Coke, *The Painter and the Photograph*, Albuquerque, New Mexico, 1972, 10–11, and in Gerald

Needham 'Manet, Olympia, and Pornographic Photography', in *Woman as Sex Object*, edited by Thomas B. Hess and Linda Nochlin, New York, 1972, 88–9. Needham sees the models for some pornographic photographs as 'leering at the spectator' in much the same manner as Manet's *Olympia* (81–2).

[155]Guérin, no. 64; Harris, *Graphic Works*, no. 57.

[156]Now in the Bührle Collection in Zurich. Orienti (no. 214) follows Tabarant (289, no. 253) in dating the painting 1876. Wildenstein, 1975 (I, no. 175) dates the work 1871. A priced list of that year, written in Manet's hand, includes a work of this title. See Moreau-Nélaton, I, 134.

[157]Beatrice Farwell, A Study in the Early Work of Edouard Manet, unpublished Masters thesis, New York University, 1965, 134.

in his balloon, Le Géant. Nadar's studio had become a meeting place for such figures as Corot, Manet, Guys, Baudelaire, Daumier, Delacroix, Georges Sand, Sarah Bernhardt, Berlioz and Wagner, and he offered it to the Impressionists for their first group exhibition in 1874. The painting Manet made for Nadar is thought to be a portrait of his mistress, although this identification has never been firmly established. It has also been suggested that it was intended as a pendent to the *Olympia*, and thus a homage to Goya's twin paintings, the *Maja Nude* and the *Maja Clothed*.[158] In 1859 Baudelaire had written to Nadar urging him to buy two small copies of Goya's paintings. If he did so, we can be certain that Manet would have seen them. Spanish *majas*, women of easy virtue, did wear adaptations of men's clothing, ultimately making the bolero style so fashionable that it became standard feminine dress as well. A Spanish reference is certainly obvious here, but too many other facts argue against the conclusion that the *Young Woman Reclining in Spanish Costume* and the *Olympia* were intended as a pair: they are not of the same model, they are not of the same size or format, and they were not painted in the same year.[159] On the other hand, the male costume, and the seductive pose, certainly shows that the young woman, like Olympia, belonged to a special type of liberated Parisian female which Manet and his friends and colleagues would have known.[160]

[158]Thomas Bodkin, 'Manet, Dumas, Goya and Titian', *Burlington Magazine*, L (1927), 166–67. See also Paul Jamot, 'Manet and Olympia', in the same volume, 27–35.

[159]If a black ribbon, a bracelet, and pair of slippers can be considered a 'costume' the *Olympia* should be considered as a 'Costume Piece'. However, in view of its other associations with past models and with contemporary mores, the painting will be discussed under the category of 'The Nude'.

[160]Beatrice Farwell, (*Museum Journal*, 204–5) suggests that the costumes worn by *Mademoiselle Victorine as an Espada* and by the model for *Woman Reclining* 'could be related to the affections of the "liberated" Second-Empire—but also, and more likely, to what seems to have been a chic flouting of the female image among some members of the flourishing demimonde of the time by dressing in men's clothes.' She refers the reader to several illustrations of famous courtesans of the 1850s and 1860s in Joanna Richardson, *The Courtesans*, Cleveland and New York, 1967, 109, 116, 211, 216. See also Baudelaire, 'Salon of 1846', *Art in Paris*, 69, for a description of a lithograph by Tassaert (Fig. 17) which shows a man in women's clothing, and a woman in men's clothing taking the aggressive role and lifting his skirt. For other examples of women dressed in men's clothing, see, F. Loliée, *Women of the Second Empire*, London, 1907, 26; Loliée, *The Gilded Beauties of the Second Empire*, London, 1909, 160, 186, 220, 294; Claude Blanchard, *Dames de coeur*, Paris, 1946, 64, 136. There are undoubtedly many more such examples.

6. The Nude

By the nineteenth century 'the nude' had loosened its connections with history painting and become a category in itself. Previously, whether playing out a role in a Christian or Pagan drama, the nude figure was either necessary to the narrative or played an allegorical role representing innocence or virtue. With the eighteenth century the increasing strength of Venus' place in the repertoire of subjects involving nude figures no doubt had responded to the increasing desire of painter and spectator for the sensuous pleasure to be offered by the ideal beauty of the female figure. 'The nude', who was in this sense always Venus, came to stand for beauty itself. Curiously it was with Ingres that the concept of the nude was freed from history painting, and not with Watteau's and Boucher's deliciously artificial and suggestive figures, which, with the exception of Miss O'Murphy still play out their roles in a Parsassian world. In contrast to such rococo delights the nude returns to a monumental role worthy of the gods in Ingres' Valpincon *Bather* of 1808,[161] but she is a new invention nevertheless. In the Valpincon *Bather* there are minor references to an exotic locale, the turban, the towel, and the tiny fountain so curiously compressed into the irregular visual crevasse formed by the edges of the long curtain on one side and the leg and towel on the other, but they are dominated by the intensely tangible, indeed photographic, presence of the figure as a figure devoid of references and allusions. The *Grande Odalisque* of 1814,[162] with its more persistent orientalia is less monumental, less classical, and more psychologically curious. The elongated proportions, the suggestive glance, combine with the sensuously inviting textural interplay throughout the painting to create an image simultaneously both forbidding and erotic. Later, Ingres' *Turkish Bath*[163] explodes with orgiastic frenzy, neither functioning as a celebration of beauty nor as a precise record of customs in far-away places. It is, however, a work of 1862, publicly protected by Ingres' own status as leading academician, and thus needing to offer little cover for its voyeuristic intentions. *La Source* or the *Venus Anadyomene*,[164] in part deprived of the precisions of Ingres' own brush, are softer in both their contours and their effect, becoming the norm for the sensuously pretty figures which were to populate

[161]Robert Rosenblum, *Ingres*, New York, 1967, Pl. 12, Louvre Museum Paris.
[162]Rosenblum, Pl. 24, Louvre Museum, Paris.
[163]Ibid., Pl. 48. 1862–3, Louvre Museum, Paris.
[164]Ibid., Pl. 41, *Venus Anadyomene*, 1808 and 1848, Musée Condé, Chantilly; Fig. 58, *La Source*, (Ingres and pupils) 1856, Louvre Museum, Paris.

the Salons by mid-century. It did not escape the critics that a figure like Cabanal's famous *Birth of Venus* was both sensuous and silly, its classical references slight, but a convention had been established which allowed the artificialities of such a work to be viewed as 'good taste', the decorative niceties to be seen as harmony and purity.[165] Nevertheless the academic nude in general does not deserve the sweeping damnation often given it by modern writers. Gérôme, in particular, created some very fine and expressive pictures, and the smaller sketches of many of the popular academicians were often delightful.

The requirement of academic training that the clothed figure be first studied as nude, or even as a skeleton or flayed figure meant that drawing from life was an essential part of academic instruction. The male nude was thus studied as frequently, if not more frequently than the female, in David's day. As the category of 'The Nude' developed in the nineteenth century the nude female model became more and more a necessary element of studio equipment. Kenneth Clark makes an apt observation about Courbet's *Bather* of 1853, which provoked the disgust of the emperor himself, that 'even she is in a pose that reeks of the art school'.[166] The models learned the conventions of pose from the art; the art in turn depicted them in these conventional poses, and an element of artificial distance which grew out of this repeated repertoire, served as a protection against the possibilities of a figure seeming too accidental, and thus too real.

Proust writes that Manet tried to get the model, Dubosc, to take a more natural pose, 'Is that the way you hold yourself when you go to buy a bunch of radishes? Dubosc haughtily answered him that Delaroche had the highest praise for him and that thanks to him, many young men had gone to Rome. Manet's answer 'We are not in Rome and we don't want to go there. We are in Paris, let's stay,' is for Proust an early declaration of his independence against the constructions of academic training and a search for more natural form. Proust tells another story, that Manet persuaded another model to take a natural pose and to wear some of his clothes. Couture supposedly entered the room and said 'Do you pay Gilbert not to be nude? Who made this joke?' 'Me,' said Manet. 'My poor boy, you will be nothing but the Daumier of your own time.'[167] Proust's stories about Manet are not always to be precisely believed, but they do give a picture of the dominant role played by the nude model even in the relatively free atmosphere of Couture's studio.

[165]See Rewald, 88, for an illustration and a selection of critical comments. An engraving after the painting was published in the *Gazette des Beaux-Arts*, XV (1863), 572. In his 'Salon of 1863', Castagnary poked fun at three *Venuses* in the exhibition, including Cabanal's. For an English translation of his views see Linda Nochlin, *Realism and Tradition in Art: 1848–1900*, New York, 1966, 14–16.

[166]Kenneth Clark, *The Nude: A Study in Ideal Form*, New York, 1959, 223.

[167]Proust, 21–2. Boime (69) has pointed out that Couture's remark to Manet was a clever paraphrase of a remark Gros once made to Couture when he was a student, 'If you continue to paint like this you will be the Titian of France'. He sees the incident as good natured studio banter, and points out that Couture himself on one occasion had 'transformed a model posing in classic position and "brought her up to date" by giving her a coquettish movement and placing a little red cap on her head.'

These asides on the nude in the studio and the nude in the Salons, may explain to some extent what Manet meant when he said, 'It seems that I have to make a nude. Very well, I will make one.' Manet was accepting the challenge to work in a Salon mode, just as he had accepted the challenge to show in the Salon, but he set his own terms. According to Proust, Manet's remark was made when the two of them were watching some women bathing in the Seine at Argenteuil. He quotes Manet further as saying, 'When we were in the studio I copied a picture of some women by Giorgione, the women with the musicians. It's black, that painting. The ground has come through. I want to re-do that and to re-paint it in a transparent atmosphere with people like those you see over there. I know it's going to be attacked but they can say what they like.'[168] The painting was, of course, his famous *Déjeuner sur l'herbe*, which Manet himself called *Le Bain*, reflecting his first interest in the bathing women.

The monumental nude figure in *Déjeuner sur l'herbe* was preceded in Manet's *oeuvre* by a copy of Titian's *Venus of Urbino* (Pl. 39) and a small series of nudes in landscape settings which culminated in *The Surprised Nymph* of 1861 (Pl. 63). These studies, which include drawings and prints as well as oil paintings, are heavily dependent on old master sources for both themes and motifs, developing from an early drawing of a clothed woman depicting the finding of Moses, to studies of the Pharoah's daughter, nude and surrounded by her maids, to simple studies of bathers.[169] The painting known as *The Surprised Nymph* shows only a nude woman in the woods and thus displays no overt subject matter connections. Barskaya, however, discovered that when this painting had been sent to Russia by Manet in 1861 it included the figure of a satyr, and was entitled *Nymph and Satyr*.[170] Both the use of this figure which gives the picture an anecdotal element, and its removal which deprives the picture of explanation or justification, are steps in Manet's own development toward the presentation of the modern nude.

Manet has thus made his usual art historical explorations into the motifs and styles of nude figures even before he approached the task of painting *Déjeuner sur l'herbe* (Pl. 62). If Proust is to be believed, Manet himself identified his major source in referring to his own earlier copy of Giorgione's *Fête champêtre* in the Louvre. Whatever the appropriate interpretation of this picture may be, it should be remembered that the French viewer in Manet's day would not have seen it as allegory, but as a realistic scene of Venetian life in Giorgione's times.[171] As such it seems to offer Manet an invitation to go further than his copy, and just as he had done in the *Concert in the Tuileries*, to recast his subject into the depiction of the manners and dress of his own day. That such an approach would not be found acceptable seems to have crossed

[168]Proust, 43.
[169]Oil studies: Private Collection, Paris; National Gallery, Oslo. Drawing: Museum Boymans-van Beuningen, Rotterdam (De Leiris, *Drawings*, no. 144).
[170]Barskaya. Hanson, *AB*, 1966, 436. Corra-

dini, 149–54. For a summary of information about the Surprised Nymph and an interesting interpretation of meanings of the presence and removal of the satyr, see Krauss, 622–7.
[171]See above, 75.

his mind, but not deterred him in his attempt to paint a modern picture.

A second source for *Déjeuner sur l'herbe* was noticed as early as 1864 by Ernest Chesneau, a group of figures from Marcantonio Raimondi's engraving after Raphael's *Judgement of Paris*.[172] This went largely unnoticed until the question of the meaning of the painting was reopened by twentieth-century scholars. Most recently, Wayne Andersen has offered a fresh analysis of the relationship of Manet's painting to this source. Instead of focusing his attentions on the three river gods which supply the poses for Manet's three major figures, he considered the Raphael composition as a whole, where Venus, the winner of Paris' judgement is crowned by a flying figure. He answers questions raised by two minor curiosities of the painting, the odd gesture of the man who reclines in the foreground of the picture and the tiny bullfinch which flies above the central group. The pose of the man has been precisely copied from the most prominent of Raphael's river gods, but Manet has removed the oar held by the god, leaving his modern man extending an empty hand in what might be thought of as a conversational mannerism. Andersen proposes that he extends his fore-finger like a perch inviting the little bird to join the picnickers.[173] If his interpretation of the finch as a symbol of promiscuity can be accepted, then these small details make more explicit the lascivious nature of the scene which the public and the critics seem to have felt obvious from the first. While the fact that the man does not look toward the bird he wishes to lure seems to cast some doubt on this interpretation, it is not inconsistent with the facts of Manet's interest in the demi-monde. Andersen's more elaborate proposals for re-interpreting the entire composition as a kind of Judgement of Paris in reverse, the new judgement being made by the City of Paris and the new Venus being a whore, seem less plausible. They depend in part on the assumption that Giorgione's painting would have been seen as an allegory to which Manet could offer a recognizable paradox, and in part on a structure of compositional triangles within the Raphael which would allow Manet's composition to be interpreted as reflecting the whole picture and not just the lower three figures in the right-hand part which he obviously used for his motif. The further suggestion that the wading woman wearing a shift in the background would have been seen by the public as a 'confession of licentiousness' is untenable.[174] Bathing women in similar shifts (Pl. 64) were seen as a part of simple country life in contrast to their fashionable city sisters who could afford to buy the latest in bathing costumes.[175] Much of Andersen's analysis depends on the belief that the Salon goer had in mind a great deal of complex information about pagan subject matter. His need for extensive explanations in exhibition catalogues combined with the frequent errors of identification

[172]Hamilton, 44, n. 6. Beatrice Farwell shows that Manet may have used other Raimondi engravings as well, and explains how these engravings would have been available to Manet in *Museum Journal*, 197–207.

[173]Andersen, 63–9.

[174]Andersen, 68.

[175]Pierre Dupont, *Chants et Chansons* (4 vols.) Paris, 1855, 'La Rivière', IV, 135, shows three women in simple shifts. In contrast women in bathing costumes similar to those worn by Manet's later models (De Leiris, *Drawings*, nos. 573, 577) can be found in *La Vie parisienne*, X (1872), 525, 569. The original title of the painting, *Le Bain*, indicates the importance of the bathing figure.

of subjects in critical writings would tend to prove that this was not the case.[176] His knowledge of mythology probably carried him no further than to find delicious Cabanal's pretty presentation of a Venus with flying putti. Andersen presents us in the end with no different interpretation than we have had before; that by contrast with the distance which the spectator felt from the *Fête Champêtre*, the *Déjeuner sur l'herbe* was an unabashed extension of those elements in the real world which propriety dictated were to be kept out of public sight.

Manet's picnic seems to take place in the same landscape at Saint-Ouen which he had previously depicted in the oil painting called *Fishing* (Pl. 65).[177] A figure in a boat in the watercolor of the same title leans over the water in much the same pose as the wading woman in the background of *Déjeuner sur l'herbe*. Reff has offered the suggestion that a bending fisherman in Raphael's *Miraculous Draught of Fishes*, might have supplied this motif for *Fishing*, and therefore also for the *Déjeuner sur l'herbe*.[178] While an appropriate source for a fishing scene, Reff admits that it has no apparent thematic connection with Manet's wading figure. Fried believes that 'the basic conception of the *Déjeuner sur l'herbe* is far closer to Watteau than to either Raphael or Giorgione,' and that without his *fêtes champêtres* Manet might never have conceived his painting. The only support he offers for this contention other than his general thesis concerning the importance of Manet's debt to French sources, is the suggestion that the wading figure is derived from Watteau's *La Villageoise*.[179] While not conclusive, this is one of Fried's more convincing proposals for visual borrowings.[180] Once again popular illustrations, while providing no precise motifs, can bridge the gap between past and present, recasting Watteau's *fêtes galantes* into more democratic and more contemporary pleasures. There is again an embarrassment of choices for the theme of ordinary Frenchmen enjoying themselves in the country. One charming example is an illustration by Gavarni from *Physiologie de la grisette* (Pl. 66), a little book which describes the lives of the pretty young women of the working class who while not courtesans are known to be free with their favors. The picnic with the whole family may be indeed a wholesome event, but even fully clothed couples sprawled in undignified poses on the grass suggests freedoms beyond those of ordinary bourgeois society. Even today the average vacationing Frenchman is willing to pack on top of his car the folding tables and chair which allow him to avoid such lack of restraint. The theme of casual, if not abandoned, enjoyment of nature, can be combined with that of modernity if we turn to another illustration, this time a picture of a savage described in a song by Pierre Dupont (Pl. 67).[181] Reflecting the subject of the song, the brotherhood of all mankind, the standing savage is framed by a series of scenes, not of his own habitat, but

[176]Sloane, *AQ*, 104, n. 3.

[177]For a discussion of early paintings which use the Saint-Ouen landscape, see Hanson, *Manet*, 47–8.

[178]Reff, *Artforum*, 46.

[179]Fried, 40–41.

[180]Too often Fried requires that the models he proposes turn to right or to left, shift their weight, or move an arm or a leg in order to complete the comparison.

[181]*Chants et Chansons*, I, 101–3.

of modern France. Across the bottom of the page a modern French steamer
glides along the river under the attentive eyes of a curiously mixed company
of two clothed modern men, and partially unclothed antique river god and
goddess. While happily suggesting that the enjoyment of nature is not incom-
patible with the progress of the modern world, it also presents Giorgione's
combination of clothed and unclothed figures already cast in a contemporary
setting. The same contrast of elements can be seen even more brashly stated
in an illustration to Béranger's 'Ma nacelle' (Pl. 68),[182] where the muse of
song shares her small sailboat with a fully dressed modern man while three
attractive graces lunch on the river bank with two stylishly dressed and jovial
young Parisian men, one of whom is busy uncorking the wine. By contrast
to the up-to-date provisions in the foreground, the entire scene is framed in
with a grapevine supported above by a teenaged putto.

Such sources put us into Manet's own time but leave for him the important
jump from their last lingering references to past ideals to a fully tangible
confrontation with the world of his own day. While they close the historical
gap between Manet's depiction and its earlier sources, they in no way explain
the shock[183]—and shock it was—of direct confrontation with Manet's nude,
a recognized model, looking at you, the spectator, unashamed, her fertile
freshness reflected in the cornucopian picnic basket, her modernity clearly
declared by the fashionable clothes she has left on the ground. Subtle icono-
graphic references about promiscuity seem hardly necessary to teach the
public the meaning of such a scene. If even unprotected little shop girls were
assumed to be 'bad', the public certainly had no doubts about artists' models.
Yet the picture was not simply a flaunting of public morals. The academic
nude had become a stale convention. Even Courbet's nudes in the out of doors
had a strong flavor of the studio to allow the viewer to overlook the conditions
under which they were painted. How then, could an artist 'do a nude' which
was neither an allegory nor a studio exercise? He could peek into the boudoir
to watch the toilette of some unsuspecting lady as both Manet and Degas did
a few years later, or, if the model was to be painted in nature in the challenging
lighting of a landscape setting, he could simply paint her there *as* a model
resting between poses. Whether or not Manet actually posed or painted a nude
in the out of doors, the picture, like the *Concert in the Tuileries* is a direct depiction
of modern life, its shock depended not on its probability but on the pattern of
French social customs which covered license with prudery. What better
answer to the double standard which allowed the warm appreciation of the
Salon *Venus* but banned the mention of an ankle from polite conversation,
than to make a picture which would ask the spectator if he even dared to look?
He must choose whether to be joined into the group by Victorine's cool

[182]Could the putto perhaps suggest the
flying figure over Manet's group? The sugges-
tion seems no more unlikely than Andersen's
proposal that the finch is a transmutation
of the winged Victory in Raphael's *Judgement
of Paris*.

[183]According to Zola, (*Mes haines,* 267)
there were more than fifty paintings in the
Louvre in which a mixture of nude and clothed
figures were portrayed. 'Mais personne ne
va chercher à se scandaliser au Musée du
Louvre.'

glance, or to remain apart as a voyeur enjoying the lubricity of a forbidden pleasure. Rosalind Krauss has recognized this quality of voyeurism in *The Surprised Nymph*, where the peeping satyr in the background was removed to allow the spectator outside the picture to take his place, and she rightly points out that Manet would soon after introduce 'the voyeurist idea to disrupt the spectator-object relationship' in the *Olympia*.[184]

That the *Olympia* (Pl. 69) is a direct comment on Titian's *Venus of Urbino* is an inescapable conclusion because of its many similarities to the Venetian painting which Manet had copied in his student years. It would have seemed more apt if the *Olympia*, rather than the *Déjeuner sur l'herbe*, had been the result of Manet's pledge to 'do a nude', since it relates more directly to the Salon goddesses and odalisques which continued the long tradition of the reclining nude begun by Giorgione and Titian in Venice. Manet had other sources as well. He could have read a poem by George Marcy published in *L'Artiste* in 1861, about a beautiful woman named Olympia who, like so many of her salon sisters, had a pagan body and a christian heart.[185] Virgin and Venus, Marie and Psyché, she would have inspired Giorgione and Titian, as well as Cellini, Shakespeare and others. If the name of this beauty caught Manet's attention, he certainly was interested in her rather traditional attributes only as a foil for his more realistic depiction. The name, of course, would have been known to him already in the clear and strong literary model of Olympia, mistress of Armand Duval in *La Dame aux camélias*, which appeared as a book in 1848 and a play in 1852.[186]

In 1846 Baudelaire had made the daring suggestion that the nude—'the darling of the artists, that necessary element of success—is just as frequent and necessary today as it was in the life of the ancients; in bed, for example, or in the bath, or in the anatomy theater. The themes and resources of painting are equally abundant and varied; but there is a new element—modern beauty.'[187] Later in 1863, he was to explain, 'By "modernity" I mean the ephemeral, the fugitive, the contingent, the half of art whose other half is the eternal and the immutable.'[188] He points out that the paintings of the old masters are still convincing 'morally speaking' because they record the details of their own period

> from costume and coiffure down to gesture, glance and smile ... In short, for any 'modernity' to be worthy of one day taking its place as 'antiquity', it is necessary for the mysterious beauty which human life accidentally puts into it to be distilled from it ... If a painstaking, scrupulous, but feebly imaginative artist has to paint a courtesan of today and takes his 'inspiration' (that is the accepted word) from a courtesan by Titian or

[184]Krauss, 625.

[185]'Poésies Païennes; Olympia', XII, 165.

[186]The name appears in other works of the 1860s for the same kind of character. See Reff, *GBA*, 1964, 120. 'With the international success of Dumas' novel and play, the name

Olympia became established as an epitome of heartless venality...'

[187]Baudelaire, *Oeuvres complètes*, 952, *Art in Paris*, 119.

[188]*Oeuvres complètes*, 1163. *Painter of Modern Life*, 13.

Raphael, it is only too likely that he will produce a work which is false, ambiguous and obscure. From the study of a masterpiece of that time and type we will learn nothing of the bearing, the glance, the smile or the living 'style' of one of those creatures whom the dictionary of fashion and successively classified under the course or playful titles of 'doxies', kept women, lorettes, or biches.[189]

The dictionary may not have defined 'auguste jeune fille', but the average Parisian would have recognized it as still another similar euphemism. It appears in a poem by Zacharie Astruc the first five lines of which Manet affixed to the label of *Olympia* leaving no doubt of her role as a courtesan.[190]

Baudelaire assumes the courtesan role of the Venuses of the past, and Manet's choice, from a variety of possible sources of a Venus in a domestic setting signifies his interest in the 'realistic' elements of Venetian art which might teach him how to find similar elements in the life of his own day. Fried attempts to dissuade the eye by rejecting Titian's Venus as Manet's major source and proposes instead a lithograph by Achille Devéria (Pl. 70) showing a pretty nude flirtatiously posed behind a heavy curtain on a rumpled bed.[191] In 1845 Baudelaire had found Devéria's lithographs 'faithful representations of the elegant and perfumed life of the Restoration', but when he mentions Devéria again in his Salon of 1859 he is speaking of him as an artist of the past and he is still seeking the artist of his own day.[192] While rococo revival art of this type may well have interested Manet, Devéria's print is not sufficiently similar to Manet's painting to serve as a compositional source,[193] and its flirtatious tone is in opposition to the directness of his modern Venus. The lithograph, however, allows us an important observation. The pretty nude is caressing a little lap dog. The sensuality of her touch, the tactile suggestions of soft fur against human flesh are not designed to encourage any virtue of abstinence or fidelity. Put simply, this little dog cannot possibly represent *fides*. Just as courtesans of this and other periods often played childish games to while away idle time, they enjoyed the company of birds and cuddly little pets. The more handsome of these creatures became extensions of their wardrobes, attractive articles to be carried and handled with enticing gestures like playing with a fan. The tendency of modern writers is to contrast Manet's

[189]*Oeuvres complètes*, 1163, 1164, 1165. *Painter of Modern Life*, 13–14.

[190]'La Fille des îles'. The entire poem of fifty verses is printed in Jules Meier-Graefe, *Manet*, Munich, 1912, 134. Originally published in *Journal des curieux*, 10 March 1907, p. 3. The verse Manet used can be found in Tabarant, p. 105. Tabarant believes that Astruc baptized Manet's painting.

[191]Fried, 42–3.

[192]*Art in Paris*, 12, 180. It was not until 1863 that he announced his choice of a 'Painter of Modern Life'.

[193]Reff, *Artforum* (47–8), points out that Léon Noël's lithograph after Henri Decaisne's *Odalisque* would better perform this task since it is identical to the Devéria in every aspect except that it is reversed and thus matches Olympia's pose more closely. However, Reff rejects a relationship of the *Olympia* to such a romantic source, 'For it is precisely the extent to which it transcends the trivial eroticism of the initial conception and, with the help of Titian's *Venus of Urbino*, achieves a greater formal and expressive power, that makes *Olympia* the brilliant image it is.' While not influenced by their style, Manet could have been interested in the erotic subjects of such artists as Devéria and Octave Taessart.

promiscuous cat with Venus' 'faithful' dog, but while the hissing cat is certainly a very different image from the sleepy puppy curled at Venus' feet, the two cannot possibly be thought of as opposite symbols representing vice and virtue. The dog in Titian's picture may mean no more than the fine hangings or elegant plant on the window ledge, in other words, to set the luxurious scene for this domestic goddess.[194] The cat, on the other hand, hissing to alarm the approaching visitor, is a recognized symbol of irresponsible love. The cat would have been immediately connected to Baudelaire's imagery. Its essential character was to be described at length by Champfleury in *Les Chats*, a book which follows the patterns set for human *études de moeurs*. Although this book was not published until 1869, it is essentially a collection of already existing myths and prejudices. Manet's own *Cats Meeting* (Pl. 71), a lithograph made as a poster for Champfleury's book confirms his view of cats as lascivious nocturnal prowlers.[195] The sinuous contours and simplified forms of Manet's poster are generally thought to be influenced by Japanese art. Still another Japanese cat may have suggested the imagery for *Olympia* (Pl. 72). It stands on the bed of two copulating lovers, back arched and hissing directly at the viewer of the print, an Eastern brother to Olympia's cat which similarly challenges the intentions of the spectator who views a suggestive, though less overtly pornographic scene.

Olympia was rebaptized 'Venus with the Cat' by Claretie only a few days after the Salon had closed,[196] and a spate of cartoons quickly made the cat into Manet's special symbol. It is not only directly depicted in cartoons of the *Olympia* itself, but it reappears in imagined scenes of Manet and Courbet meeting, of Manet sweeping out the Salon, and it invades other paintings on the Salon walls, and reappears later to float in the water of *The Battle of the Kearsarge and the Alabama*.[197]

More than one critic made a point of noting the fact that the bouquet being presented to Olympia was wrapped in paper, and one cartoonist depicted it enclosed within an enormous covering of newspapers.[198] The effect of the still-wrapped flowers was to increase the element of anecdote, and to assure the spectator that Olympia was looking out at the sender, but in the criticism there was discernable scorn for such a coarse presentation of a token of esteem.

Olympia's impertinent stare is not to be found in so overt a form in earlier art, but the insistent gaze of the model in Goya's *Maja Clothed* and *Maja Nude*, might well have suggested to Manet some deviation from the traditional

[194]Manet uses a little lap dog as a stylish addition to the portrait of Nina de Callias as The Woman with the Fans (Fig. 60). He painted 'portraits' of small dogs: *Tama: Japanese Dog*, Paul Mellon Collection, Upperville, Va., 1875; *Bob*, J. Cheever Cowden Collection, New York, 1875; *King Charles*, National Gallery of Art, Washington, 1875; *Douki*, Private Collection, Paris, 1875; *Minnay*, formerly Lathuille-Joliet Collection, Paris, 1879.

[195]Hanson, *Manet*, no. 90.

[196]*Figaro*, 20 June 1865, here quoted from Hamilton, 73.

[197]Curtiss, nos. 6, 7, 8, 9, 11, 17, 20, 21.

[198]Ernest Fillonneau and Gautier père, (Hamilton 72, 75) both remark on the paper wrapped flowers. The cartoonist Bertall in *Journal amusant*, 27 May, shows the paper wrapped flowers greatly enlarged (Curtiss, no. 4). Mallarmé's description of the painting in his essay of 1876 mentions the bouquet, 'yet enclosed in its paper envelope', (Harris, *AB*, 1964, 560).

possibilities of either shyly or coyly diverting the eyes, or of feigning sleep. While it does not seem possible to accept the idea that the *Olympia* and the *Young Woman Reclining in Spanish Costume* were intended as a similar pair, there is every reason to think that Manet would have been interested in Goya's highly personal presentation of a 'Venus' of his own day.

François Mathey was first to call attention to another possible source for the *Olympia,* Jean Jalabert's *Odalisque.*[199] Like Manet's picture it shows a reclining nude attended by a black servant. However she is painted in an acceptable technique of academic modeling, is protected by the innocence of sleep, and depicted in a Turkish setting surrounded by rich jewels and fabrics, thus removing her far from modern Paris and insuring her acceptability to the French public both in terms of traditional style and educational content. Both Ingres and Delacroix had produced views into the secret world of the harem, and an army of their admirers made such scenes familiar to the Salon goer. Even Manet's teacher Couture grew tired of 'turquerie',[200] and Manet could only have seen the repetition of orientalia to justify the painting of a nude as both hypocritical and dull. Nevertheless, his choice of a black servant for his pale nude may have been an intentional comment on this popular theme, a direct modernization of the pervasive motif of odalisque and slave. If so, Manet has again chosen to contrast a distant source with a scene familiar to his own life. His servant is painted from a Parisian model. 'Laure, very beautiful negress', he had jotted down next to an address in a little notebook of 1862.[201] She appears in three of Manet's paintings: a portrait (Pl. 73), the *Children in the Tuileries,* and *Olympia.* The portrait shows her, frankly pretty, wearing a necklace, earrings and a low cut gown. For her role as child's nurse in the *Children in the Tuileries* or servant in the *Olympia,* she wears a modest uniform. While blacks were rare in Paris in Manet's day she might have seemed an exotic addition to the scene in the park, or suggested a chic elegance in a courtesan's boudoir, but there is little reason to think that the depiction of Laure in the *Olympia* was intended as a symbol of primitive passion.[202] Baudelaire's fascination with negresses and mulattos added to the general belief that they were sexually uninhibited. It has been suggested that Laure is included in the picture in order to intensify its sexual meaning, but the

[199]Musée de Carcassonne, in *Le Musée des chefs-d'oeuvre*, Paris, 1948, 4–6. In discussing the tradition of women being dressed by their maids, Beatrice Farwell offers other examples in Nattier's *Mlle de Cleremont at the Bath* in the Wallace Collection, London, of 1733, and Joseph Vernet's *A Greek Woman after the Bath*, in a private collection, of 1755 'Courbet's *Baigneuses* and the Rhetorical Feminine Image', in *Woman as Sex Object*, edited by Thomas B. Hess and Linda Nochlin, New York, 1972, 65–8. See also Théodore Chassérieau, *Interior of a Harem*, Louvre, Paris, 1856.

[200]*Méthode*, 266. Also see Proust's description of Diaz being laughed at for his turkish style, 43–4, and see below n. 341.

[201]Tabarant, 79.

[202]This idea is suggested in an unpublished paper by Laura Rosenstock, 'Olympia, the Negress and the Bouquet', New York University, Qualifying Paper, 13 April 1972. The author points to nineteenth-century sources including the Larousse of 1866 to show that negroes were generally believed to be passionate and uninhibited. A different, and slightly later view of the black servant can be seen in on advertisement for a sewing machine in *La Vie parisienne*, X (1872), 191. 'Grâce à la "Silencieuse" de bonne maîtresse, Cora pourra se faire une robe blanche pour le bal des gens de maison.'

merging of the roles of servant and mistress would confuse rather than enforce such an aim. The focus is, after all, on Olympia herself; and Laure, bringing flowers to her mistress plays up her role as courtesan while, like the cat, informing her of the incoming visitor. To include Laure further in the drama would have weakened its curious psychological force.

One of the most alarming aspects of Manet's painting is that while the sexual situation is clearly announced, it is in no way palliated or diverted through either surface sensuality or moral story. Couture's *Decadence of the Romans* had shown years before that good rousing evil, overt, but handsomely expressed, could be understood as moral warning. It is the very lack of such excitement, the very ordinary and individual quality of Olympia, which shocks. Kenneth Clark pointed out that the one characteristic common to all salon nudes was that they 'glossed over the facts'. Of *Olympia* he said, 'To place on a naked body a head with so much individual character is to jeopardize the whole premise of the nude.'[203] Zola could be certain that she was 'a girl of sixteen, without a doubt a model whom Edouard Manet copied tranquilly just as she was.'[204] He further explains that 'when our artists give us a Venus, they correct nature, they lie. Manet asked himself, why lie, why not tell the truth; he makes us recognize Olympia, that girl of our day whom you meet on the sidewalks and who hugs her thin shoulders in a scanty shawl of faded wool.'[205] While he apparently sees her in terms of the poor little grisette, part courtesan, part working-girl, who might serve well as a subject of one of his own works, the obvious luxury of her surroundings indicates that at least for the moment she is a more successful member of the demi-monde, a lorette or even the cocotte who played an important role in the social life of Paris. Olympia's thin figure was apparently *à la mode*. Sandblad quotes a passage from the diary of the brothers de Goncourt which in turn quotes Gautier's description of the women he had seen at the Empress's reception: thin, emaciated, flat and bony.[206] Mallarmé saw her, 'that wan and wasted courtesan, showing to the public for the first time, the non-traditional, unconventional nude ... captivating and repulsive at the same time, eccentric and new ...'[207] In a recent article Gerald Needham compared the *Olympia* to pornographic photographs of the 1850s. While exotic settings were often used, the figures themselves could not be recast by the camera into exotic styles, and seemed brutal and vulgar in contrast to their painted sisters in the Salons. Manet might well have seen and enjoyed such photographs of women 'more or less naked and leering at the spectator with a conscious impudence', though no precise model for the *Olympia* has been found among them.[208]

For George Moore, who found in most of Manet's works fine painting but

[203]Clark, *The Nude*, 224–5.

[204]*Mes haines*, 269. Earlier (222) he refers to 'L'Olympia qui a des fauts graves de ressembler à beaucoup de demoiselles que vous connaissez.' The curious sense of combined innocence and evil produced by the *Olympia* may in part come from the childish proportions of her sensuous figure. She appears to be only 5½ or 6 heads tall.

[205]*Mes haines*, 269–70.

[206]Sandblad, 98.

[207]Harris, *AB*, 1964, 560.

[208]Needham, 81–9.

little meaning, *Olympia* was unique, having a 'symbolic intention'. 'The redheaded woman who used to dine at the Ratmort does not lie on a modern bed but on a couch of all time; and she raises herself from amongst her cushions, setting forth her somewhat meagre nudity as arrogantly and with the same calm certitude of her sovereignty as the eternal Venus for whose prey is the flesh of all men born.'[209] But meanings change, and George Bataille could later speak of *Olympia* in terms of its formal beauties alone. 'Conventions were meaningless here since the subject, whose meaning was cancelled out, was no more than a pretext for the act—the gamble—of painting.'[210] The shock, the meaning alone, could not have allowed that wan courtesan to exert her powers for so many generations, and while it would not be possible to agree with Bataille that Manet's artistry depends on pure painting in this deprived sense, one cannot carry social prejudices and tastes into another age. Bazire recalls that after Manet's death he took a friend to see the *Olympia* who had seen the painting once before twenty years earlier (in 1863) and who had thought it detestable. 'It's funny, he said, it no longer produces the same effect.'[211]

The *Olympia* and the *Déjeuner sur l'herbe* can both be dated in 1863. Manet was not to paint another nude for nine years, and by then his approach was quite different. He no longer found it necessary to work through allusions to earlier arts, and although his paintings frequently resembled popular illustration toward the end of his career, they probably did so as much from their fidelity to nature as from his need to find suggestions for motifs in accepted imagery. The later nudes are not ambitious works. *Brunette Nude*[212] was painted in 1872; *Blonde Nude* (Pl. 74), later in the 1870s. Both are half-length studies of fashionable and pretty women without setting or anecdote. In addition to this type Manet made several studies of women dressing or bathing most of which are executed in pastel.[213] Like Degas' 'keyhole' scenes, these are even more intimate, catching their subjects unaware in casual and even awkward poses.[214] Being minor works among the prolific production of his last years, these intimate nudes have largely gone unnoticed by students of Manet's *oeuvre*,

[209]Moore, *Modern Painting*, 41. Reff states that the *Olympia* is not a contemporary genre scene and remarks on its 'peculiar tension between the literary symbolic and the visually expressive'. He sees behind it the 'growing awareness in France of moral corruption and political decline.' *GBA*, 1964, 120–21.

[210]Bataille, 82.

[211]Bazire (144) writing in 1884, does not date the incident but refers to it as occuring 'tout récemment'.

[212]Louvre, Paris, 1872.

[213]Oils: *In Front of the Mirror*, S. R. Guggenheim Museum, New York, 1876; *Nude Combing her Hair*, Private Collection, Paris, 1879; Pastels: *Young Woman Combing her Hair*, Private Collection, Switzerland; *The Bath*, Private Collection, New York; *In the Bath*, Louvre, Paris; *Nude*, Bührle Collection, Zurich; *Woman Fastening her Garter*, Ordrupgaard-

sammlingen, Copenhagen, all of 1879.

[214]In her discussion of Courbet's Bathers in *Women as Sex Object*, Beatrice Farwell discusses the development of nineteenth-century lithographs of women dressing and undressing, often attended by maids, from eighteenth-century images of Bathsheba and Suzanna. She suggests that Manet and Degas may have developed their intimate 'girl-watching themes' from this tradition, 69–75. In view of Manet's dependence on other kinds of popular imagery this seems likely that he would have used such sources. Degas' first depictions of half-clothed prostitutes and women dressing were in pastel over monotype and date *c.* 1879. Most works in this genre, however, were made later in the 1880s. See Paul André Lemoisne, *Degas et son oeuvre*, 4 vols., Paris, 1946–8, III, nos. 547, 548, 549, 550.

and such subjects are usually thought of as belonging more to Degas' approach. Degas' similar works, however, seem to have been made after Manet's death— certainly after the date of these works of the late 1870s. It was Manet, then, who invented the new and modern nude which was to interest not only Degas, but Toulouse Lautrec, and later Bonnard and Picasso.

7. History Painting

THOSE writers who believe that Manet's subject matter was just a pretext for painting are most puzzled by his forays into the realm of 'history painting' since these generally involved subjects which Manet could not have seen in everyday life, and since they seemed, in some ways, to be concessions to academic requirements. While it is clear that Manet was enough of an original thinker not to be able to repeat the repetitious Salon formulas which the critics themselves found outworn, it seems obvious from a number of his works in the 1860s that he believed that a more potent and effective expression could be achieved by bringing traditional approaches up to date, rather than by the invention of a completely new pictorial language. The latter came about in due time as a reasonable development from his own reconstructions of the past together with the liberation made possible by the increasing acceptance of everyday genre throughout the 1870s. If Manet felt the need to 'do a nude', we can reasonably expect him also to have felt the need to make paintings in what was considered to be the historical mode.

By the middle of the nineteenth century the range permitted to history painting had enlarged and the lines between history and genre, history and historic landscape, history and portrait, had blurred.[215] In two areas the category remained clear: religious subjects which followed traditional form and symbol, and elevated moral lessons told through recognized pagan stories. Subjects of these kinds were assigned as topics for the Prix de Rome, and for other lesser prizes which were the stepping stones to recognition for the student artist. But 'history' could embrace more than these traditional restrictions. In discussing 'la peinture d'histoire' in his *Salon of 1868* Castagnary quoted Constable who divided all painting into History and Landscape, the 'History' including portraits and familiar scenes, the 'Landscape', landscape, fruits and flowers.[216] This arrangement neatly avoids the difficulty of drawing the line between the 'history' of the Davidian ideal and the invention of motifs for more

[215]Castagnary (*Salons*, I, 279–314) treats the Salon according to his own divisions, including several sections of 'peinture d'histoire' which are mostly genre. Portraits are separated (315–18), but Manet's *Portrait of Zola* (314) is discussed as 'history'. Castagnary (280) notes that G. Brion won a medal of honor with *La Lecture de la Bible*, a little genre picture which only the jury noticed. Earlier, in 1859, Baudelaire had discussed under the rubric 'Religion, History, Fantasy', works by M. Legros and Armand Gautier which might better be characterized as 'church genre'. *Oeuvres complètes*, 1045–6.

[216]Castagnary, *Salons*, I, 279. 'On peut diviser la peinture, dit Constable, en deux genres...'

recent history, or more personal and intimate history, which nevertheless offer similar moral messages. When Théophile Gautier suggested that an artist who had painted a swineherd with his pigs could give 'much more importance to his composition' by making the painting depict *The Prodigal Son Driving Swine* he demonstrated how little it took to change the category of a work of art.[217]

Sloane has pointed out that parellel to the changes in facture which the realists and Impressionists brought about, there was a strong need felt to revitalize subject matter in order to reinvest it with meaning. Such men as Gustave Moreau and Chenevières were remarkably inventive in their search for subjects and interpretations of subject appropriate to a modern sensibility. Sloane even suggests that no one could have known at the time which direction was to bring about the new art of the future.[218] Earlier, the question as to how to define 'history' had been answered, often in liberal terms by David and his followers, through the depiction of the contemporary or nearly contemporary event. In almost any form, Napoleon's exploits were considered elevated subjects, but one can question whether *The Crowning of the Empress Josephine* is not a very large group portrait, while the portrait of Napoleon in his study, with its clear references to his recent liberalities is not in effect a history painting. By the time of *The Raft of the Medusa* and Delacroix' depictions of the Greek war, Gros had already recounted the horrors of *The Pest House at Jaffa*. The differences were not which paintings were more 'historic' in terms of how distant the event might be in time or place, but how 'historic' they were in terms of noble message. When the Romantics spoke of dishonor and tragedy rather than moral rectitude, they vastly widened the scope of history painting whether the academy found their direction acceptable or not.[219] As long as religious sentiment and historical event had meaning to the average man, and they did in Manet's day, they remained appropriate subjects for a modern artist bent on expressing his own age. They could not, however, operate as they had in the past. Modern man was considerably less educated to the complexities of Academic subjects and consciously aware of seeking new social, political and religious answers to the new life which confronted him.

The paintings by Manet which can be assumed under the general category of history, as it might have been viewed at mid-century, are his two religious paintings, the *Dead Christ with Angels,* and *Christ Mocked,*[220] and his paintings

[217]'Salon de 1837', *La Presse*, 8 March 1837, here quoted from Rewald, 21.

[218]Sloane, *French Painting*, 6–7, 129 31, 134–41.

[219]Couture regarded *The Raft of the Medusa* as the beginning of modern art. *Couture par lui-même*, 145. 'La méduse, Gros la connaissait et c'était une révélation: l'art moderne était trouvé.'

[220]There was also a head of Christ, cut from a larger canvas which must have been another version of the *Christ Mocked*, Edward Hanley Collection, Bradford, Pa. We do not discuss

in the text his *Monk in Prayer* of 1865, now in the Boston Museum of Fine Arts, which seems more an example of 'church genre' than religious painting in the more academic sense. It does not involve the complexities of either of the two works sent to the Salons, and relates to the depictions of nuns and monks illustrated and described in studies of Parisian types. However, it has also apparently been inspired by familiar masters such as Zurburan and Fra Angelico. According to Florisoone it relates to a *St. Francis in Prayer* by Zurburan, now in the National Gallery, London. Although

of contemporary events, *The Battle of the Kearsarge and Alabama*. *The Execution of the Emperor Maximilian*, and *The Escape of Rochefort*. One might also consider the nudes already discussed as 'history' recast in modern terms. If, as Jules Janin suggested in his introduction of *Les Français peints par eux-mêmes*, that history of the age would be told in a magic lantern show of the new world,[221] then we might reasonably include Manet's numerous scenes of everyday life as history in the making. In fact the whole question, as we will see, devolves on the distinction between direct recording of events whether they be dramatic or ordinary, and the interpretation of events in acceptable moral, social and political terms as expected by conservatives bent on preserving what they considered the very *raison d'être* of art itself. If one were to follow Constable's distinction between History and Landscape, then most of Manet's *oeuvre* would have to be designated as History. He made very few landscapes where nature was not invaded by his Parisian friends or touched by their existence, and even his elegant late still life paintings seemed 'portraits' of objects which speak of his own life in terms similar to those of the many anonymous portraits of people who surrounded him in his last years. A major distinction between Manet and the Impressionists can be made in these terms, for the landscapes of Manet, Pissarro and Sisley, even Cézanne, are not, in the same sense, documents of the way society looked and behaved.

In 1864 Manet sent to the Salon his large costume piece *The Incident in the Bull Ring* and the *Dead Christ with Angels* (Pl. 75). In general the critics who chose to comment liked neither work, but they had different things to say about each of them. If the bull-fight picture disturbed their sense of appropriate drawing and composition, their concern for the *Dead Christ* was much more directed toward subject matter and meaning.[222] The lack of warm-toned modeling in the flesh made the figure seem simply dirty—a criticism soon after leveled against the *Olympia*. Today it requires something of an intellectual exercise to see how the critics interpreted the strongly lit body in that way. Their use of the word 'cadaver' is easier to understand in terms of the almost photographic realism of the body.[223] If Manet's direct perception of his parents seemed to lack proper filial respect, how much more of an insult to propriety was this unidealized depiction of the highest Christian ideal! No meaning was to be found in this realistic treatment by the average viewer since the picture was supposedly a depiction of that very part of the Christian story which depended on mystery and faith. Grünewald could show the sore-ridden suffering Christ because he would also show him resurrected in ideal beauty of body as well as spirit. Manet had simply painted a dead man. One anonymous critic advised the Salon visitor not to miss 'the Christ by M. Manet,

Manet may not have remembered the work from 1853 when the collection was dispersed, numerous reproductions in engraving and lithograph were available to him. See Blanc, *Histoire, École espagnole*, Paris, 1869, 4. Manet's own copies after kneeling figures by Fra Angelico are in the Cabinet des dessins, Louvre, and the Rouart Collection, Paris. See De Leiris, *Drawings*, nos. 3, 4, 5, 6.

[221]See above, Part I, 11.
[222]Hamilton, 51–65.
[223]Hamilton, 57.

or "The Poor Miner Pulled out of the Coal Mine" painted for M. Renan!'[224]
In 1863 Ernest Renan had published a book entitled *La Vie de Jésus* which
sold sixty thousand copies in the first six months and was soon translated into
other languages. In presenting Christ only as a historical figure devoid of
miraculous powers, Renan had raised much discussion and controversy, and
the reading public certainly would have understood clearly the critic's
reference. A potentially dangerous doctrine appeared to have been directly
illustrated by an artist already thought to be willing to trample underfoot the
standards of decent society. Although a serious attempt at a necessary religious
redefinition, the romantic sentiment of *La Vie de Jésus* produces a vastly different
effect than Manet's blunt picture. In fact, Manet may never have read the
book at all. He could not have escaped hearing about it, however, and it seems
reasonable to believe that it served as a catalyst for another attempt on Manet's
part to reinterpret traditional story and motif into intensely modern terms.

Manet has been accused of lack of knowledge about his subject because he
painted Christ's wound on the left side. Baudelaire had apparently written
him a note urging him to check in the Gospels and to change the placement of
the wound before the picture was exhibited.[225] Tabarant claims that
Baudelaire's warning arrived too late for him to change the oil painting before
the Salon, but that Manet had made a watercolor after the painting in which
the wound was correctly placed. The watercolor, however, reverses not only
the wound, but the entire picture, since Manet apparently used it as an
intermediate step in the preparation of his etching of the *Dead Christ* where
the entire composition is once again reversed and the wound restored to the
left side.[226] The precise date of the etching is not known, but it can be assumed
that Manet had had time to take Baudelaire's advice if he had thought it
important to do so. Manet may well have checked the Gospels; they do not
describe the location of the wound. Furthermore, Manet may have known what
Baudelaire apparently did not, that the tradition for the placement of the
wound is not fixed, but varies with changes in religious interpretation.[227]
Manet could have seen paintings of Rubens and Rembrandt showing the
wound on the left side. Further, one must remember that the practice of
reproducing pictures through etching or engraving which automatically
reverses composition, meant that many works of art were seen frequently in
reverse. One certainly cannot agree with writers who have regarded Manet as
misinformed about religious matters on the basis of the placement of the
wound. Surely it was Tabarant who lacked information if he could refer to
the location of the wound as 'treason to the "texte évangélique" '.[228]

Far more interesting than the details of the placement of the wound, is the
inscription included on the stone in the lower right hand corner of the picture,
which reads 'John XX 5–12'. Here one finds a description of the angels at the

[224]1 May 1864, *La Vie parisienne*. Hamilton, 60. Tabarant, 83. "...le Christ de M. Manet, ou le *Pauvre mineur qu'on retire du charbon de terre, exécuté pour M. Renan.*'

[225]Tabarant, 81. Bazire, 41, is Tabarant's source for this story.

[226]De Leiris, no. 198. The etching is Guérin, no. 34, and Harris, *Graphic Works*, no. 51. Both authors comment further on the location of the wound.

[227]Gurevitch, 358–62.

[228]Tabarant, 81.

empty tomb. The painting is now known as the *Dead Christ with Angels,* and had been called *Dead Christ* by the critics in 1864, but it had been sent to the Salon under the title *Angles at the Tomb of Christ.*[229] Like the passage from John the Evangelist, the title refers to the angels at the tomb, but not to the presence of Christ's body. Why then, has Manet placed a body, and a very real fleshly body, in the miraculously empty tomb? The precision of Manet's reference to John seems to preclude the idea that he might again have been simply mistaken about religious doctrine. Surely his picture more directly raises questions parallel to those of Renan, perhaps close to those which might have been discussed among his friends, about the role of Christianity in modern life. The miraculous disappearance of the body has potent meaning in connection with traditional Christian faith in Christ as man-god, but this faith had been weakened by repetition of liturgy and imagery to become cant, or at least to lose much of its direct meaning to a modern man. By contrast, the presence of the body becomes a confrontation with doctrine, and at the same time an intense depiction of *real* suffering. It need not be interpreted as saying there were no miracles or that Christ did not rise from his grave, but instead as insisting that religion must have something to do with the believer on a direct human level. Late in his life Manet said he had always wanted to paint a crucifixion. 'The Crucifixion, what a symbol! One could search until the end of time and find nothing comparable. Minerva is fine, Venus is fine. But the heroic image, the image of love can never be worth as much as the image of sorrow. That is the root of human nature—in it is the poem.'[230] He saw in an age old theme, with all its association for western man, an opportunity to express a universal quality, not to repeat a doctrine. One wonders how he might have carried out such a project had he been allowed the time. Castagnary had asked in 1857 if a return to religious or heroic themes were possible. 'Is humanity finished with these two sources of inspiration?' If there was to be a religious art of the future, he felt that it must present many different types, fresh young motifs 'full of intimate and penetrating poetry.' He wanted a variety of beauty like that of the gods of Olympus, and he could not have imagined what Manet's approach would be. Nevertheless he clearly understood that religious art could not continue without some sort of new direction which could capture more intimate, more poetic, more universal meaning.[231]

As with the *Olympia* and the *Déjeuner sur l'herbe,* the public felt the sting of the *Dead Christ,* but the figure of what one critic called 'the most beautiful of men' simply appeared to be ugly to them.[232] They were largely unwilling to share with Manet's angels their intense sorrow over so ordinary-looking a man.[233]

[229]Hamilton, 59–61.
[230]Proust, 123.
[231]*Salons,* I, 14.
[232]Hamilton, 60.
[233]Zola is an exception here. His doctrine of realism which did not demand symbol, and his interpretation of Manet as uninterested in meaning, allows him to take pleasure in what he sees as a non-religious picture. 'On a dit que ce Christ n'était pas un Christ, et j'avoue que cela peut être, pour moi, c'est un cadavre peint en pleine lumière, avec franchise et vigueur; et même j'aime les anges du fond, ces enfants aux grandes ailes bleues, qui ont une étrangeté si douce et si élégante.' *Mes haines,* 268.

Tabarant states that a snake unwinds between the rocks; Hamilton writes of 'the rock in the foreground under which lies crushed the old serpent of Adam.'[234] The painting is dark, the paint freely applied in this peripheral section, and it is extremely difficult to decide which writer is correct. The etching made after the painting seems to show the snake alive behind the rock.[235] A crushed snake might have been intended to show triumph over evil as a part of the long tradition of Virtues crushing the symbols of Vice. The connection of the serpent with evil, with Adam, and therefore with the need for the sacrifice of the new Adam, Christ, is so pervasive that it would have had some meaning to Manet, if only in general terms.[236] It is hard to know whether he might have intended a more complex meaning. In any case, the symbol of man's fall, though present, is overshadowed both literally and figuratively by the almost heraldic presentation of the body of Christ. The motif of Christ flanked by two angels has a very long history as a separate device, disconnected both from the symbolic suggestions of man's need for Salvation through Christ and from the narrative depiction of the angels at the tomb as an event in the Christian Story. Manet may have been familiar with any one of a number of Medieval and Renaissance representations of the dead Christ displaying his wounds. No critic, however, was aware of such a possibility. Thoré saw the influence of El Greco as predominant but he likened the modeling of the right arm and the foreshortening of the leg to Rubens' *Dead Christ* in the Antwerp Museum and mentioned 'certain *Christs*' of Annibale Carraci as well.[237] Certainly neither El Greco's motifs nor the proportions of his figures are echoed in Manet's painting. If a Spanish master were to be chosen for the source of Manet's coloristic qualities, and particularly the 'lampblack' shadows which disturbed another critic,[238] Murillo would be a better choice.[239] Many years later Florisoone pointed to more direct sources for the composition of Manet's picture in Veronese's *Descent from the Cross* in the Hermitage, and Tintoretto's *Dead Christ with Angels* in the Louvre.[240] Undoubtedly other close models can be found, but these suffice to demonstrate once again that Manet was intentionally recasting a traditional image painted by a great master into the terms of his own vision.

He followed this approach once again a year later in his *Christ Mocked* (Pl. 76) for which a number of sources can be pointed out.[241] De Leiris discusses

[234]Tabarant, 81; Hamilton, 60.

[235]Guérin, no. 34; Harris, *Graphic Works*, no. 51.

[236]Whether Manet might have understood a painting such as Vermeer's *Allegory of the New Testament* and have been attempting to bring further dimensions into his own work seems unlikely but not impossible.

[237]15 June 1864, *L'Indépendance belge*. Hamilton, 61–2.

[238]Raoul de Navery, 7 June 1864, *Gazette des étrangers*, Hamilton, 60.

[239]A study should be made of Murillo's influence on Manet. Murillo's *Little Beggar*

in the Louvre certainly came to his attention as a general source for his studies of Parisian urchins, but he undoubtedly learned from Murillo's color as well.

[240]*L'Amour de l'art*, 26–7. In the Veronese Christ is attended by Mary and one angel.

[241]*Christ Mocked* was shown in the Salon of 1865. François Mathey suggests that a religious subject was submitted with the *Olympia* as a conciliation of the jury. This seems unlikely, however, after the negative reception of the *Dead Christ* in the previous year. (*Olympia*, Paris, 1948, 2) Reff presents a more tempting proposal (*GBA*, 1964, 115–16) that

Manet's dependence on Titian's *Christ Crowned with Thorns* in the Louvre and on Bolswert's engraving after a painting of the same subject by Van Dyck.[242] I have previously suggested that Manet's composition is closer to a *Christ Mocked* in the Museum at Lille attributed to Terbrugghen, while the kneeling figures with the arrow appear to derive from Velasquez' *Adoration of the Magi* in the Prado, and the man holding the cloak from his *Forge of Vulcan* in the same museum.[243] Gautier had remarked that Manet's technique recalled 'the most foolish sketches of Goya,'[244] and Thoré had recognized Manet's debt to Van Dyck,[245] but the critics seemed generally unaware of Manet's borrowings and were more concerned with his use of 'ignoble, low, and horrible types'[246] for a subject which required dignity and idealization. Manet had posed a familiar model named Janvier, who also worked as a locksmith, and Manet's friends, with good humor, had dubbed the painting 'Le Christ au serrurier', or 'Christ the Locksmith'.[247] The critics were less kind. Louis LeRoy accused Manet of using comedy in religious art,[248] and Felix Deriège, perhaps following his lead, stated that Manet had tried to introduce caricature into religious iconography.[249] On the other side, comedy was used to attack the painting and Bertall in the *Journal amusant* called it 'The Foot Bath' and explained that the astonished rag-picker was about to have his feet bathed by sewage collectors.[250] Like the *Dead Christ with Angels*, *Christ Mocked* is not linked to any historical period, but Manet could hardly have dressed Christ's tormentors in anything as timeless as angels' wings and robes. Hamilton notes that figures were 'commonplace contemporary types, dressed in a curious mixture of modern clothing and theatrical costume.'[251] In 1865, Dubosc de Pesquidoux had said that Manet thinks that 'to strike an epoch as blasé as our own it is necessary to overturn everything, common sense, traditions, accepted ideas and even to hazard ridicule. He gives us a salad of German mercenaries and Roman soldiers in buckskin boots for Christ's tormentors.'[252] Hamilton finds the *Christ Mocked* 'the most eclectic of all his paintings. The Italianate composition, the sombre Spanish coloring, the theatrical properties, and the contemporary personages are parts which fail to coalesce into a whole convincing either as design or expression.'[253] If Manet's sources from paintings of different countries and styles are recognized and considered with the inconsistencies and artificialities of the costumes of his actors, the work can appear to be a pastiche, but the disjunctions may have been intended, and if so, the parts will 'coalesce' in a rather different fashion.

Manet might have been imitating Titian. J. Northcote in his *The Life of Titian* (2 vols. London, 1830, II, 233) tells a story that when Titian was summoned by Charles V to Vienna in 1547, he presented a *Christ Scourged and Crowned with Thorns* and a *Venus*. Reff says that this story was popular in the nineteenth century.

[242]De Leiris, *AB*, 1959, 198–201. See also Reff, *Artforum*, 44, 48, n. 23.

[243]Hanson, *Manet*, 91.

[244]24 June 1865, *Moniteur*. Hamilton, 67.

[245]Hamilton, 77–8.

[246]Hamilton, 67. Tabarant, 106.

[247]Tabarant, 104.

[248]11 May 1865, *Charivari*, Tabarant, 106.

[249]2 June 1865, *Le Siècle*, Tabarant, 106.

[250]20 May 1865, 'Le Bain de pieds', Tabarant, 106.

[251]Hamilton, 66.

[252]24 May 1865, *L'Union*. Tabarant, 106.

[253]Hamilton, 66.

Manet's Christ is particular and immediate, recognized as a contemporary Parisian. His flesh is reddened where the sun has reached his neck above the collar, his hands even redder where the ropes have cut off the circulation. In contrast his body, set off against the red-brown cloak, is pale, naked and vulnerable. His tormentors are darker skinned, but like their costumes, not identifiable to any particular culture or type. If Christ's ordeal were being shown to us as it occurred centuries ago consistent historical references would be appropriate, but it is not. Manet has attempted to make a universal image for all time, any time, all people and all places which has to do with human feelings on a level shared by saints and heroes with the most ordinary of men. He attempts to say too much with almost too little, and he creates an image with curious tensions. Any lack of resolution here functions as an added emotional vibration comparable to the lack of resolution or direction of religious feeling aroused in a time and place where traditional practice can no longer serve for its appropriate vehicle. The modernity in Manet's *Christ Mocked* is not simply a matter of his having painted contemporary people in a realistic style but having caught poignantly the irresolutions of a century fighting equally hard against both past and future. If it speaks of the present, it is because the present was not comfortable then and is not now.

Sorrow was again to be the basis of Manet's expression when, in the summer of 1867, Paris received the news of the execution of the Emperor Maximilian by the Juarist government in Mexico. Manet made four paintings and a lithograph (Pls. 77–82) between the time the first news of the event reached France in the first week of July and the early months of 1868.[254]

Like the subject of *The Raft of the Medusa* many years earlier, the Maximilian affair pointed up problems, at the least bad judgement, at the highest levels of government. Maximilian seemed an unwitting victim of Napoleon's designs for imperial expansion. A French army had secured his power on the Mexican throne, but partly under the pressure of the American government, loath to see strong forces so near its borders, Napoleon had withdrawn Maximilian's support, leaving him defenseless against the Mexican troops. The details of the news reports which told of his courage and dignity to the end, could only have further aroused public sympathy. His last works were for his beautiful wife, 'poor Charlotte'.[255]

Once again Manet used a painting of a master he admired as a basis for his composition and a foil for his personal expression. In this instance only one major source has been suggested by scholars, rather than the many images to be found as sources for most of the works early in the 1860s. Here Manet is no longer dependent on a variety of Italian, Flemish and Dutch sources, nor does he continue his homage to Velasquez. This painting, like *The Balcony* which would follow in 1868, is based directly on a work by Goya. Since the

[254]The execution took place on 19 June 1867. Sandblad (109) points out that rumours were reported in the French press on the first of July; that the court received confirmation of the news and went into mourning on the second, and that the news was published as fact in the *Mémorial diplomatique* on the third.
[255]Sandblad, 112.

painting was not shown in France during Manet's lifetime, the critics had no opportunity to remark on its resemblance to Goya's *Third of May*, but it is reasonable to assume that Manet intended the reference to be recognized. Certainly in the twentieth century, the comparison of the two has become standard fare in art historical surveys. Sandblad, however, was the first to point a basic, indeed crucial difference in the two compositions. The Goya painting presents two opposing parts, the crowd of victims being pressed forward to their deaths at the left; the file of soldiers continuing into the distance at the right. It is a clear statement of the oppressor and the oppressed and therefore rises above the particulars relating it to a specific war to become a comment on man's inhumanity to man. Manet's pictorial construction comprises three, not two, parts. The smaller group of victims, numbering only three, stands to the left, the group of soldiers in the center is specifically limited in number in four of the five versions, and the figure of the sergeant to the far right provides a balance with the victims for which the execution squad serves as fulcrum. Sandblad shows that this modification of his source gives Manet's pictures not only a different appearance but also a different meaning.[256]

As in the case of his earlier works, Manet did not depend on the masters alone for visual information. It has been frequently noted that for this picture, as for the later *The Escape of Rochefort* (Pl. 87), Manet set about collecting facts to assure the accuracy of his representation. Like Géricault's investigations in reading reports and interviewing survivors as preparation for *The Raft of the Medusa*, Manet's research can be seen as an appropriate equivalent to the kind of preliminary study expected for major historical machines contesting for academic prizes. Manet undoubtedly viewed this as a proper approach to history painting, but it should be noted that in turning to written accounts in newspapers, magazines, photographs, and perhaps books, he was again using verbal and visual imagery available to the average man, and that the language of the reports and the styles of the illustrations were similar to those of the descriptions of peoples and places he had used previously, even if the content was not. Manet's working method for translating past to present was thus consistent for all his larger projects of the 1860s.

Earlier writers, Meier-Graefe, Jedlicka, Martin, and Sloane, have all discussed *The Execution of the Emperor Maximilian* in terms of the actual facts of the event, arriving, however, at different conclusions.[257] In general they have based their information on reliable reports, but not considered whether such reports were in fact available to Manet at the time.[258] By careful analysis

[256]Sandblad, 122–3.

[257]Jules Meier-Graefe, *Edouard Manet*, Munich, 1912; Jedlicka; Kurt Martin, *Die Erschiessung Kaiser Maximilians von Mexico von Manet*, Berlin, 1948; Sloane, *AQ*, 1951. A new approach to the study of the painting is taken by Boime in *AQ*, 1973. Boime sees 'explicit autobiographical references in Ma-net's paintings of the 1860s' (190); and finds in Manet's paintings of Maximilian a projection of his feelings about himself (191–3). It is difficult to accept this view on the basis of the evidence offered.

[258]The fullest and most useful of these is Ernst Schmit Ritter von Taverna, *Die mexikanische Kaisertragödie*, Vienna, 1903. See Sand-

of information offered in French news reports through the summer and early fall of 1867, Sandblad has been able to demonstrate Manet's reactions and to narrow the dating of the pictures. His essay on *The Execution of the Emperor Maximilian* is a thorough and fascinating account of the development of Manet's series combined with a straightforward and sensible interpretation of his finds. Like all other Manet scholars, he places the Boston version of the subject (Pl. 78) first, before Manet had seen photographs or had read extensive information about the event.[259] Tabarant says that Manet began his work on the theme in late June and early July before he left for a holiday at the seaside. He also stated that Manet had worked quickly on his canvas in hopes of adding it to his exhibition at the Pont de l'Alma (The exhibition paralleled the Exposition Universelle of 1867 which closed on 30 October.[260]) Sandblad is able to show, however, that Manet probably did not begin work on the Boston picture until some time after the 10 August article in the *Mémorial diplomatique*. If Tabarant is correct that Manet did not return to Paris until early September, the painting may not have been begun until that time. The 10 August report gave information about the clothing of Maximilian and the two generals, but not about the soldiers. Although the Boston painting is very freely brushed it is clear that the general visible through the smoke is in shirt sleeves and that Maximilian wears dark trousers and a Mexican hat. More important, the report described the role of the sergeant in the drama. It had already been hinted in earlier news stories that Maximilian had not died instantly; now the public was told the grim details of the unsuccessful *coup de grâce*, and even the necessity to reload the sergeant's rifle before the final shots. The story thus separates the sergeant from the other soldiers and represents a further sequel to the action of the firing squad which Manet directly portrayed.[261] In the later versions the handling of the figure of the sergeant further strengthens this aspect of Manet's pictorial report, and thus further separates it from the more generalized meaning of his source, Goya's *Third of May*.

Sandblad notes that for the Boston painting Manet could have found any number of illustrations of Maximilian and had turned quite precisely to a xylograph in *L'Illustration* of 1865 which portrayed an engagement in the Mexican war, for the details of his sergeant's costume.[262] Manet was to learn of the size of the squad and the appearance of their uniforms only later when he somehow obtained a photograph taken shortly after the execution. Just when this source might have come to his hands is not known, but Sandblad states strongly that this information would not have been available in France before the return of Tudos, the Emperor's valet, who had been

blad, 120. It was recognized early that Manet used photographs for documentation. One of these was published by Taverna in 1903, another by Max Liebermann, in 'Ein Beitrag zur Arbeitsweise Manets', *Kunst und Künstler*, July 1910, 483–88. Meier-Graefe mentions the photographs and Kust Martin discusses such sources at length.

[259]Sandblad, 121.
[260]Tabarant, 143.
[261]Sandblad, 121–7.
[262]Ibid., 125. Information about the two generals appeared in articles of 20 July and 28 September (135).

an eye witness to the entire event.[263] Tudos' account was published in the
Mémorial diplomatique on 10 October, and although it gave no information
about the uniforms, it did give information as to the number of soldiers of
the firing squad. Too much still remains in question to allow one to agree
with Sandblad that 10 October was precisely the moment for abandoning
the Boston version and beginning a new composition; but certainly, if Manet
had not begun his work on the subject until early September a loose reading
of this date is reasonable.

Manet painted another large canvas of the execution which, for reasons
unknown, was cut into fragments probably by Manet or Léon Leenhoff.
Four of the fragments were found and brought together by Degas; they are
now in the National Gallery in London (Pl. 81). Duret states that this was the
second version. It showed the event taking place in open country, a fact to
be gleaned from the 10 October report. Thus it was probably painted after
that date. It is clear that for this picture Manet had used French soldiers as
models for his firing squad, and we are told that his friend, Commandant
Lejosne, had brought soldiers from a nearby barracks to pose for him. Although
the uniforms shown in the photograph of the squad are not identical to those
of the French soldiers, they are sufficiently similar to have suggested to Manet
that he might use French models.[264]

Tabarant assumes that the smaller oil sketch of the scene which is now in the
Ny Carlsberg Glyptotek in Copenhagen (Pl. 80) preceded the London
version probably in preparation for the larger work.[265] The large painting
in the Städtische Kunsthalle in Mannheim (Pl. 77) is generally thought to be
the definitive canvas. Jedlicka puts the works in the same order as Tabarant;[266]
Duret's catalogue places the Copenhagen sketch last in the series. He does
not discuss the lithograph to which it obviously relates.[267] Since Manet often
made prints after completing printings of a given theme, sometimes a con-
siderable time after, his lithograph of *The Execution of the Emperor Maximilian*
(Pl. 82) is usually considered to have followed all of the paintings. Sandblad
proposes a different order: Boston, London, lithograph, Copenhagen, Man-
nheim.[268] His reasons largely turn on evidence in the paintings themselves.
He places the lithograph immediately after the London version because of
Maximilian's hat squarely on his head rather than tipped back to form a sort of
visual halo as it is in all but the Boston painting. Since the figure of Maximilian
is missing from the London fragments, we have no way of knowing how this
type of evidence might apply to the dating of that work. Sandblad, of course,
notes that a wall has been introduced behind the figures of the last three
pictures, but he offers no reasons for this change other than that it creates
an 'increase in tension, a concentration on the event', and that it provides
a means of introducing the Mexican people who were variously described in

[263]Ibid., 128. He gives no reason for this
stricture, nor does he state when Tudos
actually arrived.
 [264]Duret, 1902, 71.

[265]Tabarant, 140–42.
[266]Jedlicka, 139–46.
[267]Duret, 1902, 71, 218.
[268]Sandblad, 127–48.

news reports as being either jubilant or filled with compassion. The 10 October report had indicated that a crowd of people, mostly poor Indians, had watched the execution from a nearby hill. Since this account also stated that the event took place in open country, Manet could not have been following this report, and it is hard to see how the introduction of the people or the wall can be linked to it. In fact we know that the execution took place in an area surrounded by a rough brick wall[269] although we have no evidence as to when or how Manet might have learned this fact.

Sandblad relates the Copenhagen sketch to the lithograph because of their obvious similarities. The painting, however, shows Maximilian's sombrero on the back of his head, and, in Sandblad's mind, thus links it to the final Mannheim version.[270] It would seem, however, that almost any order for the last three works might be supported. The evidence of the hat which Sandblad finds so convincing, is not in itself that strong, since we lack information about the London picture and since the hat seems to be more level in the lithograph than in the Boston picture, to be pushed farthest back in the Copenhagen sketch, and to take an intermediate position in the Mannheim painting. What seems an equally important problem is the placement of the sergeant in relation to the rest of the soldiers. Although he turns toward the spectator in the Boston version he is placed directly in front of the firing squad and thus linked to the group. He is definitely set apart from the squad in the London version, overlaps the group in the Copenhagen sketch and the lithograph, and is again separated from them in the Mannheim painting. Both the placement of the hat so that it becomes a kind of halo and the separation of the sergeant as a character with a special role in the drama are of importance to the meaning of the picture. If one follows the placement of the sergeant another sequence for the paintings can be proposed. There are reasons to separate both the lithograph and the Copenhagen painting from the others of the group. First, the Boston, London and Mannheim pictures are all large works, clearly intended as major statements, whether realized or not.[271] Tabarant probably assumed that the Copenhagen sketch, being much smaller, was a first try at a new approach to the motif. However, Manet did not necessarily follow the practice of painting small oil sketches in preparation for larger works. In fact, he seems more often to have done the opposite and made smaller works *after* large ones, particularly when he was preparing a motif for translation into a print medium. Further, since Manet gave the Copenhagen version to Méry Laurent[272] it does not seem that he thought of it as a statement of the same order as the larger versions. The lithograph and the Copenhagen sketch are closely linked in composition, neither having the openness of the London and Mannheim versions, nor the lack of surrounding space of the Boston painting. The Copenhagen painting lacks the symbolism

[269]Sandblad, 115.
[270]Ibid., 147.
[271]Boston, 195 × 259 cm.; London, precise size of the original unknown but the fragments suggest a format of at least 200 × 330 cm.;

Mannheim, 252 × 305 cm. By contrast *The Old Musician* is 187 × 330 cm. and *Déjeuner sur l'herbe*, 208 × 264cm.
[272]Tabarant, 141.

of the separation of the sergeant from the group, although it retains the halo-like placement of Maximilian's hat. Thus it seems to serve as a step between the Mannheim painting and the lithograph[273] where the symbolic elements are suppressed and the image takes on more of the character of a news report. Lithography was an appropriate medium for the dissemination of information. Although photographs could be made at this time, they could not be easily reproduced in numbers and were often translated into one of the print media for wide distribution. To place the lithograph last in the series would be to reassert Manet's usual working method for making prints *after* he had worked out his ideas in paintings and drawings, and would demonstrate his recognition of the print medium as basically different than work in paint both from the standpoint of its possibilities for expression and in terms of the receptivity of its audience.

Manet's lithograph was not to reach a wide audience however, since its printing was suppressed. Evidence of this comes to us from a letter from Manet to Burty dated Tuesday, 18 February,[274] complaining that the printer refused to give him the stone and wanted authorization to efface the image. He refused to allow this or to make application to have the interdiction against it reversed. Guérin who published this letter, goes on to say that the affair was concluded in 1869 when the stone was released to Manet, but that the work was not published until after Manet's death in 1883.[275] Several writers claim that Manet had hurried to finish a painting in order to include it in his exhibition at the Pont de l'Alma, and Bazire, writing in 1884, states flatly that the work was missing from the exhibition because the administration had censured it.[276] We have no other evidence that Manet might have tried to show one of the versions, and it seems most unlikely since the unsigned and unfinished Boston painting is the only one which could have been ready in time. Even if it had been heard of and Manet had been sent official warning in advance of its completion it would not have seemed as inflammatory as the later versions. While the whole Maximilian affair was an embarrassment to Napoleon III, no public recognition could be made of the undercurrents of feeling and the court had gone into official mourning when the news had arrived of the tragedy. The vivid news descriptions during the summer had not been suppressed, and the problem of the reception of Manet's work could not have lain with the general subject alone. It seems far more likely to assume that the censure was specifically directed to the later versions which Manet could have made no attempt to show at the time, or perhaps only to the lithograph, a more usual medium for propaganda.

Napoleon had spurned Manet's work in 1863, but the artist's antagonism to the emperor probably had deeper reasons than this personal affront. Manet

[273]It is probable that there was still another intervening step. A tracing of the figural group in the Copenhagen picture is in the Museum of Fine Arts in Budapest (De Leiris, *Drawings*, no. 343, fig. 285, text 16), but it was probably put to another use since the oil and the lithograph are not the same size.

[274]Presumably 1869.

[275]Guérin, no. 73, commentary.

[276]Bazire, 57.

did not seem to have been consistently politically active, but on more than one occasion he proved himself to be a liberal Republican in his beliefs. He would not have been alone in feeling strongly that Napoleon was personally responsible for the tragedy, and that in that sense Maximilian had been killed by the French as much as by the Mexicans. It is not possible to take the formalist stand that Manet made four versions of *The Execution of Maximilian* showing the firing squad dressed in French uniforms because he needed models for his work and simply painted what was available. To be sure the uniforms were very similar to those which the Mexicans actually wore, but if Manet had the photograph of the squad in hand, he could have easily modified the French costumes, deleting the specific details which showed them to be French. That he did not may well have been to make clear his opinion—an opinion shared by other Frenchmen as well. That the French government was always sensitive to ideas expressed in lithography can be proven by the earlier suppression of Daumier's prints, and later, the fact that Manet's elaborate color lithograph of Polichinelle was restricted, suspected of being a caricature of General MacMahon.[277] Manet's protest against the interdiction of the Maximilian print, that he was astonished by the action of the authorities against 'une oeuvre absolument artistique',[278] seems more like an attempt to have his way than a statement of aesthetic principle. It has, however, been used to support the formalist view that for Manet the subject was only a pretext for painting. Sandblad gives an excellent summary of twentieth-century opinions of *The Execution of the Emperor Maximilian* tracing the belief of earlier writers in Manet's concern for his subject despite his reportorial style, to the formalist view of the 1930s and 1940s that Manet was supremely indifferent to his subjects.[279] There is little argument to be marshalled against the claim of a writer that the work simply doesn't look moving to him. For some, rather violent gestures and grimaces seem necessary to bespeak emotion; for others these devices seem artificial, and therefore lacking in feeling. Of more value is the evidence of Manet's commitment to his subject, demonstrated in his own modification and repetition of the theme; reports on the intensity with which he worked;[280] and the attitudes of those contemporaries who saw the picture. George Moore could speak of its 'solemn beauty' and describe it with admiration for its sense of reality.[281] For Bazire, 'It is incontestable that the effect is prodigiously terrifying.'[282]

Since public exhibition of the subject was not possible in France, Manet made efforts to arrange for it to be shown elsewhere. His friend the opera singer Emilie Ambre took it with her on a singing tour in the United States when she left Paris in October of 1879. The painting was shown in December in New York and in January of 1880 in Boston. 'Several American painters

[277]See Harris, *Graphic Works*, no. 80. The long tradition for using figures in the *Commedia dell'Arte* to express public sentiment explains the official concern over what appears to be an inoffensive work today.

[278]Guérin, no. 73, commentary.
[279]Sandblad, 116–20.
[280]Ibid., 116.
[281]Moore, *Modern Painting*, 40.
[282]Bazire, 57.

were particularly enthusiastic', wrote Mademoiselle Ambre's manager.[283]
It is curious that no attempt has been made to discover what the reaction of
the American public was to the picture. It was not widely noted, but a few
news reports show a consistent reaction. It is no surprise that the technique was
found too broad, one reporter calling the painting an 'example of the ultra-
slap-dash school',[284] another saying that it was 'as coarse as the work on a
piece of theatrical scenery'.[285] However, these 'crudities and inacurracies'
were not seen in a totally negative light and the critic of the *Boston Evening
Transcript* could express his fascination with the 'almost brutal realism' and
conclude that 'M. Maret [sic] has certainly produced an exceedingly dramatic
and powerful picture.'[286] Not long after Manet's death the painting is again
mentioned in the American press, 'Manet's *The Execution of the Emperor
Maximilian* is a work full of power and tragic feeling, heightened by the simpli-
city, even commonplaceness of the treatment.'[287] In sharp contrast are Georges
Bataille's views written in 1955, when he quotes Malraux as having said that
'Manet's *Execution of Maximilian* is Goya's *Shootings of May Third* minus what
the latter painting signifies.'[288] For himself Bataille added that Manet had
'deliberately rendered the condemned man's death with the same indifference
as if he had chosen a fish or a flower for his subject.' But Bataille's observations,
if we can call them that, are securely based on his view of modern art. 'To
suppress and destroy the subject is exactly what modern painting does ...'
His prejudices which suggest that he had very little to do with the modern
painting of his own day are, however, not directed against Manet whom he
sincerely admired, and his subsequent discussion is not without very real
insights into the way Manet's paintings produce their effects. Believing that
Manet approached his subject with 'callous indifference' he notes that the
spectator shares this attitude[289] and he finds that the 'absence of effect, gives
rise to an imponderable plenitude which, once perceived, is completely
satisfying.' 'This imponderable plenitude is perhaps essential to what modern
man really is, supremely, silently, when he consents to reject the pompous
rhetoric that seems to give sense to everyday life, but which actually falsifies
our feelings and commits them to a ludicrous abjection.' He sees the painting,
then 'free of the insipid comedies, the dust and litter of the past.'[290] Manet
undoubtedly would have enjoyed those words. He had succeeded in translating
the general condemnation of violence of Goya's painting to a kind of coldly
recorded news report with its involuted modern force. He saw the danger of
his method, however, for he once said that 'to undertake a history painting

[283]Hans Huth, 'Impressionism comes to
America', *Gazette des Beaux-Arts*, XXIX
(1946), 225–52.
[284]Boston, *Saturday Evening Gazette*, 4 January
1880.
[285]*New York Herald*, 29 November 1879,
4, column 4.
[286]*Boston Evening Transcript*, 13 December
1879, 4, column 4. 'The work is singularly

powerful and striking in its originality and
unconventional effects'. *The Boston Budget*
added, 'the poses and actions of these three
figures are highly dramatic.'
[287]*The Critic*, 28 May 1887, 271–2.
[288]Bataille, 50.
[289]Ibid., 52.
[290]Ibid., 55.

according to the *Chroniques des temps*, is to want to make a description of person on the basis of the description in his passport.'[291]

Constantin Guys, Baudelaire's model for the 'Painter of Modern Life' had himself been a news reporter in the Crimean War in 1855. Manet undoubtedly shared Baudelaire's admiration for this artist-journalist, but Manet recognized what transformations direct reporting required to transcend the particular event and to endow his work with a layer of general meaning. What he captures are modern man's psychological reactions. He does not record for us so much the horror of oppressed facing oppressor as he does the greater tragedy of man's enforced indifference to the events with which advanced systems of communications could bombard his sensibilities. Yet indifference was an essential part of the nineteenth-century character. The inheritor of Dandyism, he could retain his passive façade to protect the tenderness of his soul. Rosenthal saw through to Manet's intent, 'He has pretended to give to his narration the impassible character of a legal report. The effect is all the more vehement.'[292] Although 'Dandyism' had first been described by Barbey d'Aurevilly many years earlier the concept of the sophisticated and disdainful dandy was very much a part of French life in the third quarter of the century.[293] In the 1850s Paul de Musset could say that the Parisian man 'looks neither up or down, right or left, walks neither fast nor slow, lacks interest in anything and passes before everything like a sleepwalker.[294] Baudelaire in his *Painter of Modern Life*, published in 1863, writes a whole section in praise of the dandy who has the 'pleasure of astonishing and the proud sensation of never being astonished.' 'Dandyism is the last burst of heroism amid decadence ... The character of the dandy's beauty consists above all in an air of coldness which comes from an unshakable determination not to be moved; you might call it a latent fire which hints at itself, and which could, but chooses not to glow.'[295]

In *The Execution of the Emperor Maximilian* Manet has succeeded in capturing the latent fire for those who wish to find it, but the effect he produces goes beyond the pose of the dandy to reflect the disturbed spirit of modern man.

The winter of 1870–71 was to bring Manet more directly in contact with the horrors of war. The Franco-Prussian war was declared in July and on 3 September the Prussians marched into Paris. Manet had closed his studio, left some of his most important canvases with Duret and sent his family to safety in Oloron Sainte-Marie.[296] Manet's letters to his wife give news of the city under seige, the shortages of food and fuel, trees hewn down, furniture burned in the fields, spies, prisoners, and the death and wounding of his

[291]Jules Claretie, 'La vie à Paris', *Le Temps*, 28 March 1912, here quoted from Leon Rosenthal *Romanticisme*, 159. Claretie reports that Manet said this to Henri Detouche in a discussion at the Café de la nouvelle Athènes.

[292]Rosenthal, *Romanticisme*, 156.

[293]Articles on the Dandy, like those of the *Physiologies*, still appeared in the 1860s. For example see Jules Barbey d'Aurevilly, 'Du dandyisme et de Brummell', *La Chronique*

universelle illustrée, I (1860), 165–8.

[294]Paul de Musset, 'Parisiens et parisiennes', in *Paris et les parisiens au XIX siècle*, by Alexandre Dumas, Théophile Gautier, Arsène Houssaye, Paul de Musset, Louis Enault and Du Fayl, illustrated by Gavarni, Lami and Rouargue, Paris, 1856, 403.

[295]Baudelaire, *Oeuvres complètes*, 1178–80.

[296]Tabarant, 182–3.

friends.[297] He had joined the National Guard in which he served under the painter Meissonier (who did not know he was an artist). Berthe Morisot reports that Manet, always elegant and impassive, took pleasure changing his uniforms,[298] but we know that he took part in the fighting,[299] and later, when the Commune fell in the spring of 1871, that he saw the grim aftermath of executions in the street.[300]

Unable to paint, Manet did drawings of the ghastly events[301] which culminated in two lithographs: *The Barricade* (Pl. 83) and *Civil War*. The first of these shows a hasty execution. Although the composition is directly reversed, it instantly recalls *The Execution of the Emperor Maximilian*. In more than one respect, however, it is closer in both form and meaning to Goya's *Third of May* since it is based on a two-part balance of oppressor and oppressed and it is not possible to determine the number of either the soldiers or their victims. The similarity to *The Execution of the Emperor Maximilian* however, is more than mere reference. On the recto of a sheet in the Museum of Fine Arts in Budapest is a wash drawing of *The Barricade*, apparently made in preparation for the lithograph:[302] on the verso of the same sheet is a line drawing of *The Execution of the Emperor Maximilian* which is probably a tracing of the lithograph, and was apparently used to establish the general outlines of the figures for the drawing of *The Barricade*.[303] There is no question, then, that Manet used the main motif of an earlier composition to make a further statement on the subject of war. A smaller free wash drawing of soldiers in a city street may well have been made on the spot and probably served to suggest the background cityscape in *The Barricade*.[304]

According to Guérin, during the aftermath of the commune in May, Manet had sketched the cadavers he saw on the corner of the rue de l'Arcade and the Boulevard Malesherbes. His second lithograph, *Civil War* (Pl. 84), depicts the pathetic figure of a soldier of the National Guard lying in front of a rubble barricade amongst the street debris.[305] The feet of another dead figure can be seen in the lower right, the striped trousers suggesting that the civilian was as much a victim as the military. Manet's image is clearly drawn from his own earlier *The Dead Toreador*, a motif already transformed more than once. This borrowing raises the question as to whether Manet sketched from

[297]Moreau-Nélaton, *Manet*, I, 121–7.

[298]Morisot, 48. Letter from Berthe to her sister Edma, 27 February 1871.

[299]Duret, 1919, 93–5.

[300]Moreau-Nélaton, I, 130. The armistice took place on 28 January; Manet returned to Oloron on 12 February; the insurrection started in Paris on 18 March; and Manet returned to Paris in mid-May. See Tabarant, 189.

[301]*Soldats se rendant aux avant-postes, Soldats d'infanterie*, Rouart Collection, Paris. De Leiris, *Drawings*, nos. 334, 337. De Leiris (no. 335) also catalogues but does not illustrate *Convoi militaire*, Dubaut Collection, Paris. I do not think this is an authentic Manet. It is illustra-

ted in Jacques Mathey, *Graphisme de Manet*, Paris, 1961, no. 89.

[302]De Leiris, *Drawings* no. 342, fig. 287.

[303]Ibid., no. 343, fig. 285. The change in format in *The Barricade*, together with the sizes of the lithograph, the line drawing and the wash drawing, would support this idea. The lithograph differs from Manet's *Execution of the Emperor Maximilian* and Goya's *Third of May* in that it is a vertical composition showing a rubble wall and the buildings of the besieged city directly behind the ghastly event.

[304]De Leiris, no. 334, fig. 286. De Leiris does not connect this drawing with *The Barricade*.

[305]Guérin, no. 75. It should be remembered that Manet was in the National Guard.

the scene at all, and if he did, how he might have found so convenient a model. As we know, he had carefully posed Guéroult for *The Old Musician* so that he resembled figures in Velasquez, Le Nain, and antique sculpture. He, however, was a cooperative living model and it seems unlikely that Manet would have re-arranged a corpse on the street to suit his needs for a usual source. His blatant re-use of earlier motifs is taken as evidence of his lack of originality by more than a few writers. 'It is further striking evidence of the artist's inability to look at even the most moving scenes in any terms other than those of his own personal mental images ... Manet had evidence in his own life that modern times were not lacking in exciting and dramatic moments, and yet his talents were unsuited to making anything really moving out of them.'[306]

Such criticism is based on a limited concept of realism, although one which was strongly stated by Zola, that the artist is obligated to record what actually appears before his eyes. It rejects the important differences between art and life, and appears to assume that real tragedy in the raw is necessarily moving to all who see it, and that it would retain this character into the future even without the formal ordering of art. In actuality, however, those who consider Manet's works lacking in emotional expressiveness are not asking for such literal realism. Would the dead figure in *Civil War* be more moving to them if they knew that it were directly taken from a photograph instead of an earlier work of art? Probably not, for they demand not the cold actuality which Manet has so convincingly depicted, (no matter what his source or method), but gestured drama, complete with sets and lighting to heighten the expected and typical emotional reactions to the scene. Manet knew well this kind of art and had clearly rejected it in favor of the more complex, the more unpredicted emotional response more commonly found in the world in which he lived. As to the charges of his own lack of feeling, we have record of his fervor in working on the Maximilian affair; and we know from both Proust and Bazire of his harrowing visit to the cemetery at Montmartre while he was still a student at Couture's studio. Groups of twenty persons holding numbered cards were allowed to pass along rickety boards in search of familiar bodies among the victims of executions under Louis Napoleon's regime. His colleagues agree that Manet was deeply impressed and that he remembered this experience many years later.[307] We have no comparable personal testimony to his reactions to the sights of Paris in 1871, but the two lithographs seem to be evidence enough. Propagandistic in both approach and medium they view the real dehumanization of war, perhaps all the more gruesome when seen, like a news report, without idealization or hope.[308]

[306]Sloane, *AQ*, 103.

[307]Bazire, 6–8; Proust, 25–6.

[308]In *The Drawings of Édouard Manet: A Factual and Stylistic Evolution* (unpublished dissertation, Harvard University, 1957, 52–3) Alain De Leiris sees *The Barricade* as 'Perhaps the more gruesome for its anonymity and for the confrontation of coldly observed facts (buildings, firing-squad, sunlight) with the mechanical action of the soldiers and its inherent cruelty ... This deliberately composed image is perhaps as moving for its understatement of the action represented as the similar scene interpreted by Goya's *Tres de Mayo*, which impresses one by its emotional paroxysm.' De Leiris discusses the prints briefly in his book, *The Drawings of Edouard Manet*, published later in 1969, 16 and 17, but seems to have modified these views. See particularly 16, n. 12.

The two other major testaments to Manet's interest in contemporary history *The Battle of the Kearsarge and the Alabama* (Pl. 85)[309], and *The Escape of Rochefort*, have both been described as seascapes, lacking in the conventional means for signaling emotional response. The first predates the war imagery just discussed; the second was made a decade after. For neither is there a known source in the works of the old masters,[310] although both, like Manet's *The Execution of the Emperor Maximilian*, depend in part on factual information, both visual and verbal, obtained through the public press.

In the summer of 1864, the French witnessed one of the bloody engagements of the American Civil War when the Confederate ship, Alabama, was sunk by the Kearsarge off the harbor of Cherbourg. It is not surprising that the French press quickly reported on the event which took place so close to their shores. The Almanac of the *Magasin pittoresque* for 1865 included the battle (Pl. 86) in a series of illustrated reports of catastrophes worldwide.[311] They had already depicted the battle of the Monitor and the Merrimac in the 1863 Almanac, showing that mere proximity was not necessary to arouse the readers' interest.[312] While the illustration of the sinking of the Alabama is an interesting document, it undoubtedly postdated Manet's painting. There is a possibility, however, that he might have seen other similar illustrations before he set to work on his canvas.

Those scholars who believe that Manet was a realist and that realist artists must work directly from actual events have raised the question as to whether or not Manet actually saw the battle. The Alabama had for some time sought refuge under the protection of neutrality laws in the harbor at Cherbourg, knowing that she had little chance against the superior force of the Union vessel. Finally the captain had decided to leave the harbor and confront the enemy. Thus it was known that the battle would occur where it could be seen from the coast. Duret and Proust report that Manet went to Cherbourg and witnessed the encounter from a pilot boat.[313] Later writers have found this story improbable, and evidence has been offered to prove that Manet was not present at the scene. Soon after the battle, the artist wrote in a letter to a friend, 'The Kearsarge was in the harbor at Boulogne last Sunday. I went to visit it. I had guessed pretty well.'[314] Does this mean that he had never seen the Kearsarge before it came to Boulogne after the battle? Or perhaps, only that he had never seen it at close range? Joseph Sloane provides a firm answer. Manet's depiction of the Kearsarge lying at anchor in Boulogne harbor shows the ship correctly rigged; its rigging cannot be made out in the picture of the

[309]It should be noted that the second 'r' in Kearsarge, somewhat unpronounceable in French, is dropped by many French writers.

[310]While no specific sources have been named, Manet's seascapes in some ways resemble Dutch marine paintings, as well as those of Boudin and Jongkind.

[311]*Almanach, Magasin pittoresque*, 1865, 54–5.

[312]*Almanach, Magasin pittoresque*, 1863, 44–5. The formula for illustrations depicting sea

battles had been established many years earlier. See *Les Français peints par eux-mêmes*, 1840–42, I, 252 for a battle of two boats obscured by smoke, in a chapter on Province.

[313]Duret, 1919, 99. Proust, 53. See also Jamot, 'Etudes sur Manet, Manet peintre de Marine et de Combat du Kearsarge, et de l'Alabama', *Gazette des Beaux-Arts*, XV (1927), 381–90, for a discussion of the problem of Manet's presence at the scene.

[314]Moreau-Nélaton, I, 65.

battle, but the sinking Alabama is not correctly rigged. Sloane concludes from this that Manet could not have seen the ship as she went down and erred because he was relying on second hand evidence.[315] Sandblad suggests what that evidence might have been in claiming that Manet must have 'derived his inspiration' from a xylograph of the battle in *L'Illustration* on 25 July.[316] He says that close study of the details proves his contention, particularly the fact that Manet's painting shows only 'those parts of the vessels which are visible in the newspaper-picture.'[317] However, the painting shows far less detail than the xylograph and unlike the illustration it depicts the Alabama with its smokestack set behind the second mast. The rigging of the two ships is abundantly clear in the illustration, and in spite of the fact that this is just the sort of source Manet would have used, and the fact that it probably would have been available to him in time, it seems impossible that a man who had been to sea could make such a mistake when he had the visual information before him. Other sources in magazines and newspapers may have been available to him, but it is likely that they too, would have shown the ship correctly rigged and not as Manet painted it. The logic of Sloane's argument seems more convincing than the testimony of two of the artist's friends, but still another interpretation is possible. Manet's 'error' is perhaps a proof that he *was* present at the battle where the details of the smoke-covered vessels might have been difficult to see and remember. He may, then, have made his painting from sketches in direct response to his experience before 'correct' new illustrations were available to him.

The composition of the painting differs from the usual depictions of sea battles in contemporary illustrations where the action is centrally placed. It shows the battle occurring on a high horizon line obscured by clouds of smoke. The spectator is separated from the scene by an expanse of water. The newspapers reported that many small boats circled the sinking ship to see the tragedy at close range and to pick up survivors. The small sailboat in the left foreground seems to be one of these. From the realist point of view it is difficult to imagine where the spectator (the artist) would have been located unless a high cliff overhung the scene or he were clinging to the rigging of a rather large boat. This is an impractical speculation, however, since no one would propose that an artist work on a relatively large oil in either position. It is obvious instead that Manet painted this and other seascapes of the summer of 1864 from drawings, presumably made both at Cherbourg and Boulogne.[318]

[315]Sloane (*AQ*, 94) points out that the Alabama is shown with the funnel between the mainmast and the mizzenmast when it should have been between the foremast and the mainmast. Although he believes that Manet's picture was intended as a 'history' painting, he thinks it no more than 'an attractive seascape'. 'As a painting *the Kearsarge and the Alabama* has great merit; as a depiction of history it is negligible', (95).

[316]Sandblad, 131, fig. 35.

[317]Ibid., 179, n. 29.

[318]*Trois barques à voile, Proue d'un bateau, Deux voliers, Barques à voile,* all in the Cabinet des Dessins, Louvre. De Leiris *Drawings,* nos. 390, 391, 392, 393, believes that two of these were done at Berck in 1873.

This can be easily ascertained from the repetition of similar motifs in various combinations in four other seascapes of the same summer.[319]

Manet's painting was hung in the window at Cadart's shop in July, and Philippe Burty reported in *La Presse* on 18 July that he found it 'Painted with unusual power of realization.'[320] *The Kearsarge and the Alabama* went largely unnoticed among the more provocative canvases which Manet exhibited together in 1867, but it received comment when it was shown at the Salon of 1872, much of which was favorable. By this time Manet was thought of as an inveterate rebel, however, and thus he was a subject for the cartoonist's wit. Stop, Cham and Leroy all parodied his canvas. Olympia's black cat was still considered Manet's special emblem, and it appeared floating like a bath toy in the foreground of Bertall's cartoon replica of the battle.[321] It is interesting that Bertall saw no reason to include the foreground boat in his 'copy' after the painting.

Serious critics were divided as to the effect the painting produced. Jules Claretie thought the water 'admirably painted' but complained, 'I was actually at Cherbourg at the time of the battle and Manet's picture doesn't show me the dramatic side of it.'[322] One wonders how much of the 'dramatic side of it' he had actually seen and from what vantage point, or whether, in those words, he refers more to his reactions to the event. For Barbey d'Aurevilly, Manet had achieved the opposite effect. 'A less clever man than Manet would have placed the contending vessels in the foreground in order to concentrate the spectator's attention more on the battle itself ... Manet has pushed his ships to the horizon. He has *coyly* diminished them by distance. But the sea which surges all around, the sea which spreads out even to the frame of his picture, alone tells enough about the battle. And it is more terrible. You can judge the battle by its movements, by its broad swells, by its great waves wrenched from the deep.'[323]

For the water suggested more drama than a focused depiction of the battle could convey, and this is just the element in the painting which appears to be Manet's unique invention. Whether or not Manet used any contemporary illustrative material as source for his image, the battle itself shares the character of much visual reporting in the press. Here is history as it occurred, without allegorical gloss or moral message, depicted in clear daylight rather than traditional chiaroscuro. Manet had painted the history of his age in the spirit of his age, leaving for the admired past the allegory of *Liberty at the Barricades*, and the artifice of the *Raft of Medusa*.

Manet was clearly pleased with his picture. He exhibited it three times and

[319]*Marine*, Philadelphia Museum of Art; *Outlet of Boulogne Harbor*, Art Institute of Chicago; *The Kearsarge at Anchor at Boulogne*, Mrs. Peter H. B. Frelinghuysen Collection, Washington, D. C.; and an etching entitled *Marine*, Guérin, no. 35. There is also a watercolor of The Outlet of Boulogne Harbor, Rouart Collection, Paris, De Leiris, *Drawings*, no. 202. For a full discussion of the inter-relationship between these works see Hanson, *AB*, 1962, 332–6.

[320]Hamilton, 64. Manet wrote a letter to Burty thanking him for his article.

[321]Curtiss, no. 11.

[322]Hamilton, 157.

[323]Ibid., 158–60. This statement appeared in a review of the Salon in Gaulois, and was later published in 1887 in *Sensations d'Art*.

in 1880, when he set about painting his *The Escape of Rochefort* (Pl. 87), he consciously tried to repeat his success. Marcellin Desboutins had arranged for Rochefort's cooperation with the project. He reported to Manet in a letter, 'I saw Rochefort today at noon. The proposition has been received *with enthusiasm*. The perspective of a sea *à l'Alabama* is exciting'.[324] Presumably a composition based on his earlier drama at sea had already been in Manet's mind when he asked his friend's intervention. We learn also from Desboutin's letter that Manet was to approach his task by carefully collecting the facts and interviewing the participants, 'You will have at your disposition when you wish, not only Robinson-Rocheforte, but also Olivier Pain-Friday.' These references to *Robinson Crusoe* are best explained by a recounting of the escape.

Henri Victor Rochefort, Marquis de Rochefort-Luçay was an active leader of the Republican opposition to the rule of Napoleon III. His outspoken journalism more than once led to confrontation with the ruling authorities, and more than once cost him his freedom. As editor of *La Lanterne*, he was fined and imprisoned when that periodical was seized and suppressed in 1868. In 1869 he was elected to the Chamber of Deputies, but he again renewed his onslaught on the government in a new paper *La Marseillaise*, and was again imprisoned and not released until the Empire fell in September 1870. During the winter of 1870–71 he was in the government of the National Defense and head of the Barricades Committee but his scathing articles in *Le Mot d'ordre*, which expressed sympathy for the Communards, brought about his arrest and condemnation to life imprisonment. Together with several other journalists he was exiled in 1874 to a French penal colony on New Caledonia. Three months later Rochefort and several of his friends, including Oliver Pain, escaped from the island in a small whaling boat. The liberal Republican, Gambetta, had apparently made the necessary arrangements and an Australian ship was waiting for them to take them to safety in America. From there, Rochefort went to London and Geneva where he resumed publication of *La Lanterne*. Manet's immediate interest in the story was brought about by a general amnesty in 1880, and Rochefort's final return to France. Needless to say, French opinion was still divided, and the subject of Manet's painting politically controversial. Nevertheless Manet apparently worked furiously in hopes of having a history painting ready for the Salon of 1881. Two versions of the painting are known to us today, but apparently neither was considered appropriate (if either was ready in time) and Manet sent a portrait of Rochefort (Pl. 88) to the Salon instead. The painting was not well received. Rochefort himself did not want to accept it as a gift. Manet sometimes had difficulties with portraits when he felt that regular sittings could not be assured, and there seems to be evidence of this in the worried textures of the face. Huysmans unkindly referred to the flesh as 'green cheese, all speckled and spotted.'[325] Yet the portrait is forceful: Manet

[324]Moreau-Nélaton, II, 78. [325]Hamilton, 245.

had caught Rochefort's taut bearing, his tufted hair, and nervous aristocratic face. Few critics liked it. Charles Flor seemed to understand why. 'Compare this portrait with any other in the Salon and it will look false to you, but confront it with nature, with a man passing by, or, if possible, with Rochefort himself, and you will be struck by the great style, by the masterly bearing, by the powerful sincerity of this portrait, conceived and executed without regard for the banal conventions of the craft ...'[326]

Manet not only studied Rochefort's appearance with some care, but made a portrait of Olivier Pain, and it is Pain's features which are recognizable in the man at the tiller in the larger of the two versions of the escape.[327] This work is unsigned and perhaps unfinished since Pain's head is the only one completed among the roughly sketched figures in the boat. None of the figures can be identified in the smaller signed version of the Escape of Rochefort.[328] We have no evidence as to which version was made first. Both show a small boat on a vast sea, and in both the rescue ship can be seen close to the top of the canvas on a high horizon. The larger work is vivid and freely brushed, the whaling boat dominating the center of the composition. The smaller version is taut, the sense of suspense and danger heightened by the reduction of the size of both the small boat and the distant rescue ship. The blue-green water thus plays a larger part in the drama emphasizing the struggle toward safety. Except for the general reference to *The Battle of the Kearsarge and the Alabama* in the role the water is allowed to play in the total composition, we know of no sources for *The Escape of Rochefort*. Manet's overt references to the old masters had gradually diminished during the 1870s; at the same time his use of Japanese prints and popular imagery had become more digested. By the end of the 1870s he had developed an extremely facile style which seemed remarkably unified with his directly recorded subjects—now all overtly scenes of modern life.

Manet is usually thought of as an apolitical figure, yet *The Execution of the Emperor Maximilian* and *The Escape of Rochefort* are strong political statements. Two drawings of the trial of General Bazaine suggest that he had plans for still another painting of an inflammatory nature.[329] His lithograph of *Polichinelle*, was suspected of being a caricature of General MacMahon and suppressed.[330] If Manet intended this connection, it further supports his interest in the intrigues of the Franco-Prussian war. An educated man, he could not have been unaware of the effects of his subjects on the public nor the possible repercussions for himself. Although never actively politically involved, he was in close contact with men who took part in shaping the government, and he followed a consistent liberal Republican position. In 1848, during his year as a Naval cadet, he had written a letter to his cousin

[326]Ibid., 246.
[327]There is also a preparatory sketch for the boat showing Pain at the prow which was in the Crocker Collection in San Francisco and now appears to be lost. Orienti, no. 342C.

[328]Collection of Mrs. Frank J. Gould, Cannes.
[329]De Leiris, *Drawings*, nos. 418, 419.
[330]Guérin, no. 79.

Jules de Jouy describing his experiences and expressing his interest in the new French government.[331] De Jouy, slightly older, a lawyer and already politically involved, undoubtedly had considerable influence in forming Manet's political opinions. The two remained in close contact throughout Manet's life.[332] Manet painted a robust portrait of the lawyer in 1879.[333] Its freedom and force suggest that he felt at ease with his sitter. Manet painted two portraits of Georges Clemenceau in the same year,[334] only a few months before he founded his radical journal *La Justice*. Clemenceau apparently enjoyed chatting with Manet during his many sittings.[335]

While studying in Couture's studio Manet had met Antonin Proust who later turned to journalism and politics instead of art. In 1870 he became Gambetta's secretary, and he acted as Minister of the Interior during the Siege of Paris. Gambetta himself had begun his career as a clerk in De Jouy's office.

Manet had sent two portraits to the Salon of 1881, his Rochefort, and a strange picture of his friend Pertuiset posing as a lion hunter (Pl. 46). The works were not generally liked, nevertheless Manet was awarded a second class medal, his first official recognition since the Honorable Mention he received in 1861. The jury had apparently been persuaded that Manet deserved some recognition, but the award was controversial. One critic was to report, 'The commotion which occurs at each Salon over the name Manet had been increased this year by an official award which some consider a very tardy and inadequate reparation, while others are tempted to see in it an incomprehensible bit of mystification. In this case this award satisfies no one . . .'[336] Thanks to Gambetta's brief government, Manet was to receive a greater honor later in the year. Gambetta became premier in November and appointed Antonin Proust as his Minister of Fine Arts. On 30 December Manet was made a Chevalier of the Legion of Honor.[337] In a sense, then, this coveted award had political connections. (See Pl. 89 for a cartoonist's view of his two awards.)

While a number of works can be looked on as having political connotations, Manet should not be thought of as being strongly politically involved. He apparently had definite convictions and was willing to support them when occasion presented itself to him, but he was a man broadly involved with all aspects of life around him, of which politics was only a small part. Too often historians would like to categorize their subjects as either fully involved or completely disinterested. This naive view overlooks the role the nineteenth-

[331]Moreau-Nélaton, I, 12–15.

[332]De Jouy helped arrange Manet's exhibition in 1867. After Manet's death his widow lived with De Jouy at Gennevilliers, and De Jouy was responsible for the estate, and the exhibition and sale in 1884. Tabarant, 136, 267, 487–8.

[333]Private Collection, London. See Tabarant, 360.

[334]Jeu de Paume, Louvre, and G. K. Tan-hauser Collection, New York.

[335]Tabarant, 358–9.

[336]René Ménard, in *L'Art*, here quoted from Hamilton, 242. Armand Silvestre in 'Les Recompenses du Salon', *La Vie moderne*, III, no. 17 (4 June 1881) 355, says 'Une seconde Médaille pour avoir eu une grande influence sur son temps! Ne trouvez-vous pas cela un tantinet mesquin?'

[337]Tabarant, 435.

century artist played as sensitive receiver for a wide variety of experiences and involvements. Manet was an artistic genius but his political interests, his delight in fashion, his fascination with the art of the past, his interest in the papers and magazines which lay on the table in his home, his urbanity, all attest to the fact that he was also a normal man of his own class. In a way he fills Baudelaire's requirement for a 'modern hero', the anonymous man in his dark suit, who was to be the real subject of the history of his age, or as Baudelaire called it 'the epic side of modern life.'[338]

[338]Baudelaire, *Oeuvres complètes*, 949–50.

8. Modern History: Scenes of 'La Vie Moderne'

IF, as Constable had proposed, 'History' should be considered to include portraits and familiar scenes,[339] and if the average Frenchman saw his own life, with all its new inventions and events, as the history of tomorrow, the bulk of Manet's *oeuvre* must be seen as history in the making.

Couture had early recognized that the railroads and large industries would create a need for a new monumental art.[340] He had encouraged his students to be of their own time, and not to try to escape from their own country into the art of past periods and far away places.[341] Manet remembered once when coming back from Versailles he had ridden in the locomotive with the engineer and fireman. He later told his friend Jeanniot, 'This is a dog's life, but these are the men who are the heroes of today. When I am well again, I will use them as the subject for a picture.'[342] Certainly such a subject seemed suitable to everyone's interests. The frequent world's fairs in London and Paris proudly displayed national inventions and commercial successes as if material gains were proof of superiority in all areas of life.

Chennevières, who became Director of Beaux-Arts in 1874, wanted to have public buildings decorated by the new artists, and in 1881 he conceived a plan to commission Carolus-Duran, Cazin, Duez, Besnard, and Manet, to decorate the Trocadéro.[343] If the new patron of the arts was to be the average man; if public buildings were to reflect his interests, then why should they not be painted with scenes of his own city—a city of which he was inordinately proud? This was Manet's suggestion when he wrote the Prefect of the Seine in the autumn of 1879 offering to decorate the conference room of the Municipal Council in the new Hôtel de Ville in Paris with a series of compositions representing 'the public and commercial life' of his day: 'Paris-Halles, Paris Chemins de fer, Paris-Port, Paris-Souterrains, Paris-Courses et Jardins.'[344] What immediately springs to mind are Manet's many scenes of Paris and its environs, the gardens, the streets, the race courses, the skating

[339]See above, 103, 105.

[340]*Méthode*, 148–9, 254–5. Couture also related large art to large feelings, 270.

[341]*Méthode*, 266. 'Perdez-vous cette funeste habitude de fuir la nature de votre pays. Pourquoi des Italiens? Pourquoi des Arabes, pourquoi des Turcs? Soyez donc Parisiens comme on était Athéniens. Ayez confiance dans vos forces, ne vous suicidez pas dans le passé.'

[342]Courthion and Cailler, 11.

[343]Boime, 16.

[344]Proust, 94. Manet's use of the term 'le ventre de Paris' in that letter probably refers to Zola's book of that name published in 1874.

rink, the river scenes and the cafés. These subjects had been depicted again and again in the French press. The *Chronique universelle illustrée* published articles on sections of Paris, and books such as *Le Nouveau Paris* and *Paris et les Parisiens*, contained similar essays and descriptions, all illustrated in an anonymous reportorial style. In view of the critics' demand for inner meaning and narrative in Salon pictures, the lack of these qualities in the average illustration is remarkable. Manet might have been expected to plan such clearly lit scenes of the life around him for his decorative scheme. Yet according to Proust, Manet's plans for the Hôtel de Ville were also to include portraits of the important men of his day and allegorical figures. He quotes Manet as saying 'Allegory first of all, the wines of France, for example. The wine of Bourgogne represented by a brunette, the wine of Bordeaux by a woman with chestnut hair, the wine of Champagne by a blonde.'[345] We can readily picture the kind of figures he intended from his plans to represent the Four Seasons with beautiful women elegantly dressed in the latest Parisian styles or possibly from his studies of blond and brunette nudes.[346] However, his pictures of *Spring* and *Autumn* seem as much a new kind of allegory, as his *The Escape of Rochefort* is a new kind of history. They make no references to historical allegories of the seasons: they include no traditional attributes. Had he attempted such subjects in the 1860s Manet might well have translated into modern dress motifs borrowed from the masters. In the 1880s, he no longer felt such a need. Instead he could suggest his peripheral meaning through evocation—a visual poetry inherent in his facile technique and the directness of his intimate subject matter.

The same change is clear when one compares *The Execution of the Emperor Maximilian* with its careful structure and its strong reference to Goya, and *The Escape of Rochefort*, which looks like many seascapes but none in particular, and depends for its force on an almost simplistic record of the event. The *Olympia* with its strangely sensuous tensions and references can be similarly held up to Manet's depiction of *Nana* (Pl. 90) of 1877.[347] Although Zola's novel, *Nana*, was not published until two years later, Nana had already made her appearance in *L'Assommoir* as the daughter of the two main characters Gervaise and Coupeau. At the end of the book she has 'caught a count'[348] who marries her in the novel, *Nana*. Manet's painting shows her dressing in her elegant boudoir while a fully clothed man (her count?) waits seated on the plush sofa. The direct naturalness of her glance toward us, the spectators to the scene, has none of the effect of impudence of Olympia's steady gaze. Through its composition the painting of Olympia is so overtly compared to the models on which it depends, that her arrogance takes on the quality of

[345]Proust, 95. Proust remarks that the final commissions for the decorations of the Hôtel de Ville, divided up among several artists in the official heirarchy, constitutes the strangest '*bouillabaisse* one could dream of' (98).

[346]See above, 86–7, 181.

[347]See above, note 69. Theodore Reff (*GBA* 1964, 120–21) believes that the formal and symbolic character of *Olympia* makes it very different from *Nana*, which, instead portrays an 'incident of modern life'.

[348]*L'Assommoir*, translated by Altwood H. Townsend, New York, 1962, 431.

an attack. If her black cat has symbolic meaning, so does the crane in the Japanese decoration on Nana's wall, but the differences are vast. Without connections with past art, *Nana* is simply an intimate scene of contemporary life and the Japanese design is quite appropriate and expected in this environment. Naughty, perhaps, but accepted as part of the modern world.[349]

In some of Manet's later works the old acidity is gone, the tensions relaxed, replaced by the easy sensations of pure pleasure, yet *The Bar at the Folies Bergère* (Col. Pl. IX) has all of the complexity and force of his best work.[350] Not only in its luscious facture, but in its interpretation of subject as well. The barmaid, surrounded by all the sights, smells, noises and textures of a lively café concert, is a simple enough subject, linked to the popular traditions for illustrations of café and theater scenes. An interesting little episode, or even a moral message could be suggested if she were to give us as much as a coquettish glance. Instead she stands mute, separated by her own musing from the active life around her, a kind of impassive and blunted onlooker to the scene of modern life. The psychological suggestions here replace the historical suggestions of the *Déjeuner sur l'herbe*, and we are allowed to see modern life both from the outside and the inside at once. With her beauty and her indifference, her fashion and her universal mood, she becomes a heraldic emblem of the modern age. Manet's source may have been an illustration in the new magazine *La Vie moderne*.[351]

La Vie moderne had produced its first issue on 10 April, 1879, promising 'to put on the family table each week the spiritual distractions and intellectual joys which civilized man needs as he needs his white bread', neglecting only the discordant world of politics.[352] 'La vie moderne,' proclaimed Armand Silvestre, 'is achieved today in the sincerity of its allures, its manner and its dress.'[353] This open appreciation of the fashions of the day interestingly relates to Baudelaire's earlier statements on the reflection of the eternal in the transitory elements of everyday life.

> Beauty is made up of an eternal invariable element, whose quantity it is excessively difficult to determine, and of a relative, circumstantial element, which will be, if you like, whether severally or all at once, the age, its fashion, its morals, its emotions. Without this second element, which might be described as the amusing, enticing, appetizing icing on the divine cake,

[349]For Bazire (100) she was 'cette créature parisienne et moderne'. Mallarmé saw Manet's later works as part of a democratic vision, referring to such works as *Le Linge* as 'contemporary social normality', Harris, *AB*, 1964, 561.

[350]To try to test the accuracy of the reflection in the mirror in *The Bar at the Folies Bergere* by matching bottle to bottle is to ignore the power of the suggestions and savor of the subject. For a further discussion of the painting's form and meaning see below, Part III, 204–5.

[351]A café scene after a drawing by Rochegrosse 'Le café de la garde nationale', is illustrated in *La Vie moderne*, I, no. 5 (8 May 1879), 75. It shows a girl behind a bar with gas lamps in the background. The diagonal placement of the tables in the foreground, however, is more reminiscent of Degas' café scenes, than Manet's.

[352]Armande Silvestre, *La Vie moderne*, I, no. 1, 6. The resolve to avoid politics was broken only in the case of news of Gambetta. See V, no. 2, 18; cover of no. 3 and pages 41–2.

[353]*La Vie moderne*, I, no. 1, 6.

the first element would be beyond our powers of digestion or appreciation, neither adapted nor suitable to human nature. I defy anyone to point to a single scrap of beauty which does not contain these two elements.[354]

While the magazine seemed to give little serious thought to eternal matters it clearly glorified the pleasures of life in more than frivolous terms. It discussed an exhibition of reproductions of old master drawings;[355] it celebrated Shakespeare's 315th anniversary.[356] The telephone and the telegraph were praised and seriously discussed,[357] and new forms of lighting considered for their various merits.[358] It was noted that electric light brought out relief in sculpture, and looked more like daylight, avoiding the reddish glow of gas.[359] As a whole, the magazine was a sensitive reflector of the interests of Manet's own class in Paris—interests which centered around those issues which could then be described as basic to 'la vie moderne'.

As an adjunct to the magazine, the galleries of *La Vie moderne* opened in December 1879 with an exhibition of painted tambourines by a number of artists.[360] Manet's contribution was decorated with two pairs of dancers' feet, a reworking of a detail from *The Spanish Ballet* which he painted in 1862.[361] Manet's friend De Nittis had submitted a picture of a young woman taking a walk which inspired one spectator to remark 'How Parisian!'[362] The exhibition of tambourines was followed in March by another group show, this time painted ostrich eggs. Manet was included with a depiction of his *Polichinelle*.[363] The public was delighted with these playful and fashionable objects, but the gallery was also to devote itself to more traditional and serious forms of artistic expression. In April of 1880 twenty five oils and pastels by Manet were exhibited at *La Vie moderne*.[364] It must have been a remarkable sight. Fashionable portraits and scenes of modern life were hung against 'the most marvelous and rich oriental fabrics' loaned for the purpose by M. Dalsème, a celebrated rug merchant. It was explained that Manet's figures would detach themselves from the walls if the usual neutral ground was used. Here, instead, was a unified presentation, fashionable works in fashionable surroundings. The exhibition drew a crowd of literary and artistic celebrities and 'mondaines',[365] and in spite of some negative criticism repeating the old complaints,[366] it was generally enjoyed.[367]

Most of the pictures were selected from Manet's recent work and all were

[354]Baudelaire, *Oeuvres complètes*, 1154; *Painter of Modern Life*, 3.
[355]*La Vie moderne*, I, no. 8 (29 May 1879), 239.
[356]Ibid., I, no. 8 (29 May 1879), cover design.
[357]Ibid., I, no. 3 (24 April 1879), 39.
[358]Ibid., I, no. 8 (29 May 1879), 126–7.
[359]Ibid., I, no. 38 (27 December 1879); 605.
[360]Tabarant, 372.
[361]Phillips Collection, Washington, D.C. and see above Part I, n. 230.

[362]*La Vie moderne*, II, no. 1 (3 January 1880), 4. See also II, no. 2 (10 January 1880), 19–20, and II, no. 37; 592.
[363]Ibid., II, no. 13 (27 March 1880), 195. See also II, no. 12 (20 March 1880), 183.
[364]Moreau-Nélaton, II, 66. The exhibition opened on 8 April.
[365]'Actualités', *La Vie moderne*, II, no. 16 (17 April 1880), 255.
[366]Hamilton, 226–30.
[367]'Actualités', *La Vie moderne*, II, no. 19 (8 May 1880), 303.

appropriately concerned with aspects of modern life. The seven portraits were of pretty women and interesting figures like George Moore and Constantin Guys, and Manet's cousin Jules De Jouy. The earliest of the works shown was the charming picture which can perhaps be dated 1868 of Madame Manet seated on a couch listening to Leon Leenhoff read to her.[368] It is thus consistent with the casual genre approach of the other works, which were largely café scenes and intimate studies of women bathing and dressing. *Skating*, a particularly fashionable Parisian pastime, was the subject for an oil (Pl. 91) and a pastel.[369] Repeatedly described and illustrated in popular magazines the 'Skating-Club' near the Jardin d'Acclimatization offered the same opportunities to see and be seen as the races on the outskirts of the city (Pl. 92). The lake was brilliantly lit at night, food and hot wine were available in the big chalet club-house, and, best of all, one could talk about what everyone else was wearing.[370] Poems were even dedicated to the sport; 'Au dessous de zéro' and 'A Miss Mary la patineuse'.[371] The name of the sport itself was most frequently used in its English form and we are told that many foreigners enjoyed the lake. Thus Manet's oil *Skating* shows an elegantly dressed mother and child in the foreground in a composition which curiously predicts that of *The Bar at the Folies Bergère*. The excitement and motion of the skaters and spectators are shown behind the immobile central figure just as the trapeze artist and the café goers are summarily depicted in flickering and suggestive brushwork behind the mute bar maid. The difference lies in the mood of the two works. The elegant redhead at the Skating-Club seems to be thoroughly enjoying the admiration of her friends. It is this sense of pleasure and satisfaction which seems to dominate the works in the exhibition, and thus to reflect quite precisely the tone of the magazine *La Vie moderne*. The term 'realism' might be appropriate since both real actions and real sensibilities are depicted here, but the word has unfortunately come to carry with it the concepts of the struggles of the lower classes, and the grim realities of the life of the poor. Certainly those aspects of realism are consciously missing here.

Gustave Goetschky, who had not previously written on Manet contributed a long article to *La Vie moderne* on 17 April.[372] Writing in 1867 Zola had attempted to soothe the public by describing Manet as a perfectly acceptable gentleman,[373] but the legends of him as a sort of wild man were still apparently alive thirteen years later, and Goetschky felt it necessary to inform his readers that Manet was a man of 'perfect education, excellent manners, cultivated spirit, and amiable character, a Parisian by race, and even that he dressed like "M. Tout le Monde".'[374] We sense a difference however. Zola had been arguing a new cause about which he himself was not

[368]*La Lecture*, Jeu de Paume, Louvre.

[369]Present location unknown. Orienti does not catalogue the pastel. Wildenstein, 1975, II, 5.

[370]*La Vie parisienne*, 1867, 48, 63–5, 80–81.

[371]Ibid., 85.

[372]*La Vie moderne*, II, no. 16 (17 April 1880),

247–50.

[373]*Mes haines*, 250–51. 'Nous trouvons dans Edouard Manet un homme d'une amiabilité et d'une politesse exquises, d'allures distinguées et d'apparence sympathique.'

[374]*La Vie moderne*, II, no. 16 (17 April 1880), 247.

convinced. Manet now had followers; both his subjects and his technical facilities were better understood. In the context of Goetschky's enthusiastic descriptions of his works, the remarks on Manet-the-man seem less defensive and more intended to assure the reader that the artist, like his paintings, was very much a part of 'la vie moderne'. Goetschky sees, 'en pleine lumière,' real people who live and move in their own environment, rendered with broad brush strokes and clear colors. Instead of criticising the lack of 'finish' which still seemed to bother other writers, he analyzes Manet's approach as a simple process of simplification and synthesis. 'In the symphony of a work, he makes each object sound its particular note with a touch of the brush.'[375] We are reminded most forceably of the synthetic elements in Mallarmé's thought, his belief that a word or phrase, if just, could evoke far more than could be said by the accumulation of details.[376] It is in this sense that Manet's pictures are not realistically painted. Instead they evoke 'reality' by sounding the notes of the life around him. In this sense Manet's painting approaches poetry, and his relationship with poets of his day can be better understood. However, Armand Silvestre's statement that the *Olympia* could serve as a frontispiece for Poe[377] is provocative indeed. Unlike Baudelaire, the images called up in one's mind by the name of the American poet seem far from the blunt objectivity of the depiction of a Parisian courtesan. Yet an evocation, a mystery, a suggestiveness is nevertheless present in many of Manet's works, allowing them to provoke a variety of reactions in the spectator. These qualities are far easier to see in Manet's late sketches and watercolors which, rendered in a remarkable shorthand style, call upon the viewer to complete their imagery in his own mind.

Manet made a number of prints to serve as book illustrations; others were used for this purpose after his death. Three books were entirely illustrated by him; all were poetry, Charles Cros' *Le Fleuve* (Pl. 93), Mallarmé's *L'Après-midi d'un faune* (Pl. 94), and Mallarmé's translation of Poe's *The Raven* (Pl. 95). For the first two Manet made tiny images which do not serve as precise illustrations of the words of the two but are evocative like the poems themselves. Particularly for Mallarmé, who was concerned with the appearance of the page in relation to the structure of his words, these illustrations could serve as enrichment and extension of an essential mood. To illustrate *The Raven* Manet made a cover design of a crow in profile, an ex-libris of a flying crow, both strongly dependent on Japanese sources, and four large transfer lithographs illustrating selected lines from the poem.[378] Mallarmé himself found them of 'very fantastic character'.[379] As soon as the book was published in 1875 Manet had sent a copy to Arsène Houssaye who commented in the *New York Daily Tribune* that 'Manet has endeavored to reproduce the vague,

[375]Ibid., II, no. 16 (17 April 1880), 250.

[376]See above, Part I, 41–3, and below, Part III, 171, 173.

[377]*La Vie moderne*, IV, no. 2 (14 January 1882), 106.

[378]Hanson, *Manet*, 149. Guérin, nos. 85, 86.

[379]'Literary Gossip', Saturday, 26 June 1875, from *Les 'Gossips' de Mallarmé: 'Athenaeum' 1875–1876*, edited by Henri Mondor and Lloyd James Austin, Paris, 1962.

the profound, the nocturnal, and the luminous, to be found in that admirable poetry, which embraces so much of the ideal and suggestive.' Although irritated at Manet's unwillingness to 'submit to the laws of design' in his paintings he found in Manet's works a strong 'approximation to nature'. In relation to the illustrations, Houssaye praised Manet's 'high literary sense'.[380] He cannot mean, of course, that sense for didactic narrative encouraged by the academy which could be referred to as 'literary', but rather the sense of the kind of literature being written in his own day and often by his own friends. The categories of 'realism' and 'symbolism' imposed on history in an attempt to give it order, fail to account for the new kinds of synthesis of the nineteenth century which were fast closing the gap between subject matter and form in all the arts. Form could now represent idea without the intervention of an elaborate historical system of references. Redon is seen as symbolist because he selected his subjects from the world of dreams; and Manet as realist because he depicted excerpts from the vibrant life he saw and heard around him. But both artists had rejected the old separation of story and composition; the old belief in the role of art to teach and to persuade. Both could synthesize form and content into a new kind of expression available to modern man, because it was responsive to his moods.

It is in this area, somewhat outside what is usually thought of as subject matter, that Manet differs from the Impressionist painters as much as his technical methods differ from theirs. While the Impressionists seem to have plunged more directly into scenes from everyday life than Manet, they did so largely in terms of landscape, a freer tradition even than that of genre. They concerned themselves in large part with the perceived world, they created potent pictorial images of modern life, but it was not until long after Manet's death that Gauguin, Cezanne and Monet had brought about in their own works the intimate synthesis of external and internal worlds, which depended on the radical simplification of nature, and the development of new pictorial language.

Manet made no sudden commitment to scenes from everyday life. His early ingenious forays into the problems of finding appropriate modern meanings and appropriate modern forms to express his age involved infusing tradition with fresh sensitivities (as in *The Old Musician*), or infusing modern life with the stability of traditional references (as in the *Concert in the Tuileries*). The fact that he never lost his concern for the possible meaning of his subjects; that he could rarely do what the historians had claimed for him—simply compose a beautiful picture regardless of subject—is a clue to the lasting quality of his images. They exist in a perpetual state of tension, the old and the new in precarious balance, reflecting the frictions of change which could be felt as a constant state in the nineteenth century. Manet's paintings were more than pictures of the appearance of modern life. They succeeded through their own hesitancies and inconsistencies in capturing those feelings of his own society. They thus remain raw, tough and essentially alive today.

[380]Monday, 9 August 1875, 2.

Part III

1. The Critics' Views;
The Historians' Sources;
Definition of Terms

'MANET is merely a painter, and a painter of fragments—devoid of ideas, imagination, emotion, poetry, or powers of draughtsmanship. He is incapable of composing a picture.'[1] This remarkable, and apparently damning, statement of Joseph Péladan is part of an essay which purports to discuss 'Manet's Methods', and which ends with the further observation that 'After Courbet, Manet must be considered as the greatest teacher of the second half of the century.'[2] Other than discuss Manet's dependence on the works of a variety of old masters, Péladan has little to say of his 'methods'. He finds everything wrong with his color and composition, yet throughout the essay he clearly conveys his warm but puzzled acceptance of Manet as an artist of extraordinary force. 'Merely a painter' here, is a compliment, meaning something close to George Moore's praise ... 'in Manet there is nothing but good painting.'[3] Péladan is not by any means the only writer who leaves us in doubt as to why Manet should hold so high a position in French art if his work is flawed in so many ways. Recent writers who can announce that 'Manet's sense of design was faulty'[4] or that he 'could not compose'[5] seem to grumble at the artist while pointing out his 'errors' in specific works, only ultimately to concede that he was a master and the bulk of his oeuvre was of great importance for the future. It is curious that those writers who find fault with Manet's style are most often those who see little interest in his subjects and find him a 'pure painter'[6] while writers involved with Manet's subjects and his borrowing from the masters seem to take little interest in his facture, and only concern themselves with his composition in terms of source motifs.[7]

From criticism contemporary with his first exhibitions to the most recent publications, an enormous quantity of material has been written about Manet's painting. Those who have liked his work have found his approach vigorous and true to life; those who have disliked it have seen it as crude, careless and inept instead. Both groups, however, described it in much the

[1]*L'Artiste*, February 1884. Here quoted from Courthion and Cailler, 186.

[2]Péladan, in Courthion and Cailler, 197.

[3]Moore, *Modern Painting*, 41.

[4]Richardson, 13. Richardson also discusses Manet's 'compositional difficulties' on pp. 13 and 14.

[5]Hamilton, *Art News*, 122.

[6]Hamilton, *Art News*, 163. Also see Courthion, 9 where he uses the term, 'peinture-peinture'. He sees only formal values in Manet's art, 'no psychology and nothing to allow us to glimpse the secrets of mind or heart'.

[7]Alain De Leiris is a notable exception to this statement, having displayed in his articles a sensitive understanding of both subject and style.

same manner: painted with broad strokes with the surface left unfinished: constructed with flat patches of bright, light colors lacking in middle values; poor, weak or faulty in drawing or composition.[8] The frequent charge that Manet lacked imagination[9] referred to his choices of subjects and repetitions of motifs, not to his painting style which, for some, was more original than they liked. Here and there one finds a deviation from or addition to this extraordinarily general summary of the technical aspects of his painting, but it is easier for most writers to praise him as gifted,[10] his approach as instinctive, his results as virtuoso. Zacharie Astruc, who had opportunity to watch Manet at work could claim 'His individuality is so powerful that it eludes technical consideration.'[11]

Yet it is certainly possible to discover how Manet prepared his canvases and worked up his vivid layers of paint. His 'individuality' of technique was to effect just as profound changes in nineteenth-century art as his 'individuality' in treating his subjects. It is no more true that he rejected academic painting methods overnight than it is true that he suddenly stopped borrowing themes from earlier art. A study of his gradual development, of the selective way he used tradition, of his innovations and even the connections between those innovations and his new subject matter, can tell us a great deal about Manet the man, and much about nineteenth-century thinking.

Some evidence is available to us. Moore, Duret, Blanche and Proust have all left descriptions of the artist at work, though none is particularly thorough or observant.[12] Zola's early criticism helps to some degree.[13] Written evidence can be read against the paintings themselves, and a few X-rays and unfinished works make it possible to reconstruct the actual painted layers. It is not possible to judge Manet's contribution, however, without some knowledge of contemporary practice, which the advice of other artists and instructions in painting manuals can offer. In the past this information has not been easy to find. Contemporary critics usually regarded craft as being outside their area of interest and competence. As Castagnary said, 'When one is at the table and the dish is good, does one go to the kitchen to ask what the cook has put in the sauce?'[14] Twentieth-century painting manuals usually give information about past practice through the seventeenth century, but do not say what is applicable to the nineteenth century. The technical advice of men like Delacroix or Manet's teacher, Couture, is scattered throughout writings on many other subjects. It requires considerable patience to search through contemporary instruction books and to surmount the problems of technical vocabulary. Albert Boime's recent book, *The Academy and French Painting in the Nineteenth*

[8]These views can be found repeatedly expressed by nineteenth-century critics throughout Hamilton's book, *Manet and his Critics*. Similar views have been expressed more recently by Hamilton *Art News*, 162; Richardson, 18, 30–32; and Bataille, 55; to cite only a few examples.

[9]Sloane, *French Painting*, 192, 197.

[10]Duret, 1919, 64.

[11]Hamilton, 46.

[12]Moore, *Modern Painting*, 41; Duret, 88; Blanche, 30; Proust, 100–1.

[13]See below, 191.

[14]Jules Castagnary, *Salons* (2 vols.), Paris, 1892, I, 272.

Century is thus an enormous boon.[15] It offers a great deal of information about the training of the artist in the nineteenth century, and acts as a corrective to the over-simplifications which crop up repeatedly in the literature. Joseph Sloane had earlier pointed out that the traditional view of the battle between the 'academy' and the 'avant-garde' offered an extremely 'misleading account of the real state of affairs.'[16] Boime's careful distinctions between 'academic' and 'official' art shows the complexity of co-existing views, and helps to explain why Manet could hope for success in an apparently hostile camp.[17] Just as Manet was encouraged to adopt contemporary subjects in answer to a call for an expression suited to his time, he was also encouraged by many of the accepted practices of his own time to explore new means of picture construction. The view of him as a rebel leader of a new band of artists who together invented a completely new and intuitive approach to painting is indeed unrealistic.

Although Manet cannot be counted as an Impressionist painter, he was linked to men like Monet and Renoir through friendship and mutual admiration. Their works differ from each other in many ways, but contemporary critics saw in all of them a freedom of brushwork and casual composition which to them appeared as unfinished or unrealized—merely impressions. The meanings of the word 'impression' were as diverse in the nineteenth century as they are today, having to do with general concept, or the immediate effects of sensory data. The artist's first 'impression' of a motif was often depicted in a free sketch. Thus an 'impression' appropriately used to record nature and to provide a basis for a developed painting was seen as useful and proper, while an 'impression' greatly enlarged in size and presented as if it were a finished painting was seen instead as an attempt to avoid the necessary labors of painting and to play for easy success through the attractions of its most fugitive qualities.[18]

Various kinds of sketches were accepted as necessary steps in learning the craft of painting and in the preparation of definitive works. Drawing was, of course, the basis of academic training, and drawings were made normally not only as studies both for individual figures and details but also for planning the total composition. The drawing could definitively set both line and tonal modulation, and thus act as a precise guide for finished rendering; it could not give the general effect of color and mood possible through small oil sketches or

[15]London/New York, 1971.

[16]Sloane, *French Painting*, 179–80. Sloane's book offers analyses of philosophical points of view without going into questions of painting practice.

[17]Boime, 15–21. This book was already in its early stages when Boime's book was published. I had originally planned to cover some of the same ground, and his excellent work has relieved me of that task. In some cases, however, I have arrived at the same conclusions on the basis of different evidence and I will offer it to reinforce his statements;

in other cases where I disagree in matters of interpretation, I will present my case. Otherwise, I will simply cite his book with both gratitude and admiration.

[18]See Sloane, *French Painting*, 109, n. 2. Although Sloane does not go into the problems of sketches in this volume, in the 1950s he was already encouraging his students to investigate the role of the sketch in the development of French nineteenth-century painting. George P. Mras, *Eugène Delacroix's Theory of Art*, Princeton, 1966, 80–84, discusses the history of arguments in favor of the sketch.

esquisses peintes.[19] Such sketches were a routine part of academic practice. David himself had started a monthly competition for composition sketches, and preliminary trials for major competitions such as the Prix de Rome were based on oil sketches.[20] Thus most students became adept at rapid and direct work in oil colors. Nineteenth-century critics clearly perceived the charm of these works but often thought of it as a danger if it diverted artists from the more difficult task of conceiving larger works and bringing them to completion. Nevertheless they were exhibited on occasion and definitely admired.[21]

Boime makes a distinction between the *étude*, an oil study made directly after nature, and the *esquisse*, also an oil study, but an imaginative pictorial plan instead.[22] In both cases the aim was to develop a preparatory composition, but the growing respect for the direct study of nature was to have marked influence on changes in both subject and style as the century progressed. A purely technical development undoubtedly played a part: by about 1840 tubed paint became generally available,[23] making it far easier to carry painting equipment to motifs outside the studio. While this was a great boon for landscape painting it had definite effects on painting craft in general.

The drying qualities of paints as well as their density and viscosity can be controlled by the media in which the pigments are ground, and the more laborious work of starting with powdered pigments leaves the artist free to use a variety of combinations and a variety of approaches in building up the painted surface. By contrast the standardized consistency of tubed paints encouraged an *alla prima* approach. Traditionally each painted layer of a studio canvas is allowed to dry fully before another layer is painted on top of it. The principle of 'fat over lean,' that is to say, the thinner dryer layers below the thicker more oily layers reflects this kind of control. While tubed paints can be thinned in various different media and thus made either dryer or oilier, the natural temptation is to take advantage of the pasty consistency already so easily provided. With a deft touch it is possible to lay in wet tubed color over underpaint which is not yet dry, allowing for accidental effects which add to both the luminosity and the spontaneity of the works. This approach could be combined with the traditional practice of toning the canvas. A ground color provided an instant means for unifying hues, and a middle ground against which both darks and light could be judged. For landscape paintings, where a lighter color key is required, however, the darkened ground was not usually used. Then speed became important. Since it is extremely difficult to work

[19]Small individual drawings were usually called 'croquis': 'dessin' referred more often to compositional drawings. Both 'étude' and 'esquisse' were used for oil studies where the planning of the total composition and color harmony was the goal. For Boime's discussions of these terms, see 81, 88–9, 149.

[20]Boime, 44, notes that from 1817 onwards the oil sketch was required for the Prix de Rome contest, whereas previously the student could submit either an oil sketch or a drawing.

See also 11.

[21]Boime, 116, shows that arguments over the danger of the sketch were already full blown in 1830–31. Boime points out, 150, that the *Dictionnaire de l'Académie des Beaux-Arts* by the 1858 edition speaks of the 'étude' as a 'work in its own right' rather than a preparatory sketch.

[22]Boime, 149.

[23]Ralph Mayer, *The Artist's Handbook*, Third Edition, New York, 1970, 155–6.

colors directly against a white ground and keep tonal and chromatic qualities in good balance, the artist had to try to cover the canvas with pigment as quickly as possible, eliminating the sharp contrasts provided by the blank canvas areas and establishing essential relationships as if to grasp a single impression. At this stage a sketch can appear to be almost a color abstraction. It would later receive the touches which would establish the elements of the motif, and might even be brought to a fairly high degree of finish, depending on the particular use to which it was to be put. Naturally few such canvases are in existence today. The oil sketches preserved in the Musee Gustave Moreau are rare examples of an accepted nineteenth-century approach[24] which to twentieth-century eyes appears radical indeed. The mistaken attempts to relate Moreau's sketches to Abstract Expressionism, or even to a more general proto-abstraction by writers in this century have largely resulted from a general lack of knowledge about nineteenth-century practice. Moreau's use of the word 'abstraction' has been grasped to prove an extraordinary kind of sight into the future, but if his statements are put into context, it is clear that his concern was 'abstraction' in subject matter and meaning, not in facture—that he was speaking of the generalized effects of mood or 'intuition' to be gained through suggestive details of costume and architecture and not the arrangement of colors and forms for their own sake.[25]

Copying paintings by the masters was an accepted method of training students. Not only did they make detailed copies of approximately the size of the original, but the essential qualities of an admired work were studied through quick oil sketches which seemed to reveal the invisible underlayers of composition rather than the surface. Such copies are similar in their small size and broad facture to oil sketches from nature or imaginative oil compositions.

A third kind of 'sketch' must be considered. The underpainting on a full sized canvas intended to be carried to a greater degree of finish in succeeding layers of paint is called the *ébauche*.[26] The aim again was to establish general placement of forms and overall tonal harmonies on the canvas surface pre-

[24]Julius Kaplan, *Gustave Moreau*, Los Angeles, 1974, nos. 15, *Study for Young Man and Death*, 1865; 58, *David*, c. 1878; 81, *Oil Sketch*, n.d.

[25]See *Odilon Redon, Gustave Moreau, Rodolphe Bresdin*, Museum of Modern Art, New York, 1961. This exhibition included a large proportion of the more freely painted oil sketches including several of unknown subject and date. See 115, 139, 140, 141, 143. The text on Moreau written by Dore Ashton, finds him involved with abstract forms and colors and gives him the role of precurser to the Abstract Expressionists. See 109, 132, 142–3. Writing in the 1970s Kaplan had a better understanding of the use to which Moreau's oil and watercolor sketches might have been put. His entire text is useful for a balanced understanding of Moreau's ideas

and how they fit into his own time. See in particular, 35, 41.

[26]Modern dictionaries do not make distinctions between terms such as *esquisse* and *ébauche* and their casual use in twentieth-century discussions of paintings suggest that these terms have lost their nineteenth-century precision. The *Dictionnaire alphabétique et analogique de la langue française*, Paul Robert, Paris, 1955, Vol. II, 1717, gives '*ébauche*' and '*croquis*' as synonyms for '*esquisse*'. On p. 1413, however, it does define '*ébauche*' as 'première forme que l'on donne à un ouvrage de peinture, de sculpture, de littérature; premier état de cet ouvrage.' By contrast the *Dictionnaire de la langue française*, E. Littré, Paris, 1885, Vol. II, 1260, is much more precise. '*Ebauche*' is given as 'preparation d'un ouvrage de peinture, de sculpture dans laquelle les

paratory to the more laborious working out of lines, textures and details. In photographic reproductions *esquisses peintes* and *ébauches* often look much alike, but it must be remembered that the *ébauche* is the size of the proposed final work, while the *esquisse* is usually considerably smaller. While both are steps in the painting process, the *ébauche* is covered by the actual work, while the *esquisse* exists as a separate record of the painters thought. It is of some importance in understanding the criticism leveled against Manet and his contemporaries that the term 'impression' was also used for the underlayer of paint, that is the ground color and *ébauche*. Thus to criticize a painting as an 'impression' meant to say both that it was a hastily perceived view of the world, offering no intellectual challenge, and also that it was not a finished work, but only an initial sketch.[27] For the critic who believed in the primacy of the heroic mold, the Impressionist method seemed an easy evasion of the true tasks of painting. It avoided education in subject matter necessary for a moral statement, the compositional planning that historical information required, and the careful finish which would cast the image into timeless permanence. The Impressionists' refusal to face these issues seemed clearly an affront to France.

parties principales sont seulement indiquées'. '*Esquisse*' is given as a synonym, but with the explanation, 'l'ébauche est le commencement même, encore informe du travail, d'où l'oeuvre sortia accomplie. L'esquisse n'en est que le trait, que le plan et n'entre dans l'oeuvre que comme préparation'. On p. 1497 '*esquisse*' is defined as 'premier plan d'un ouvrage ... L'esquisse est séparée du tableau, dont elle est comme le plan; et l'ébauche se fait sur le tableau même; elle en est le commencement'.

[27]*Dictionnaire de la langue française*, E. Littré, Paris, 1885, Vol. III, 38. Impression, 'terme de peintre. La couleur qui se met sur la toile ou sur un panneau, soit à l'huile soit en détrempe, et qui sert de première couche.' The dictionary then cites Manuels Roret, *Manuel du peintre en bâtiments*, Paris, 1843, 159, 'Peinture d'impression, peinture à couches plates qui font les peintres en bâtiment.' It should be noted that the Italian work, 'imprimatura' derives from the same verb, 'imprimere' to impress. See L.-C. Arsenne, *Manuel du peintre et du sculpteur*, Paris, 1833, Vol. II, 332–8, where 'impression' is described as the layer of paint on top of the 'encollage' or canvas sizing. J.F.-L. Mérimée's book, *De la peinture à l'huile, ou des procédés matériels employés dans ce genre de peinture*. Paris, 1830, is a source for many later painting manuals in French and in other languages. Merimée, 242–3, speaks of the 'première couche d'impression' as being colored brown, red-brown or umber, and describes, 249, the making of the *ébauche* on the *impression*. He clearly uses the word to refer to the layer and not the drawing, but, in time, the term came to cover any underlayer of color.

2. Traditional Picture Construction

There are as many different ways of building up the painted surface of a canvas in oil colors as there are artists. To simplify our discussion, however, two theoretical extremes will be described in terms of the outworn antipathy of line versus color, drawing versus painting. A 'linear' approach of course, is based in a belief in the supremacy of drawing, the science of simulating relief. For its adherents the fugitive charm of color, a matter of instinct, is a desirable luxury but not the basic element in painting.[28] The extreme of this view is vividly expressed in Ingres' claim that one could best judge the merits of paintings through reproductive engravings since, devoid of color, their compositions are more readily perceived.[29]

The artist begins with careful drawings in crayon or pencil of the entire composition and of numerous details to be included in the work.[30] The composition drawing would then be transferred to the canvas surface, then re-established in carefully painted lines.[31] The building up of light and dark, and eventually of color, would then take place within these precise delineations. Various methods were taught for tracing drawings on the canvas. Drawings which have been 'squared off'—that is to say, which have over them a grid of lines or are composed on a paper which already has a grid printed on it— demonstrate a practical guide used for their enlargement to the size of the canvas, or in many cases to even larger dimensions for mural decorations. This 'linear' method might involve not only preparatory drawings, but also oil color sketches which in rough form block out the general color and value harmonies to be developed more subtly and precisely in the finished work. Such sketches can appear startingly fresh and painterly and were appreciated by the strictest academician. But it was understood that it was necessary to remove all traces of facility in the final work. 'That which is called 'the touch' is an abuse. Instead of the object represented it shows the process; instead of the thought it displays the hand.'[32] Edmond About admired

[28]Edmond About, *Nos artistes au Salon de 1857*, Paris, 1858, 10–12. About is paraphrasing Ingres.

[29]Henri Delaborde, *Ingres: sa vie, ses travaux, sa doctrine*, Paris, 1870, 149.

[30]Ingres is supposed to have claimed that since Raphael great artists execute their figures from drawings, not from the model.

Delaborde, 150–51.

[31]M. P. L. Bouvier, *Manuel des jeunes artistes et amateurs en peinture*, Paris, 1832, 232, and Laughton Osborne, *Handbook of Oil Painting*, New York, 1849, 170. Both works are strongly influenced by Mérimée, even repeating identical recipes.

[32]Delaborde, *Ingres*, 125, 150.

Delacroix, but thought Ingres a more complete artist since he carried his work to a greater degree of finish. 'It is not the finish which makes remarkable drawings, it is the beginning. A beautiful drawing pushed to the last details is a perfect work; stopped mid-way, it is a beautiful sketch.'[33] One might expect a minimum of change in drawing and composition in the paint layers of pictures which were planned in advance in such careful detail. In practice it is hard to find a painting which shows no trace of any change of heart. When such a work is found it is reasonable to suspect that it might be a copy of a completed painting where all the formal problems are resolved in the original.[34]

A great many such changes can be expected in works made in the opposite method, the painterly, which grew out of the very development of oil paint itself. For Delacroix it was more appropriate to the craft of painting than the methods of the 'school which sets out to imitate ancient frescoes in oil painting ...'[35] In this method, the major elements of a work are blocked in in broad strokes of paint, both color and composition being developed simultaneously. Often such direct *ébauches* are preceded by separate drawings or by chalk or charcoal drawings on the canvas itself, but they are more spontaneous than definitive and not intended as the final boundaries within which the color would be laid.[36] Artists who worked extensively in a painterly manner usually developed a facility to draw in paint on the canvas directly from nature. Delacroix favored such an approach and called on the authority of Reynolds to support him in this practice, saying, 'Reynolds says that a painter must draw with a brush.'[37] This is not quite a correct interpretation of Reynold's words, 'What therefore I wish to impress upon you is that whenever opportunity offers, you paint your studies instead of drawing them,'[38] and it is not entirely clear whether Reynolds was speaking of the drawing under the finished layers of paint on the canvas or simply of separate preparatory studies. Corot urged that the first impression be preserved in the finished picture and believed that the freshest works could be done *au premier coup*.[39] Thomas Couture was proud of his ability to work in this manner and frequently demonstrated to his students how he could capture quickly the salient features of his models.[40] A painterly method demanding both facility

[33]About, 15–16. See also 40–41.
[34]Many changes in underlayers of paint can be seen in X-ray. For an example see below, 165–6, and n. 153.
[35]*Journal de Eugène Delacroix* (3 vols.), Introduction and Notes by André Joubin, Paris, 1932, III, 6, 5 January 1857.
[36]Osborne, 169, strongly recommends that the artist draw directly on the canvas in order to capture the spirit of the original idea. He then suggests redrawing in a sauce of red-brown color with a sable brush in the manner of a watercolor, keeping the original drawing fresh, 171. See also Bouvier, 236–8.
[37]*Journal de Eugène Delacroix*, III, 10, 11 January 1857.
[38]*Discourses on Art*, edited by Robert Wark, San Marino, 1959, 34, here quoted from

George Mras, *Eugène Delacroix's Theory of Art*, Princeton, New Jersey, 1966, 128. This book is an extremely useful study of Delacroix's ideas and their sources in earlier theoretical writings. It demonstrates that Delacroix did not simply follow a romantic program, but frequently adopted ideas of the French classical tradition.
[39]Etienne Moreau-Nélaton, *Corot raconté par lui-même*, Paris, 1924, 149, and Camille Corot, *Pensées et écrits*, Paris, I, 88.
[40]Writing to present Manet in the most favorable light, his first biographer, Bazire (5), accused Couture of wanting to perpetuate himself in the work of his students, 'Le "chic" et l'empâtement étaient élevés par lui à la hauteur de doctrines.'

and speed of execution might not have been officially recognized by academic theoreticians at mid-century, but there is no doubt that it was extensively practiced.

There were those who felt that the craft of painting had undergone a decline at the end of the eighteenth century and that by 1830 there were too many untried methods being used.[41] They bewailed the quality of the commercially prepared colors and canvases, and the indifference of the artists who used them.[42] Delacroix laid the blame on no less a figure than David 'because he affected to despise material means'.[43] It is probable that a prevailing attitude of mind over hand has obscured a real interest in craft among artists of all persuasions. Hope seemed to lie in a Venetian approach.[44] Although the work of the Venetian painters was thought by many to lack idea and ideal, their processes were universally admired, much discussed, and cited by critics and artists in favor of drawing as well as those who championed color. Ingres saw the Venetian manner as a full justification of his own approach. Since the Venetians used colored glazes he believed that they could develop their underpainting entirely in gray, without color, a 'sort of monochrome cameo'. He felt that in spite of the lack of color these underpaintings gave a feeling of color, and thought that many draperies were painted dead white and were colored by overlays of glaze not only by Venetians like Titian, but by Andrea del Sarto and Fra Bartolomeo as well.[45] There is little evidence to support such an idea. Delacroix described the Venetian manner as having quite the opposite virtues. He called Titian the 'least mannered, and consequently the most varied of artists'[46] and praised Veronese for the simplicity and absence of details which allowed him to establish local tones from the start.[47] Thus the champion of line claimed Venetian art was based in drawing, the champion of color, that it began with color itself.

Manet's teacher, Thomas Couture, was liable to preach Raphael while practising Veronese. He certainly encouraged his students to emulate both approaches.[48] In his final 'Adieu' in the *Méthode et entretiens d'atelier* he stated

[41] Johan George Vibert, *The Science of Painting*, London, 1892, 14–16.

[42] Delacroix has earlier complained of the poor quality of commercial paint and the decline of the painting craft. *Journal de Eugène Delacroix*, Joubin, II, 400.

[43] *Journal de Eugène Delacroix*, III, 12, 11 January 1857, 'Essais d'un dictionnaire des beaux-arts: Technique'.

[44] Paul Mantz, 'Un nouveau Véronèse au Musée du Louvre', *Gazette des Beaux-Arts*, II (1859), 31–9. Mantz urged the study of Venetian methods to extend and correct the poor education offered by the academies.

[45] Delaborde, *Ingres*, 134–5. Ingres explains that the Venetian manner was revealed to him by a sketch of an English painter named Lewis after Titian's *Jésus porté au tombeau*. His description, however, seems to fit Lewis' style better than Titian's. See also M. Deléc-

luze, *Précis d'un traité de peinture*, Paris 1828, 85. 'On dit même que quelques tableaux de Titian ont d'abord été peints en grisaille et que c'est par le secours des glacis employés avec grand soin que le peintre est parvenu à leur donner cette vivacité suave de couleur qui charme tant. On croit que le *Christ flagellé* de ce maître a été exécuté en grande partie de cette manière.'

[46] *Journal de Eugène Delacroix*, III, 4–5, 5 January 1857.

[47] *Journal de Eugène Delacroix*, I, 234–5, 10 July 1847.

[48] Thomas Couture, *Méthode et entretiens d'atelier*, Paris, 1867, p. 191. Anselm Feuerbach, who studied with Couture, remembered that Couture led his students to paintings by Raphael, Titian and Veronese in the Louvre. Letter of November 1862 quoted in Jedlicka, 33. See also *Couture par lui-même*, 38.

that he felt a new national art had been born with Gros and Gericault and urged students to take up again their beautiful painting, be more frankly French in form, and 'your art will equal in grandeur and majesty the most splendid Venetian works. You will become not copyists, but equals of the Greeks.'[49]

In his own paintings he combined elements of both linear and painterly approaches, depending on whether he was making a simple genre work, or constructing an elaborate historical machine which would require a more considered approach to the complexities of composition and a more intellectual concern for the meaning of the subject portrayed. He required that his students first learn to draw proficiently before learning to paint, and stated at the beginning of his treatise that drawing is primary, color and light secondary.[50] While he thought that division of color and drawing were necessary for the beginner, he did not recommend it for the practicing artist,[51] and believed that all great artists combined the two to some degree.[52] Throughout his writings he devoted considerable space to the problems of accurately recording values and to questions of color; little to drawing or composition. For the figure he recommended first a knowledge of anatomy, then a knowledge of the antique. He suggested a thorough study of Houdon's flayed figure and a familiarity with works like *The Gladiator, The Laocoon* and the Praxitelean *Faun* so that the irregularities of nature could be corrected in the light of antique perfection.[53] Simultaneously he urged his students to carry a sketchbook at all times and to draw men, women and children in natural poses, going about the normal task of their daily life.[54] 'Several lines rapidly traced, your observations and some notes taken in the fire of your impressions will guide you better than frightful models ...' For him, ugly models, 'Men and women of the lower classes draped in old curtains and coverlets' are not natural. It is here that Couture's writing takes on a tone of excitement, 'action, movement, light, passion, thought: follow all these marvels of life as a hunter follows his prey.'[55] If he seemed to lean toward a preference for spontaneity in both drawing and painting, he nevertheless combined the best advice from all camps. Much of that advice can be found in other forms in painting manuals of the first half of the century, suggesting that his approach was already considered good practice.[56] Both his book, *Méthode et entretiens d'atelier* and his

[49]Couture, *Méthode*, 362.
[50]Ibid., 25, 31.
[51]Ibid., 245.
[52]Ibid., 240–43.
[53]Ibid., 47.
[54]Ibid., 38, 50–51. He assumes that Raphael, Leonardo, Lesueur, Poussin and Andrea del Sarto all drew after nature.
[55]Ibid., 51–2.
[56]I cannot agree with Boime's view (145) that Couture 'taught an entirely original method a painting'. Couture himself admits that the method he claimed to have invented with such labor, was already in use by des-

cribing an earlier work painted in the same manner. See *Couture par lui-même*, 109. Much of what Couture recommends can be traced to J. F. L. Mérimée, *De la peinture en l'huile*, Paris, 1830 and P. L. Bouvier, *Manuel des jeunes artistes et amateurs en peinture*, Paris, 1827, which in turn are sources for other writers such as L. C. Arsenne, *Manuel du peintre et du sculpteur*, Paris, 1833, and M. Delécluze, *Précis d'un traité de peinture*, Paris, 1828. Delécluze directly refers to his debt to Mérimée in his bibliography. Like Couture, he sees Spanish paintings as lacking in the 'ideal', 20–21; Venetian paintings as lacking

notes prepared for an unrealized later edition were published after Manet's student days, but they surely reflect what Couture taught, and are thus excellent links between past practice and the new methods which Manet ultimately developed.

While Couture admitted that he did not know all the secrets of the masters, he seems to have been particularly observant of their processes. Unlike Ingres, he did not believe that Titian painted his underlayers in *grisaille*. He was convinced by an unfinished work he had seen that Titian painted in rather crude local colors, and then glazed over them in more neutral tones.[57] He thought Veronese used this method only on occasion for draperies, and that in general he painted more directly. Further, he praised him for not over-mixing his hues, and noted that his use of complementary colors took advantage of their effects on each other—'the perfect accord of opposites'.[58] It was Veronese whom Couture admired most,[59] and it was largely what he thought to be Veronese's method that he taught.

Couture's directions for beginning work on a canvas are offered in simple terms in his *Méthode et entretiens d'atelier*[60] and more fully in the later notes.[61] He humbly stated that he does not pretend to have rediscovered the great tradition, but that he believes he has found a healthy and lasting technique.[62] His instructions are as follows: Trace your drawing on the canvas. Lightly tap the canvas to remove loose charcoal dust. Then take a sable brush and a thin preparation of oil, turpentine and pigment and redraw the lines. He recommends black and red-brown, or bitumen and cobalt as appropriate combinations of pigments for obtaining a warm colored 'sauce' for this purpose. The contours indicated, the artist should then lay in washes of sauce to the shadowed areas, creating a sort of sepia drawing in oil. This under-drawing should be allowed to dry. He then suggests the colors to put on the palette and promptly changed the subject in order to advise students to live a healthy and virtuous life, but leaving them the task of searching through the remaining pages of the book for the next steps of the painting procedures.[63] Elsewhere Couture states his preference for working on a colored ground. Struck by the difficulties of preserving harmonies when applying colors on a

in poetry, simply 'passive copies of objects', 13–14, but praises their methods. His instructions for the application of paint layers, 73–83, lay down the basic principles Couture recommends including such rules as to paint darks transparent, whites thickly, and not to loose the freshness of colors by overmixing with the brush. Mérimée's book was published in translation with some additional material in London in 1839 under the title *The Art of Painting in Oil and Fresco*, and by 1849 it showed its effects in other works such as Laughton Osborne, *Handbook of Oil Painting by an American Artist*, New York, 1849. It is easy to verify these connections since the same recipes are copied from one work to the next.

[57]Couture, *Méthode*, 218–19.

[58]Ibid., 221, 223. 'Il peint en pleine pâte et au premier coup, les procédés dits vénitiens sont employés par lui, seulement pour certaines draperies, et avec de franchise qu'il n'y a aucun doute.' '... le juste accord des contraires.'

[59]Ibid., 220–21.

[60]Ibid., 32–5.

[61]*Couture par lui-même*, 105–23.

[62]Ibid., 122.

[63]Couture, *Méthode*, 2–34. See also Bouvier, 232–41. Bouvier, 261, says that an able man can do an *ébauche* of a head in only three or four hours, a practice at which Couture was particularly adept.

white ground, he prefers working on a warm middle tone and recommended a mixture of bitumen and cobalt with which to cover his white ground.[64] He discusses the colors used for the imprimatura by artists of the past, many of which were opaque, dense, and often thick enough to crack and thus harm the upper layers of paint. He preferred instead to use a luminous transparent ground requiring a thin application of paint. His ground color is in essence the same material as his 'sauce'.[65] Because of its transparency it is not possible to make a totally flat looking surface. Instead a sense of depth is already created by the simple application of color. Couture then explains that he works on this layer as he would draw on colored paper, establishing his lights and half tones. He recommended drawing in white, and also of drawing in the color of 'dead leaves' but it is not clear from the scattered descriptions of his procedures whether he intended to recommend one over the other, or a combination of both. His own works suggest that he used different procedures for different pictures. In discussing the use of white he observed an interesting phenomenon, the production of what are called 'optical grays'.[66] As a white is attenuated over the surface becoming thinner and thinner to create a change in value it appears more and more to have within it the color complementary to that which is dominant in the ground tone, in other words, not only to appear to be a gray, rather than a white, but also to appear cold against a warm ground or warm against cold. Couture describes this optical phenomenon from a craftsman's point of view. 'In the flesh tones, which are so fugitive and so varied, one can obtain the azure tones of the veins under the skin without applying any blue.'[67] Scraping the impasto white off the colored canvas surface to varying degrees can have the same effect as that produced by painting the cold white on the warm tone beneath.[68] Another method of obtaining such effects in a small area is to take a dry and clean brush and lift out a small quantity of the still damp white paint. If such a cleaned area is relatively isolated the effect can create a startingly strong blue with no use of blue pigment whatever.[69] Couture suggests the addition of a little yellow ochre to the white paint used for this preliminary layer in order to diminish the crudity of this optical effect and to preserve a warm harmony.[70] Grays mixed on the palette tend to look heavy and dense in contrast to the optical grays obtained by taking advantage of the transparency of the paint itself. Couture's instructions never continue in order from page to page in either the *Méthode et entretiens d'atelier* or the later notes, but descriptions of the processes he used can be found in more orderly form in manuals of the period and in modern painting instruction books. Osborne, who in 1849 took much

[64]*Couture par lui-même*, 108, '. . . ces toiles blanches sont fatigantes à couvrir et d'ailleurs, quoi qu'on fasse, elles laissent la coloration creuse.' 119. 'Une toile d'un ton ambré est préférable à une toile blanche.'

[65]Ibid., 112.

[66]Couture does not use this term, but he clearly describes the effect. Ibid., 108, 119.

See also Max Doerner, *Materials of the Artist and Their use in Painting*. Translated by Eugen Neuhaus, New York, 1934, 31, 347–8.

[67]*Couture par lui-même*, 108.

[68]Ibid., 132.

[69]Ibid., 120.

[70]Ibid., 116.

of his material from Mérimée, describes the process of drawing first in red-brown transparent color and then an opaque white 'as if you were laying in the whites of a design on gray paper.'[71] Exactly the same procedure is described as Titian's method by Max Doerner in what is one of the more extensive painting manuals of the twentieth century. Doerner discusses the various ground colors used by the masters and describes in some detail the laying of a transparent brown imprimatura over a brilliant white ground on which the artist drew in black, white or a combination of both.[72] He also discusses the effects of 'optical gray' and the advantages of adding a little yellow ochre to the white to make it seem less cold.[73]

All writers agree that the completed underdrawing should be allowed to dry before additional colors and glazes are added. Osborne in fact suggests a rather heroic treatment of the *ébauche*. It should be scraped with a palette knife, thoroughly washed with water, and allowed to dry either in the open air or near the fire.[74] This process effaces the irregularities of the surface and leaves a useful image on the canvas, making it a suitable method for the tighter application of smooth layers of opaque colors on top of the drawing. Being flat, however, it does not allow for the building of color layers through scumbling or similar more painterly procedures. When scraping is used to remove paint from selected areas it can have the opposite effect. Depending on the texture of the canvas surface more or less pigment is left in the spaces between threads and an effect of transparency is obtained with opaque pigments since the removal of the color from the raised threads allows the underlying tone to show through or, one should say 'between', the paint particles of the upper layer. Similarly, if an upper layer of paint is scraped over an irregular lower layer, the color is forced into the spaces between projections of dried impasto.[75] 'Scumbling' produces equally vivid effects by almost opposite means. The paint on a loaded brush dragged across an irregular surface is caught by the raised projections of dried paint and misses the crevices between them.[76]

While Couture, like most writers, recommended that the underlayer of paint be allowed to dry before the colors are worked up on top, he seems to have practised a quicker method, especially when demonstrating for his students how to work from the live head. He apparently was quite capable of working deftly on top of still damp colors, a technique which later served

[71]Osborne, 172.

[72]Doerner, 339–47. Doerner carries well into the twentieth century ideas and information offered in nineteenth-century painting manuals and testifies to the extent to which they were believed reliable. In recent years Doerner's analysis of the methods of Rembrandt, Rubens, Van Dyck, and Vermeer, has been seriously challenged. See Helmut Ruhemann, 'Book Review: Max Doerner, *The Materials of the Artist and their Use in Painting*, London, 1955', *Studies in Conservation*, IX (1964), 170–72.

[73]Doerner, 348–9.

[74]Osborne, 221.

[75]Castagnary writing on the Salon of 1868 remarked on transparent effects produced by scraping in paintings of Courbet and Daubigny. He says that Courbet handles the knife with unparalleled dexterity. *Salons*, 272–3.

[76]*Journal de Eugène Delacroix*, I, 430–31, 29 April 1851, 'frotter'. The term 'scumble' is used by Charles Lock Eastlake in *Materials for a History of Oil Painting* (2 vols.), London, 1847, II, 365–6.

Manet well. It is therefore often difficult to decide where the *ébauche* stops and the finished painting begins, although for Couture, this distinction was clear at least in theory. While recognizing the seductive qualities of a fresh sketch, he was committed to the traditional view that finished works are superior in both technique and expression. He told a story that once his friends very much admired an *ébauche* he had made of a woman's head and urged him to preserve it rather than to cover it with a finished work. Secretly, he copied the *ébauche* and then proceeded to make the painting on the copy. As expected, his friends regretted the loss of the original sketch, but when the painting was finished, Couture revealed his ruse. He produced the first *ébauche* and proved his point by comparing it to his finished work, which all agreed was superior. At another point he states in cavalier fashion that when he had completed his picture he used his sketches to light the stove.[77]

Once the *ébauche* is complete, the artist must begin working up his finished paint layers. Mérimée describes two methods of proceeding, the transparent or the opaque, offering again either a more linear or a more painterly approach. The whole picture can be built up with transparent and thin paint layers of consistent texture washes, or the artist can work with opaque colors and then apply glazes over them, both methods thus giving transparent results. According to him, the first method was used by Bronzino and Fra Bartolomeo, the second by Rembrandt and Titian.[78] It is the latter which is generally recommended in French nineteenth-century painting manuals which Couture has adopted with some variations. While offering many advantages the method presents some problems as well since it depends on color effects which must be developed gradually and which cannot be precisely predicted in advance, and it demands a swift and able technique. When ground in oil certain pigments become opaque, others transparent, and thus the colors must be applied to the canvas in different ways. Colors containing white are more opaque than many darker tones, but they must be applied densely enough to remain light over colored grounds. Transparent browns, blues and reds, however, can be painted in thin, luminous layers using the effect of the colored ground and *ébauche* as bases for the eventual tonality. The usual rule is to paint the lights thick, the darks thin, the inequalities giving the painting a natural and vivid contrast of surface,[79] and a more spontaneous appearance, but allowing for less precision of detail.

Scattered throughout Couture's writings and doggedly repeated in various forms is advice to the artist to simplify masses, to work quickly, to avoid color mixing on the palette, and to use complementary color harmonies. Delacroix had admired Veronese's simple color areas with their absence of detail and Couture spoke of the simplicity of the great masters and warned that detail could destroy form and the unity between forms.[80] 'Be simple in your contours,

[77]Couture, *Méthode*, 235–8, and *Couture par lui-même*, 109.

[78]Mérimée, 38. Arsenne, 271 remarks that the two processes of impasto and glazing can together give very beautiful results.

[79]Osborne, 143–4; Delécluze, 77–83.

[80]*Couture par lui-même*, 106; Couture, *Méthode*, 287, '. . .le détail mange les masses.' Couture recommends squinting the eyes while looking at the object being painted in order to better see the distribution of masses, *Couture par lui-même*, 121.

your modelling and your coloration', but he felt that this advice left the student without guidance unless he was told how to proceed.[81] His recommendations were incessant sacrifice of detail, incessant search for essential lines and forms,[82] and sufficient speed to rapidly establish the areas of light and shade.[83] 'La peinture au premier coup,' that is to say the direct method of applying paint to canvas without glazing, requires many brush strokes and presents the constant danger of muddied color. A deft hand is needed to preserve the freshness and only long practice in drawing can enable the artist to lay in each brush stroke with one sure touch.[84] Couture was not only concerned with the problems of actually applying the paint on the canvas but also with the way colors function in relation to each other. Many manuals recommend that colors be extensively mixed on the palettes in careful gradations so that they can be applied to the canvas in appropriate order to imitate the graduated tonalities of turning surfaces.[85] Couture warns that such a procedure will take all the life from the colors since each admixture tends to reduce their intensity,[86] 'As often as possible use your colors in their pure state without mixing. If it is absolutely necessary to employ several colors in order to obtain a certain hue, never mix more than three ... and then, mix those three colors like three threads.'[87] Couture is obviously quite aware of the color theories advanced by Chevreul,[88] particularly his Law of Simultaneous Contrast, based on the observation that colors complementary in hue or opposed in value, intensified the effects of their opposites. Chevreul, a chemist and the Director of the Gobelins textile factory, worked in developing dye colors and color relationships in the manufacture of tapestries, and was thus involved with the juxtapositions of colored threads. Since Chevreul's discoveries were well known, it is probably no accident that Couture should refer to his own practice of lifting unmixed strands of paint from the palette with a single brush stroke as mixing the colors 'like threads'. His awareness of the effects of complementary colors on each other is obvious again and again throughout his remarks. 'True harmony comes from the accord of opposites; colors have different sexes, we have the male and the female, so that red which is certainly the most robust tone is happy and complete only when it has a green to accompany it; orange in its turn, demands blue.' He goes on to say that if these contrasts are too strong they can be tempered with neutral tones, blacks, whites and grays.[89] He points out complementary color harmonies

[81]Couture, *Méthode*, 283.
[82]Ibid., 287–8.
[83]*Couture par lui-même*, 120–21, 128.
[84]Ibid., 107–8. 'La peinture au premier coup' that is to say, the direct method of applying paint to canvas without glazing, requires many brush strokes and presents the constant danger of muddied color. Couture preferred working on colored grounds in part because they allowed quicker development of his image than white grounds, and present fewer difficulties in establishing color unification.
[85]Osborne, 174. See also *Couture par lui-même*, 118 on the palettes of his teachers.

[86]Couture, *Méthode*, 212, 214.
[87]Ibid., 211–12. See also *Couture par lui-même*, 107. Osborne warns against the loss of light and force through too much manipulation on the canvas, 144.
[88]Michael Eugène Chevreul (1786–1889), French chemist best known for research in animal fats (soaps and candles). Director of the Gobelin tapestry works and author of *De la loi du contraste simultané des couleurs*, Paris, 1839.
[89]Chevreul, 229–30.

in his specific praise of artists he admires[90] and frequently repeats it in discussing properties of colors and technical approaches.[91] Further, he is fully aware of the effects of complementary colors when laid one on top of the other. He points out, for instance, that grays can appear insipid unless they are laid over warm colored grounds,[92] and he is particularly sensitive to the way half tints react to each other in producing contrasting optical effects.[93] Couture is not in any way isolated in his interest in optical effects. In discussing a new Veronese at the Louvre in 1859, Paul Mantz commented both on his use of a complementary orange-blue color scheme and his beautiful silver grays[94]—grays which Couture had praised in identical terms.[95]

Couture's *Little Gilles* (Pl. 96) in the Philadelphia Museum of Art offers an excellent example of his own 'Venetian technique'. The entire ground has been toned a luminous brown. On it is laid a thinly washed drawing in the 'color of dead leaves,' onto which has been worked impasto whites. Dragged from the highest point towards the darks they reveal surprising changes in apparent color—warmer lights toward cooler middle values. Additional hues have been used to make opaque flesh tones, but again their fresh scumbling on the surface of the canvas allows the ground color to show through, sometimes increasing the vital warmth of the skin where the color layers are analogous, sometimes creating additional optical hues where the upper color layer is complementary to the lower. A glaze of a warm tonality has been laid over part, but not all of the figure, in order to reduce the intensity of the contrasts and to warm some of the colder whites. This luminous surface also tends to unify the transparent darker colors and the impastoed lights, forming a more integrated fabric as a whole, but in no way dimming the vivacity of the touch. No color illustration, however excellent, can convey the effects described, since the process of printing is itself uniform, not only in the size of the screen but also in the relative transparency and opacity of the colored inks.

Couture did not always follow this method of paint application. Like other painters of the period he was concerned over the dangers of glazing procedures and warned that great works by men like Titian could be ruined in restoration if colored glazes were to be removed (a warning sadly unheeded in some quarters). Yet for him the effects of transparencies were precious, and he was never appropriately able to resolve his desire to work with transparent effects and his fear of the possible results.[96] In addition, there is the problem of the

[90]Chevreul, for example, 228, Correggio; 221, Veronese.

[91]See *Couture par lui-même*, 113–14 and Couture, *Méthode*, 215–16.

[92]*Couture par lui-même*, 117.

[93]Ibid., 119.

[94]Paul Mantz, 'Une nouveau Véronèse au Musée du Louvre', *Gazette des Beaux-Arts*, II (1859), 38. '. . .ces beaux gris argentins dont Véronèse seul a le secret.'

[95]Couture, *Méthode*, 223. 'Il [Véronèse] aime comme tous les Vénitiens les colorations fortes, savoureuses, les harmonies héroïques, c'est-à-dire, celles obtenues par le juste accord des contraires; mais chez lui, sa peinture s'adoucit, prend une haute distinction par l'introduction de tons neutres, et surtout de ses beaux gris argentins. . .'

[96]Osborne, 137–8, discusses the disadvantages of glazing; discoloration, monotony, and danger of removal in cleaning. He says that no one glazes much any more. Couture himself states a preference for the processes of Rubens 'qui peint en pleine pâte', to those of Titian whose thin upper colors could be removed in cleaning. *Couture par lui-même*, 132.

loss of intensity of whites when they are sandwiched between dark grounds and colored glazes. This is usually described as the ground 'growing through' the upper layer of color. It is instead caused by the gradual disappearance of the thinner areas of white paint through saponification, leaving only the thicker whites.[97] It is thought that some of the extreme effects in Tintoretto's painting may not have been originally intended, but were caused by the disappearance of middle tones.[98] In the nineteenth century Titian was known to have prepared his under painting in tempera, which successfully isolated the lights from this kind of later damage.[99]

While colored grounds and glazes can offer notable advantages, there was much to be said for working on white grounds and for avoiding transparent upper layers. Delacroix more than once praised white grounds and pointed out that they were used by both Flemish and Venetian artists.[100] Corot recommends working on white to preserve freshness.[101] Many painters varied their methods, working sometimes on colored, sometimes on white grounds. What is not discussed, however, is the partial toning of the ground, or rather the use of *ébauche* washes as ground color when developing depth and subtlety of the colors laid on top. An unfinished painting of a nude figure, once thought to be by Couture, demonstrates this procedure.[102] While always difficult to see in reproductions, it is nevertheless clear that a warm brown undertone is painted in the background and under parts of the flesh tones, but not under the white sheet or the lighter lights. Being unfinished this painting would not be expected to have an overlay of glaze, but the handling of the colors, their harmonies already precise in this early stage, suggest that none would have been used. Couture's little preparatory study for *The Romans of the Decadence* (Pl. 98) in the Rhode Island School of Design Museum in Providence, clearly intended as an oil color sketch and not a finished work, shows the same partial underpainting on which free flat areas of local color have been applied. Crisp lines painted into these areas reassert the original drawing.[103] Couture's work has been discussed at length both because he was Manet's teacher and because the methods adopted were to such a large extent universally used. George Moore could later grumble that 'education has proved a vigorous and

[97]Doerner, 350.

[98]Proust, 43–4, quotes Manet as saying that when he copied 'The women with the musicians' of Giorgione he noted that it was dark and that the ground had come through. 'Les fonds ont repoussé.' He went on to say that he wanted to remake the picture with a transparency of atmosphere.

[99]Arsenne, 253, 335, 337. Mérimée, 249, describes making the *ébauche* in tempera impression with glue size and oil as medium, or in tempera as practised by Vermeer.

[100]*Journal de Eugène Delacroix*, I, 243–5, 5 October 1847; I, 501, undated passage after 30 November 1852; III, 38, 5 January 1857. Eastlake notes that Rubens preferred a light ground, p. 333.

[101]*Pensées et écrits*, I, 82–3, 87.

[102]*Odalisque*, Cleveland Museum of Art. This work is now listed as 'Anonymous', and the Museum is interested in suggestions as to its authorship. While I cannot offer a suggestion, I am certain that it is a French painting of the middle of the nineteenth century, and thus relevant here.

[103]This work is lighter in tonality than many similar free oil sketches. The *Bathers* by Carpeaux in the same Museum shows figures lightly drawn on a heavy dark ground with only the slightest indications of light blue water. Jean Jacques Henner's many oil sketches in the Henner Museum, Paris, are almost devoid of local color in favor of a brownish chiaroscuro. See also the Henner, *Arcadian Landscape*, in the Rhode Island School of Design Museum.

rapid solvent, and has completed the disintegration of art.' He described in detail what by the end of the century had become an academic approach:

> A young man goes to the Beaux Arts to produce at the end of two years' hard labour a measured, angular, constipated drawing, a sort of inferior photograph. He is then set to painting, and the instruction he receives amounts to this—that he must not rub the paint about with his brush as he rubbed the chalk with his paper stump ... no medium must be used; and when the large square brush is filled full of sticky, clogging pigment it is drawn half an inch down and then half an inch across the canvas, and the painter must calculate how much he can finish at a sitting, for this system does not admit of retouchings. It is practised in all the French studios, where it is known as *la peinture au premier coup*.'[104]

[104]Moore, *Modern Painting*, 61–2.

3. Manet's Picture Construction

THE earliest known works by Manet are copies after the masters—certainly an acceptable and appropriate beginning for an aspiring young artist. A great many of his copies must have disappeared, but what remains attests to Couture's guidance toward masters of painterly technique: Titian, Tintoretto, Rembrandt, Delacroix, and Velasquez. There is considerable variation among the copies. The Titian *Virgin with the Rabbit* and the Tintoretto *Self Portrait*, both after paintings in the Louvre, are fairly complete and detailed, while the *Jupiter and Antiope* after the Titian in the Louvre, the *Venus of Urbino*, after the Titian in the Uffizi, and the Rembrandt *Anatomy Lesson* after the painting in the Hague, are all executed in the typical broad strokes traditionally used when copying was practiced in order to capture the essential structure of the picture. The contrast is most forceful in the two copies after Delacroix' *The Barque of Dante* (Pl. 99) (in the Luxembourg in Delacroix's day and now in the Louvre.) The version now in the Musée des Beaux-Arts in Lyon is fully worked out in detail and chiaroscuro; that in the Metropolitan Museum in New York is an extraordinary free sketch, no aspect of which has been resolved. Neither promises anything about Manet's future style. In fact, although Manet requested permission from Delacroix to copy the painting, he was not a great admirer of the older artist.[105] The copies after Rembrandt's *Anatomy Lesson* and the *Venus of Urbino* were probably both painted during an extended trip to several countries made in 1857.[106] Both these paintings have been worked on colored grounds with simplified forms, thin darks, and impastoed whites. While Manet was later to adopt extremes of dark and light suggested by the Rembrandt and elements of the motif in the Titian, neither copy can be seen as representative of a personal style. One need only turn to Boime's book on the French Academy to find several copies, sketches and *ébauches* with such similar characteristics[107] to conclude that Manet was working in a mode common for copyists at that time. This raises real problems of attribution. The Velasquez *Infanta Margarita* in the Louvre was a frequently

[105]Proust, 33, quotes Manet as saying of Delacroix, 'Je n'aime pas son métier, mais c'est un monsieur qui sait ce qu'il veut...'

[106]This trip is sometimes listed as having been in 1856, but a letter of 1857 to the authorities in Florence asking permission to copy works of art seems sufficient evidence that the trip took place in the following year. See Wadley, 7.

[107]Boime, Figs 27, 35, 61, 63, 83, 93, 113, 117 to cite only a few. See also Joanna Richardson, *The Courtesans*, Cleveland/New York, 1967, for a Carpeaux Sketch of *Bal costumé aux Tuileries*.

copied work and we know from the Louvre records that Manet was inscribed to copy the picture.[108] Tabarant has supposed the painting to be lost[109] but in recent years two if not three copies have appeared, all supposedly by Manet.[110] Decisions as to their authenticity are difficult indeed. The two which I have seen are charming pictures, but typical in facture of a *kind* of painting not of a specific artist. The version which is illustrated here (Pl. 100), is particularly lively and fresh, and uses colors to be found in Manet's palette. It is thus perhaps the best contestant for the place, but the existence of authenticated sketches by artists of completely different persuasion which resemble it in method makes it almost impossible to firmly arrive at such a decision. Boime, in fact, illustrates a Cabanal copy of the same *Infanta*,[111] which, though clumsier than the purported Manets, has all their breadth and freshness. Considering the tight facture of Cabanel's *Birth of Venus* which was the rage at the 1863 Salon[112]—a Salon which would not accept Manet's offerings—one must conclude that this type of facile and spirited painting was too universally practised to be considered a personal artistic trait even though it seems to predict much of Manet's later freedom.

While the records do not show that Manet ever copied the painting of the *Dead Soldier*, believed in Manet's day to be by Velasquez (Pl. 57), it is certainly reasonable to believe that he might have done so since his *Dead Toreador* is directly dependent on the picture.[113] A copy of this picture has appeared in Paris,[114] but it presents quite another problem from that of the three copies of the *Infanta*. It, too is broadly painted, but without the secure craft of the oil sketches after Velasquez or Manet's own early copies. It shows none of the understanding of essential structures which such copies were designed to teach, nor does it demonstrate the usual paint layers and color handling recommended not only by Couture but by many nineteenth-century painting manuals. The motif alone cannot be considered as adequate for attributing the work to Manet.

[108]Reff, *AB*, 1964, 552–59. Manet first registered to copy as a student on 29 January 1850. On 1 July 1859 he registered as an artist. Both Manet and Degas copied the *Infanta* in 1859.

[109]Tabarant, 20.

[110]A painting measuring $18\frac{1}{2} \times 15$ in. which depicts the *Infanta* in a somewhat smaller format than the Velasquez painting is in a private collection in the United States. This work has not been published. Two collectors in Switzerland have written me to say that they have copies of the *Infanta*. Although each claimed ownership, the photographs they provided appear to be of the same work. The painting was first published in Jacques Mathey, *Graphisme de Manet, II, Peintures réapparus*, Paris, 1963, Fig. 85. It has been authenticated by Pierre Courthion in 1969, and is included in the supplement, as a work of which the authenticity is under discussion in *Tout l'oeuvre peint d'Edouard Manet*. Introduction by Denis Rouart, documentation by Sandra Orienti, Paris, 1970, no. 428. In the English language version, here abbreviated as 'Orienti', the painting is illustrated in the main catalogue of authentic works with the caption 'See 29'. This number, however, refers to a lost watercolor which it supposedly resembles, and not the painting in question. It is therefore not clear whether the author considers it to be authentic.

[111]Boime, Fig. 114.

[112]Rewald, 88.

[113]See above, Part II, 83–5 and Hanson, *Burlington*, 158–61.

[114]Jacques Mathey, *Graphisme de Manet, III, Dessins et peintures réapparus*, Paris, 1966, no. 77. Listed as Collection of R. Caby, Paris.

It is always possible that previously unknown early Manets will be found, but it will remain difficult to attribute works which preceed Manet's emancipation from Couture's doctrines and the development of his more personal and recognizable style.

Manet has persistently been represented as a rebel, precipitously turning his back on the past. Perhaps one should instead see his early development as a normal and necessary gradual emancipation from the methods of his teacher. Manet's first biographer, Bazire, tells us that Couture wanted to perpetuate himself in the work of his students. ' "Chic" and impasto were elevated by him to the height of doctrines', and that he was angry at students too original to follow his methods.[115] What Bazire states with disdain, Couture himself confirms with bitterness in saying that he fed his students like a pelican nourishing its young, but that they left him to go off and seek their fortunes nevertheless.[116] Both accounts affirm Couture's sincere concern for his students, as Couture's own writings affirm his belief in his own methods. It seems from Couture's words however, that Manet was not alone in rejecting him in order to seek his own fortune and future in his own way. Manet's early works show clearly that his six years of study with Couture had been profitable for him, and it is difficult to find any precise moment of rupture or rejection in the works themselves. Two different sources, however, recount an incident usually considered to be the final break between teacher and student. Moreau-Nélaton reports the story as told him by Degas:[117] Antonin Proust who had been a fellow student in Couture's studio, remembers having been present when the event occurred.[118] It must be remembered that more than half a century had passed before Proust put his memories into print and there is every reason to think that his account might have been colored by all that intervened. The story is a simple one. Manet had been in the habit of taking his works to Couture for his advice even long after he had left the studio. When he brought *The Absinthe Drinker* (Col. Pl. II) to his master, Couture dismissed the picture as though the artist, not the subject, had had too much absinthe.[119] The story is generally understood as proof that Manet's subject matter was unacceptable to his teacher, and probably to the public as well. The painting was rejected from the Salon of 1859, despite an affirmative vote by Delacroix who served on the selection jury. However, if one reads further in Proust's account of Manet's words, it appears that it was as much the method as the subject which supposedly disturbed the master. 'Well, so be it, I had the stupidity to make concessions to him. Without thinking for myself I prepared my ground according to his formula. That is over. He was right to speak to me that way. It puts me on my own feet.'[120]

[115]Bazire, 5. '"le chic" et l'empâtement étaient élevées par lui à la hauteur de doctrines.'

[116]Couture, *Méthode*, 370.

[117]Moreau-Nélaton, I, 26.

[118]Proust, 33.

[119]Moreau-Nélaton quotes Manet as saying, 'Mais, mon pauvre ami, le buveur d'absinthe, c'est vous. C'est vous qui avez perdu le sens moral.' Proust recalls the words slightly differently, 'Mon ami, il n'y a ici qu'un buveur d'absinthe, c'est le peintre qui a produit cette insanité.'

[120]Proust, 33.

In the eyes of Manet's contemporaries the painting certainly appeared to be dependent on Couture. Zola remarked that Couture's influence was still evident in *The Absinthe Drinker*.[121] Bazire on the other hand argued that the painting seemed to depend less on Couture than on Spanish paintings in the Louvre.[122] This is hardly an alternative suggestion, however, since Couture admired Velasquez and recommended him to his students as an appropriate model.[123]

Colored illustrations reproduce the color harmonies of *The Absinthe Drinker* poorly.[124] They depend on precise but controlled relationships of relatively dull colors, applied with little modeling. While these colors relate strongly enough to suggest that the picture was painted on a toned background, examination of the surface instead shows that it was probably worked on top of an *ébauche* painted in washes of a warm brown color—a method used by Couture. Transparent staining is apparent under the more opaque and lighter paint which has been dragged across the surface of the wall or bench on which the figure sits. Similarly, the sand colored foreground is laid over a deeper tonality. It is generally recommended that black be rendered by a mixture of other colors but Manet uses pure black and gray mixed from black quite directly in the shoes and for obtaining an optical effect in the bottle in the foreground. Here he has played the highlight, a warm light brown, against the coldness of the black bottle to produce the effect of a deep green, when no green pigment is actually used. His debt to Couture's teaching seems evident enough. It is clear that Manet applied his paint light over dark and kept deeper tones as luminous as possible. This is particularly apparent in the area of light beige/gray paint behind the model's head. While the individual colors are not particularly bright, even as it is now mellowed by varnish and time the painting presents some abrupt value contrasts, particularly in the foreground, the head and the absinthe glass.[125] Proust tells another story which concerns the question of values. Couture once asked Manet's opinion of a portrait he had on his easel, and Manet answered that the color was heavy and the painting encumbered by half-tones. 'Ah,' said Couture 'You refuse to see the succession of intermediate tones which range between the shadow and

[121]*Mes haines*, 250, from his essay on Manet of 1867. In 1884, Péladan (Courthion and Cailler, 188) described the picture as being 'made entirely on Couture's prescription'.

[122]Bazire, 15, says that Manet took from Goya and Velasquez 'la pleine clarté', and admired works 'où le noir arrive à être lumineux'.

[123]*Couture par lui-même*, 106, 120, 132, and *Méthode*, 217.

[124]They also obscure paint textures. The surface of the picture under the light area behind the model's head suggests that Manet's drawing may have been modified in this area. Thickened ridges to the left of the head suggest that the artist may have moved the figure or originally included another form next to it.

White canvas is visible along the edge of the shadow at the left of the figure and at the lower edge of the cloak, suggesting that the canvas was not entirely toned when Manet began to paint. Much of the dark background around the figure was clearly painted after the figure itself was complete—a method Manet used throughout his career. It can be detected by following the dark brush-strokes along the edges of forms to ascertain if they overlap the form or the colors of the form overlap them.

[125]Although the painting was cleaned, re-lined and retouched in 1966, its present coat of varnish is heavy enough to make precise color relationships difficult to read.

the light.' 'Manet, in turn declared that for him the light presented itself with such unity that a single tone sufficed to render it. Although it might appear brutal, it was preferable to pass brusquely from light to dark, rather than to accumulate things the eye cannot see, and which if included not only weaken the vigor of the light passages but attenuate the color of the shadows.'[126] It must be remembered that extremes in value were acceptable for a preliminary sketch and were often necessary in an *ébauche* to which middle-tones or glazes were to be added. Manet's use of them in a finished work of considerable size, however, could only have seemed crude and inappropriate both to Couture and to the Salon jury.

Manet's *The Spanish Singer* of 1860 is again a genre subject, and again the layers of paint have probably been developed largely according to Couture's formulae. However the painting is finished in greater detail and more half-tones tie together extremes of light and dark. Manet's facility, already remarkable for so young a painter, did not go unnoticed, and the painting won him an Honorable mention at the Salon of 1861.

Although Manet continued to use certain aspects of Couture's method, he soon rejected others. His *The Reader* (Pl. 101) of 1861 seems at first glance to be a rather conservative painting. A typical genre subject is rendered in close, if lively, flesh tones, against a traditional warm brown background. If one critic saw the more highly finished *The Spanish Singer* as a 'violent *ébauche*'[127] in its own day, *The Reader* might have seemed painterly indeed. Moreau-Nélaton found it reminiscent of Velasquez[128] and certainly its sober color harmonies separate it from the more vivid works of the following years.[129] The paint application, however, demonstrates a definite break with Couture's usual method, although possibly responding to Couture's fears about the fragility of glazing techniques.[130] The differences can easily be seen by comparing the painting with Couture's *Little Gilles*. The surface of *The Reader* is densely covered, however, one can see from tiny areas within the figure that some of the whites and flesh tones are clearly laid on white ground, suggesting that the figure was probably drawn in paint on a white canvas. The disjunction between the strong lights and the warm dark ground confirm this observation, since the lights give no evidence of a ground color penetrating through. Couture's painting not only depends on the actual transparencies achieved by the scumbling of whites across a warm dark ground, but also the application of colored glazes over large parts of the surface to bind together the discrepancies of value and of hue. The method, simple in principle, can create

[126]Proust, 31–2. 'Manet soutint que pour lui la lumière se présentait avec une telle unité qu'un seul ton suffisait pour la rendre et qu'il était de plus préférable, dût-on paraître brutal, de passer brusquement de la lumière à l'ombre que d'accumuler des choses que l'oeil ne voit pas et qui, non seulement affaiblissent la vigueur de la lumière, mais atténuent la coloration des ombres qu'il importe de mettre en valeur.'

[127]Paul Mantz, 'Exposition du Boulevard des Italiens', *Gazette des Beaux-Arts*, XIV (1863), 383.
[128]Moreau-Nélaton, I, 32–3.
[129]For a contemporary view of Velasquez' color, see Charles Blanc, 'Vélasquez à Madrid', *Gazette des Beaux-Arts* IV (1863), 67. He praises the transparency of the darks.
[130]See above 152.

rich and complex coloristic effects. Lacking a uniform colored ground on which the whites could be worked to achieve optical effects, Manet's lighter colors had to be thickly painted. Their coloristic brilliance depends, then, not on actual transparencies as in the *Little Gilles*, but on sensitive choice of exact hues and values. Such choices become more obvious in later, more colorful paintings, but even at this early stage one can apply Matisse's words of admiration for Manet, 'instead of the long work of preparation necessary to obtain a transparent tone he applied the color at one time and, with the relationships true and precise he realized the equivalent of that transparency.'[131]

It is clear that Manet learned from Couture his remarkable ability to apply the paste-like paint with a surety of touch. Both the work of the master and that of the student appear remarkably fresh and alive. But Manet's application of the upper paint layers depended on different principles. His method seems more simple and direct. He could be charged with impatience in not being willing to take the time to work up separate painted layers, were it not for repeated evidence that he worked very slowly, taking considerable time to come to the point when he could consider a work appropriately finished. Bazire said the *Bon Bock* required eighty sittings,[132] and Blanche that Manet, 'labored greatly on the pictures he sent to the Salon, yet they looked like sketches. Manet rubbed out and repainted incessantly.'[133] Albert Wolff had written on Manet in 1869 and said that although the artist lacked imagination he could 'admirably render his first impression of nature.'[134] He grudgingly agreed to pose for Manet in 1877 when the artist was at the height of his powers. Expecting a quick and easy sketch, he was surprised to discover how slowly the artist struggled from his 'lumps and splashes' of paint to his final effect, and thought him a very 'incomplete artist' because of it.[135] George Moore had quite the contrary reaction, finding Manet's repeated application of paint on paint truly miraculous. 'The color of my hair never gave me thought until Manet began to paint it. Then the blonde gold that came up under his brush filled me with admiration, and I was astonished when, a few days after, I saw him scrape off the rough paint and prepare to start afresh. 'Are you going to get a new canvas?' 'No; this will do very well.' 'But you can't paint yellow ochre on yellow ochre without getting it dirty?' 'Yes, I think I can. You go and sit down.' Half-an-hour after he had entirely repainted the hair, and without losing anything of its brightness, he painted it again and again; every time it came out brighter and fresher, and the painting never seemed to lose anything in quality. That this portrait cost him infinite labour and was eventually destroyed matters nothing; my point is merely

[131]Henri Matisse, *L'Intransigeant*, 25 January 1932, here quoted from Michael Florisoone, *Manet*, Monaco, 1947, 122. Mallarmé had earlier said that 'no artist has on his palette a transparent color for open air.' 'The Impressionists and Edouard Manet', *Art Monthly Review*, I (1896), 119, here quoted from Jean Collins Harris, *AB*, 1964, 561.

[132]Bazire, 82.

[133]Blanche, 33, 55–6.

[134]20 May 1869, *Le Figaro*, here quoted from Tabarant, 160. See also Hamilton, 139.

[135]Duret, *Manet*, 69–70. See also Duret, 1902, 120–22.

that he could paint yellow over yellow without getting the colour muddy.'[136]

Many of the early manuals instruct the painter to prepare a succession of related tones on the palette in advance. Couture, instead, had urged a limited number of colors, used with as little mixing as possible, and an understanding of the effects one hue has on another. Here, again, Manet's training in Couture's studio seems to have served him well. Moore tells us that 'he did not prepare his palette; his color did not exist on his palette before he put it on the canvas.'[137]

Since Manet had clearly learned extensively from Couture, it is reasonable to ask why he gradually discarded Couture's transparent layers in favor of a more blunt effect. The answer must be found in his desire to reject, not Couture, but the look of the masters in favor of an art which would more directly reflect the reality of modern life. There can be little question that Manet knew what kind of picture would be guaranteed to please, but he had already argued with Couture that the fine gradations of chiaroscuro demanded by tradition were not visible to the human eye. Similarly, he saw in the external world not only sharp contrasts of value but pulsating areas of vivd hue. Paul Mantz had seen promise in *The Spanish Singer*, but he later saw no reason to support a painter who produced works like *Lola de Valence*, *The Spanish Ballet*, and the *Concert in the Tuileries* which 'in their riot of red, blue, yellow and black, are the caricature of color and not color itself.'[138]

There has been some disagreement as to when the *Concert in the Tuileries* (Col. Pl. I) was painted. Both Tabarant and Wildenstein believe that it was painted in 1860,[139] while Sandblad, Rewald and Richardson regard 1862 as a more appropriate date.[140] Certainly the *Concert in the Tuileries* resembles far more closely the small *The Spanish Ballet* (Pl. 102) in the Phillips Collection in Washington, which can be securely dated 1862, than it does *The Students of Salamanca*[141] or *Fishing* (Pl. 65) which were painted about 1860. The two earlier works still show misty overlays of semi-transparent color reminiscent of Couture's approach, while the ballet scene displays sharper disjunctions in value relationships and curiously isolated areas or vivid hues. Other early paintings like the *Scene in the Spanish Studio* and the *Little Cavaliers*[142] have a broad facture like that of the *Concert*. Proust, always ready to dramatize Manet's rejection of Couture says that when Manet first saw the *Little Cavaliers* in the Louvre he exclaimed, 'Ah, thats clean ... How one is disgusted with all the stews and gravies.'[143] Nevertheless the two small Spanish pictures while

[136]Moore, *Modern Painting*, 32. Blanche, 51, wrote that he had seen the artist painting toward the end of his life 'Manet rubbed out and repainted incessantly.' Blanche describes his redrawing of the hat of *The Amazon* and of correcting the shapes of plates and crystal vases in his still lifes. See also Blanche, *Propos de peintre, de David à Degas*, Paris, 1919, 140.

[137]Moore, *Modern Painting*, 32.

[138]Mantz, *Gazette des Beaux-Arts*, 1863, 383.

[139]Tabarant, 38. Wildenstein, 1932, no. 36. In the 1975 edition Wildenstein lists it with paintings of 1862, and notes that it is signed and dated. See no. 51.

[140]Sandblad, 26–8 and caption to Figure 12. Rewald, 54–5. Richardson, 17, 119, no. 8.

[141]Private Collection, London.

[142]Private Collection, Paris. Private Collection, New York.

[143]Proust, 24.

brilliant with the effects of light and dark, are still relatively controlled in hue. In them Manet was not only dependent on Velasquez and his school for subject and motif, but for color harmonies as well. By 1862 he was less dependent on any specific source, and had begun to develop his spirited personal style.

Sandblad claims that the *Concert in the Tuileries* is painted on a colored ground.[144] This is certainly not the case. Repetitions of transparent brown under the more opaque tones indicate instead that the composition was first drawn in the typical lines and washes of a brown *ébauche*. The clear deep greens in the trees, themselves transparent, are laid over white areas, and in turn lightened with overlays of more opaque yellow and white-filled pigment. Sometimes, scraped areas in the greens reveal white canvas beneath. In addition to the pervasive greens, vivid blues, rust-reds, blacks and grays dominate delicious pale yellows, pinks and peach tones. The effect is still startling.

The *Concert in the Tuileries* appears to be crudely painted, an effect which is heightened in photographic reproductions, since the canvas is smaller than might be expected from the number of figures it contains. The lack of detail in many areas seems more natural when the painting itself can be seen. Although the picture successfully conveys the sense of bustling activity, animated conversation and distant music, its facture suggests that Manet had intended to work on it further. The very center of the picture is the part most loosely painted, and while clear portraits can be identified in many cases, other figures seem to be waiting for their significant features to be added. Further, the paint itself is extremely thin in many areas and there is evidence of scraping as though in preparation for further layers of paint. The build-up of rich color relationships seems not to have yet taken place. The painting may not have been signed until just before it was shown in the Galerie Martinet in 1863. One wonders, then, why Manet would show what he might have considered as a partially finished oil sketch. Both subject and style suggest the answer that he had attempted to capture the raw beauty and vivid reality of his own society, and that he had made the first real step toward the recording of the spirit of modern life.

The lighter and brighter tonalities of the *Concert in the Tuileries* were not frequently repeated during the early 1860s. There are relatively few landscapes of this period and the single figures, still lifes and interior scenes tend to have warmer and darker backgrounds. Further, had the painting been brought to a higher degree of finish it might have lost some of its abrupt color transitions. It is difficult to draw consistent conclusions, however. We know, for instance, that the painting Manet made of a Gypsy family originally depicted the figures against a vivid blue sky, quite similar to the intense triangle of sky

[144]Sandblad, 60. He sees in the painting a continuation of Couture's influence because he believes it to have been painted on a colored ground and because of its primary colors and contrasting color harmonies. He does not seem to have had a full understanding of Couture's instructions.

blue in the *Concert in the Tuileries*. When the picture was later cut into fragments the blue ground behind the Gypsy boy was covered with the luminiscent brown so often found in Manet's *oeuvre*.[145] Thus we cannot draw any conclusions concerning chronology based on either the continuation or rejection of the traditional brown ground tone. It is used less frequently in his later work, to be sure, but even in the last years of his life he returned to this device in a number of still lifes and a few portraits. What is worth observing, however, is that these dark grounds are often painted last. A close look at the *Asparagus*[146] of 1880 or the vivid *Lilacs and Roses* (Pl. 103) which was probably painted in the last year of his life will show that the brown has been painted around, not under, the main elements of the motif, just as the same color was added around, but not under the figure of the gypsy boy.

Not only does Manet repeat throughout his career the use of a luminous brown background tone, but he continues another approach clearly derived from the example of Spanish painting and from Couture's training. Manet frequently cools parts of the brown ground by laying over it areas of light gray. This slightly more opaque pigment is spread in varying thicknesses over the darker and more transparent brown achieving an effect of depth or density. This treatment can be seen in early works such as the *Absinthe Drinker* and *Mademoiselle Victorine as an Espada*, and is still in use in 1880 when Manet painted his portrait of Clemenceau (Pl. 104).[147]

Enough unfinished paintings remain to us from Manet's mature period to allow us to reconstruct his method layer by layer. We might start with a drawing on paper, the portrait of Henri Vigneau (Pl. 105).[148] With remarkable facility Manet has captured not only the features of the sitter, but a sense of light and life with a few deft lines. Shadows are hastily indicated with free zig zag lines as though a looser form of the hatching normally used for shading in more contained pencil or chalk drawings. While the darks are thus forceably indicated, the lightest light is not indicated at all. The contour becomes extremely thin over the model's brow and down his nose, to disappear at the tip as though the strong light falling on the face had consumed the line as natural light often obliterates detail. The amount of information given in so abbreviated a drawing is truly amazing.

[145]Hanson, *Burlington*, 165 and Fig. 51.

[146]Wallraf-Richartz Museum, Cologne.

[147]Jeu de Paume, Louvre. Some early studies such as *Tête d'homme*, Private Collection, Paris, and *Tête de vielle femme*, Private Collection, New York, appear to have been painted in the same manner. Couture used it in works such as *Study of a Man's Head* in the Cincinnati Art Museum; *The Widow*, Museum of Fine Arts, Boston, and *Woman in a White Cap*, Private Collection, New York, illustrated in *Thomas Couture, Paintings and Drawings in American Collections*, University of Maryland, College Park, Md., 1970, no. 38.

[148]There is some disagreement about the spelling of this name. In the catalogue of the

Manet exhibition in Philadelphia in 1966 I followed Bazire (31) who should have known the names of Manet's friends and whose work was published only a year after Manet's death. Léon Leenhoff's papers, however, include two letters from 'H. Vigneau' and there is an annotation in photograph album number 87 identifying the drawing as the same Vigneau who served as a second in Manet's duel with Duranty. Copie pour Moreau-Nélaton de documents sur Manet appartenant a Léon Leenhoff vers 1910, MS, Paris, Bibliothèque National, Cabinet des estampes. The duel is briefly mentioned by Tabarant, 173.

While there is considerable evidence that Manet made quick sketches from nature[149] there seems to be little or no evidence that he ever made drawings to transfer to canvas. Quite the opposite, he seems to have been able to dispense with both the compositional plan and the usual chalked-in indications on the canvas itself. His unfinished portrait of George Moore (Pl. 106) in the Metropolitan Museum shows how he could 'draw' directly on the canvas with a 'sauce' using the same coarse hatchings to indicate shadows and the same attentuated lines for the lights which are demonstrated in the drawing of Vigneau. Manet's method differs, however, from the usual use of *ébauche* underdrawings to establish motif and chiaroscuro *before* the addition of any color. The Irish Moore had a pink complexion and blond-red hair. While laying in his essential lines, Manet has also indicated the basic color harmonies as well. The head is drawn in light brown with slight touches of red at the lips and ear, the hat and coat in Manet's characteristic blue-black indicate the dark cold tones which would have served as a foil for the warm blond features in the finished work. On the hands, Manet has begun a second step—that of establishing thicker and more opaque tonal areas. Here it is clear that flesh color is to be painted directly on the white canvas.

The next step in building up his colors can be demonstrated with an unfinished painting of a young woman in the Chicago Art Institute (Pl. 107). One can see that Manet had drawn the contours and indicated shadows with the brush just as he had in the portrait of George Moore. He had then filled in the major areas with thin washes of color, color which while dull, predicts the harmonies planned for the finished work. As in the Moore, he had added some thicker areas of light opaque paint, around the eyes, for instance, only to scrape it away with the palette knife in preparation for the addition of more color. This is a technique we find him using many times. Like the thin washes, the scraped areas establish tones which can be used as foils for the colors which will lie on top of them, a modern adaption of the method of working in lights and darks on a colored ground, but now used for portions of the canvas surface rather than uniformly throughout. It is interesting to note in the preliminary stages of Manet's paintings, his willingness to let a wet wash dissolve a contour, and to see his changes in the contours themselves as he developed his forms.

Several works could be used to show both the thicker application of brighter colored paints to the washed and scraped drawing and the reassertion of lines which have been lost in the painting process. A particularly good example is the portrait of the painter Guillaudin on horseback (Col. Pl. IV). Here Manet has taken full advantage of the transparencies and color overlays to be achieved both through scraping and through thin washes of color. The background although apparently unfinished, gives the impression of light filtering through the foliage of a lush garden and acts as a luminous if indistinct foil for the sitter's ruddy complexion. The head has been carried further than

[149]De Leiris, *Drawings*, illustrates many such works, for example, nos. 207, 208, 251, 252, 253, 255, 275, 276.

the rest of the painting. Here details are sharper and the actual paint has been built up to a slightly thicker surface. Since artists must take advantage of the time their models offer them, he had undoubtedly focused on Guillaudin's features, leaving his clothing and his mount to be further developed in his absence. Manet's portrait of Georges Clemenceau (Pl. 104) is another work which graphically demonstrates his painting processes. The warm grey background has been extensively scraped, and the head has been heavily outlined in black to re-establish the silhouette. The ground color has not yet been painted up to the new edges of the forms, and thus Manet's changes in drawing are still visible.

We don't know why the portrait of Guillaudin was left unfinished but an explanation has been offered for the unfinished state of Manet's picture of Claude Monet and his wife Camille in Monet's floating studio (Pl. 108). Manet had great admiration for Monet whom he helped financially from time to time,[150] and we are told that he did not want to waste the artist's time by asking him to pose for the repeated sittings his approach required.[151] Monet's face, the most awkward passage in the entire canvas, appears to be ready for scraping. It is possible that Camille had more time to sit for the artist for her features have been vividly if simply expressed. The entire picture, colorful and charming, despite its raw state, shows how Manet related color and value harmonies over the entire surface of the canvas from the start.

When Manet abandoned his portrait of Monet he began instead a picture of two weekend visitors, who presumably had more time to spare.[152] The man and woman in the boat in the painting in the Metropolitan Museum provide a motif sufficiently close to that of *Claude Monet in his Floating Studio* to afford an interesting comparison. By contrast, *Boating* (Pl. 109) looks highly finished. Actually, many areas like the woman's head and the flickering stripes of her blue and white dress are painted with great facility and freedom. There is more paint over the entire canvas surface and the transparencies of the under layers have been replaced by precisely chosen hues which seem to suggest instead the real transparencies of water and air. Manet apparently used the more nebulous relationships of the colors of the underpainting to help him establish the tonalities he sought for the final effect. It is probably quite correct to assume that below the top layer of paint in *Boating* one could find a thin and freely painted underlayer. What can be seen in unfinished works can be confirmed in X-rays of finished ones. A thorough laboratory study of Manet's *Le Bon Bock* (Pl. 110) in the Philadelphia Museum[153]

[150]Tabarant, 249.

[151]Wildenstein, 1932, I, remarks under no. 240, a closely related work.

[152]According to Tabarant (247), they were Rudolph Leenhoff and an unidentified woman.

[153]Siegl, 133–41. X-rays of other works confirm this approach. As an adjunct to *Impressionism: a Centenary Exhibition*, held at the Metropolitan Museum in New York from 12 December 1974 to 10 February 1975 there was a small exhibition 'Some Technical Aspects and Working Methods', which included enlarged X-rays of the works of various artists. An X-ray of Manet's *Boating* revealed that the rope from the boat to the boom was once held in the man's hand and at a very different angle. While a relatively small change in paint structure, this represents a major change in composition. An X-ray of

reveals numerous changes in drawing under the final surface. At one point the drinker had held his glass half-way to his mouth only later to replace it on the table. He was also once accompanied by another solitary drinker at a table in the background.

Le Bon Bock is an interesting work, surprisingly similar in both motif and construction to *The Reader* already discussed. Manet apparently intentionally returned to a more conservative approach in order to succeed in the Salon of 1873. While the painting received some negative criticism, and Manet was accused of paraphrasing Franz Hals to some extent, the picture was generally favorably received.[154] Its warm color harmonies were far more acceptable to the public than those of other works of the period, and are in marked contrast to *Le Repos* (Pl. 44)[155] the more colorful and more modern picture he sent to the same Salon.

While *Le Bon Bock* is a vivid painting, particularly since its recent cleaning, there is a definite technical problem in its construction, the use of the color called bitumen, a favorite of nineteenth-century artists. 'Bitumen' is a generic term for a number of natural substances of similar composition. The bitumen used by nineteenth-century painters was a variety of asphaltum.[156] Dissolved in turpentine and mixed with oil it produces a truly beautiful transparent brown. It has other enticing properties as well, since it mixes easily with other transparent colors and has a fluid consistency which makes it perfect for both glazing and for the quick brush drawing of the *ébauche*. The danger of bitumen is purely mechanical, not chemical. Ground in quantities of oil it liquifies easily when the temperature rises. When painted thickly it simply does not dry. Worse, on exposure to air and light it quickly forms a skin which effectively cuts off the air from the inner portion so that it appears to be dry when it is not.[157] Thus colors laid on top of areas of bitumen lack a solid base and will develop cracks from the shifting of the underlayer and a dark oily material will rise to the surface through the cracks. Vibert dramatically says that the

Claude Monet's *Women in the Garden* shows that his method is similar to Manet's. The head, arms and umbrella of the seated woman were originally several inches higher. By contrast the X-ray of Degas' *Belleli Family* shows only one minor revision, the lengthening of Giulia Belleli's skirt—perhaps requested by the family. The label reads: 'The absence of any major revisions during the process of painting reflects the careful working of drawing, sketching and studying that preceded the actual rendering of the composition.'

[154]See Hamilton, 164–72. According to Doerner, 365, Hals was influenced by Rubens, using warm browns glazed over a grey ground with cooler opaque colors on top.

[155]See above, Part II, 76–7.

[156]The name 'bitumen' was used by the Romans for a variety of natural hydrocarbons. Asphalt is a type of bitumen. It is widely distributed geographically and early travelers noted that it could be found floating on the surface of the Dead Sea. Osborne (pp. 86–90) reminds the reader that the asphaltic lake was mentioned in Pliny's *National History*. Asphalt is principally used in the manufacture of paving materials, but has been used in art both as a colorant and as an addition to varnishes in painting and in the preparation of etching plates. The more extensive use of asphalt in painting began in the seventeenth century with the rise of oil painting. (Mayer 41, 588) According to Adrien Recouvreur (*Grammaire du peintre*, Paris, 1890, 91) the 'bitumen' or 'asphaltum' used by nineteenth-century painters was still collected from the Dead Sea or the Asphaltic Lake in Judea. In his little book of 116 pages on supports, oils and colors, he devoted fifteen pages to a discussion of the properties of bitumen.

[157]Recouvreur, 91–98. Doerner, 88–9.

paintings of yesterday 'darken, crack and weep tears of bitumen.'[158]

Bitumen is far less dangerous when mixed with other colors or driers like siccative oils or varnish. Couture recommended using bitumen with cobalt (a fast drying color) for a thin ground tone, for drawings in the *ébauche*, and for creating a rich black.[159] When used thinly as a glaze it is safe but its tendency to darken makes its use somewhat questionable.[160] It works well to establish a luminous dark over a colored ground. Used on a white ground, however, it is too transparent to create a dark tone unless it is thickly applied. Manet rarely if ever used colored grounds after his earliest student days, and in painting the *Bon Bock* he had used bitumen without appropriate caution. The painting surface shows a definite bituminous cracking which has damaged its surface, and will no doubt, damage it again in time.[161] The dark background of the *Olympia* shows similar minor damage. The use of bitumen seems to have been the only fault in Manet's otherwise meticulous craft.[162]

In recommending a fresh approach for sketching and for laying in the first layers of paint Couture did not intend to suggest that paintings should be left 'unfinished'. Loosely brushed images were admired for what they were— preparatory studies. It is clear from much of the criticism against Manet that many of his paintings were seen as 'unfinished', and there was sometimes even to be a tone of moral rectitude in those criticisms which suggested that the artist simply hadn't completed his job. Gautier writing about *Dead Christ with Angels*, a painting which certainly seems finished by twentieth-century standards, said of Manet, 'From one end of the painting to another his figures are like the preliminary sketches of a master. Unhappily, Manet intentionally abandons them at this stage and does not carry his work very far.'[163] Gautier's

[158]Vibert, 15. Vibert offers as a solution to the problems his own 'Vibert Brown' which he claims has all the advantages and none of the defects of bitumen (171). Earlier writers were not so anxious to abandon so delightful a color and most manuals include specific instructions for its proper use. Mérimée, (102) warns that it dries poorly and causes cracking and offers a recipe which includes a large quantity of siccative or drying oil. The English edition of his book, London, 1839, 182, gives the recipe as follows: Venice turpentine 15 grains; Gum lac 60 grains, Asphaltum 90 grains, Drying Oil 240 grains; White wax 30 grains. This exact recipe appears again in Arsenne, 241, Osborne, 89. Recouvreur recommends the addition of wax to prevent the color from running too freely (160), and Bouvier offers instructions for its preparation (193–4) although he suggests substituting Prussian Brown to avoid its poor drying qualities and still obtain its rich transparent color (52–3).

[159]*Couture par lui-même*, 112, 117, 119, 121, and see Bouvier 42.

[160]Rembrandt apparently used bitumen for glazing. Doerner, 89.

[161]Siegl, 133–42. X-rays and infra-red pho-tographs demonstrate that the drinker's hand was moved in the process of making the painting and that a figure at another table in the background had been covered over with paint by the artist. In these two areas, and in other areas as well Manet apparently used bitumen too thickly. Cracking has occurred in areas of paint laid on top and still liquid bitumen has leaked through these cracks, 'weeping tears of bitumen' to use Vibert's words. See Siegl's micro photograph, Fig. 5, 134. Siegl cleaned the dark bitumen out of the tiny cracks and inpainted them, thus returning the picture to its former brilliance. However, since there is no way to remove the underlying layer of bitumen it is expected that the picture will crack again in time and will once again require treatment.

[162]Manet had only one real student, Eva Gonzalès. Her paint application is often similar to his. The bituminous cracking in *La Loge* in the Jeu de Paume, Louvre, in the darker areas of the background, the man's suit and the shadows of the red velvet railing strongly suggest that she followed Manet's instruction, both wise and unwise.

[163]*Moniteur*, 25 June 1864, here quoted from Hamilton, 57.

use of the word 'intentionally' is important here, since he realized that the artist did not 'abandon' his work from lack of knowledge or laziness. Unfortunately, few contemporary critics, however sympathetic, could understand Manet's new view of what 'finish' was, and how the degree and kind of finish imposed on an image could affect the spectator.

It would be naive to think that the nineteenth century was demanding from all artists the ivory perfections of an Ingres or a Gérôme or the miniscule detail of a Meissonier. Rubens and Delacroix were much admired, and a broad facture was not necessarily condemned. Baudelaire could discuss in his Salon of 1859 the size of brush marks in relation to the size of the painting, explaining that in larger works the marks would fuse when the painting was seen at the appropriate distance.[164] For Charles Blanc, Velasquez was a 'veritable magician' since his paintings looked like rough *ébauches* when seen close at hand, but were perfectly resolved from several steps away.[165] However, whatever the surface texture of the picture, a certain kind of resolution of formal relationships was expected through the imposition of what could be frankly seen as art or artifice. Castagnary seemed to have a sophisticated understanding of the problem when he repeatedly urged Manet to carry his works to a greater degree of finish. He realized that outdoor light and open air tend to obliterate detail, and that Manet painted as he saw nature before him. 'From the point of view of sincerity he is above reproach. But it is nevertheless true that, since our imagination is accustomed to complete the information our eye gives us when we know it is insufficient or to correct it when we know it is wrong, we cannot be satisfied with Manet's summary sensations ... I think it would be an advantage to take the best qualities of the open air and put aside the imperfect ones.'[166] Manet, however, was not willing to take Castagnary's advice. When still a student in Couture's studio a comrade supposedly had suggested that he finish a work, and Manet had answered, 'Do you take me for a history painter?'[167] This incident as recounted by Proust to illustrate Manet's independent spirit, also suggests that Manet already felt that the depiction of modern life would require a new approach. His raw canvases may have represented in part a rebellion against Salon standards but they were not painted for rebellion's sake alone, but in an honest search for the kind of surfaces which could speak more of a vivacious present than of a frozen past.

It is surprising to what extent the idea that sketches and *ébauches* can be loose and free, and that definitive works should have tighter facture, has persisted in critical thinking. In the twentieth century Manet's own cataloguers

[164]*Oeuvres complètes*, 1042–43. 'Plus un tableau est grand, plus la touche doit être large, cela va sans dire; mais il est bon que les touches ne soient pas materiellement fondues; elles se fondent naturellement à une distance voulue par la loi sympathique qui les a associées.'

[165]'Velasquez a Madrid', *Gazette des Beaux-Arts*, XV (1863), 72.

[166]Castagnary, *Siècle*, 29 May 1875, here quoted from Hamilton, 193. He firmly urges Manet to render his hands and faces with more modeling and detail. He made similar recommendations in the same publication in 1873, 1874 and 1879. See Hamilton, 167, 179, 215.

[167]Proust, 29.

use terms like *'esquisse'* and *'ébauche'* for freely painted works, and where there are several works of the same motif they choose the most finished version as the *'toile définitif'*. They seem to continue the assumption that the artist would make several oil sketches in preparation for the definitive work. Traditionally such sketches would have been small, but works designated as *'esquisses'* or *'études'* by Tabarant and Wildenstein are sometimes of considerable size, even exceeding the measurements of those called definitive canvases.[168] On the other hand the *'ébauche'* being the preliminary sketch on a canvas would naturally be the size intended for the finished work. There seems to be no consistency whatever in the use of this term by Tabarant and Wildenstein, *'étude'*, *'esquisse'* and *'ébauche'*, being used interchangeably for freely brushed works regardless of their size or their degree of resolution.[169]

Manet's several versions of *The Execution of the Emperor Maximilian* have already been discussed in terms of chronological sequence and meaning.[170] Roughly the same subject and composition they also offer an opportunity to contrast different pictorial surfaces of approximately the same date. Three of the four paintings are very large, exceeding the size of the *Old Musician*, and probably the original size of *The Incident in the Bull Ring* from which *The Dead Toreador* was later cut.[171] By contrast, the modest size of the Copenhagen version (Pl. 80), suggests that it served a different purpose, possibly as a preparatory sketch but more likely as preparation for Manet's lithograph of the same subject.[172] Since a similar simplified facture was normally used both for sketches and for copies after finished works[173] the painting itself could not be expected to offer a solution to this question. It is directly painted in summary areas of color over a white canvas. While the costumes of the soldiers and the disposition of the figures in space are clearly presented the upper portion of the background is left unresolved and no attempt has been made to define detail. The large version of *The Execution* (Pls. 78, 79) in Boston is also freely painted but represents a completely different approach. Its warm coloring and its rich scumblings, scrapings and transparencies reflect

[168]Wildenstein, 1932 I, nos. 138, 140, 239, 240, 456, 458; Tabarant, 141, no. 132; 404, no. 325. 'Esquisse' is the term most frequently used by both authors.

[169]The following chart of unfinished works already discussed illustrates this inconsistency:

	Tabarant	Wildenstein, 1932
George Moore in the Café	ébauche	esquisse
Young Woman	donne l'aspect d'une acquarelle	ébauche
Portrait of Guillaumin	esquisse	toile
Monet in his Floating Studio	esquisse and ébauche	esquisse

See Tabarant, 179, 250, 331, 366; Wildenstein, 1932, I, nos. 182, 239, 329, 337. Both books refer to the largest version of *The Execution of the Emperor Maximilian* as an 'esquisse', Tabarant, p. 141, Wildenstein, 1932, I, no. 138, as does Wildenstein, 1975, I, no. 124.

[170]See above, Part II, 110–18.

[171]See above, Part II, 114, n. 271.

[172]See above, Part II, 113–15.

[173]See above, Part III, 141, 155–6.

the best of Couture's teaching for the preparatory *ébauche*. At a distance it looks as though the paint had been applied to a toned ground. Actually the upper layers have been laid over a transparent brownish wash drawing, possibly more unified in color, but clearly worked in steps like those demonstrated by the *George Moore in the Café* and the *Young Woman*. This is then an *ébauche* brought to roughly the same stage as the *Claude Monet in his Floating Studio*, the difference lying not in the paint application but the lightness and clarity of the color of the later work. *The Execution of the Emperor Maximilian* is actually more colorful than it first appears. The green shirt, the ochre hat, the rusty-brown jacket are played against the darker blacks, browns and grays of the uniforms, but a consistent repetition of related tones and the lack of any light clear color gives the canvas a unity lacking in the other versions of the motif. The resulting almost romantic effect makes the picture reminiscent of its source, Goya's *Third of May*, an effect which Manet may well have appreciated. It is usually assumed that he abandoned the painting in this stage because he had received further information about the event and wanted his final picture to be true to life. Its qualities as a powerful statement are nevertheless obvious and may have provided another reason for him to begin again on a new canvas. Had further paint layers been applied, however, a tighter surface with more controlled disjunctions in color would probably have resulted. In other words, the change in uniforms aside, it might have become a picture like the Mannheim version (Pl. 77), which, generally considered to be the 'definitive' canvas, presents both a greater degree of detail and stronger linear patterns while preserving a vigorous surface not unlike that of other works of the 1860s.

The London version (Pl. 81) was thickly painted in much the same manner although brought perhaps to an even tighter surface. It gives a radically different effect, however, since the figures are set against open countryside and a vivid blue sky. Thus they are more strongly silhouetted and the contrast between the innocence of nature and the horror of the event becomes an expressive element. It is the kind of unromanticized record which a photograph can present, and is all the more disturbing for its mechanical coldness. Why this apparently finished work was cut into fragments is unknown. Manet did experiment with his own compositions through cutting, but if it was he who dismembered the picture during his period of working on the motif, his reasons for doing so will probably remain obscure.

Throughout the 1860s Manet seems to have been preoccupied with rich but subtle harmonies of colors of relatively low intensity. The seascapes of 1864 are notable exceptions, and other pictures present color surprises such as the introduction of delicious pale lavenders, pinks, peaches and yellows into the costumes of *Mademoiselle Victorine as an Espada* and *The Dead Toreador*. Manet may well have taken up Baudelaire's challenge, 'Great colorists know how to create color with a black coat, a white cravat, and a grey background,'[174] when he painted a portrait of his friend Duret (Pl. 19).

[174]*Oeuvres complètes*, De l'Héroïsme de la vie moderne, 951. *Art in Paris*, 118.

'The costume was a gray suit set against a gray background. The picture was therefore entirely in grays.'[175] Manet was clearly indebted to Velasquez here since his 'gray' background was created by laying more opaque tones over a warm brown, creating a singularly luminous effect, which he used in a number of works of the period such as his two paintings of philosophers in Chicago. When Duret thought the painting finished Manet, without explanation, arranged a few small objects on a low table next to his model, thus introducing accents of red, green and lemon yellow.[176] The later small portrait of Manet's friend Mallarmé (Pl. 111) includes no bright clear colors, but in general gives a far lighter effect. The poet leans against white cushions in front of light tan wallpaper with Japanese motifs. His dark blue coat and ruddy face are highlighted in relatively clear colors. The paint application has a virtuoso freeness. Compared to the portrait of Duret, the portrait of Mallarmé seems spontaneous, informal, and pointedly modern. The difference is not only that of Duret's stiff stance and Mallarmé's informal pose, but both color and paint texture effect a sense of instant presence which pervades the later work. What has intervened is Manet's friendship with Mallarmé and their interchange of ideas over the same years when the artist was most closely associated with Impressionist painters. It is not easy to say whether Manet's tendency to capture and synthesize the essential qualities of objects in a few brief marks may have influenced Mallarmé in the development of his thinking, or whether instead Mallarmé's views about capturing and evoking the essence of objects encouraged Manet toward a briefer virtuoso shorthand. Undoubtedly their relationship was mutually enriching.[177] Whatever the source, Manet was to continue and develop the evocative nature of his imagery and the facility of his brush over the years of their friendship which lasted until his death.

His relationship with the Impressionist painters seems also to have been mutually beneficial. Manet's notoriety at the Salon des Refusés made him something of a hero to a group of younger artists with whom he met at the Café Guerbois on the rue des Batignolles. Fantin-Latour's painting *Studio in The Batignolles Quarter* which was exhibited at the Salon of 1870 and is now in the Louvre, shows Manet surrounded by artists and writers including the painters Monet, Renoir and Bazille. Seen as the leader of a new school he had traditionally been associated with the Impressionist painters either as a forerunner or as one of their number.

It is difficult to arrive at an appropriate definition of the word 'Impressionism'[178] and thus to decide whether or not Manet should be claimed for the movement. The term was not coined until after the opening of the first exhibition of the *Société anonyme des artistes, peintres, sculpteurs, graveurs,* in 1874,

[175]Duret, 1906, 113.
[176]Duret (117) points out that the same sort of still life color accents were used in *Déjeuner sur l'herbe, Olympia,* and the portrait of Emile Zola.
[177]See above, Part I, 41–3.
[178]See above, Part III, 139, 142.
[179]Rewald, 318. Louis Leroy wrote an article which appeared in *Charivari* on 25 April entitled 'Exhibition of the Impressionists'. The term was presumably taken from one of Monet's offerings, *Impression Sunrise.* The word had been used in titles of landscapes previously without so forceable a critical reaction.

and then its first use was pejorative.[179] Manet chose not to exhibit with the group. The reason most often given is that he wanted to prove himself in the official Salons, and thought that sharing with the Impressionists might put him on the wrong track. In fact, he had a painting and a colored lithograph in the Salon of the same spring. It is probable however that ideological differences were even more a factor in his decision to refuse the invitation to exhibit with the new rebels.

One might logically call 'Impressionist' those artists who showed in the eight Impressionist exhibitions which took place between 1874 and 1886.[180] However, Degas had persuaded several more conventional artists to lend their paintings to the first exhibition, and the last exhibition included artists like Redon, Seurat and Gauguin. The exhibitors, then, did not have a unified style, and could hardly be grouped together on that ground alone. If instead one considers as Impressionist those artists who share similar stylistic qualities, other problems arise. It is generally thought that Impressionist artists shared an interest in landscape, in casual scenes of everyday life, and particularly in natural lighting effects of changing seasons and weather. Manet, Degas and Renoir were certainly more concerned with the figure than the landscape itself. As for the changes in time of day, weather and season, Degas was actively against working out of doors. 'Art is not a sport', he grumbled. Not only did he choose to work in the studio, but he re-drew from his own drawings after working from the model, thus removing his work still a step further from nature.[181] In the late 1860s Manet was still composing landscapes with figures in the studio from groups of quick drawings in his sketchbooks. According to Bazire, The Garden of 1870[182] was the first painting Manet made entirely out of doors. If this is so, his The Departure of the Folkestone Boat (Col. Pl. V) of the previous year is all the more remarkable since it so forceably conveys a sense of fresh air and strong sunlight. The scene is set against a clear blue sky and blue-green water, and there are spots of vivid color in the clothing of the waiting passengers, but the painting's luminous effect still depends heavily on abrupt contrasts of dark and light tones of blacks, grays, tans and whites. The paint is applied freely in relatively broad flat areas, but it should be remembered that Monet, in the late sixties, had not yet developed his method of building color areas with numerous small brush marks. His Terrace at Saint Adresse of 1866 shows greater refinement of detail, but similar simplified color application.

By 1874 when the first Impressionist exhibition took place Monet and Renoir were both moving toward the flickering surfaces usually considered typical of Impressionism. Their paintings already showed a smaller brush-stroke and more regular surface than Manet was ever to use.[183] Although

[180]See Rewald's chart of the participants in all the exhibitions, 591.

[181]R. H. Ives Gammell, The Shop-Talk of Edgar Degas, Boston, 1961, 22–4. Degas repeatedly traced his drawings to refine them when developing motifs for a painting.

[182]Bazire, 9, 65. Havemeyer Collection, New York.

[183]For examples see Rewald, 284, Monet, The Artist's Garden at Argenteuil, 1873; 285, Renoir, Monet working in his Garden at Argenteuil, 1873; 286, Monet, Duck Pond, and Renoir Duck Pond.

Manet did not exhibit with his friends, he spent some time in August of that year with Monet at Argenteuil.[184] If Manet had influenced his younger comrades in the 1860s, his landscapes of 1874 and 1875 show the marked effects of his experience working side by side with Monet on the banks of the Seine. His paintings at Argenteuil are certainly his most Impressionist works, yet even these have characteristics incompatible with Monet's development toward an atmospheric veil of luminous color. Characteristically, Manet combines in one work paint areas of differing textures according to the placement of objects in space or the importance of their focal position. *On the Banks of the Seine at Argenteuil* (Pl. 112) comes closer to achieving a more uniformly flickering surface like the river paintings of both Renoir and Monet of the same year. Small brush marks of clear colors comprise the foreground river bank, the striped dress, the rippling water and even the distant strip of blue sky. This optical effect was not to be repeated again in so definite a form. Manet's two paintings of the Grand Canal in Venice,[185] made one year later, are still composed of numerous active strokes, but the marks are larger in relation to the size of the canvas, they vary markedly according to the surfaces they describe, and black has re-asserted itself as an important color element.

Landscape paintings were traditionally lighter in tonality than indoor scenes, and this is certainly true of Manet's *oeuvre*. In general his works after 1874 revert to his personal color and value harmonies of clear lights played against sombre tonalities. With exceptions like the curious portrait of Pertuiset (Pl. 46) the broad and blunt color disjunctions of his earlier years give way to more agitated brushing and more integrated color relationships. His own increasing dexterity played an important role, but his close association with Monet had also helped in the development of his later style however much it remained his personal evocative poetry. In his essays on Manet, written in 1874 and 1876, Mallarmé wrote of 'Manet and his school', and grouped him with the 'Impressionists,' but Mallarmé's discussion of the paintings stressed qualities peculiar to Manet's art alone. He wrote of 'the represented subject, which being composed of a harmony of reflected and ever-changing lights, cannot be supposed always to look the same, but palpitates with movement, light and life',[186] but he was also concerned that these natural effects preserve the 'truthful aspect' of the thing seen. This 'aspect' is both less and more than an accumulation of simple perceptual data—less in that it can be achieved through a synthesis of perceived forms in space; more because such simplified forms can evoke far more of nature than paint could describe.[187] Manet had achieved an 'extraordinary oneness of nature and artistic vision', to use his friend Moore's admiring words.[188]

This achievement did not depend, however, on the repetition of active

[184]Hanson, *Manet*, 141–5.
[185]Shelborne Museum, Shelborne, Vermont, and Provident Securities Company, San Francisco, both of 1875.
[186]Harris, *AB*, 1964, 561, quoting from

Mallarmé 'The Impressionists and Edouard Manet', *Art Monthly Review*, I (1876), 119.
[187]Harris, 562.
[188]Moore, *Confessions*, 90.

brushwork alone. Unlike Monet and Renoir, Manet did not develop toward
richly active but homogenous surfaces. Instead his later paintings show a
variety of surface treatments. The critics were pleased with *In the Conservatory*
(Col. Pls. VI, VII) when it was shown in the Salon of 1879, since the faces and
hands were rendered in some detail and the entire surface covered fairly evenly
with opaque paint, the painting appeared appropriately 'finished'.[189] Only
a few months earlier, however, Manet had painted *Le Journal illustré* (Pl. 113,
Col. Pl. VIII) with the bare canvas showing through the freest of brushwork.
Both works are signed, suggesting that he considered them equally finished,
and certainly they both convey to the spectator the model's features and
personalities as well as the light and color of their surroundings. Together
the two paintings present for the 1870s the same contrast of a finished and a
sketch-like work that the two versions of *The Execution of the Emperor Maxi-
milian* offer for the 1860s. In both periods Manet seems to have worked from a
loose *ébauche* up through various stages of paint layers, stopping at any point
in this process when he had reached successful expression of the problems
of form, color and meaning. There is, however, a real difference between
Le Journal illustré and the Boston version of *The Execution of the Emperor Maxi-
milian*. The later work has been painted far more quickly and there is no
evidence of a brownish *ébauche* drawing under the light clear colors. Instead
brighter hues have been used from the start and the image built up quickly
with few changes in drawing. By the late 1870s Manet's developed craft
freed him from a dependence on past methods and allowed him to choose the
approach appropriate for the work before him.[190] He thoroughly understood
that the virtuoso brushing of *Le Journal illustré* described both a flickering
atmosphere and a vivacious character, while the more contained outlines of
the figures *In the Conservatory* expressed a quieter, more contemplative mood.

In spite of Manet's painterly approach to his craft, he seems to have admired
Ingres and to have valued the force of the effects the older artist could achieve.
Proust describes a portrait which Manet had made while still a student in
Couture's atelier.[191] It clearly reflected Ingres' influence and was heartily
admired by the other students much to Couture's intense annoyance. Among
the possible sources for Manet's *Lola de Valence* (Pl. 114) is certainly Ingres'
Madame Moitessier,[192] Lola's right arm with its heavy bracelet seems almost
an excerpt from Ingres' painting. The rounded form and icy precision of detail
is in marked contrast to the freely rendered black skirt with its vivid red flowers,
producing an optical effect as if the skirt were out of focus behind the more

[189]Hamilton, 211–12, 214–16.

[190]A number of Manet's other paintings
are constructed as directly as his *Journal
illustré*. See for instance his portrait of Isabelle
Lemonnier in the Ny Carlsberg Glyptothek,
Copenhagen. Others like *Blonde Nude* (Fig.
74) show opaque light tones built up over
thin colored washes, here clear green rather
than brown.

[191]Proust, 28.

[192]National Gallery, Washington. For a
discussion of other sources for *Lola de Valence*
see Hanson, *Museum Studies*, 66, and Hanson
in Finke, 154–5. For Emile Bernard *Olympia*'s
clean contours were reminiscent of Ingres
(94). Rosenthal *(Aguafortistes*, 127) quotes
Guichard as saying that the Olympia was
'almost a study by Ingres'.

linear arm and hand. Manet's awareness of these differences is pointed up
by a story told by Proust of Lord Leighton's visit to Manet's studio some time
in the late 1870s. *Skating* was on the artist's easel. "That's very good, but
don't you think Monsieur Manet, that the dancing figure and the contours
of the figures are not sufficiently arrested?' 'That figure does not dance, it
skates,' Manet answered, 'but you are right, it keeps moving, and when figures
move I am not able to freeze them on the canvas. I have been told on another
occasion, Monsieur, that the contours of the *Olympia* are too static. So that
makes up for it.'[193] The dapper gentleman painted in the background is,
indeed, in a most active pose, as he skates across the artificial ice in front of a
bustling crowd of onlookers. Although his figure is defined by strong dark
contours, the entire background is painted with an agitated brush in contrasting
flickers of dark and light, dull and bright colors. The foreground strokes are
larger and broader—so free, in fact, that the pink face and white bonnet of the
tiny child are hardly indicated at all. The spectators' interest is forceably drawn
to the main figure who is detached from her surroundings by a sharp contours
of her black shoulder and sleeve against the shimmering grays of the ice, and
of her forehead, cheek and chin against a darker mass of onlookers. Her head
and costume are painted with verve, but are nevertheless considerably more
detailed than the other figures or her surroudings. The result is a combined
effect of a strong presence of the handsome young woman and of the motion
and excitement of her world. By simplifying the facture of the foreground and
sides of the composition, attention has been drawn to the strong face and the
active figure which lies right beside it on a two dimensional plane, though far
behind it in illusory space. One does not, at first, realise that Manet is re-using
a favorite compositional device. A glance at his *Mademoiselle Victorine as an
Espada* (Pl. 49), however, shows a similar figure, momentarily diverted from
action, to stop and stare at the spectator, while in the distance behind her
shoulder, an exciting action takes place. The questions of Manet's space
construction are still to be discussed, but it is possible to see here that the change
in surface alone has effected a remarkable change in the sense of reality and
modernity which the later picture conveys.

The persistence of the assumption that sketchier works are somehow
'unfinished' serves only to limit or even prevent an understanding of the new
function of imagery in the mid-nineteenth century. The old idea that all works
should be brought to a certain level of finish is based on a belief that the
meaning of a picture rests directly on the story portrayed. The formalist
idea that a deeper kind of meaning can be expressed through the abstract
placement of forms, textures, and colors, regardless of subject, represents the
opposite extreme. By mid-century art could no longer be thought of as a
simple matter of imagination versus perception, mind versus senses. Neither
position can be used to explain Manet's art, which depends on the sensitive
combination of subject and execution for its expressiveness. The perception

[193]Proust, 89–90.

of image and the perception of meaning are closely interlocked. In Manet's last great masterpeice, *The Bar at the Folies Bergère* (Col. Pl. IX) it is not only color, composition and subject, but also the combination of surface effects which serve as his means for capturing the essence of modern life.

4. Composition

PAINT application has been discussed separately from composition, or drawing, because just such a separation was normally made in Manet's day. Couture expected students to learn to draw before they learned to paint, and it was assumed that preparatory drawings would be made before any painted picture was attempted. Drawing and painting were further separated in academic teaching method. Various kinds of drawing, from the cast, from life, anatomy and perspective were taught in the Ecole, while painting was largely taught in the artists' studios. Being preliminary and basic, it was in drawing that the composition was set, not only in terms of the placement of the figures in a manner best fitted to express the picture's message, but also the 'drawing' of the lights and shadows which would give them rotundity and establish them in space. The words 'drawing' and 'composition' were thus often interchangeable in the nineteenth century, although their meanings are quite different today.

Couture offers little specific advice about composition. There are sections on 'Composition' in both his 1867 book on methods and in the notes he left for an unrealized later edition, but these seem to be largely digressions offering general advice and encouragement rather than instructions as to how to proceed.[194] His reasons for this approach only gradually become clear. He feels that following the old rule of placing a well lit pyramidal group in the middle of the canvas and surrounding it with shadows is oversystematic and can produce disagreeable results.[195] Instead, he believes that new and personal methods had to be developed from the artist's own feelings about the subject to be portrayed.[196] He begins, then, by advising the aspiring artist to be guided by nature and by the great masters of the past, and recommends as good models, antique statuary for both forms and subjects, works of the Middle Ages and the Renaissance for Christian ideas, and the Venetians for a new realism.[197] 'These studies are necessary to give yourself a good language. As soon as you possess it, speak; but speak about your own time.'[198] He

[194]Couture, *Méthode*, 28, 'Principes élémentaires de la composition'; 245–82, 'De la composition'. *Couture par lui-même*, 123–34, 'Sur la composition'.

[195]*Méthode*, 248.

[196]This is not clearly stated at any one point but pervades the sections on composition. See, for example, *Méthode*, 270–71.

[197]*Couture par lui-même*, 125, and *Méthode*, 249–51.

[198]*Méthode*, 253. See also 265–6.

comments that the timid want their route to success mapped out for them, but that this can only result in repetitions and mediocrities. For true art, 'the unsatisfied echo of the spirit, the thirst for the infinite', the artist must strike out on his own.[199] In the light of these firm convictions, his repetitious and rambling encouragements to young artists become more understandable.

In many places throughout his writing he repeats his advice to observe nature, make quick sketches, draw in masses and omit details.[200] 'You should make it a habit to catch nature on the wing.'[201] Drawing in masses not only allows the artist to establish value harmonies quickly and successfully, but also to capture the model's actions and gestures.[202] As appropriate steps in 'composition' he suggests first making preliminary studies (*maquettes*) with elements taken from observation of nature; then broadly indicating color harmonies; next posing models in the positions already established and making quick drawings to establish gesture, light and shade. Finally, after such studies have been made they should be refined and traced on the canvas.[203] He speaks of 'the placement of the figures' without discussing the picture space as a whole. Elsewhere he advises the learner to begin with 'compositions' of two and three figures and work up to larger groups.[204]

For Couture, composition is nature correctly observed and correctly recorded. He notes that in the most admirable examples of ancient sculpture straight and curved lines are in perfect accord. 'Is this a system? No, it is the perfect knowledge of nature.'[205] His 'laws of beauty' seem to apply to the objects depicted rather than to the picture as a whole. The idea that one element on the picture plane should be adjusted to work well with another seems not to have entered his mind. He says simply that when a part of a painting causes trouble it is because it is badly executed.[206] Couture believes that formal differences come from expressive intent, and obviously assumes that his students, like the critics and the public, will understand that the message to be conveyed will dictate the disposition of motifs drawn from true sources—nature and earlier art.

Couture recommends using a horizontal and a vertical line, either actual or imagined, in front of the object to be reproduced. However, this is not a device for composing the surface of the canvas but one for assuring correct drawing by establishing reference points.[207] Nowhere does he give advice as to how to construct the space into which to place figural groups. He was apparently not alone in his disregard for the subject. While taken for granted as 'true', perspective drawing seems to have been rather casually practised by painters in the nineteenth century. Architects were expected to be proficient in mathematical perspective, but for painters exact construction seemed necessary only for pictures of buildings. 'How many painters today are familiar

[199] *Méthode*, 277–8.
[200] *Couture par lui-même*, 126; *Méthode*, 38.
[201] *Couture par lui-même*, 129.
[202] Ibid., 128; *Méthode*, 28.
[203] *Couture par lui-même*, 126. See also *Méthode*,
50, 249.
[204] *Couture par lui-même*, 130.
[205] *Méthode*, 48–9, in a chapter on drawing.
[206] *Couture par lui-même*, 131.
[207] *Méthode*, 27.

COMPOSITION 179

with perspective?' Léon Lagrange could ask in a review of David Sutter's new simplified book on the subject, and continue, 'Perspective today is nothing more in the eyes of the artists than a boring and obscure study, or a means of making money.'[208] Adhémar, who taught perspective at the Ecole des Beaux-Arts argued his cause in print, but admitted that he did so only for the sake of his conscience since he knew that painters would pay no attention to his words.[209] Concern for the quality of artists' education was expressed in an article by Violet le Duc in 1862, entitled 'The Teaching of Art: Something must be done'.[210] He bewails the low state of the arts in France and wonders if the new commission which has been formed to offer advice will be able to effect a change. He feels that education is the place to start. He seems to approve the general curriculum set up by the law of 4 August 1819 which provides for daily study from the antique and from live models and special courses in anatomy, perspective, and the history of antiquities. He notes that the details of the law were still being carried out, but to little effect. Teaching methods were confusing, some of the courses were followed by few students, and too many were learning outside the Ecole. A system of prizes, also set by law, was intended to encourage study, but the competitors for the Prix de Rome became worse year by year.[211] Adhémar reported that in 1832 or 1833 he had met a professor of the Ecole des Beaux Arts who came to judge a perspective competition. Adhémar asked him if there were lots of contestants and good results, only to hear his report, 'There was ONE ... and he didn't do a thing.'[212]

Nevertheless, the discussions of perspective in the pages of the *Gazette des Beaux-Arts* suggest that at mid-century there was a revival of concern with the problems of space construction which would interest not only the specialists, but the public as well. The casual intelligent reader, like Manet himself, could learn that David Sutter had just published a new book on perspective which started with the theory of vision rather than with geometry, and which was written in a manner so simple that the readers were taught geometry without knowing it. M. Sutter, while presenting his ideas with admirable clarity, nevertheless included in his work a section on the difficult and controversial problems of the intersection of curved surfaces.[213] A slightly earlier book review by Maurice of another work on perspective sheds considerable light on opinions about a system generally considered to be scientific and accurate since the fifteenth century. Adhémar had written a book on perspec-

[208]*Gazette des Beaux-Arts*, V (1860), 122. Léon Lagrange, review of David Sutter, *Nouvelle théorie simplifiée de la perspective*, Paris, 1859.

[209]B. Maurice, 'Nouvelles études de perspective par M. J. Adhémar', *Gazette des Beaux Arts*, IV (1859), 172.

[210]E. Violet le Duc, 'L'enseignement des arts, Il y a quelque chose a faire', *Gazette des Beaux-Arts*, Part I, XII (1862), 393–402; Part II, XIII (1862), 71–82.

[211]Violet le Duc, I, 394–7. Violet de Duc

recognized that young artists were interested in observing nature. Like Couture, he advised that they constantly draw from life 'here in Paris', I, 397, 400. Couture never mentions perspective drawing and felt that a long study of anatomy was useless. 'It suffices to know perfectly Houdon's flayed figure and to work from nature and the antique.' *Méthode*, 47.

[212]Maurice, 171.

[213]Lagrange review of Sutter, 122.

tive in 1839 and a new and corrected edition in 1859. In addition, he had just published 'Etudes supplémentaires', to complement this second edition. He begins by attacking Delécluze, who had discussed 'Picturesque perspective' in his review of the Salon of 1859 in the *Journal des débats*. We are thus presented with a three-way conversation between Adhémar, Delécluze and the reviewer, Maurice.[214] Maurice thinks Adhémar's system is perhaps a little too absolute; Adhémar finds Delécluze's opinions heretical. Delécluze speaks from the standpoint of the artist working from nature. For him the abstract principles and conventions of the 'science of perspective' (which he calls 'perspective savante') do not take into account the curvature of the horizon or the circle of human vision, and frequently result in unattractive anamorphoses.[215] Picturesque perspective would take these problems into account. Adhémar argues that there cannot be two kinds of perspective—there is only exact perspective, and that the problem lies not with the system but with those who don't understand it. He observes that painters make pictures of people and landscape. 'Why not architecture?' Because they don't know their geometry.[216] He argues intelligently with Delécluze that the curvature of the horizon is mathematically so microscopic that recording it could not make pictures more 'picturesque',[217] and feels that one cannot draw well unless one understands well what one sees. He is convinced that able painters can learn perspective principles by observing nature, but this takes years, while several months of geometry would have sufficed to achieve the same results.[218] For Adhémar, mathematical perspective represents truth to nature, a truth which would not allow for the doubts which the observation of nature was raising in the minds of artists and critics alike.

Adhémar is right in insisting that mathematical perspective works if both artist and viewer follow the rules, and particularly if they realize that a correctly constructed perspective drawing must be seen from a single, static viewing point. Only if the viewer takes a position at the right distance from the canvas and relative to the vanishing point in the picture will the convergence of the orthogonals appear to record the natural world.[219] The artificiality of mathematical perspective lies in the fact that the painter or viewer must look at nature from one point of view with one unmoving and unblinking eye. The system served well the need of the Renaissance artist to impose a clarity and formal order on the complex ideas he wished to express, and to give permanence to the haphazard world he saw around him. In the nineteenth century artistic

[214]Maurice's review concerns the second edition of Adhémar's *Traité de perspective*, published in 1859 and his 'Etudes supplémentaires', a small brochure of glosses on the book which he distributed to his friends. Maurice quotes liberally from Adhémar's own words.

[215]Maurice, 167–8.

[216]Ibid., 168–70.

[217]Ibid., 169.

[218]Ibid., 171–2.

[219]Ibid., 173, 175–6. Writers on perspective were generally aware of these limitations and ready to answer them with practical advice. A. Cassagne, *Traité pratique de perspective*, Paris, 1866, 13–14, explains that each eye gives a slightly different optical angle. For distant objects this difference is so slight that it need not be taken into account, but to draw objects close by one should close one eye.

interests had changed. Increasing observation of nature, new painting techniques to quickly capture that observation, together with a desire to express the passing world of modern life, required new methods. The old hierarchies gone, doubts cast on the very idea of absolute principles, the new sciences demanded observation and experiment, not repetition of rules. If Sutter could discuss perspective from the standpoint of the function of human vision, it was not only in order to teach geometry by a painless method, but because there was an interest in 'why?', not just 'how?'.

Adhémar wanted elaborate history paintings, full of figures and architecture, and high moral ideas; he wanted them hung on the wall at the appropriate eye level and he wanted his spectators to see them from precisely the proper point of view. Then the truth was obvious. But the painter who worked out of doors before constantly moving foliage and constantly changing light, the gallery goer whose eyes roved over the scintillating surfaces of their new records of nature, had a different truth—the reflection of their own changing observations and changing beliefs. Adhémar accused Delécluze of giving no adequate definition of his 'picturesque perspective',[220] but since in the artists' practice observation had so largely replaced rule he might have been hard put to describe an approach which was unsystematic by its very nature.

The overt rejection of mathematical perspective was to come many years later in Cubist paintings and Cubist tracts. The artists of the nineteenth century had no program for rejecting the system the Ecole still taught, but men like Manet, Degas and Cézanne were gradually to discover how to record the casual world of modern man as seen by modern man himself.

If space is not to be systematically hollowed out through perspective construction, it can be forceably suggested by the volumes of the figures and objects depicted. Gradations of values can convincingly describe solidity and thus create the space to contain it. It is clear that for Couture 'composition' involved not only the choice and arrangement of subject, but also the establishment of chiaroscuro.[221] It would be easy to be misled by his constant repetition of the advice to see in masses and to capture quickly the most significant lights and darks [222] into thinking that he approved of blunt steps from one value to another without the use of intervening half-tones. Apparently he did not feel the need to stress what he thought obvious—that developed chiaroscuro was necessary for a finished work. While he insists that masses be established *first* he advises that the details can, and should, be added to the properly placed masses, such details naturally requiring the use of graduated values.[223] Proust stresses the fact that Manet found Couture's values heavy and false and wanted to simplify passages from light to dark areas in his own painting.[224] He tells of an occasion when Manet found a portrait Couture was working on

[220]Maurice, 168.
[221]*Méthode*, 54.
[222]See above, 150 and *Méthode*, 56–9.
[223]*Couture par lui-même*, 118–19. It was customary for the artist to prepare graduated tones on the palette. See Bouvier, Lesson XVIII, 207–29, and Corot, *Pensées et écrits*, I, 82–3.
[224]Proust, 16–17.

too 'encumbered by half-tones,' only to have Couture's irritated answer, 'You refuse to see the succession of intermediary tones which lead from shadow to light.'[225] Manet's response reads like a manifesto for his early style, though it must be remembered that Proust's memory of his precise words may have been far from accurate or, at least, deeply colored by his knowledge of the paintings which followed the incident. 'The light presents itself to me with such unity that one tone is sufficient to render it, and it is preferable, even if it seems brutal, to pass brusquely from light to dark than to accumulate things the eye cannot see and which not only weaken the vigor of the lights, but attenuate the coloration of the shadows which are important to render in correct values.'[226] According to Proust, his admiration for *The Little Cavaliers*, a painting in the Louvre then thought to be by Velasquez was based in part on his appreciation of its blunt value contrasts. 'That's clean! How one is disgusted with stews and gravies!'[227] Manet's interest in the painting led him to copy it in oil, and then in etching (Pl. 115). The print even more than the painting captures a strong sense of outdoor light as a result of the simplification of value areas.[228]

We have already seen that systematic linear perspective had been called into doubt as an artificial system which differed from the way the eye recorded nature. Similarly, the careful gradations of value used to ensure the solidity and rotundity of forms regardless of their natural lighting conditions could be seen as artificial in contrast to the vivid veil of color which nature offered the perceptive observer. Landscape was traditionally allowed different rules and greater freedoms than history painting. It was well understood that an outdoor scene could have completely different coloration than one which took place away from natural light. Bouvier, for instance, recommends a brownish *ébauche* for beginning an oil painting of a figure, but suggests for the preliminary drawing under a landscape ultramarine blue slightly lightened with white, bluish grey, or on a warm orange ground a variety of colors, the choice depending on the desired natural effects.[229]

The observation of nature in the increasing practice of *plein air* painting toward the middle of the century undoubtedly laid the groundwork for a more open acceptance of new influences when they arrived.

Manet was thus free to discover from outdoor light what Zola referred to as his own 'law of values'.[230] His personal approach was certainly obvious to Degas who wrote from New Orleans, 'The light here is so strong that I have not been able to do anything here on the river... Manet, more than I, would see beautiful things. One loves and one brings to one's art, that which one is used to ...'[231]

[225]Proust, 31.

[226]Ibid., 32.

[227]Ibid., 24.

[228]Hanson, *Manet*, 39 41. Bazire (114) wrote of Manet's prints in general, 'There, more than ever, is the light he is looking for.' 'Là, autant que jamais, c'est la lumière qu'il cherche.'

[229]Bouvier, 238, 409 Osborne (275) re-commends a yellow-orange ground for a summer landscape effect.

[230]*Mes haines*, 307.

[231]Marcel Guérin, *Lettres de Degas*, Paris, 1931. Letter to Henri Rouart, 5 December 1872, 9. These remarks not only refer to Manet's preference for brightly lit subjects, but also to Degas' poor eyesight which he dared not risk by painting in too strong light.

If Mallarmé can be cited as the critic who best understood Manet's art of the 1870s and 1880s, Zola is certainly the best spokesman for the value composition of the pictures of the 1860s. Certainly Manet had often been counseled by his own teacher to see in masses and to record them on the canvas. Zola realized what Couture had not, however, that Manet chose his values and his colors so precisely that he could allow the simple masses to remain unrefined and achieve a surprising relief without intermediate gradations of values.[232] 'I don't know if it is possible to get a more powerful effect with less complicated means', he said of *The Fifer*.[233] In describing the effect of Manet's paintings among the weakly sweet works of other artists at the Salon, Zola says simply, 'They break the wall!'[234] Bazire was later to say of the same picture 'this jaunty urchin, so jauntily painted, lively and gay, detaches itself from the dark background as if he were about to walk out of it.'[235]

Not every critic understood what Manet was doing. His work is still today spoken of as 'flat'.[236] Even Manet's friend, George Moore could see his seizing three or four points and leaving the spaces in between unaccounted for as a 'deficiency' in Manet's painting.[237] Courbet had thought that the *Olympia* looked like a playing card, and in 1867, Zola was already defending Manet against the accusation that his works looked like the popular wood-block prints called *Images Epinals*.[238] The simplified color areas of such prints are often cited as sources for Manet's simplified forms and flat colors. It is true that Manet drew subject matter from popular illustrations, or, to be more exact, he used subject matter which also appeared in such illustrations because he was interested in portraying similar scenes from modern life. Despite this connection, Manet was probably not influenced by the style of naive commercial art in itself. Zola noted the difference between the raw blocky colors of the 'Images Epinals' and Manet's carefully chosen tones and values,[239] and it should be remembered that many of the other popular illustrations which might have served as sources, though inelegantly drawn, were rendered in a full gradation of values.

Despite the primitive appeal of some contemporary illustration, Manet seems to have been more concerned with the struggle to record his own vision of the modern world. Here other influences were to play a part—the photograph and the Japanese print. Both seen as reflecting nature, as realistic in their own terms, they had a profound influence on nineteenth-century French artists. It is difficult, if not impossible, to establish a chronology. The history of photography is still obscure, and it is hard to know just when and how each stage of scientific development affected the kinds of images which could be produced, and how and when those images came to the attention

[232]*Mes haines*, 221, 223, 257, 307.
[233]Ibid., 222.
[234]Ibid., 223.
[235]Bazire, 22–3.
[236]Courthion, 12. Sloane, *French Painting*,
181.
[237]Moore, *Modern Painting*, 43–4.
[238]*Mes haines*, 267, Hamilton, 69, Sandblad, 70–71.
[239]*Mes haines*, 344.

of artists. Similarly, although we know approximately when the flow of Japanese art into France began, we know far too little about the precise images which were first seen.[240] In summary terms, however, it is fair to say that both the photograph and the Japanese color wood-block print raised questions about the illusion of space. These questions might be divided, as we have divided out general discussion, into the charting of space itself, and the suggestion of volume, and thus spatial depth, through the use of values. Both prints and photographs were accused of looking 'flat' and oversimplified, although in both cases there was great disagreement as to whether these qualities were falsifications of the truth or Truth itself. There is no need here to solve such arguments, or even to review them fully, in order to see that they might deeply affect the thinking of artists who were already concerned with re-evaluating past methods of creating spatial illusions in the light of the needs of modern man to express his own life in suitably vivid and active terms.

[240]Hanson, *AB*, 1971, 543–5.

5. Japanese Art

IT is important to realize that the vogue for things Japanese included far more than wood-block prints on paper, and that even among these there were great differences in motif and style. Chinoiserie had long been popular for the decorative arts, and as soon as they were available Japanese fabrics, screens, fans, and ceramics all quickly found active European markets. Further, the fine arts—sculpture, painting, and brush drawings—were brought from Japan by discriminating collectors, who may have shared with the Japanese themselves disdain for the cheaper and more popular prints of recent date.[241] The interest in Japan was not entirely new. Collections of Japanese art had existed in Europe many years earlier, and objects from the Siebold Collection in Holland were illustrated in French journals even before the opening of Japan to European trade.[242] Manet's friend Duret traveled to Japan in 1870 with Henri Cernuschi who returned to France with objects of considerable value. There can be little question that Manet was familiar with the collection, since he painted Tama, a little dog which Cernuschi and Duret had bought in Japan, with a Japanese doll on the floor in front of him.[243] Exactly what the collections included is unknown but contemporary books and articles on Japanese art include a few illustrations which give some idea of its range.[244] One of these, a brush drawing of a crow, was Manet's model for the bird in his lithographs for Mallarmé's translations of Poe's *The Raven* (Pl. 95).[245] Manet's tiny illustrations for Mallarmé's *Afternoon of a Faun* (Pl. 94), are based instead on drawings in Hokusai's *Mangwa*

[241]Sandblad, 76, notes that there were no wood-block prints in the Exhibition of 1867. The best early source of information about the Japanese craze in Paris is Ernest Chesneau in 'Le Japon à Paris', *Gazette des Baux-Arts*, XVIII (1878), 385–97, 841–56. Chesneau, 387, mentions Manet first in his list of artists who frequented Madame De Soye's shop where things Japanese could be bought.

[242]See above, Part II, n. 123.

[243]Paul Mellon Collection, Upperville, Va.

[244]See for example Louis Gonse, *L'Art japonais*, 2 vols., Paris, 1883. Other early sources are: Aimé Humbert, *Japan and the Japanese*, London, 1874. Humbert was in Japan as a minister plenipotentiary of the Swiss Republic in 1863–4. His work appeared in two French editions. The English version and a translation of the second. It is illustrated with European engravings after Japanese works (or photographs of them). Albert Jacquemart, 'L'art japonais au Palais de l'industrie', *Gazette des Beaux-Arts*, VIII (1873), 281ff, 446ff, IX (1874) 52ff. Works of Theodore Duret including *Voyage au Japon*, Paris, 1874; 'L'art japonais, le livres illustrés, les albums imprimés, Hokusai', *Gazette des Beaux-Arts*, XXVI (1882), 113–32, 300–19, 'L'art japonais', in *Critique d'avant garde*, Paris, 1885.

[245]Hanson, *Manet*, 149 and Hanson, *AB*, 1971, 545.

(Pl. 116),[246] which was well-known to his circle in Paris in the 1860s. Bracquemond, who taught Manet etching techniques, had used motifs from the *Mangwa* as decorations for a tea service which was exhibited in the Exhibition of 1867.[247] The *Mangwa* comprises fifteen volumes of facsimiles of Hokusai's sketchbooks, laboriously produced in Japan in woodblock. Few of the pages represent unified scenes. Instead they are collections of little motifs informally scattered over the sheets, making excellent sources for designs in a Japanese manner. Some of these drawings are cartoon-like renderings of people going about everyday tasks; many more are quick observations of nature—insects, plants, animals—and thus in their own way reflections of everyday life. Any French artist who followed Couture's advice to 'catch nature on the wing' would have had similar sketchbooks full of unrelated little drawings.

In the case of Manet's illustrations and a few drawings it is possible to point to the *Mangwa* (Pls. 117, 118) as a precise source.[248] He seems also to have been influenced in more general terms by the compositional arrangements and value distinctions of separate prints by artists like Sharaku, Haronobu, Utamaro, and Kiyonaga.[249] These works, of considerably larger size, showed scenes of everyday life in Japan or portraits of popular figures such as actors, fighters, and courtesans. Thus, they were parallel to many popular prints and illustrations showing aspects of everyday life in France.[250] It is clear that curiosity about an unknown people was a strong reason for the French interest in Japanese prints. Not only could they see pictures of the interiors of their homes and bath houses, but pornographic prints had made their way to France as well. George Moore recalls a visit to Zola when he saw the walls of the stair well were covered with Japanese pictures of 'furious fornication'.[251] Several writers have seen the influence of Japanese prints in the strong contours and value contrasts of the *Olympia*.[252] The subject was quickly recognized in France as a modern courtesan, and therefore a view of intimate French life not unlike the intimate views into Japanese life which many wood-block prints provided.[253]

It is hard to establish whether the French saw Japanese art as naturalistic

[246]For brief descriptions of the Mangwa see J. Hiller, *Hokusai*, London, 1955, 44; and the Introduction of James A. Michener, *The Hokusai Sketchbooks: Selections from the Mangwa*, Rutland Vermont and Tokyo, 1958.

[247]Gabriel Weisberg, 'Félix Bracquemond and Japanese Influence in Ceramic Decoration', *The Art Bulletin*, LI (1969), 277–80; and Yvonne Thirion, 'De l'influence japonaise sur la peinture français dans la seconde moitié du xixᵉ siècle', unpublished Ph.D. dissertation, University of Paris, 1947, 17.

[248]Hanson, *AB*, 1971, 544–5, Figs 1, 2, 3, 4. Motifs on pages of the Mangwa are shown to have been almost directly copied by Manet for one of the illustrations for Mallarmé's *L'Après-midi d'un faune*, and for a pencil and watercolor drawing in the Louvre, Cabinet des Dessins.

[249]One of which appears on the wall behind Zola in Manet's portrait of the writer of 1868. See above, Part II, n. 100. For an excellent summary of Japanese influences, see Sandblad, 71–7.

[250]In a letter to Arsène Houssaye (1861), Baudelaire referred to Japanese prints as 'images d'Epinal du Japon'. See Sandblad 73, 84–5. Louis Aubert, *Les Maîtres de l'estampe japonaise*, Paris, 1914, 17, remarks that the subjects of Japanese prints are like 'nos images d'Epinal'.

[251]Moore, *Confessions*, 248. For information about erotic Japanese prints, Philip Stanley Rawson, *Erotic art of the East*, New York, 1968.

[252]Sandblad, 79.

[253]See above, II, 96–8.

because the subject matter was largely natural, or whether they also saw truth to nature in the refreshing simplicity of the forms and colors themselves. Chesneau, writing on Japanese art in 1878, said that the Japanese had developed a synthetic way of expressing nature and stressed their primary dependence on nature.[254] As we have seen, more than one critic regarded seeing nature in masses as natural—that is to say as reflecting nature's appearance. Their quarrel was that the eye alone was not enough and that man should improve on the raw data collected from nature by adding to it what he knew intellectually as well.[255] Today we speak of Japanese forms in terms of their abstract qualities, but it would be an anticipation of later history to claim that the French artists who were influenced by Japanese art in the 1860s and 1870s were mainly interested in trying to develop synthetic forms. Their concerns were still too focused on problems of perception.[256] Japanese influence in France seems to have come in two great waves: the first from the middle of the 1850s to about 1880 when it served to provoke new ways of seeing; and the second at the end of the century, concurrent with Synthetism and Art Nouveau, when it provided delightful sources for decorative elements and a new understanding of the expressiveness of abstraction.

The absence of linear perspective in Japanese wood-block prints might have struck the average Frenchman as a singular curiosity. A few prints do show orthogonals converging toward a central vanishing point, but only when the spectator looks into a building frontally. Probably the few existing examples of this type were influenced by western art.[257] Normally the receding planes of architectural spaces are indicated simply by the use of parallel diagonal lines—a device sufficiently effective to create a strong sensation of space.[258] Size diminution is also effectively used in Japanese pictures to suggest depth, and a powerful effect is often obtained by the use of a large form cut off in the foreground plane which serves psychologically to connect the spectator to the scene and also to create the illusion of a more distant picture beyond this framing device. The use of a high horizon line can create spatial tension by seeming to flatten the receding spatial plane while asserting its depth through the diminishing size of the forms placed on it. In landscapes, continuing planes are broken by sea, fog, mountains or other natural devices, so that depth is read by sequences of planes or layers seen either as above

[254]Chesneau, 844, 854. Sandblad (75–6) points out that William Michael Rosetti spoke of Japanese landscapes as having 'direct naturalistic treatment', and that their 'strange effects of nature' were remarked on in the Goncourts' diary in 1864.

[255]In his criticism of the 1868 Salon, Thoré said of Manet 'When he has put on his canvas the 'spot of color: by which an object or person appears in its natural surroundings, he thinks he is done.' Obviously further refinements were expected. Here quoted from Hamilton, 123–34. In Art and Industries in Japan (London, 1878, 82) Sir Rutherford Alcock expressed a widely held view about the Japanese. 'They never produced a picture, because the princi-

ple element of pictorial art is wanting—light and shade.'

[256]Zola talks of Manet seeing in masses, 'after analysis, the synthesis', (Mes haines, 258), but for Zola synthesis is directly connected to the initial perceptions.

[257]Perspective prints, called Uki-ye, were sometimes used for depicting dramatic scenes. Hokusai made two illustrations of Act I of the Chûsingura, the earlier version in European perspective, the later using diagonal parallel lines. See Hillier, Hokusai, 26, nos. 22, 23. See also 34, no. 29.

[258]A single diagonal line on a white sheet of paper will suggest recession into illusory depth.

each other or behind each other. This approach is surprisingly close to nature, far more 'natural' than the rational order of much western landscape. All these means of creating space could suggest new approaches to French artists, particularly when they seemed to reaffirm elements observed in nature itself.[259]

As early as 1878 Chesneau was prepared to argue that the Japanese were not ignorant of perspective and modeling. He explained that placing the point of view (the horizon) very high in the pictorial format might go against western conventions, but did not break the rules of mathematical perspective. He felt their approach quite appropriate to capture the picturesque qualities of the mountainous landscape which was often seen from high vantage points.[260]

The use of a frequently repeated motif in Japanese prints as a source for the pose of *Mademoiselle Victorine as an Espada* has already been discussed. In this painting the silhouette is strongly reminiscent of the dark forms of actor and courtesan prints. The painting so clearly quotes Goya in the use of a motif from his *Tauromaquia* for the bull fight which is seen in the distance behind Victorine's shoulder, that the idea of a Japanese source for its placement seems driven out by the power of the Spanish imagery. However, many scenes of Japanese life (Pl. 53) present a ground plane which rises sharply to a high horizon on which distant objects in small scale seem to appear almost suspended behind the head or shoulders of standing figures. The examples, like the models for the figure of Victorine herself, are so numerous that precise choices are difficult to make.[261]

In *The Battle of the Kearsarge and the Alabama*, the water with the distant sea battle appears to have been seen from a high promontory much in the manner of many Japanese views of landscape and water. The relative intensity of the entire blue-green surface tends to make the surface seem curiously flat, as if related to the surface of the canvas as much as to the illusion of depth. Hiroshige's whaling scene (Pl. 119)[262] is an example of a type of wood-block print where some aquatic action takes place on a broad expanse of blue water which rises to a horizon high on the pictorial field. Manet's 'perspective' in

[259]Chesneau, 396, points out that French artists took from Japanese art qualities which had affinities with their own gifts and confirmed their personal manner of looking at nature.

[260]Ibid., 844. One wonders if Chesneau were acquainted with Delécluze's arguments for 'picturesque perspective'. See above, 180.

[261]Part II, 80–2. The sheer number of prints in France make it difficult to cite precise sources. By 1878 Chesneau reported that thousands of prints had reached France, 387. However, it is possible to point to a recurring practice in Japanese art, that is the use of small, supposedly distant objects or figures located in the two-dimensional plane near or at the level of the head of a large foreground figure. The following are some examples: Louis Aubert, *Les Maîtres des*

l'Estampe japonaise, Paris, 1914, Plate XXVII, Utamaro, showing a standing woman with little boats in the background. J. Hillier, *Japanese Masters of the Colour Print*, London, 1954, Figure 27, Buncho, and Fig. 57, Utamaro. It is interesting to note that in these and other examples the background figures are active, the large foreground figures still.

[262]See also Hillier, *Hokusai*, 111, and Pl. XVII. Duret, 1919, 99, recognizes that Manet painted *The Battle of the Kearsarge and the Alabama* as if from a boat or a cliff from which he would see the water mounting up like a plain to the horizon. In other words, he sees the high horizon as a possible natural effect. Jules Claretie, *Salon*, 1872, spoke of *The Battle of the Kearsarge and the Alabama* as being treated 'a bit too much in the Japanese style'. Here quoted from Hamilton, 157.

The Battle of the Kearsarge and the Alabama (Pl. 85) became the butt of the cartoonists' humor. According to Cham, 'The Kearsarge and the Alabama, thinking Manet's sea improbable, have gone off to fight on the edge of the frame.'[263] Stop went further, ' . . . not caring for the everyday bourgeois laws of perspective, Manet has given us a vertical slice of the ocean so that we might read on the fishes' faces their impressions of the battle taking place over them.'[264] They may have found the sea unnatural, but there were others for whom Manet's seascapes presented 'Nature herself'. Barbey D'Aurevilly saw the expanse of sea not only as a powerful and direct visual record, but as a vehicle for any expression of the passions of the event. He seemed to feel that Manet has succeeded in escaping 'the vaunted and execrable culture which corrupts us all.'[265] Mallarmé, too, was anxious to forget the systems of the past.

If we turn to natural perspective (not that utterly and artificially classic science which makes our eyes the dupes of a civilized education, but rather that artistic perspective which we learn from the extreme East—Japan for example) and look at these sea-pieces of Manet, where the water at the horizon rises to the height of the frame, which alone interrupts it, we feel a new delight at the recovery of a long obliterated truth.[266]

Manet was by no means the only artist whose 'perspective' was criticised. His *The Incident in the Bull Ring* which was harshly attacked and subsequently cut into fragments, was clearly related not only to the *Dead Soldier* in the Pourtales Collection, but also to Gérôme's *Death of Caesar* (Pl. 58). Gautier, writing in 1864, when the work was exhibited, advised Manet to consult a handbook on perspective,[267] and the usual explanation of the dismemberment of the canvas is his distress over just such criticism.[268] However he would already have had sufficient warning against using Gérôme's format if he had read Maurice's *Gazette des Beaux-Arts* review of Adhémar's book on perspective. Like *The Incident in the Bull Ring*, *Mademoiselle Victorine as an Espada*, and *The Battle of the Kearsarge and the Alabama*, Gérôme's *Death of Caesar* is drawn from a high vantage point—an impossible position for an artist or spectator to hold. Adhémar says that this treatment has been explained on the grounds that the entire space of the Senate is suggested, as if it were part of a larger composition. Nevertheless he found this a poor approach believing that the perspective should be drawn for each particular scene in reference to the placement of the principle subject of the picture.[269] Although Adhémar clings to a conservative position, he nevertheless recognizes exactly the effect which this kind of pictorial organization can have—that is to suggest to the spectator that he is looking at a 'slice of life', a portion of an action which continues beyond

[263] *Journal Amusant*, 2 June 1872, here quoted from Hamilton, 156.

[264] Stop, *Journal Amusant*, 25 May 1872, here quoted from Hamilton, 156.

[265] *Gaulois*, 3 July 1872, here quoted from Hamilton, 158–60.

[266] *Art Monthly Review*, 1876, 119, here quoted from Harris, 218.

[267] *Moniteur*, 25 June 1864, here quoted from Hamilton, 59.

[268] See above, Part II, 82–5, for a fuller discussion of this picture.

[269] Maurice, 174–5.

the borders of the picture itself. For Mallarmé, this method 'of cutting down pictures' allows the artist to create paintings which have the reality and informality of scenes from nature, arbitrarily selected by framing with the hands.[270] In the perceptual terms which Mallarmé describes it becomes a device for the Impressionist painters, more than for Manet.

Similarly the Japanese devices of cutting off forms which appear to be compressed close to the picture plane, or using such cut forms as framing devices for more distant scenes, are more commonly used by Degas and later Toulouse Lautrec. However, Manet's *Boating* (Pl. 109) in the Metropolitan Museum would probably not have been possible without the combined effects of observation of nature and the Japanese methods for hollowing out space.[271] Manet's use of borrowed motifs and stylistic devices is far less overt in the 1870s than it had been in the 1860s and such influences are less easy to isolate and define. Perhaps only one other painting of the decade can be so precisely related to Japanese sources, *The Railroad* (Pl. 120) of 1873. Two figures, a seated woman and a little girl are placed close to the picture plane immediately in front of the railings of a metal fence. Through the fence, and radically diminished in size one sees the smoke filled rail yard. Once again sources are numerous. Japanese courtesans were popular subjects for wood-block prints, They are frequently shown in their quarter in Yeddo called 'Yoshiwara' against bamboo window dividers which separate figures in the frontal plane from the distant action in the landscape beyond (Pl. 121).[272] While this picture construction was hardly as startling to western eyes as the use of high horizons or thrusting diagonals there is a sharp contrast in size between the large foreground figures and the small background forms. This indication of depth is held in tension by the intervening screen which reasserts the picture plane through its rhythmic repetitions of parallel lines.

When *The Railroad* was shown in the Salon of 1874 it brought on a storm of criticism. Its Japanese sources went unnoticed but not its broad facture. Manet was accused of having attained 'the heights of painters of tavern signs' and even a favorable critic found the simplified areas of the woman's face and hands 'unfinished'.[273]

[270]*Art Monthly Review*, 1876, 119, here quoted from Harris, 561.

[271]For examples of Japanese prints with large forms cut off in the foreground see Hillier, *Japanese Masters of the Colour Print*, no. 22, Isoda Koryusai, 'Feeding Carp', bridge cut off in the foreground; Hillier, *Hokusai*, 31, Pl. 4, 'Mimigura in the Snow'; Aubert, Pl. XLVI, Hiroshige, 'Lever à lune, au crepuscule sous le pont Riyogaku', large bridge cut off in foreground. Joris Karl Huysmans, *Voltaire*, 1879, noted that in *Boating* the boat was 'cut off by the frame as in certain Japanese prints'. Here quoted from Hamilton, 217.

[272]An excellent comparison for Manet's *The Railroad* is *Two Celebrated Lovers*, Hillier, *Hokusai*, Pl. II. My thanks to Anne Van Buren for pointing out this source. Other examples of prostitutes in front of slatted window openings are Hillier, *Japanese Masters of the Colour Print*, Kiyonaga, *A Night of the Ninth Month*, Fig. 33; and Moronobu, *On Parade in the Yoshiwara*, in *Masterpieces of Japanese Prints*, Art Institute of Chicago, 10 March—17 April 1955, no. 11. Like *The Railroad*, Manet's *Skating* does not seem obviously dependent on Japanese sources. However, a similar composition with a major figure pressed against the front plane can be found in Aubert, Pl. XXI, Harunobu, *Jeune femme et son petit garçon chassent les lucioles.*

[273]Hamilton, 174.

If we turn from the spatial box to the objects which it contains, wood-block figures often seem flat, in the sense that they appear to deny the illusion of spatial recession. The method of cutting strong contours into wood and inking them with clear colors provided none of the graduated half-tones which Europeans had been trained to expect. By some the Japanese were thought ignorant of western methods; Chesneau again came to their defence. He pointed out that eleventh-century Japanese wall paintings in the Exhibition of 1867 fully demonstrated their ability to render the most delicate illusion of relief in light and shade, and argued that their suppression of chiaroscuro in the decoration of objects was appropriate for things which were to be moved and handled. He avoided applying such 'rules' to the ubiquitous wood-block print, which goes unmentioned in his article.[274]

Chesneau was remarkably sensitive, however, to the qualities in Japanese art which influenced French painters: Stevens, certain delicacies of color; Tissot, curiosities of composition; Whistler, finesse in sketching; Manet, the frankness of pattern and spirit of strange forms; Monet, the suppression of detail in favor of impression; and Degas, the 'realistic fantasy' of his group scenes like the café concerts.[275] Few of these men adapted Japanese vision to their own imagery without considerable modification. Half-tones may be radically suppressed in favor of frank pattern in Manet's *Olympia* or the *Mademoiselle Victorine as an Espada*, but they do exist. To the new artist, wedded to his own perception of the world under natural light, however, the heavy chiaroscuro of past art seemed to belong to the Museum, not to the immediate life they wanted to express. Sandblad thought Manet's early pictures had a museum-like quality typical of his age, and believed that the Japanese wood-block provided the 'decisive impulse' which led Manet to his own personal form of realism.[276] Zola described it as having a 'sweet brutality', and it was Zola who understood what might most appeal to Manet in Japanese art. Rejecting the accusation that Manet's pictures were like '*gravures Epinals*', he pointed out that although their processes were sometimes similar, the popular printers used raw tones without thought to their values, while Manet sought precise relationships. 'It would be much more interesting to compare this simplified painting with Japanese prints which more nearly resemble it in their strange elegance and their magnificent shapes.'[277]

The inclusion of a portrait of a Japanese actor with its strong contours and value contrasts into Manet's portrait of Zola (Pl. 37) confirms the writer's observation. It shares space on the wall behind Zola with an etching by Goya after Velasquez' *Drinkers* as if to acknowledge simultaneously Manet's debts to Spanish and Japanese art. A photograph of Manet's *Olympia* overlaps the print and half-covers the Spanish etching. As relatively small details in a larger work, all these illustrations have been simplified. The result is that light and dark patches in both the Olympia and the Japanese print seem more abstract, and a dependence on simplified seeing seems stressed in both exam-

[274]Chesneau, 845–6. [276]Sandblad, 71.
[275]Ibid., 396. [277]Zola, *Mes haines*, 258–69.

ples. Similar strong shapes appear as essential qualities in many of Manet's paintings of the 1860s, *The Fifer* and *The Balcony* (Pl. 45) being among the more obvious examples, and the frequent accusation of the critics that Manet's painting was unfinished and 'flat' often results from the domination of shape over western devices for insuring an illusion of depth. A certain amount of conventional 'drawing' in terms of value gradations does appear in both works, but the sharp contrast of the little boy's black shoes and white spats, or the vivid green of the balcony railing hold these elements in a frontal plane. When Berthe Morisot spoke of Manet's paintings as being like 'unripe fruit' she undoubtedly had in mind her blunt portrait in *The Balcony*. 'I am more strange than ugly', she said.[278]

[278]Morisot. Letter from Berthe to Edma, 2 May 1869, 26–7. *The Balcony* combines Spanish and Japanese influences. It is clearly based on Goya's painting, *Majas on the Balcony*. See Sandblad, 104–5, and Hamilton, 133–4, 139, 140.

6. Photography

IN summarizing Manet's work in his large exhibition of 1884, a hostile critic and conservative painter said he had been influenced by the Spanish, then the Japanese, and then the photograph, 'for he sees certain realities of things like the photograph and he errs in his values like photography.'[279] The effect of photography on Manet's art is even more difficult to evaluate than that of the Japanese wood-block print. The writer suggested a neat order, first Spanish, then Japanese, then photography, but actually all these influences, combined with observations of nature, converged and overlapped, sharing in common blunter value contrasts than those generally accepted by conventional French painting with its careful gradations of tones. Remarks in the visitors book in Manet's studio where *Le Linge* (Pl. 1) and *The Artist* were shown when they were refused at the Salon of 1874 amply demonstrate the hostility towards Manet's rejection of the traditionally idealized canvas. 'The strict imitation of nature is barbarous art, the triumph of the Chinese.' 'It is photography.'[280] The writers were apparently not experts in oriental art, but they clearly knew what they liked and it was not to be found in the strange simplifications of Manet's painting.

Years earlier photography had received a welcome from many quarters as a potential aid to the artist. The first volume of *Les Français peints par eux-mêmes* even predicted that pictures of the future might have a different look since the camera could produce landscapes in which no one hour of the day would resemble another.[281] Delacroix found photography a useful tool[282] as later did many other artists like Meissonier, Degas, and Manet.[283] More than one writer, however, saw dangers in the artistic use of the new science, or 'industry' as Baudelaire called it. To him photography would serve as a 'refuge of every would-be painter, every painter too ill-endowed or too lazy to complete his studies.' Worse, it would 'ruin whatever might remain of the divine in the French mind.'[284] Baudelaire was even concerned that because

[279]G. Dubufe fils, 'Manet', *La Nouvelle Revue*, XXVI (1 February 1884), 588.

[280]Bazire, 96.

[281]*Les Français peints par eux-mêmes*, Paris, 1840–42, I, xiii.

[282]See *Correspondance générale*, 5 vols., Ed. André Joubin, Paris, 1936–8, 196, 7 March 1854; and Beaumont Newhall, 'Delacroix and Photography', *Magazine of Art*, XLV (November 1952), 300–3.

[283]Aaron Scharf, *Art and Photography*, Baltimore, 1969, Chapter 4, 40–51 and Chapter 8, 162–6.

[284]*Oeuvres complètes*, Exhibition of 1859, 'Le public moderne et la photographie', 1031–6. He chides the public for its appetite for curiosities and the artist for his desire to astonish. Photography should be no more than a humble servant to the sciences and the arts.

of its literalness it encouraged the French love of pornography. 'Even women look at it.'[285]

About's dicussion of photography is more restrained. He saw it as a means of making faithful copies of the visual world, but he noted that people could walk past exhibited photographs with a curious indifference. 'The view of the most beautiful objects mechanically transposed leaves us cold.' The photographic industry may help to put nature on canvas, but it does not create art, because art requires selection.[286] Much of the basis for criticizing Manet's apparent 'naturalism' lies in his lack of the sort of 'selection' or idealization which About thought necessary to make images of nature meaningful and elevating. About's view was surely that of the majority, but there were important dissenting voices. As early as 1839 Jules Janin had observed that photographic realism, devoid of artistic elaboration, could hold the interest of the curious viewer and even take on an artistic character.[287] With the increasing use of naturalism in literature as well as painting such 'artistic character' and even a modern kind of meaning would have become obvious to many men of Manet's generation. His friend Moore held firm against it in fear that it would lead artists away from the necessary observation of nature itself, but he understood that the invention of photography had brought about real changes in the perception of the external world.[288] Like the Japanese print it provoked the more original thinkers to question how they saw.

The camera, a 'petrified Cyclops',[289] seemed to reassert mathematical perspective since both systems require a single fixed and unmoving point of view, but its summation of detail and its simplification of light and dark areas seemed strange to eyes trained to the artist's more complete and intellectualized vision. Like perspective, it required considerable control. About pointed out that it functioned well when the subjects of a photograph were all located on one plane, but that photographs of deep space could produce disturbing distortions, orthogonals which too quickly converged, or grossly enlarged objects in the picture plane.[290] Since Leonardo, writers had been aware of just such distortions in mathematical constructions where the spectator (camera) was not located with real knowledge of the effects its position might produce.

It seems that the entire question of the construction of pictorial space had been reopened by the second half of the nineteenth century. The observation of nature with its 'picturesque' and unmeasurable elements, the introduction of different spatial systems from a vastly different culture, even the apparent confirmation of traditional systems in the new and mechanical form of the photograph, so unlike the moving focus of human vision, all conspired to open

[285]Baudelaire, *Oeuvres complètes*, 1034.

[286]Edmond About, *Nos artistes au Salon de 1857*, Paris, 1858, 30, 31.

[287]*L'Artiste*, 25 August 1839, here quoted from Rosenthal *Romanticisme*, 357.

[288]Moore, *Modern Painting*, 'The Camera in Art', 182–6.

[289]Aaron Scharf, 'Painting, Photography, and the image of movement', *The Burlington Magazine*, CIV (1962), 190.

[290]About, 158–9.

the way for new means of expressing spatial depth, and new uses of that depth for conveying ideas. There is no reason to think that Manet attacked the problems of space from an intellectual point of view. He may have read articles on the photograph and on perspective; he could even have read Leonardo's *Trattato*; but everything we know of him as a man suggests that his spatial inventions resulted from his own taste and his own vision as he gradually developed his personal style.

As for pictorial format, photography is often credited with inventing the 'snapshot' or the 'slice of life' type of composition. The careful preparations necessary for making early photographs, and the long exposure times, would not have encouraged the sort of hasty image collecting of the later amateur. Figures were often carefully posed in the manner of the works of noted artists. While street scenes and casual landscapes were to appear by the 1850s it is not easy to decide whether their apparently arbitrary cropping preceded the influence of similar effects in Japanese prints, or for that matter, of the direct observation of nature itself. The primacy of one influence or another can perhaps never be resolved.

There can be little question that Manet was familiar with the most advanced photography of his own day, though there is not sufficient evidence to conclude that he, himself, was a photographer, nor to guess what kind of pictures he might have made. Tabarant claims to have owned a photograph of fishermen taken by Manet and signed and dated 1873.[291] It is not clear whether this was a picture of the actual scene or of one of his own paintings. The inventory of the Thomas Evans collection, which included paintings by Manet, also listed a photograph 'by Manet' of a stag in the forest,[292] a subject which seems more appropriate to Courbet's tastes. We have no idea what it might have looked like. In the Fogg Museum there is a drawing on the back of a photograph of Manet's painting *Spring*, which was apparently used by him in preparation for an etching of the same subject.[293] It seems that the photograph had been held up to the light and a fresh drawing made along its basic outlines on the photographic paper.[294] It is an example of the inventive use of the new science, but while we might logically assume that Manet had made the photograph himself there is no evidence to support that view.

As for Manet's other uses of photography, Baudelaire's etched portrait which was carried into three plates, was directly drawn from a photograph of the poet by Nadar,[295] and paintings such as his portrait of his parents, *Angelina, Madame Brunet*, and later *Emilie Ambre as Carmen* (Pl. 122), all show

[291]Tabarant, 116–17.

[292]Typed list copied from original inventory among objects and papers left by Evans to the University of Pennsylvania, now housed in the Library of the Thomas W. Evans Dental Institute of the University.

[293]De Leiris *Drawings*, no. 588 and Figs 423, 424, 425.

[294]On the Fogg Drawing see Carl Chiarenza, 'Manet's use of Photography in the creation of drawing', *Master Drawings*, VII (Spring 1969), 38–45.

[295]Guérin, nos. 36, 37, 38. Hanson *Manet*, 63. The photograph is illustrated in Scharf, 41, Figure 29, and in Harris *Graphic Works*, 134. Harris' catalogue numbers for the three plates are 46, 60, 61. Sandblad, 64–5, named the photographer as Carjat, taking his information from Moreau-Nélaton, II, 109–11. Neither illustrates the photograph.

the distinct effects of the summary lighting of early photographic portraits. Like many Parisians, Manet kept a photograph album. It is largely comprised of commercial pictures of his friends. Many are missing; some have been identified in writing, others are clearly recognizable. A few of these pictures were used as 'sketches' for Manet's paintings of figures such as Clemenceau, Rochefort, and Madame Brunet. Clemenceau's portrait (Pl. 104) amply demonstrates the typical simplification of light areas across the brow and down the nose common to both Manet's painting approach and to the frequently overlit 'carte de visite' of his day.[296] Manet undoubtedly used photographs as well as engraved illustrations in working out his various versions of *The Execution of the Emperor Maximilian*, and it is reasonable to assume that he followed the same method for his *The Escape of Rochefort*.[297] The effects of his sources are difficult to assess. Artists with conventionally acceptable styles also made use of photographs in preparation for paintings, but they used them as they might have used a preparatory oil sketch or *ébauche*, for their general indication of forms, and they added the detail and value gradations which the photographs so often lacked in order to heighten the story of moral message. For Manet, instead, the photograph offered a blunt record of nature as the human eye sees it in 'masses' of different values, devoid of imposed interpretation, mechanical and unfeeling. It was exactly this new, direct vision which could survey the world with the accuracies of science and the cool detachment of a fashionable dandy, which must have appealed to Manet's desire to reflect the spirit of modern life.

While Manet may have adopted the value contrasts of the photograph and its unselective naturalism, he avoided the stasis of its space construction in favor of the delights of flickering atmosphere seen with the normal human vision of two moving eyes.

[296]Courthion, 23–6, mentions the inclusion of these photographs in Manet's album. He illustrates the photographs and their companion paintings: *Madame Brunet* (Private Collection, New York), Figs. 6, 7; *Clemenceau* (Louvre, Paris), Figs. 47, 48; *Rochefort* (Kuns-thalle, Hamburg), Figs. 49, 50. He also illustrates Nadar's portrait of Manet which shares many of the same characteristics. Fig. 45.

[297]Scharf, 42–9, Figs. 33, 35, 37, 39, 41. Courthion, 35, Fig. 50.

7. Manet's 'Compositional Difficulties'

OF all the qualities of Manet's art, his picture construction has been least understood. He has been charged with faulty composition not only by his own contemporaries, but by writers of the present day.[298] It is hard to believe, however, that his paintings would have their extraordinary presence if their structure were actually so contrary to human vision and to human understanding. Zola avoided the entire question by stating firmly that Manet simply set himself in front of nature and recorded what he saw. 'Composition has disappeared. There are only familiar scenes, one or two figures, sometimes a crowd seized at random ... '[299] It is obvious that Zola closed his eyes to the facts of Manet's frequent borrowings from the masters and quotations from his own works. Like most other artists, Manet had to achieve his apparent spontaneity through a more laborious route than simply copying nature, by putting together selected elements and creating a newly unified whole. Corot was once discovered painting a landscape scene which stretched before him. Asked where he saw a beautiful tree which he had put in the picture, he pulled his pipe from his mouth and without turning around, pointed it at a chestnut tree directly behind him.[300]

It must be remembered that the very word 'composition' has subtly changed its meaning in the last hundred years. Now used to indicate not only the placement of illusionistic forms, but the organization of color and shapes on the two-dimensional surface, it can be discussed separately from the story or meaning of a picture. In the nineteenth century, when the duty of craft was to explicate subject, no such abstract separation was possible. To 'compose' a picture meant to draw the forms and figures which would present the idea through details and gestures,[301] not through the poetry of color harmonies and rhythmic forms. Not that such harmonies and forms did not exist, but they were thought of as an extra delight and were considered secondary to the intellectual message. Thus advice about composition would have necessarily centered on the knowledge of history, of perspective, of anatomy, and of gesture, and would have been of little aid to the landscape artist or the painter of modern life, each of whom had to select from the multiple stimuli of his vision, elements to express a condition rather than a narrative. Neither the

[298]See above, III, 137.
[299]Zola, *Mes haines*, 307.
[300]Corot, *Pensées et écrits*, 91.

[301]Thus Zola could say, 'that which is called composition does not exist for him.' *Mes haines*, 259.

conventional rules for composing a history painting, nor the twentieth-century rules for composing an abstract design were applicable to Manet and the Impressionists who had to create new methods appropriate to evoke a mood, to produce an effect, to capture the intangible spirit of their age.

Once again, Manet began by using some of Couture's advice, and then, through trial and error, developing his own approach. Couture had inspired him to admire the masters, and had trained him to copy in the museums, and it was natural that he would have drawn his early motifs from art as much as from nature. He had also followed Couture's advice to sketch constantly and quickly, collecting an extensive vocabulary of natural forms. Couture recommended setting models in the positions taken from sketches after nature[302] (as well as from the poses in great works of art), and Manet seems always to have needed to work directly from the model. No artist, however, can set up simultaneously all the models and props needed for an elaborate compositional scheme, and it is in putting together elements separately drawn from nature that Manet's composition differs from that of the past. It is here that Couture had no further advice, and Manet was left to find his own way.

We have already discussed the way Manet composed *The Old Musician* (Pl. 11) from a wide range of sources selecting figures both for their forms and for the meanings which they carried with them.[303] Arrayed across the frontal plane of the canvas they appear like the enumeration of a series of ideas, but their very separation and isolation provide them with a new collective meaning. It is tempting to describe Manet's earlier paintings as experiments which lead eventually to the more integrated canvases of his last years. In one sense such a development occurred, but paintings like *The Old Musician* and the *Déjeuner sur l'herbe* for all their qualities of the pastiche, and their aroma of the old masters, are complete works, their ultimate expressiveness depending precisely on their apparently naive conjunctions of subject and form. We have also seen that Manet did not abandon a motif once he had successfully used it. *The Absinthe Drinker* reappeared as an important character among the figures in *The Old Musician*, and again in drawings and a print.[304] Further, Manet seems to have cut up his paintings, not just because he felt despair over his failure to compose in an accepted mode, but because by giving a figure a new format he gave it a new meaning as well.[305]

Manet's use of the masters as models for his lower class genre and costume pieces and his history paintings might have seemed inappropriate for pictures of modern life. *The Concert in the Tuileries* is a pastiche of Manet's own sketches of his friends and colleagues rather than of figures from earlier art, but Sandblad has realized, that underlying this obviously fashionable contemporary scene, was the structure of a supposed Velasquez which gave the painting

[302]See above, III, 178.
[303]See above, Part II, 61–6.
[304]De Leiris, *Drawings*, nos. 147, 147a, 148. Guérin, no. 9.

[305]See the discussion of *The Incident in the Bull Ring* above, II, 82–85; and the later use of the figure of *The Dead Toreador* in Manet's lithograph, *Civil War*, II, 119–20.

another layer of meaning.[306] By the end of the 1860s Manet had left behind his references to Western painting, and had turned instead to the suggestions of the contemporary illustration, the photograph and the Japanese print, but his own drawings from nature served him even more. Preparatory drawings exist for paintings like *On the Beach at Boulogne*, *At the Races*, and some of the seascapes,[307] and it is reasonable to believe that he made many more similar drawings for other works.

It is not Manet's collection of motifs in quick sketches which is unusual, but his singular method of combining those motifs. It is exactly this which has been so widely misunderstood. In recent years, the question of Manet's 'compositional difficulties' has been raised once more. In his otherwise perceptive and informative book *Edouard Manet, Paintings and Drawings*, John Richardson coined that unfortunate phrase. For him, Manet's paintings of the 1860s were 'badly composed, out of scale, incoherent, especially if the composition involves a degree of recession or indicates two or more isolated figures or groups ... '[308] Two scholars immediately came to Manet's defense: Alain De Leiris in an article on *The Beach at Boulogne* (Pl. 123), one of the pictures which Richardson found badly composed; and Alan Bowness in a direct answer to Richardson in an article called 'A note on Manet's Compositional Difficulties',[309] which he ends with the words, 'It is always unwise for the critic or historian to castigate a great artist for his apparent mistakes and deficiencies: better try to understand why things appear as they do. We do not censure Manet's elimination of half-tones, why should we be so critical of his "compositional difficulties"?'[310] In a very brief statement without illustrations, Bowness attempts to lay the groundwork for such an understanding. Citing the *Luncheon in the Studio* and *The Balcony* as examples of composition which none of Manet's contemporaries could rival, he believed that Manet was trying to develop 'something strikingly new'[311] which would assert his instinctive feeling for the flatness of the canvas. 'He is not concerned with illusionistic space, and will sacrifice to make the space as shallow and restricted as possible.' Bowness sees what others call 'faults' as deliberate experiments. He proposes that Manet, either knowingly or unconsciously, used proportion systems to organize his canvases, and sees the Golden Section numbers as the underlying structure of the *Concert in the Tuileries*, and a double square with right angle triangles behind *On The Beach at Boulogne*. Unfortunately he does not include any diagrams to make his thinking clear, and it is

[306]See above, II, 67. For drawings for the *Concert in the Tuileries*, see Sandblad, 19–20, Figs. 7, 8; De Leiris *Drawings*, nos. 170, 171, 172, 173, 174.

[307]De Leiris, *GBA*, 53–62; and De Leiris *Drawings*, nos. 240–81. For *At the Races*, De Leiris, nos. 204, 205, 206, 211; the seascapes, nos. 202, 302, 303, to cite only a few examples. The controversy over whether or not Manet was present when the battle between the Kearsarge and the Alabama took place comes about in part because of Zola's conviction that Manet painted what he saw on the spot. If, instead, his actual method was to collect separate figures and details in quick sketches, the question of his presence at any precise moment has less importance. See above, II, 121–3.

[308]Richardson, 13–14.

[309]De Leiris, *GBA*, and Bowness, *Burlington*, 276–7.

[310]Bowness, *Burlington*, 277.

[311]Ibid., 276.

difficult to find indications of such systems among the myriad small marks and color accents scattered across the surfaces of the two works. Bowness also points out in general terms, the fact that Manet often stresses the picture plane by allowing 'figures and objects in different planes in space' to touch on it by relating them to the edges of the picture. Concerning the *Mademoiselle Victorine as an Espada* he says that Manet 'is surely trying to relate on a single plane, the bull-fighting scene in the middle distance and Victorine's arm in the foreground.'[312] These are important observations, but Bowness' conviction that Manet was interested primarily in surface, prevents him from noting the extraordinary tension which results from the simultaneous depiction of spatial depth and assertion of the canvas as an object with its own reality.

De Leiris offers quite a different approach to Manet's aims and methods by analyzing *On the Beach at Boulogne* and discussing Manet's relationship to Impressionism. He illustrates several drawings which Manet made at Boulogne in the summer of 1869 and explains that 'Manet's intention, in the painting, was to transcribe, essentially unaltered, the sum of individual studies made from life.'[313] Thus Manet has moved a step from Couture's procedures in which quick sketches were used only as indications for later study from more formal poses by using not only the figural positions and gestures indicated by the sketches, but their spontaneously simplified forms as well. As for their organization, the individual groups retain their 'un-expected but characteristic isolation, a series of discoveries freely reunited in a composite scene.'[314] In speaking of 'successive components' or a 'series of discoveries' he touches on an essential quality of the picture, that its elements are observed and understood sequentially, not with the totality of instant 'impression' expected in both academic studies and Impressionist paintings, and mechanically offered by the photograph. He believes that Manet developed this unity by the early 1870s when 'The painting itself becomes the initial sketch or record, rather than a composite of distinct and final visual impressions', but found him returning again to 'the aesthetic autonomy of each image' in his later works.[315]

These two articles go far in suggesting bases for the understanding of Manet's singular methods which seem to rest on two related aims: the need to capture the activity of the modern world through the activity of normal sight, and a tendency to signal the tension between the illusion of real depth and the reality of the canvas surface. If these aims seem schizophrenic because they appear to stand undecided between the clarity of intellectual intention of earlier subject painting, and the total abstraction of later twentieth-century art, it must be remembered that such arbitrary divisions made by historians cannot be fairly used in judgement of a man who properly belongs to his own age. Manet was not alone among the more inventive artists in the nineteenth century in clinging to the illusion of the real world as a basis for his art, and

[312]Bowness, *Burlington*, 277. [314]Ibid., 57–8.
[313]De Leiris, *GBA*, 57. [315]Ibid., 60–61.

at the same time, through the craft itself, of changing the character of the canvas away from its function as a window. The assertions of surface in works by Monet, Cézanne, Van Gogh or Gauguin have been frequently discussed, and a look back at history shows how their new thinking eventually brought about the Cubists' witty questioning of the very nature of reality and illusion, and the Dadaists' proposals, extended to contemporary conceptual arts, which challenge the definition of art itself. While Manet might fairly be seen as a progenitor in this long development, it is hardly reasonable to propose that he was consciously aware that his personal sensitivities to the decorative elements of the pictorial surface might ultimately call into question the very intentions of painting. Instead like many of his contemporaries, his interests seem to center on means of expressing what he saw and what he felt about the world around him.

There is a very slight and somewhat irregular curvature in the horizon line of *On the Beach at Boulogne*. Correctly drawn mathematical perspective with its arbitary abstractions would have required a straight line parallel to the edges of the picture. The variations in the horizon might have resulted from Manet's having pieced together several drawings of the distant boats, but it is also a phenomenon often observed in nature when a considerable expanse of water and sky can be taken in at a glance. This curvature of space, or curvature of bi-focal vision, has provided a challenge for theorists since Leonardo, and in Manet's own time it had been discussed in terms of 'picturesque perspective'.[316] It is highly unlikely that Manet was involved in the theoretical details of arguments over space construction, but his repeated use of a slightly curved horizon in several seascapes confirms his pragmatic acceptance of his own fleeting observations (Pl. 124).[317]

The unifying geometry of mathematical perspective with its rigid requirement of a single point of view might have been appropriate for the expression of a Renaissance belief in rule and order, but the apparently random organization of a picture like *On the Beach at Boulogne* or the *View of the Universal Exhibition* (Pl. 125) express more intimately the casual enjoyments of the seaside and the park. Perspective rules require that figures diminish in size in exact proportion to their distance from the spectator, but in both these pictures figure size is often arbitrary.[318] The result is to break the sense of spatial unity, to reverse the expectation that the entire scene can be realized all at once, and instead to invite the eye to jump from group to group, as it would in viewing an actual scene on a beach or in a park. The preservation

[316]See above, 179–80.

[317]*Sortie du port de Boulogne*, Art Institute of Chicago, 1864; *Arcachon: beau temps*, Private Collection, New York, 1871; *Marine*, Cleveland Museum of Art, 1873; *Marine: temps d'orage*, Matsukata Collection, Tokyo, 1873; *Marine: temps calme*, Wadsworth Atheneum, Hartford, 1873.

[318]Richardson sees this as an error on Manet's part. Bowness, *Burlington*, 277, n. 10, argues that a man with Manet's thorough training could have made correct perspective constructions. He surely knew, if only from observation, the more general rules of diminishing figure size. However, in view of the carelessness of perspective training at mid-century and Couture's apparent lack of interest in the subject, I doubt that Manet had much knowledge of the details of mathematical perspective.

of the separate and sequential character of Manet's sketches in his finished work is not just a matter of revealing his process but, as De Leiris rightly says, of 'revealing the artist's initial visual experience of the scene.'[319] This visual experience involves moving the eyes, if not the head or entire body. It is extremely difficult, even experimentally, to stabilize the human eye, but recent experiments confirm what medieval opticians asserted, that the eye is literally blind when not in motion.[320] It cannot take the static position of the camera or mathematical theory and still function. The nineteenth-century artist would not have needed medical information or philosophical theory to know this, since the increasing practice of *plein air* painting revealed in more practical terms the problems of capturing the constantly moving and flickering natural world with the normal scanning motions of the human eye. Manet's compositions involve different kinds of motion, different kinds of sequences, at different periods in his career. *The Old Musician* can almost be read from left to right like a chart. The *Concert in the Tuileries* is far more complex because of the large number of figures both across the surface and into depth, but the important portraits can be enumerated across the second plane into depth starting at the extreme left with the self-portrait of the artist. The sheer density of the crowd in the garden and the rhythmic repetitions of the tree trunks gives a unity to the casual groupings of chairs, children, parasols and elegant clothes. By contrast, in the *View of the Universal Exhibition* and *On the Beach at Boulogne* the groups are separated by large areas of open space and are disposed not only across the surface but at different distances from the frontal plane. No suggestion is offered by their placement, their coloration, or their gestures, as to where the viewer should begin or what order he should follow in reading the scene. Consequently he jumps haphazardly from point to point in patterns much like the normal 'tracking motions' of the human eye in the brief period when it quickly scans a visual image in order to recognize its characteristic features.[321] We have already pointed out that Manet

[319]De Leiris, *GBA*, 57.

[320]R. L. Gregory, *Eye and Brain: The Psychology of Seeing*, London, 1966, 42–4, 46. E. Llewellyn Thomas, 'Movements of the Eye', *Scientific American*, CCXVI (August 1968), 88–95. David Noton and Lawrence Stark, 'Eye Movements and Visual Perception', *Scientific American*, CCXXIV (June 1971), 34–43. L. A. Riggs, and A. F. Ratliff, J. C. and T. N. Cornsweet, 'The disappearance of steadily fixated test objects', *Journal of the Optical Society of America*, XLIII (1953), 495–501. For a discussion of medieval views of optical perceptions see Alessandro Parronchi, *Studi su la dolce prospettiva*, Milan, 1954, 'Le misure dell' occhio secondo il Ghiberti', 321–7, on excerpts from medieval writers in Ghiberti's Third Commentary. In relation to the size discrepancies in Manet's painting, it is worth noting that objects seen in central (foveal) vision are overestimated in size, and those perceived in the peripheral visual field are underestimated. See Jean Piaget and Bärbel Inhelder, *The Psychology of the Child*, New York, 1969, 38. In normal perception motion parallax is an important indicator of object size and spatial depth. A good explanation of the effects of this phenomenon can be found in D. L. MacAdam, 'Stereoscopic perceptives of size, shape, distance and direction', *Journal of the Society of Motion Picture and Television Engineers*, LXII (1954), 271–9, 288–9. While this article deals with motion pictures, the problems are the same as for the illusory depth of still pictures where it is not possible for the eye to see around the edges of depicted objects.

[321]Noton and Stark, 37, show a drawing of the head of Queen Nefertiti, together with a record of the eye motions of a subject viewing the drawing.

never adopted the uniform surface textures of Impressionist painters like Monet or Renoir which seem to serve as a kind of equivalent for the retinal veil. The closest he comes to such a surface treatment is in his *Argenteuil*, or *Blue Venice*, (Pl. 112, 126) where he uses many small repetitious brush strokes. However even in these paintings there are more broadly painted areas, particularly the black boats, which rupture the flickering surface and assert the identity of specific objects. The later works select and contrast elements even more, so that the brush itself, like a conductor's baton, indicates the continuing action of perception from one point to another.

If Manet breaks the unity of spatial depth in his canvases and denies a uniform surface texture, he nevertheless respects the picture plane in his own personal way. Bowness noted that he often relates objects or figures to the edges of the picture. He probably had in mind works like *The Battle of the Kearsarge and the Alabama* or *Marine* where flags fly on the masts of boats located deep within the pictorial space. In each case, however, an edge of the flag exactly parallels and almost touches the edge of the canvas, coming exactly to the overlapping edge of the frame. Such a conjunction of forms with the pictorial surface stresses the remarkable patterns of the dark boats on the blue-green water and almost seems to challenge the illusion of depth.[322] The avoidance of overlapping in the seascapes tends to reinforce this effect, as does Manet's use of blacks.

Pure blacks were consistently avoided by both academic painters and Impressionists, though for entirely different reasons. The painting manuals of the nineteenth century suggested various combinations of browns, blues, and sometimes other hues as well, to create 'blacks' which would have life and warmth and would relate to the coloristic harmonies of the entire canvas. It was thought important that darks and lights be linked with half-tones, and an isolated black would create too great a jump from one value to another. For the Impressionists, of course, the rejection of black lay in a conviction that no black exists in nature, black being the complete absence of light.[323] But for Manet it was an essential element of his style serving both his need to describe his age and his taste for elegant forms. Throughout his career Manet used large areas of black and near-black color in his major forms. The intense absorption of light by dark colors, particularly the dark blues, grays and blacks worn by the well dressed gentlemen and ladies in his circle, makes it impossible to see changes in value which would describe the volume of the figures. What is difficult to see in normal light conditions is further obliterated by intense light and ignored by the lens of the camera. Thus Manet's use of

[322]Théophile Gautier, père, described the surface as seeming like the rising floor of a stage. While this for him was a negative criticism, it points out the use of raised surfaces to make the action which takes place on them more easily visible. Gautier's criticism and other aspects of the composition of Manet's seascapes of 1864 and particularly *Harine*, Philadelphia Museum of Art, are discussed in Hanson, *AB*, 1962, 332–6.

[323]The Impressionists' use of color related far more to observation than to scientific theory. For a sane discussion of their color use see J. Carson Webster, 'The technique of Impressionism: A Reappraisal', *College Art Journal*, (November 1944), 3–22.

unmodulated blacks and near blacks are an element of his realism. At the
same time, his love of strong value contrasts, reinforced by his admiration for
Spanish and Japanese art, led him to use blacks to establish silhouettes as
isolated focal points in space, but unifying patterns on the two-dimensional
plane. It is not only the drawing of objects like the boats with their obedient
flags which created tensions between surface and depth, but also his choice
of color and value which often make their positions seem to fluctuate within
the illusory spatial field. Although Manet renders many areas simply, with
little internal modeling, the use of the world 'flat' is inappropriate to describe
his pictures. The intensity of a hue or the strength of a value establishes its
position in spatial depth in relation to the tones which surround it, but this
position is retained only if it agrees with other space indicators such as the
overlapping of forms. The intense green of the railing in *The Balcony* holds
it in a foreground plane, but the repetition of the same green for the umbrella
in the young lady's arms and the shutters behind the figures gives the picture
a vivid life by seeming to alternate between compressing and expanding
space. Such effects repeat many times in Manet's *oeuvre* as if perversely avoiding
the kind of aesthetic resolution which might endanger the vitality of his art.
In discussing his 'painter of modern life', Baudelaire had said that in the
trivial aspects of daily life there is constant rapid change which requires of
the artist an equal speed of execution.[324] We have already seen how the
dancing contours and varied paint textures of *Skating* (Pl. 91) keep the picture
perpetually alive.

In *The Bar at the Folies Bergère* (Col. Pl. IX) all the elements of Manet's
genius seem to be fortuitously combined. It becomes impossible to discuss
subject apart from craft in this last great work, because the essence of the
subject—modern life itself—can only be realized through the kind of viewing
required by its multiple forms. The barmaid standing in front of the large
mirror is a representative of a genre type, the pretty young working girl,
already too wise, gazing bluntly into our own world. If *The Dead Toreador* can
be seen as an iconic representation of the cold indifference to tragedy, here
is the symbol for cold indifference itself—not tragic, just part of the everyday
repetitions of ordinary life. Many explanations can be offered for the mirror
images behind her. We seem to see the reflection of her back, and just beyond,
the figure of a dapper gentleman. Although crowded into the upper right
corner of the painting, his head is dominantly large in proportion to the
reflected barmaid and one is repeatedly drawn to search his abbreviated
features again and again. Who is this man? It has been suggested more than
once that he is *you*, the spectator. It may well have been Manet's intention to
make the picture seem an extension of the viewer's world. The blunt gaze
of Mademoiselle Victorine in the *Déjeuner sur l'herbe*, the cat, hissing at an
intruder, in the *Olympia*, show his predilection for continuing his story beyond

[324]*Oeuvres complètes*, 1155. '...il y a dans la
vie triviale, dans la métamorphose journa-
lière des choses extérieures, un mouvement
rapide qui commande à l'artiste une égale
vélocité d'exécution.'

the confines of the pictorial field, but this mirror image will not stand up to rational analysis. It is impossible to chart a position for the imagined spectator which would explain the placement of his mirror image and still allow for the angle of the orthogonal on the edge of the reflection of the marble bar. Probably Manet never intended that such a static position be inferred. There are further curiosities. The daydreaming barmaid is rendered in tighter contours and stronger silhouette than the other figures. She stands coldly detached, timeless, neither reacting to any event which may have occurred, not predicting any future action. Contrary to expectation, normal mirror images do not blur or soften reflected forms. Instead they often give the effect of heightening details. A realistic rendering of a mirror might capture some reflections on its surface, but would not blunt its imagery. However, the barmaid's reflection is not only rendered with a looser brush, but the contours of her sleeves and her corseted waist are obscured. She seems considerably less stiff and frozen than her counterpart, her torso more relaxed, leaning slightly toward the man as if to engage him in conversation. There is a strong contrast between the lonely modern individual isolated by her firm contours and her own reverie from the activity which surrounds her, and her other self, sociably serving a customer, a part of the fugitive atmosphere of a French *café-concert*. This interpretation would be impossible were it not for the noticeable differences in finish in different parts of the picture which constantly draw the eye in and out of focus and create apparent fluctuation of space. Nor does Manet leave us to quietly contemplate only these larger forms. The eye is invited to savor the seductive textures of the sparkling bottles, the flowers, the fragrant oranges, and to search the crowd in the hopes of recognizing a friend. We are rewarded with the portraits of Gaston Latouche, Méry Laurent and Jeanne de Marsy among the more anonymous figures of the spectators, and we discover the feet of the trapeze artist reflected above their heads, seen for only a passing moment. The round white gas lights on the background columns serve to punctuate the scene. Although evanescent light, they seem more solid than the crowd, which is rendered with such a hasty facture that it seems constantly out of focus, constantly in motion. The confusion of forms suggests an equal confusion of sounds, the clink of glasses, the performers' music, and the chatter of agitated conversation. Stasis and action in perpetual balance, Manet had admirably fulfilled Baudelaire's admonition that the modern artist must extract from the ephemeral and transitory the poetic and eternal qualities of his own age.[325]

[325] *Oeuvres complètes*, 1154, 1163–4, 1192.

Conclusion

'IF Manet's genius could be reduced to a formula, it might be stated as his gift for extracting from the undifferentiated visual whole of everyday life just those aspects which we see and feel as qualitatively "modern" rather than chronologically "contemporary".'[1]

'La vie moderne', the spirit of modern life in nineteenth-century France, has long since become just another chapter of history. Distant from our own age it offers the romantic appeal of a period of optimism and discovery. The vivid images of its gardens and its race tracks, its parks and cafés, all peopled with well dressed gentlemen and ladies, serve as admirable settings for those delightful moments when we can recreate through literature or through imagination, the stories of an age irrecoverably past. The clothing of the ordinary man, which seemed ugly to his contemporaries (even to Baudelaire) now appears elegant and charming rather than immediately fashionable. What, then, can the artist be expected to preserve if he records precisely those superficial elements of dress and manners which though 'modern' one day will seem historical the next? It is obvious that Hamilton felt beneath the exterior surfaces which Manet so brilliantly portrayed the new isolation of the modern individual, whether willing or not, detached from his past by the myriad complexities of modern life. With only a few exceptions, Manet's paintings depict moments of peace and pleasure. But close beneath that superficial skin is a psychological portrait of Baudelaire's modern hero, facing an unknown future with nothing more than his 'outer husk' of appearances to protect his inner vulnerability. It is this man (and woman) who is still very much with us a century later. The complexity of our own lives makes his image all the more poignant, since in us his dilemma remains unresolved.

It is in his poetic recognition of the state of modern man which Manet differs so greatly from Courbet. Historians have made a just and natural connection between the two great realists. Courbet had been a rebel leader in elevating casual genre subjects to a new monumentality; his private exhibition at the Universal Exhibition of 1855 had inspired Manet's similar private exhibition in 1867. Courbet had intentionally chosen his title 'Pavillon de Réalisme', and the dominance of his great work, rejected from the official

[1]Hamilton, 280.

exhibition, *The Studio of the Painter: A Real Allegory*, fixed a definition of 'realism' in the public mind. Although the sources of Courbet's genre subjects, his revolutionary tendencies, the political and moral aspects of his work, all still require further understanding, it is obvious that his aims and his methods were vastly different from Manet's. Zola, who claimed to have suggested to Manet that he hold a private exhibition, saw no resemblance whatsoever between the two artists.[2] He spoke of Courbet as 'realist in his choice of subject, classic in his tone and facture.'[3] Certainly Courbet himself found Manet's *Olympia* flat and lacking in half-tones, his own color harmonies depending on the unifying effects of warm grounds and value gradations. Proust quotes Manet's lament against greasy scrapings of the palette knife and bituminous colors, 'Courbet did not disdain that cuisine, but he took the easy route: he is wrong.'[4] Proust, too, was wrong in his recollection of Manet's words, for certainly the palette knife was for him a favorite tool, and bitumen a favorite color. He was perhaps right, however, in his general view that Courbet's rich harmonies pleased Manet no more than Manet's blunt luminosity had pleased the older artist. George Moore, always disposed to favor his friend, spoke of Manet's *Le Linge* '. . . beside his picture, so limpid, so fresh, so unaffected in its handling, a Courbet would seem heavy and dull, a sort of mock old master.'[5] There is no point of making a comparison of two great artists in order to dim the lustre of one and elevate the other, but Moore's prejudiced view nevertheless reveals how strong differences in craft revealed themselves to contemporary eyes.

The comparison between the subject matter of the two artists is more difficult to evaluate. Both, of course, painted from everyday life, and a large number of Courbet's pictures are as casual and as pleasurable as any Impressionist scene. Nevertheless Courbet's more programmatic works, those monumental social commentaries on rural life, find no counterpart whatsoever among Manet's scenes of Parisian elegance. Even Manet's most political pictures are distinguished by their emotional reserve, their message depending on deeper currents in the human psyche than could be obtained through dramatic representation. Courbet had made the important step of offering a third alternative to the battle between the Classicists and the Romanticists without succumbing to the weakening effects of the compromise of a 'juste milieu'. In doing so he freed the artists who followed him from that task of rebellion. More than anything else, Manet's debt to Courbet lay in the very fact of that liberation which gave him the courage and the right to develop his own particular gifts.

In spite of the outpouring of critical invective against Manet's work through-

[2] *Mes haines*, 1866, 223.

[3] *Mes haines*, 1884, 308. 'Réaliste dans le choix de ses sujets, mais classique de ton et de facture.' It is interesting to note the conservative approach being followed by Courbet in his own picture of himself in his studio. In *The Studio: A Realist Allegory* (Louvre) the small landscape on the easel in the center of the picture is an *ébauche* being worked over a red-brown ground. It is freely constructed in simplified areas and in marked contrast to the rendering of his own figure.

[4] Proust, 43–4.

[5] Moore, *Modern Painting*, 38–9.

out his lifetime, the impact of his style was immediate and thorough. Degas once wryly said, 'they shoot us but they rifle our pockets.'[6] By the early 1880s weak versions of Manet's facture with the appearance of elegant facility had become highly acceptable. It is an irony of history that younger men like Gervex and Roll, who strongly felt his influence, were members of the jury which awarded him a second-class medal at the end of his life.[7] When in 1884 Zola called Manet a 'precursor' of a new art, he was already too late. According to Henri Houssaye there were at least two hundred paintings in the Salon of 1882 which showed the influence of Manet and of Bastien-Lepage.[8] Blanche remembers that Bastien-Lepage in turn considered himself a follower of Manet,[9] and by many he was seen as the artist capable of adding a necessary nicety of finish to Manet's raw discoveries. Stranahan, in her exhaustive discussion of French painting of the period considered Bastien-Lepage the 'glorious master' and Manet the 'precursor' of the Impressionist movement.[10]

Generally speaking it was through his craft that Manet influenced his contemporaries,[11] and by the end of the century his apparent facility had been emulated by artists in all the countries of the western world. Yet his work has so much more to offer than its luminous surfaces. In fact, it is exactly the lack of the refinements which Stranahan admired in Bastien-Lepage which gives Manet's paintings their distinction and their elegance. Pissarro spoke of his prints as having a 'surprising savor';[12] Bataille used the word 'stinging' for Manet's apparent indifference to his subjects.[13] Too monumental to be anecdotal, too demanding of our perceptual faculties to be quickly read, Manet's paintings have the toughness of new discoveries, to be constantly rediscovered anew.

Mallarmé knew that Manet was a trained artist who had learned from the 'friendly counsel' of the masters, but he described Manet's approach as plunging headlong into each new work, and then discovering its appropriate method.[14] 'The eye should forget all else it has seen, and learn anew from the lesson before it.'[15] Zola, too, spoke of his 'departure for the unknown with each blank canvas which he put on his easel.'[16] This preservation of an open naiveté is the precious gift of great artists. Corot said that he prayed everyday that God make him a child, that he make him see and render nature without preconceptions.[17] Preconceptions can never be fully escaped, but the power to break through their rigidity and to learn again and again was what he sought. Baudelaire likened this renewed perception to the reawakened

[6]R. H. Ives Gammell, *The Shop Talk of Edgar Degas*, Boston, 1961, 40.

[7]C. H. Stranahan, *A History of French Painting*, New York, 1888, 464.

[8]*Revue des deux mondes*, 1 June 1882, here quoted from Hamilton, 253.

[9]Blanche, 27.

[10]Stranahan, 463.

[11]Jacques Emile Blanche, *Propos de peintre, de David à Degas*, Paris, 1927, 164. Blanche firmly believed that Manet's originality lay in the execution of his pictures, not in their conception, 163.

[12]Camille Pissarro, *Letters to his Son Lucien*, New York, 1943, 208.

[13]Bataille, 82.

[14]Harris, *AB*, 1964, 560.

[15]*Art Monthly Review*, 1876, here quoted from Bowness, *PMA Bulletin*, 221.

[16]*Mes haines*, 1884, 308.

[17]Corot, *Pensées et écrits*, I, 82, 96.

interest in the world one has as one recovers from an illness. His 'eternal convalescence'[18] is for the artist an ideal state, and Manet was never to lose his sense of childlike discovery or the joy of new perceptions. There is something both beautiful and tragic in Blanche's saying of Manet when he was fifty and already ill, that he 'retained the smile of a schoolboy in love'.[19]

It was his vivid curiosity, his open mind, which could allow Manet to find in the most ordinary aspects of modern life a new kind of content for his art, and new ways for the spectator to discover that content. Always of his own time, he nevertheless predicted not only twentieth-century discoveries as to the functions of abstract forms, but twentieth-century questions as to the role of art itself. Matisse openly admired Manet for his gifts in simplifying and intensifying the effects of forms and colors. The light-filled and fractured forms of Cubism with their little glimpses of illusionism, like small excerpts from another mode of thought, required a new analysis of the 'real'. Which could have more reality, the illusion of a perceived world or the tangible surface of the canvas itself? Surely so extreme a dichotomy could not have occurred to Manet, and yet he allowed the very tension between illusion and surface to function in his pictures as a vivifying force. The Cubists could say of him in admiration, 'We call Manet a realist less because he represented everyday events than because he endowed with a radiant reality many potential qualities enclosed in the most ordinary objects.'[20]

Early motion pictures had found their sources in the great historical machines admired in the Salons[21] but more recent movies have turned instead to more reportorial and non-narrative depiction of the human state. Their blunt images and white sounds, their continuous and unpunctuated space and relentlessly passing time might contain some memory of Manet's cold gaze at events of his own age.

The Pop' artists who selected the most ordinary commercial images for their content and form may have had no thought of Manet's earlier transformations of prosaic illustrations. But as Manet had in some way been liberated by Courbet, they too had been liberated by the many small steps in history which lay between his borrowings and theirs. The simple toughness of today's minimal forms with their sparse and arrogant elegance seem somehow to have learned from that disdainful aloofness which Manet had observed in modern man.

Yet Manet's production belonged right where it was, as an appropriate expression of the third quarter of the nineteenth century. All these fanciful leaps and connections are possible precisely because Manet found in ordinary aspects of his own time qualities which were embracing and eternal, and therefore still with us today.

[18] *Oeuvres complètes*, 1159. From *Le Peintre de la vie moderne*.

[19] Blanche, 55. This quotation is taken from the English translation by F. C. de Sumachrist, London, 1925, 59.

[20] Albert Gleizes and Jean Metzinger, *Du Cubisme*, Paris, 1912. Here quoted from Robert Herbert, *Modern Artists on Art*, Englewood Cliffs, N. J. 1964, 3.

[21] Bernard Hanson, 'D. W. Griffith: Some Sources', *The Art Bulletin*, LIV (1972), 493–515.

Selected Bibliography

A complete bibiography of writings on Manet would constitute a book in itself. Good bibliographies can be found in Bataille, Rewald, and Wildenstein. See full references below. The following list comprises works of particular importance for Manet studies today and recent publications not listed elsewhere. Abbreviations are provided for works cited in the text.

Ackerman	Ackerman, Gerald, 'Gérôme and Manet', *Gazette des Beaux-Arts*, LXX (1967), 163–76.
	Adhémar, Jean, 'Notes et documents: Manet et l'estampe', *Nouvelles de l'estampe*, VII (1965), 230–5.
Andersen	Andersen, Wayne, 'Manet and the Judgement of Paris', *Art News*, LXXII, No. 2 (Feb. 1973), 63–9.
Barskaya	Barskaya, D. G. 'Edouard Manet's Painting, *Nymph and Satyr*, on Exhibition in Russia in 1861' [in Russian], *Omagiu lui George Oprescu Cu prilejul împlinirii a 80 de ani*, Academie Republicii Populare Romîne, [Bucharest, 1961].
Bataille	Bataille, Georges. *Manet*. New York, 1955.
Baudelaire *Oeuvres complètes*	Baudelaire, Charles. *Oeuvres complètes*. Paris, 1961.
Baudelaire *Art in Paris*	Baudelaire, Charles. *Art in Paris*: 1845–1862. Transl. and ed. Jonathan Mayne, London/New York, 1965.
Baudelaire *Painter of Modern Life*	Baudelaire, Charles. *The Painter of Modern Life and Other Essays*. Transl. and ed. Jonathan Mayne, London/New York, 1965.
Bazire	Bazire, Edmond. *Manet*. Paris, 1884.
Bernard	Bernard, Emile. *Tintoret, Greco, Magnasco, Manet*. Paris, 1920.

Blanche Blanche, Jacques Emile. *Manet*. New York, 1925.

Boime Boime, Albert. *The Academy and French Painting in the Nineteenth Century*. London, 1971.

Boime *AQ* Boime, Albert, 'New Light on Manet's *Execution of Maximilian*,' *Art Quarterly*, XXXVI (1973), 172–208.

 Bouillon, Jean-Paul, 'Manet vu par Braquemond,' *Revue de l'art*, XXVII (1975) 37–45.

Bowness *Burlington* Bowness, Alan, 'A Note on Manet's "Compositional Difficulties" ', *Burlington Magazine*, CIII (1961), 276–7.

Bowness *PMA Bulletin* Bowness, Alan, 'Manet and Mallarmé', *Philadelphia Museum of Art Bulletin* LXII (1967), 213–21.

 Chiarenza, Carl, 'Manet's use of Photography in the Creation of a Drawing', *Master Drawings*, VII (1969), 38–45.

 Collins, Bradford, 'Manet's *Rue Mosnier decked with Flags*, and the Flaneur Concept', *The Burlington Magazine*, CXVII (1975), 709–14.

Corradini Corradini, Giovanni, '*La Nymphe Surprise* de Manet et des rayons X', *Gazette des Beaux-Arts*, LIV (1959), 149–54.

Courthion Courthion, Pierre. *Edouard Manet*. New York, 1962.

Courthion and Cailler Pierre Courthion and Pierre Cailler, Eds. *Portrait of Manet by himself and his Contemporaries*. Transl. Michael Ross, New York, 1960.

Couture *Méthode* Couture, Thomas. *Méthode et entretiens d'atelier*. Paris, 1867.

Couture par lui-même *Thomas Couture: Sa vie, son oeuvre, son caractère, ses idées, sa méthode, par lui-même et par son petit-fils*. Preface by Camille Mauclair. Paris, 1932.

Curtiss Curtiss, Mina, 'Manet Caricatures: Olympia', *Massachusetts Review*, VII (1966), 725–52.

Davidson Davidson, Bernice, '*Le Repos*, a Portrait of Berthe Morisot by Manet', *Museum Notes: Rhode Island School of Design*, XLVI (1959), 5–9.

De Leiris *AB* 1959 De Leiris, Alain, 'Manet's *Christ Scourged* and the Problems of his Religious Paintings', *Art Bulletin*, XLI (1959), 198–201.

De Leiris *AB* 1964 De Leiris, Alain, 'Manet, Guéroult and Chrysippos', *Art Bulletin*, XLVI (1964), 401–4.

De Leiris *Drawings* De Leiris, Alain. *The Drawings of Edouard Manet*. Berkeley and Los Angeles, 1969.

De Leiris *GBA* De Leiris, Alain, 'Sur la plage de Boulogne', *Gazette des Beaux-Arts*, LVII (1961), 53–62.

 De Leiris, Alain, 'Baudelaire's Assessment of Manet', in *Hommage à Baudelaire*. College Park, Md. 1968.

Duret 1902 Duret, Theodore. *Histoire d'Edouard Manet et de*
Duret 1919 *son oeuvre*. Paris, 1902; Paris 1919 with catalogue supplement.

Duret *Manet* Duret, Theodore. *Manet and the French Impressionists*. London, 1912.

Faison Faison, S. Lane, Jr., 'Manet's Portrait of Zola,' *Magazine of Art*, XLII (1949), 162–8.

Farwell *Apollo* Farwell, Beatrice, 'A Manet Masterpiece Reconsidered', *Apollo* LXXVIII (1963), 45–51.

Farwell *Museum Journal* Farwell, Beatrice, 'Manet's *Espada* and Marcantonio,' *Metropolitan Museum Journal*, II (1969), 197–202.

Finke Ulrich Finke, Ed. *French Nineteenth-Century Painting and Literature*. Manchester, 1972.

Fried Fried, Michael, 'Manet's Sources: Aspects of his Art, 1859–1865', *Artforum*, VII (March 1969).

 Georgel, Pierre, 'Les transformations de la peinture vers 1848, 1855, 1863', *Revue de l'art*, XXVII (1975), 62–77.

Guérin Guérin, Marcel. *L'Oeuvre gravé de Manet*. Paris, 1944.

Gurevitch Gurevitch, V., 'Observations on the Wound in Christ's Side', *Journal of the Warburg and Courtauld Institutes*, XX (1957), 358–62.

Hamilton Hamilton, George Heard. *Manet and his Critics*. New York, 1969.

Hamilton *Art News*	Hamilton, George Heard, 'Is Manet still Modern?' *Art News Annual*, XXXI (1966), 104–31, 159–63.
Hanson *AB* 1962	Hanson, Anne Coffin, 'A Group of Marine Paintings by Manet', *Art Bulletin*, XLIV (1962), 332–6.
Hanson *AB* 1971	Hanson, Anne Coffin, 'Review of Alain de Leiris, *The Drawings of Edouard Manet*', *Art Bulletin*, LIII (1971), 542–7.
Hanson *Burlington*	Hanson, Anne Coffin, 'Edouard Manet, *Les Gitanos* and the Cut Canvas', *The Burlington Magazine*, CXII (1970), 158–66.
Hanson in Finke	Hanson, Anne Coffin, 'Popular Imagery and the Work of Edouard Manet', in Ulrich Finke, ed., *French Nineteenth-Century Painting and Literature*. Manchester, 1972.
Hanson *Manet*	Hanson, Anne Coffin. *Edouard Manet: 1832–1883*. Philadelphia, 1966.
Hanson *Museum Studies*	Hanson, Anne Coffin, 'Manet's Subject Matter and a Source of Popular Imagery', *Museum Studies, Art Institute of Chicago*, III (1969), 63–80.
Harris *AB* 1964	Harris, Jean Collins, 'A Little Known Essay on Manet by Stéphane Mallarmé', *Art Bulletin*, XLVI (1964), 559–63.
Harris *AB* 1966	Harris, Jean Collins, 'Manet's Racetrack Paintings', *Art Bulletin*, XLVIII (1966), 78–82.
Harris *Graphic Works*	Harris, Jean Collins. *Edouard Manet: Graphic Works*. New York, 1970.
Harris *PMA Bulletin*	Harris, Jean Collins, 'Manet as an Illustrator', *Philadelphia Museum of Art Bulletin*, LXII (1967), 222–35.
Hofmann *Nana*	Hofmann, Werner. *Nana—Mythos und Wirklichkeit*. Cologne, 1973.
	Hopps, Gisela. *Edouard Manet*. Berlin, 1968.
	Hyslop, Francis and Lois Boe Hyslop, 'Baudelaire and Manet: A Re-Appràisal', in *Baudelaire as a Love Poet and Other Essays*. Ed. Lois Boe Hyslop, University Park, Pa., 1969, 87–130.

Jedlicka Jedlicka, Gotthard. *Edouard Manet*. Zurich, 1941.

Kovacs Kovacs, Steven, 'Manet and his Son in *Déjeuner dans l'atelier*', *Connoisseur*, CLXXXI (1972), 196–202.

Krauss Krauss, Rosalind, 'Manet's *Nymph Surprised*', *The Burlington Magazine*, CIX (1969) 622–7.

 Mauner, George. *Manet: Peintre-Philosophe: A Study of the Painter's Themes*. University Park/London, 1975.

 Mauner, George, 'Manet, Baudelaire and the Recurrent Theme,' in *Perspectives in Literary Symbolism*. Ed. Joseph Strelka, University Park, Pa., 1968, 244–57.

Moore *Confessions* Moore, George. *Confessions of a Young Man*. London, 1928.

Moore *Modern Painting* George Moore. *Modern Painting*. London [1893].

Moreau-Nélaton Moreau-Nélaton, Etienne. *Manet raconté par lui-même* (2 vols.). Paris, 1926.

Moreau-Nélation *Graveur* Moreau-Nélation, Etienne. *Manet: Graveur et lithographie*. Paris, 1906.

Morisot *Correspondence de Berthe Morisot avec sa famille et ses amis*. Ed. Denis Rouart, Paris, 1950.

Needham Needham, Gerald, 'Manet, Olympia, and Pornographic Photography', in *Woman as Sex Object*. Ed. Thomas Hess and Linda Nochlin, New York, 1972, 81–9.

Orienti Pool, Phoebe, Introduction; Orienti, Sandra, Documentation. *The Complete Works of Edouard Manet*. London, 1972.

Proust Proust, Antonin. *Edouard Manet: Souvenirs*. Paris, 1913.

Proust *Studio* Proust, Antonin 'L'art de Edouard Manet', *Le Studio*, XXI (15 January 1901), 71–7.

Reff *AB* Reff, Theodore, 'Copyists in the Louvre, 1850–1870', *Art Bulletin*, XLVI (1964), 552–9.

Reff *Art Forum* Reff, Theodore, 'On Manet's Sources', *Artforum*, VIII (Sept 1969), 40–8.

Reff *Bulletin NYP* — Reff, Theodore, 'Manet's Frontispiece Etchings', *Bulletin of the New York Public Library*, LXVI (1962), 143–8.

Reff *Burlington* 1962 — Reff, Theodore, 'The Symbolism of Manet's Frontispiece Etching', *The Burlington Magazine*, CIV (1962), 182–6.

Reff *Burlington* 1970 — Reff, Theodore, 'Manet and Blanc's *Histoire des peintres*', *The Burlington Magazine*, CXII (1970), 456–8.

Reff *Burlington* 1975 — Reff, Theodore, 'Manet's Portrait of Zola', *The Burlington Magazine*, CXVII (1975), 35–44.

Reff *GBA* 1964 — Reff, Theodore, 'The Meaning of Manet's Olympia', *Gazette des Beaux-Arts*, LXIII (1964), 111–22.

Richardson — Richardson, John. *Manet*. London/New York, 1958.

Rewald — Rewald, John. *History of Impressionism*. New York, 1961.

Rosenthal *Aquafortiste* — Rosenthal, Léon. *Manet Aquafortiste et lithographe*. Paris, 1925.

Rosenthal *Romanticisme* — Rosenthal, Léon. *Du Romanticisme au Réalisme*. Paris, 1914.

Rouart, Denis, Introduction; Orienti, Sandra, Documentation. *Tout l'oeuvre peint d'Edouard Manet*. Paris, 1970.

Sandblad — Sandblad, Nils Gösta. *Manet: Three Studies in Artistic Conception*. Lund, 1954.

Schlotterback, Thomas, 'Manet's *L'Execution de Maximilian*', *Actes du XXII^e Congrès international d'histoire de l'art—1965*, (2 vols.) Budapest, 1972.

Siegl — Siegl, Theodor, 'The Treatment of Edouard Manet's *Le Bon Bock*', *Philadelphia Museum of Art Bulletin*, LXII (1966), 133–41.

Sloane *Aesthetics* — Sloane, Joseph C., 'The Tradition of Figure Painting and Concepts of Modern Art in France from 1845 to 1870', *Journal of Aesthetics and Art Criticism*, VII (1948), 1–29.

Sloane *AQ* — Sloane, Joseph C., 'Manet and History', *Art Quarterly*, XIV (1951), 92–106.

Sloane *French Painting* Sloane, Joseph C. *French Painting Between the Past and the Present*. Princeton, N. J., 1951.

Solkin, David, 'Philibert Rouvière: Edouard Manet's *L'Acteur tragique*', *The Burlington Magazine*, CXVII (1975), 702–9.

Tabarant Tabarant, Adolphe. *Manet et ses oeuvres*. Paris, 1941.

Wadley Wadley, Nicholas. *Manet*. London, 1967.

Wildenstein 1932 Wildenstein, Georges, Paul Jamot and Marie-Louise Bataille. *Manet* (2 vols.). Paris, 1932.

Wildenstein 1975 Wildenstein, Daniel and Denis Rouart. *Manet* (2 vols.). Paris, 1975.

Zola *Manet* Zola, Emile. *Edouard Manet*. Paris, 1867.

Zola *Mes haines* Zola, Emile. *Mes haines*. Paris, 1928.

Index

About, Edmond 6, 7, 11, 12, 16, 142–3, 194
Ackerman, Gerald 84
Adhémar, M. J. 179–80, 181, 189
Ambre, Emilie 116–17
L'Ami de l'artiste Pl. 21, 66
Andersen, Wayne 53n, 93–4
Arsenne, I. C. 142n, 146–7n, 150n, 153n, 167n
'l'art pour l'art' 23–4
Astruc, Zacharie 68, 75, 97, 138
Avignon, Musée Calvet *Pl. 30*, 71

balloons 39, 88–9
Baltimore, Baltimore Museum of Art *Pls. 3, 6, 61, 94, 105*
Baltimore, The Maryland Institute, Lucas Collection *Pls. 3, 6, 61, 94*
Baltimore, The Walters Art Gallery, *Pls. 26, 58*
Balzac, Honoré 21, 38
Banville, Théodore de 40n, 77
Barbey d'Aurevilly, Jules 37–8, 118, 123, 189
Barskaya, D. G. 53n, 92
Basle, Musée des Beaux-Arts 86n
Bataille, Georges vii, 52, 101, 117, 138n, 208
Baudelaire, Charles, *Exposition universelle*, 1855 15, 19; *Le Peintre de la vie moderne* 18–20, 118, 130–1, 204, 208–9; *Peintres et aquafortistes* 3, 22; *Quelques caricaturistes français* 20–1; *Salon*, 1845 18–19, 97; *Salon*, 1846 18–20, 37, 96; *Salon*, 1859 16, 97, 168, 193–4; courtesans 96–7; the dandy 118; De Banville on Baudelaire 77; eternal and transitory elements in life 19, 24, 31, 71, 96, 130–1, 205, 209; ideas of other writers 24, 31; letter to Manet 47; letter to Nadar 89; letter to Thoré 27–8, 83; Mallarmé on Baudelaire 41; Manet and Baudelaire 3, 22, 67n, 106; Manet's *Absinthe Drinker* 36, 54, 55, 65, 66; Manet's *Concert in the Tuileries* 18, 68; modern life 18–20, 32, 71, 85, 127, 205; negresses 99; photography 193–4; Romanticism 20; universal beauty 19, 20; Zola on Baudelaire 25
Bazin, Germain 69
Bazire, Edmond 42n, 47, 51n, 83, 87, 101, 106n, 115, 116, 120, 130n, 157, 158, 160, 172, 183
Béranger, P. J. *Pl. 68*, 66, 95
Berlin, Nationalgalerie *Col. Pl. VI*
Bernard, Emile 36, 174n
Bertell (Charles Albert d'Arnoux) 46, 98n, 123
Blanc, Charles 11, 59n, 62, 65n, 69n, 70, 80, 104–5n, 159n, 168
Blanche, Jacques Emile 48, 87, 138, 160, 161n, 208n, 209

Boime, Albert 47n, 53n, 91n, 111n, 128n, 138–40, 146n, 155
Boston, Museum of Fine Arts *Pls. 42, 78, 79*, 75n, 76, 104n, 112, 113, 114, 169, 174, 163n
Boudin, Eugène Louis 34
Bouvier, M. P. L. 143n, 146–7n, 147n, 167n, 182
Bowness, Alan 22n, 26n, 33n, 53n, 68, 199–200, 203
Bracquemond, Félix 81, 186
Bremen, Kunsthalle *Pl. 38*
Brouwer, Adrien 54
Bryn Mawr, Pa., Bryn Mawr College *Pl. 115*
Budapest, Museum of Fine Arts 119
Buenos Aires, Museo Nacional de Bellas Artes *Pl. 63*
bull fights *Pl. 50*, 82, 83, 84
Bürger, Willem, *see* Thoré
Burty, Philippe 16, 115, 123

Cabanal, Alexandre 44, 45n, 46, 90, 94, 156
Le Café-concert Pl. 25, 68
Cailler, Pierre 75n, 128, 137n
Callias, Hector de 34, 87
Callias, Nina de *Pl. 60*, 87
Cambridge, Mass., Fogg Art Museum *Pls. 24, 91*, 88n, 195
Carracci, Annibale 83n, 108
Le Carrillon Pl. 89, 45–6n, 126
cartoons of Manet's work 45–6n, 46, 126
Castagnary, Jules 5, 9, 29–32, 45n, 51n, 70n, 74–5, 91n, 103, 107, 138, 149n, 168
cats 71, 88, 98, 123
Cézanne, Paul 105, 134
Chabrier, Emmanuel 77, 78n, 87
Cham, Amadée Charles, Henri (Comte de Noé), *Pl. 56*, 77, 189
Champfleury, Jules 7–8, 10, 32–5, 62, 64, 68, 98
Chardin, Jean-Baptiste-Siméon 67–70
Charivari Pl. 56, 46, 52, 77
Charlet, Nicolas 20–1
Charpentier, Edmond 39
Charpentier, Georges 39
Chenevières, Philippe (Marquis de Chennevières-Pointel) 104, 128
Chesneau, Ernest 93, 187–8, 191
Chevreul, Michael Eugène 151–2
Chiarenza, Carl 195n
Chicago, The Art Institute *Col. Pl. VIII*, *Pls. 8, 27, 51, 76, 83, 107, 113*, 65n, 164, 201n
Le Chiffonnier Pl. 17, 65
La Chronique universelle illustrée, 38, 39, 118n, 129
Cincinnati, Art Museum 163n
Claretie, Jules 118n, 123

Clark, Kenneth 91, 100
Classicism 32
Claus, Fanny 77
Clemenceau, Georges 126
Cleveland, Museum of Art *Pls. 43, 97, 124,* 153, 201n
colored grounds 147–8, 153, 162
colors, optical effects 147, 148, 152
Commedia dell'Arte 33, 40, 64, 72
Constable, John 103, 105, 128
The Cookoo's Verse Pl. 72, 98
Copenhagen, Ny Carlsberg Glyptotek *Col. Pl. II, Pl. 80,* 113, 114–15, 174n
copies 141, 155–6
Corot, Camille 144, 153, 197, 208
Corradini, Giovanni 92n
Courbet, Gustave viii, 32–5, 64n, 68, 81, 95, 98, 101n, 137, 149n, 183, 206–7
courtesans 81–2, 85–7, 89n, 96–7
Courthion, Pierre 75n, 128, 137n, 183n, 196n, 297
Couture, Thomas, *Couture par lui-même* 36n, 104n, 145n, 147–52, 158, 167, 177–8, 181; *Méthode* 5, 9, 14, 36n, 47, 48, 75, 86, 99, 128, 145, 146–7, 149–52, 157, 177–8, 179n, 181; paintings by: *Little Gilles Pl. 96,* 152, 159–60; Study for *Romans of the Decadence Pl. 98,* 57n, 153; *Romans of the Decadence* 100; artists admired by 75, 104n, 145n, 150, 155, 177; anatomy 146; chiaroscuro 146, 158, 181–2; colored grounds 147–8, 152–3, 167; composition 177; drawing 9, 146, 178, 198; finish 167; glazes 147, 152, 153; history paintings 47; Manet's *Absinthe Drinker* 54, 157–8; modern subjects 9, 14, 36n, 47, 86, 99, 128, 179n; optical effects 147, 148, 151; painting techniques 138, 144, 147, 149, 150, 151, 161, 162n; studio during Manet's student days 54, 157–8, 168, 174
Cros, Charles *Pl. 93,* 87, 133
Cubists 181, 209
Curtiss, Mina 45–6n, 98n, 198

dandyism 37–8, 118
Daumier, Honoré, 13, 20–1, 36, 64, 69–70n, 79, 85, 91, 116
David, Jacques Louis 54, 91, 104, 140, 145
Davidson, Bernice 77n
Dead Soldier (Orlando Muerto) Pl. 57, 83, 85, 156, 189
The Death of Caesar Pl. 58, 84, 85, 189
Degas, Edgar 57, 81, 95, 101–2, 113, 157, 165–6n, 172, 182, 190, 191, 193, 208
Delacroix, Eugène 4, 5, 7, 20, 29, 54, 75n, 88, 99, 104, 138, 139n, 144, 145, 149n, 153, 155, 157, 168, 193
Delécluze, M. 146n, 150n, 180, 181, 188n
De Leiris, Alain 53n, 61–2, 76n, 93n, 104–5n, 106n, 108–9, 115n, 119n, 120n, 122n, 125n, 137n, 164n, 198n, 199–200, 202
Desboutins, Marcel 124
Devéria, Achille *Pl. 70,* 97
Diogène, 38
Doerner, Max 148n, 149, 153n, 166n, 167n
dogs, 97–8, 185
Dupont, Pierre *Pls. 47, 64, 67,* 14, 78, 93n, 94–5
Duret, Théodore 113, 118, 121, 138, 160n, 170–1
Dutch art, influence of 27, 29, 59, 69

Eastlake, Charles Lock 149n, 153
ébauches 141–2, 144, 150, 153, 158, 159, 162, 167, 169–70, 174
L'Eclipse Pl. 2, 46
L'Enfant volé Pl. 13, 63
Ephrussi, Charles 73
esquisses 140, 142, 169
études 140, 167
Evans, Dr Thomas 60n, 195

Faires, Mollie 79n
Faison, S. Lane, Jr. 26, 51n, 74
Fantin-Latour, Henri 6n, 68, 171
Farwell, Beatrice 53n, 80n, 88, 89n, 93n, 99n, 101n
Feller, Gloria Colton 64n, 66
Fishermen off the Coast of the Province of Nizan Pl. 119, 188
Flaubert, Gustave 11n, 13n, 39
Flemish art, influence of 8, 27, 42; practice of 153
Florisoone, Michel 62n, 104–5n, 108
Fould, Achille 5
Fournel, Victor 64, 66
Les Français peints par eux-mêmes Pls. 4, 9, 10, 15, 20, 21, 11, 14, 38, 58n, 59, 61, 63, 65, 66, 68n, 79n, 105, 193
Fried, Michael 28n, 62, 80, 82n, 94
Friedlaender, Max 4n, 58, 66
Fromentin, Eugène 4n

Gaillard, Anne-Marie, *See* Nina de Callias
Gambetta, Léon 124, 126, 130n
Gauguin, Paul 134, 172
Gautier, Théophile 5, 12, 31, 64n, 104; 'art for art's sake' 23–4; comments on Manet's work 22, 23, 51n, 59, 167–8, 203n; depicted in *Concert in the Tuileries* 22, 68; ideas on progress 13–14
Gavarni 13, 20–1, 37, 64n, 79, 94
Gazette des Beaux-Arts, illustrations in *Pl. 16,* 80, 84n
genre painting 58–9, 103–4
Géricault, Théodore 7, 54, 83, 104, 110, 111, 146
Gérôme, Jean-Léon *Pl. 58,* 84, 85, 91, 168, 189
Gill, André *Pl. 2,* 46
Gilles Pl. 16, 62, 64
Giorgione 55, 92, 93, 94, 96, 153
Goetschy, Gustave 40, 41n, 42, 132–3
Goncourt, Edmond and Jules de 25n, 100
Gonzales, Eva 42, 167n
Goya, Francisco *Pl. 50,* 27, 55, 59, 65n, 74, 75, 80, 83n, 84, 89, 98, 99, 109, 110–11, 112, 117, 119, 170, 188, 192n
Greco, El (Domenikos Theotocopoulos) 83n, 108
Gros, Baron Antoine Jean 104, 146
Grosse Point Farms, Mich. Collection of Henry Ford II *Col. Pl. IV*
Guérard, Henri 42
Guérin, Marcel 22n, 40n, 52n, 63n, 71n, 75n, 87n, 88n, 106n, 115, 116n, 119, 125n, 195n
Guillemet, Antoine 77
Gurevitch, V. 53n, 106n
Guys, Constantin 18n, 20–3, 132
gypsies 60, 61n, 63

Hals, Franz 166
Hamburg, Kunsthalle *Pls. 88, 90,* 66n, 78n, 196n
Hamilton, George Heard, Baudelairean tone of

Absinthe drinker 54–5; Japanese prints 80; lack of drama in the *Execution of the Emperor Maximilian* 53; Manet criticism, general 45, 46n, 51n; Manet's *Dead Christ with Angels* and *Christ Mocked* 108–9; Manet's genius 206; quotations from other sources 22n, 23n, 26n, 27n, 31n, 34n, 42n, 52n, 59n, 66n, 70n, 83n, 98n, 105n, 106n, 123n, 124n, 125n, 131n, 166n, 167n, 168n, 189n, 190n, 192n

Hanson, Anne Coffin 5n, 10n, 14n, 40n, 54n, 55n, 58n, 59n, 60n, 62, 65n, 66n, 67n, 69–70n, 71n, 72n, 73n, 78n, 79n, 82n, 92n, 98n, 123n, 133n, 156n, 163n, 185n

Hanson, Bernard 209n

Haronobu *Pl. 53*, 81, 188

Harris, Jean Collins 40n, 42n, 53n, 71n, 72, 76n, 87n, 88n, 98n, 100n, 106n, 116n, 130n, 160n, 189n, 190n, 195n

Haskell, Francis 33n, 64

Hauser, Henriette 87

Hiroshige *Pl. 119*, 188

history painting 103–27, 128–9

Hofmann, Werner 53n, 58n, 66n

Hokusai, Katsushika *Pls. 116, 117*, 71n, 185n, 186, 187n, 188n, 190n

Honolulu, Academy of the Arts *Pl. 121*

Houssaye, Arsène 85, 133–4, 186n

Houssaye, Henri 208

Howe, Jerome Willard, Jr. 47n

Huart, Paul *Pl. 66*, 94

Huysmans, Joris Karl 124, 190n

L'Illustration 67, 112, 122

L'Image 38, 68

'images epinals', 183, 186n, 191

Impressionists 34, 40, 41, 44, 81, 89, 105, 134, 139, 142, 171–3, 203

Infanta Margarita (after Velasquez) *Pl. 100*, 155–6

Ingres, Jean Auguste Dominique 4, 7, 29, 54, 56, 88, 90, 99, 143n, 144, 145, 147, 168, 174

Jamot, Paul 53, 89n, 121n

Janin, Jules 11, 14, 105, 194

Japanese prints *Pls. 52, 53, 72, 116, 117, 119, 121*, 9, 41, 55, 56, 57, 74, 77, 80–3, 98, 125, 133, 183–4, 185–92, 193, 195; decorative objects 87, 130, 171

Jeanron, Philippe-Auguste *Pl. 9*

Jedlicka, Gotthard 111, 113

Les Joueurs de l'hôtel d'Angleterre Pl. 23, 68

Journal amusant 45n, 46, 52n

Jouy, Jules de 126, 132

'juste milieu' 4, 207

Kiyonaga, Torii *Pl. 121*, 190

Kovacs, Steven 71n

Krauss, Rosalind 53n, 92n

Labédollière, Emile de la *Pls. 25, 92*, 79n

Lagrange, Léon 34, 51n, 76n, 179

Lami, Eugène *Pl. 20*, 13, 37

Laurent, Méry *Pl. 59*, 86, 114, 205

Leenhoff, Léon 59, 71, 72n, 79, 113, 132

Leenhoff, Rudolph 165n

Leenhoff, Suzanne 67, 71n, 132

Leighton, Frederick 175

Le Nain, Antoine 10, 33, 62–3, 120

Le Nain, Louis *Pl. 12*, 62–3, 120

Leonardo 194, 195, 201

La Limosine *Pl. 9*, 61

Lisbon, Gulbenkian Foundation 59n

Little Gilles Pl. 96, 152, 159–60

London, Courtauld Collection *Col. Pl. IX, Pl. 112*

London, National Gallery *Col. Pl. I, Pls. 57, 81*, 62, 83n, 104n, 113, 170

London, Victoria and Albert Museum *Pl. 12*, 62n

Lowry, Bates 84n

MacMahon, General 116, 125

Magasin pittoresque Pls. 13, 86, 38–9, 63, 68, 81n, 121

Mallarmé, Stéphane *Pls. 94, 95*, 41–2, 87, 100, 130n, 160n, 171, 173, 185, 189, 190, 208

Ma nacelle Pl. 68, 95

Manet, Edouard, cartoons of his work *Pls. 2, 56, 89*, 46, 123, 189; exhibitions: Martinet Gallery 58, 60, 82, 162; private exhibition, 1867 35, 112, 115, 206; La Vie moderne Gallery, 1880 131–2; Ecole des Beaux-Arts, 1884 27, 193; honors 59, 126, 159; letter to Fantin-Latour 6n; letter to Prefect of the Seine 128; Salons: desire to show in 44, 172; choice of works for 47, 105, 126; record of acceptance in 45, 47, 54, 59, 82, 157; works by: drawings, general 164, 199; sketches of boats 122n; *At the Café Pl. 24*, 68; *The Barricade* 119; *The Execution of the Emperor Maximilian* 119; *Frontispiece Pl. 32*, 71–2; *Letter with a Plum Pl. 35*, 73; *Letter with a Snail on a Leaf Pl. 34*, 73; *Portrait of the Artist's Parents Pl. 41*, 76; *Portrait of Vigneau Pl. 105*, 163; *Salamander Pl. 118*, 186; paintings, *The Absinthe Drinker Col. Pl. II*, 21, 36, 45, 54, 55, 64–6, 83n, 132, 157, 158, 163, 198; *Amazon* (Pearlman Coll.), *Pl. 54*, 66, 86; *Amazon* (other versions) 86n; *Angelina* 195; *Arcachon: Beau temps* 20n; *The Artist* 193; *Asparagus, see Bunch of Asparagus*, and *Stalk of Asparagus*; *At the Café Pl. 26*, 68; *Autumn Pl. 59*, 86, 129; *Le Bain, see Déjeuner sur l'herbe; The Balcony Pl. 45*, 30–1, 77, 110, 192, 199, 204; *The Bar at the Folies Bergère Col. Pl. IX*, 68, 130, 132, 176, 204–5; *The Battle of the Kearsarge and the Alabama Pl. 85*, 39n, 52, 54, 98, 105, 121–4, 125, 188–9, 203; *Blonde Nude Pl. 74*, 101, 174n; *Blue Venice Pl. 126*, 173; *Boating Pl. 109*, 77, 165, 190; *Boats Pl. 124*, 201; *Le Bon Bock Pl. 110*, 31, 47–6n, 47, 58, 59n, 160, 165–6, 167; *The Boy with the Cherries* 59, 69–70n; *The Boy with the Sword Pl. 48*, 71, 79; *Brunette Nude Pl. 101*; *Bunch of Asparagus* 163; *Children in the Tuileries* 67n, 99; *Christ Mocked Pl. 76*, 47, 104, 108–10; *Claude Monet in his Floating Studio Pl. 108*, 165, 170; *Concert in the Tuileries Col. Pl. I*, 18, 22, 36, 38, 67–8, 92, 95, 134, 161, 162, 198, 199, 202; *The Conservatory Col. Pls. VI, VII*, 77, 174; *Copy after Delacroix Barque of Dante Pl. 99*, 155; *Copy after Rembrandt Anatomy Lesson* 155; *Copy after Titian Venus of Urbino Pl. 39*, 75; *Corner in a Café-concert Pl. 26*, 68; *Dead Christ with Angels Pl. 75*, 22, 25, 83n, 104–8, 167; *The Dead Toreador Pl. 55*, 82, 85, 119, 156, 169, 170, 204; *Déjeuner sur l'herbe Pl. 62*, 27, 75, 78, 92–5, 96, 101, 114n, 130, 171, 198, 204; *The Departure of the Folkestone Boat Col. Pl. V*, 68, 77, 172; *Easter eggs* 40, 131; *The Escape of Rochefort Pl. 87*, 54, 105, 111, 121, 124–5, 129, 196; *The Execution of the*

Emperor Maximilian Pls. 77, 78, 79, 80, 81, 52, 53, 54, 105, 110–18, 119, 121, 125, 129, 169–70, 174, 196; *The Exhibition of 1867* Pl. 125, 68, 201, 202; *The Fifer* 183, 192; *Fishing* Pl. 65, 56, 94, 161; *The Garden* 172; *Grand Canal, Venice* 173; *The Guitar Player, see The Spanish Singer*; *Gypsies* (destroyed), 60–1, 162–3; *The Gypsy* Pl. 7, 60; *Gypsy Boy, see The Water Drinker*; *Gitane à la cigarette*, 60n; *Incident in the Bull Ring* (destroyed) 22, 80, 82, 84, 105, 169, 189, 198n; *Incident in the Bull Ring* (Frick), 82; *In Front of the Mirror* 101n; *Le Journal illustré* Pl. 113, 66, 174; *Le Linge* Pl. 1, 42, 66n, 193, 207; *Lilacs and Roses* Pl. 103, 163; *The Little Cavaliers* 161; *Lola de Valence* Pl. 114, 79, 161, 174; *Luncheon in the Studio* Pl. 31, 30–1, 70–1, 75, 199; *Madame Brunet* 195, 196; *Mademoiselle Victorine as an Espada* Pl. 49, 79–81, 82, 85, 87, 163, 170, 175, 188, 189, 191, 200; *Marine* (Cleveland) 201n; *Marine* (Philadelphia) 203; *Marine: Temps calme* 201n; *The Milliner* Pl. 18, 66; *Monk in Prayer* 104n; *The Music Lesson* 75n; *Nana* Pl. 90, 66, 87, 129–30; *Olympia* Pl. 69, 26, 42, 47, 52, 71, 74, 75, 82n, 88n, 89, 96, 98, 99, 100, 101, 105, 107, 129, 133, 167, 171n, 174n, 175, 186, 191, 192, 204; *The Old Musician* Pl. 11, 36, 55, 56, 57, 61–7, 114n, 120, 134, 169, 198, 202; *On the Banks of the Seine at Argenteuil* Pl. 112, 68, 77, 173; *On the Beach at Boulogne* Pl. 123, 199, 200, 201, 202; *Opera Ball* 42; *The Painter Guillaudin on Horseback* Col. Pl. IV, 164, 165; *La Parisienne* 66; *The Philosopher* 65; *Polichinelle* 40; portraits 132; 'portraits' of dogs 98n; *Portrait of the Artist's Parents* Pl. 40, 76; *Portrait of Emilie Ambre as Carmen* Pl. 122, 195; *Portrait of Zacharie Astruc* Pl. 38, 75; *Portrait of Cabaner* 77, 78n; *Portrait of Nina de Callias* Pl. 60, 87; *Portrait of Chabrier* 77, 78n; *Portrait of Clemenceau* Pl. 104, 77, 126, 163, 165, 196; *Portrait of Duret* Pl. 19, 66, 75, 170–1; *Portrait of Faure* 77–8; *Portrait of Constantin Guys* 77, 78n, 132; *Portrait of Marie Lafébure on Horseback* 86n; *Portrait of Laure* Pl. 73, 99; *Portrait of Isabelle Lemonnier* 174n; *Portrait of Stéphane Mallarmé* Pl. 111, 171; *Portrait of Victorine Meurand* Pl. 42, 76; *Portrait of George Moore in a Café* Pl. 106, 77–8, 132, 164, 170; *Portrait of Berthe Morisot with a Muff* Pl. 43, 76; *Portrait of Pertuiset as a Lion Killer* Pl. 46, 78, 126; *Portrait of Antonin Proust* 41; *Portrait of Henri Rochefort* Pl. 88, 124–6, 196; *Portrait of Zola* Pl. 37, 74, 75, 80, 81, 103n, 171n, 186, 191; *The Rabbit* 69; racecourse paintings 68n; *The Ragpicker* 65; *The Railroad* Pl. 120, 77, 190; *The Reader* Pl. 101, 59, 159, 166; *Le Repos* Pl. 44, 47, 76, 166; *Scene in a Spanish Studio* 56, 161; seascapes 123n, 201n; *Skating* Pl. 91, 132, 175, 204; *The Smoker* 59n; *Soap Bubbles* 69–70n; *Sortie du port de Boulogne* 201n; *The Spanish Ballet* Pl. 102, 161; *The Spanish Singer* (The Guitar Player) Pl. 5, 22, 36, 59, 76, 159, 161; *Spring* 86, 129, 195; *Stalk of Asparagus* Pl. 36, 73, 163; *Still Life with Carp* Pl. 27, 70; *Still Life with Hat* Pl. 30, 71–2; *Still Life with Melon and Peaches* Pl. 29, 70; *Still Life with Salmon and Pike* Pl. 28, 70; *Students of Salamanca* 161; *Surprised Nymph* Pl. 63, 92, 96; *Swallows* 42; *Tama* 185; tambourines 40, 131; *View of the Universal Exhibition of 1867* Pl. 125, 201–2; *The Water Drinker* Pl.

8, 61, 163; *Woman with the Fans, see Portrait of Nina de Callias*; *Woman with the Parrot* 75; *Young Man in the Costume of a Majo* 80; *Young Woman* Pl. 107, 164, 170; *Young Woman in Oriental Costume (La Sultane)* 88; *Young Woman Reclining in a Spanish Costume* Col. Pl. III, 88–9, 99; *Young Woman with a Round Hat* 86n; prints, *The Balloon* Pl. 22, 68; *The Barricade* Pl. 83, 119; *Boy with the Tray* Pl. 51, 80; *Cats Meeting* Pl. 71, 98; *Civil War* Pl. 84, 119–20; *The Execution of the Emperor Maximilian* Pl. 82, 110, 113–15; *Frontispiece* Pl. 33, 71–2; *Gypsies* Pl. 6, 22, 60; illustrations for *L'Après midi d'un faune* Pl. 94, 133, 185; illustrations for *Le Fleuve* Pl. 93, 133; illustrations for *Le Corbeau* Pl. 95, 133–4, 185; *The Little Cavaliers* Pl. 115, 182; *Little Girl* Pl. 14, 63; *Odalisque* Pl. 61, 88; *Polichinelle* 40, 116; *Baudelaire* 195; *The Urchin* Pl. 3, 59, 63

Manet, Eugène 68
Mangwa Pls. 116, 117, 186
Mannheim, Städtische Kunsthalle Pl. 77, 113, 114, 115, 170
Mantz, Paul 152, 159n, 161
Marsy, Jeanne de 86, 205
Martin, Kurt 111
Mathey, François 99, 108–9n
Mathey, Jacques 69–70n, 119n, 156n
Matisse, Henri 43, 160
Maurice, B. 179–80, 189
Mayer, Ralph 140n, 165n
Meier-Graefe, Jules 111
Meissonier, Ernst 84, 119, 168, 193
Mérimée, J. F. L. 142n, 143n, 146–7n, 150, 153n, 167n
Mérimée, Prosper 60
Merion Station, Pa., The Barnes Foundation Pl. 1
Meurand, Victorine Pls. 42, 49, 76, 79, 82, 85, 87, 95
Minneapolis, Institute of Art 59n
La Modiste Pl. 20, 66
Monet, Claude 134, 165, 165–6n, 171, 172, 173
Monnier, Henri Pl. 21, 12–13, 64n
Moore, George, *Confessions* 11–12, 15, 79, 81–2, 173, 186; *Modern Painting* 5, 7n, 59n, 77, 100–1, 116, 137, 153–4, 159–60, 161, 183, 194, 207; against democracy 11–12, 81–2; against material progress 15; against photography 194; on lowered quality in the arts 57n, 153–4; Manet 79; Manet's work 52, 59n, 77, 100–1, 116, 137, 160–1, 173, 183, 207
Moreau, Gustave 46, 104, 141
Moreau-Nélaton, Etienne 6n, 27n, 47n, 54n, 58n, 60n, 63, 76n, 83n, 88n, 119n, 121n, 124n, 131n, 144n, 157, 159, 195n
Morisot, Berthe Pls. 43, 44, 35, 48, 86, 119, 192
Morisot, Edma 86
Mras, George 139n, 144n
Munich, Bayerische Staatsgemäldesammlungen Pl. 31
Murillo, Bartolomé Estabán Pl. 4, 59, 67, 108
Musset, Paul de 37, 118

Nadar (Gaspard-Félix Tournachon) 39, 88–9, 195
Nancy, Musée des Beaux-Arts Pl. 59
Naturalism 31–2, 34–5
Needham, Gerald 53n
New Haven, Conn., Yale University Art Gallery Col. Pl. III, Pl. 119

New Year Scene Pl. *52*, 81
New York, Collection of Mr and Mrs Alexander M. Lewt Pl. *34*
New York, Collection of Mrs Henry Pearlman Pl. *54*, 86n
New York, Collection of Edwin C. Vogel Pl. *103*
New York, Frick Collection 82
New York, Metropolitan Museum Pls. *5, 48, 49, 52, 53, 65, 75, 99, 106, 109*, 75n, 80n, 155, 164, 165
New York, New York Public Library Pls. *22, 32, 33, 71*
New York, S. R. Guggenheim Museum 101n
Nittis, Giuseppe de 131
Nochlin, Linda 4n, 33, 64n, 91n
Le Nouveau Paris Pl. *25*, 68, 129

Odalisque Pl. *97*, 153
Offenbach, Jacques 68
Orienti, Sandra 4on, 6on, 67n, 88n, 156n
Orlando Muerto, see Dead Soldier
Osborne, Laughton 134n, 144n, 146–7n, 148, 149, 150n, 151n, 152n, 167n
Oslo, Nasjanalgalleriet Pl. *125*
L'Ouvrier de Paris Pl. *10*, 61

Pain, Olivier 124–5
Panofsky, Dora 64
Paris, Musée du Louvre Pls. *36, 37, 45, 60, 62, 69, 74, 104, 111, 114, 118*, 62, 62n, 67, 69, 73, 78n, 9on, 101n, 105n, 122n, 132n, 145n, 152, 155, 156, 163n, 171, 182, 196n
Paris, Petit Palais Pl. *19*
Paris et les Parisiens 37–8, 68, 129
Paris qui s'en va 38
Les Patineurs de la glacière Pl. *92*, 132
Pauquet, Jean-Louis-Charles Pl. *10*, 61
Péladan, Joseph 75n, 137, 158n
perspective 178–81, 187–9, 201
Le Petit Mendiant Pl. *4*, 59
Le Petit Pologne Pl. *15*, 63, 67
Philadelphia, Museum of Art Col. Pl. *V*, Pls. *14, 85, 95, 96, 110, 122*, 123n, 152, 165
photography 16–17, 84, 88n, 100, 183–4, 193–6
Physiologie de la grisette Pl. *66*, 10–11, 79n, 94
Picasso, Pablo 48, 56, 63–4, 69, 102
Pissarro, Camille 105, 208
Poe, Edgar Allan Pl. *95*, 83, 133
Polichinelle 72, 131
portraiture 34, 74–8
Pourtalès Collection 83–4
Prix de Rome 47, 103, 140, 179
progress, ideas about 11, 13, 14, 15, 47, 131
Proust, Antonin 126; *Souvenirs* 44, 54n, 66n, 67n, 91, 92, 99n, 107n, 120, 121, 128n, 129, 138, 153n, 155n, 157–9, 161, 168, 174, 175n, 181–2; *Studio* 47–8; Manet and Couture 54n, 96, 126, 157–9, 161, 168, 174, 181–2
Providence, R. I., Museum of Art, Rhode Island School of Design Pl. *44*, 67n, 153

railroads 13–14, 47, 128
Raimondi, Marcantonio 8on, 93
Raphael 4, 32, 55, 56, 93, 94, 145
Realism viii, 32–5, 206–7
Recouvreur, Adrien 166n, 167n
Redon, Odilon 51n, 134, 172

Reff, Theodore 53n, 55n, 59n, 62, 64, 71n, 72n, 74n, 80, 94, 96n, 108–9n, 129n, 156n
Rembrandt 9, 29, 76n, 106, 150, 155, 167n
Renan, Ernest 106–7
Renoir, Pierre Auguste 171, 172, 173
Rest of the Horsemen Pl. *12*, 62–3, 120
Rewald, John 6n, 32n, 39n, 91n, 104n, 156n
Richardson, John vii, 79n, 137n, 161, 191
La Rivière Pl. *64*, 93n, 94–95
Rochefort, Henri Victor (Marquis de Rochefort-Luçay) 124–5
Romanticism 4n, 20, 32, 38, 104
Rosenthal, Léon 4n, 6n, 55n, 64n, 118, 174n
Rotterdam, Museum Boymans-Van Bueningen Pl. *35*, 92n
Rouart, Denis 156n
Rubens, Peter Paul 67, 80, 83n, 106, 108, 152n, 168
Les Rues de Paris, see Zaccone

Salon des refusés 75, 171
Salon exhibition, diversity of styles 7; new tendencies 44; nudes in 91, 91n, 156; range of subjects 44–5, 58; quality 4, 5–6, 9
Sandblad, Nils Gösta, Japanese prints 74n, 80, 81n, 82n, 186n, 191; Manet and Baudelaire 18n, 195n; Manet's *The Balcony* 192n, *The Battle of the Kearsarge and the Alabama* 122, *Concert in the Tuileries* 38n, 161, 162, 198–9, *The Execution of the Emperor Maximilian* 11on, 111–14; *Olympia* 100, 186n
San Francisco, California Palace of the Legion of Honor Pl. *18*
San Francisco, Provident Securities Company Pl. *126*
Sao Paolo, Museu de Arte Pl. *46*, 86n
Le Sauvage Pl. *67*, 94–5
Schapiro, Meyer 33, 58n
Scharf, Aaron 16n, 193, 195n, 196n
Schlessinger, Henri-Guillaume Pl. *13*, 63
Seznec, Jean 57n
Shelburne, Vt. Shelburne Museum 78, 173n
Shunkō, Katsukawa Pl. *52*, 81
Shunshō, Katsukawa Pl. *72*, 98
Siegl, Theodor 165n, 167n
Silvestre, Armand 40, 41, 130, 133
Silvestre, Théophile 7
sketches 139–42, 143, 164, 178, 200; *see also* ébauches, études, esquisses
Sloane, Joseph C. 4n, 6n, 8, 11n, 15n, 24n, 25n, 32n, 52, 94n, 104n, 111, 120n, 121–2, 138n, 139, 183n
Spanish art, influence of 8, 22–3, 27–8, 29, 35, 42, 67, 80, 89, 104–5n, 108, 158, 163, 193
Spanish motifs 71, 79, 87, 88
St Louis, St. Louis Art Museum Pl. *101*
Stop (L. P. G. B. Morel-Retz) 189
Stuttgart, Staatsgalerie Pl. *108*
Süe, Eugène 66
Sujet gracieux Pl. *70*, 97
The Sumada River Pl. *53*, 81
Sutter, David 179
Swarthmore, Pa., Collection of Robert Walker Pl. *84*

Tabarant, Adolphe 45, 6on, 67n, 83n, 86–7, 99n, 106, 108n, 112, 113, 114, 118n, 126n, 131n, 156,

161, 165n, 169, 195
Taine, Hippolyte Adolphe 12–13, 28
Taylor, Isadore-Justin-Séverin 23
Teniers, David 59, 63
Terbrugghen, Hendrick 109
Tintoretto, Jacopo 108, 153, 155
Titian 75, 92, 96, 97, 98, 108–9n, 109, 145, 147, 149,
 150, 152, 153, 155
Toulouse-Lautrec, Henri 102, 190
Tournachon, Gaspard-Félix, *see* Nadar
Les Triomphateurs du salon Pl. 2, 46
Le Tueur de lions Pl. 47, 78
types, illustrations of 10–11, 33–4, 61, 63–4, 66

Upperville, Va., Collection of Paul Mellon *Pl. 123*,
 78n, 98n

Velasquez 27, 55, 58, 59, 62, 65, 67–8, 75, 83, 84,
 109, 120, 155, 156, 159, 168, 171, 182, 191, 198
Venetian art, influence of 4, 8–9, 55, 69, 75, 96, 97,
 108; practice of 145–7, 153
Venus 90, 95, 96, 97, 101, 107
Veronese 108, 145, 147, 150, 152
Vibert, Johan-George 145n, 166–7
La Vie moderne Gallery 39–40, 131
La Vie moderne, periodical, 1859 13, 39
La Vie moderne, periodical, 1879 15, 39–41, 42, 130–2
La Vie parisienne 38, 68, 98n
Vigneau, Henri 163n

Villard, Nina de, *see* Nina de Callias

Wandering Jew, legend of 66
Washington, D.C., Library of Congress, Rosenwald
 Collection *Pl. 93*
Washington, D.C., National Gallery of Art *Pls. 11,
 29, 55, 82, 120*, 63n, 82, 98n
Washington, D.C., Phillips Collection *Pl. 102*
Watteau, Jean-Antoine 62, 64, 83n, 90, 94
Weisberg, Gabriel 186n
Weise, Ellen Phoebe 74n
Whistler, James McNeill 81, 191
Wildenstein, Daniel (1975) 40n, 60n, 88n, 161n
Wildenstein, Georges (1932) 60n, 67n, 161, 165n,
 169
Wolff, Albert 51n, 66n, 160

Zaccone, Pierre *Pls. 17, 23*, 38, 65, 68
Zervos, Christian 52
Zola, Emile, *L'Evénement* 3; *Edouard Manet*, 1867
 25, 51, 55, 132, 158; Russian article 26–7; Manet
 catalogue introduction, 1884 27; *Nana* 40, 129;
 on art 5, 6–7, 24–5, 35, 95n, 120, 197; Japanese
 prints 186, 191; Manet 3, 25–6, 51, 100, 107n,
 128n, 207, 208; Manet's technique 54, 138, 182,
 183, 187
Zurburan, Francisco de 104–5n
Zurich, Bührle Collection 88n, 101n
Zurich, Kunsthaus *Pl. 87*

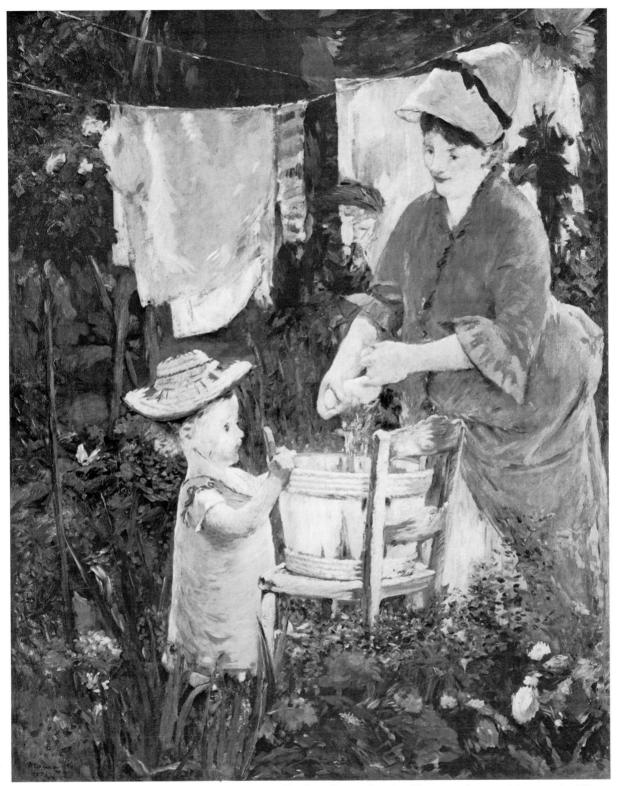

1. *The Laundress*. The Barnes Foundation, Merion Station, Pennsylvania. Photograph copyright 1977 by The Barnes Foundation.

2. (left) *Les Triomphateurs du salon*, cartoon by Gill, from *L'Eclipse*, 14 May 1876.

3. (above right) *The Urchin*, etching. George A. Lucas Collection, on indefinite loan from The Maryland Institute, courtesy of The Baltimore Museum of Art.

4. (right) *Le Petit Mendiant*, after Murillo, from *Les Français peints par eux-mêmes*, IV, 399.

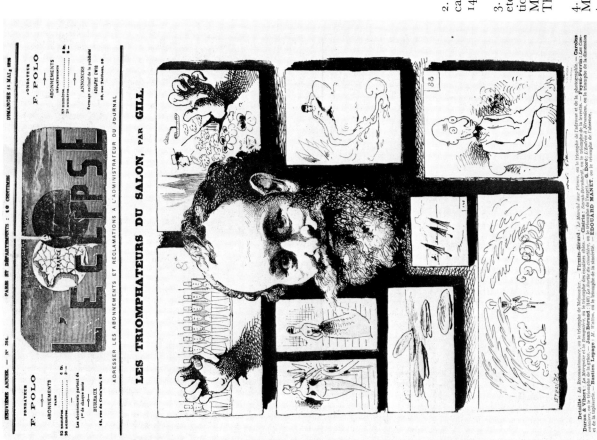

LES TRIOMPHATEURS DU SALON, par GILL.

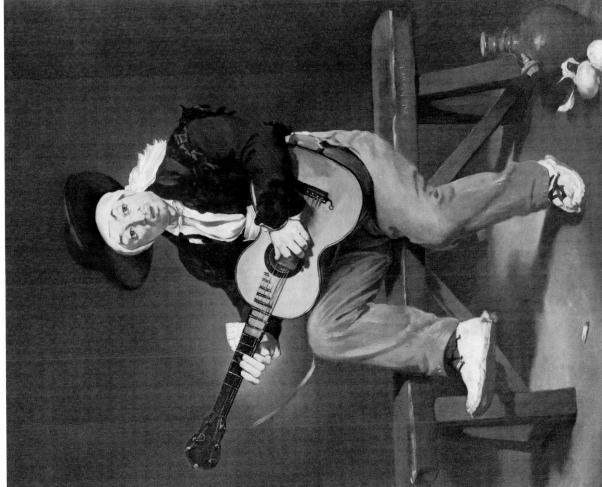

5. *The Spanish Singer*. Metropolitan Museum of Art, New York.
Gift of William Church Osborn, 1949.

7. *Gypsy*. Location unknown.

6. *Gypsies*, etching. George A. Lucas Collection, on indefinite loan from The Maryland Institute. Courtesy of The Baltimore Museum of Art.

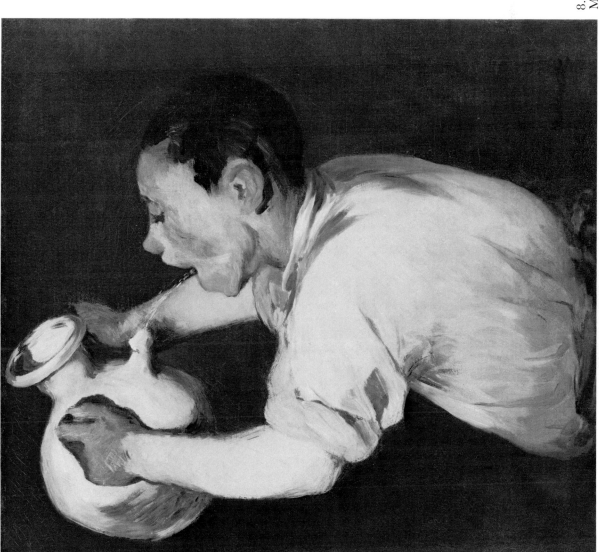

8. *The Water Drinker*. The Art Institute of Chicago. Mrs Stanley McCormick Bequest.

10. *L'Ouvrier de Paris*, by Pauquet, from *Les Français peints par eux-mêmes*, V, 361.

9. *La Limosine*, by Jeanron, from *Les Français peints par eux-mêmes*, II, 249.

11. *The Old Musician.* National Gallery of Art, Washington. Chester Dale Collection.

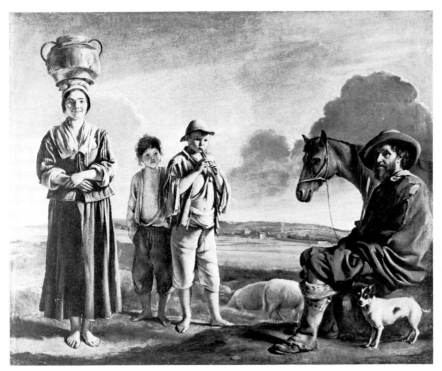

12. (left) *Rest of the Horsemen* by Louis Le Nain. Victoria and Albert Museum, London. Crown copyright.

13. (below) *L'Enfant volé*, engraving after a painting by Schlessinger, from *Magasin pittoresque*, XXVIII (1861), 293.

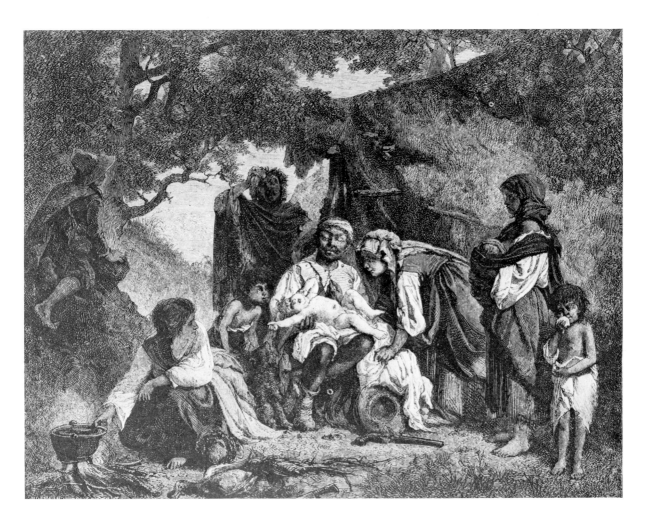

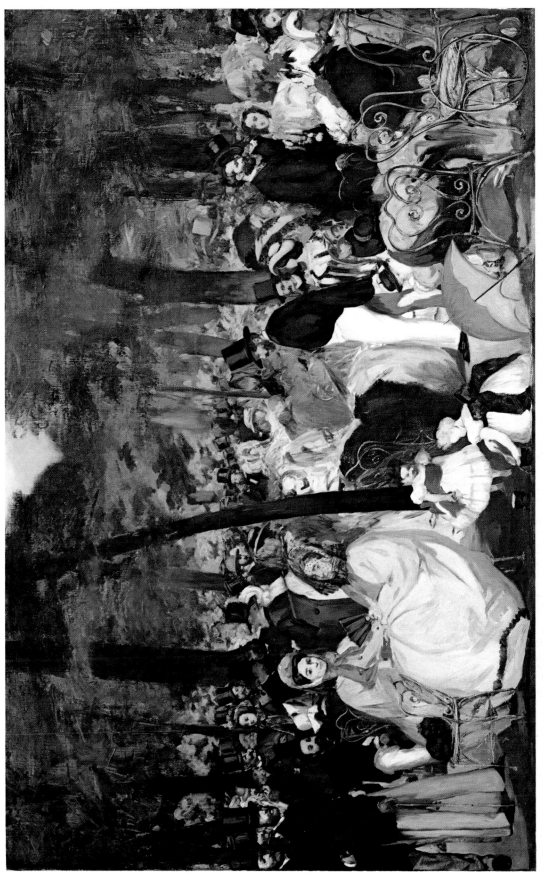

I. *Concert in the Tuileries*. National Gallery, London.

14. (left) *Little Girl*, etching. Philadelphia Museum of Art. The McIlhenny Fund.

15. (above) *La Petite Pologne*, by De Bar, from *Les Français peints par eux-mêmes*, IV, 25.

16. (left) *Gilles*, engraving after Watteau, from *Gazette des Beaux-Arts*, VII (1860), 271.

17. (above) *Le Chiffonnier*, from Pierre Zaccone, *Les Rues de Paris*, Paris, [1859], 205.

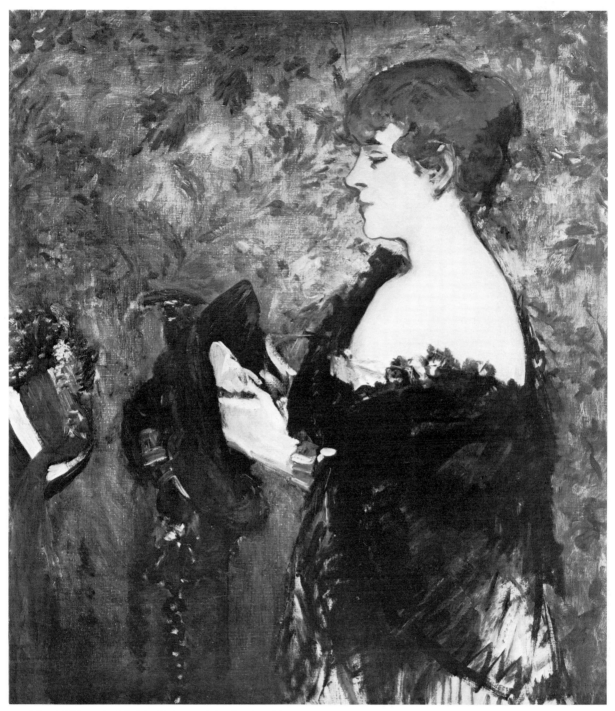

18. *The Milliner*. California Palace of the Legion of Honor, San Francisco.

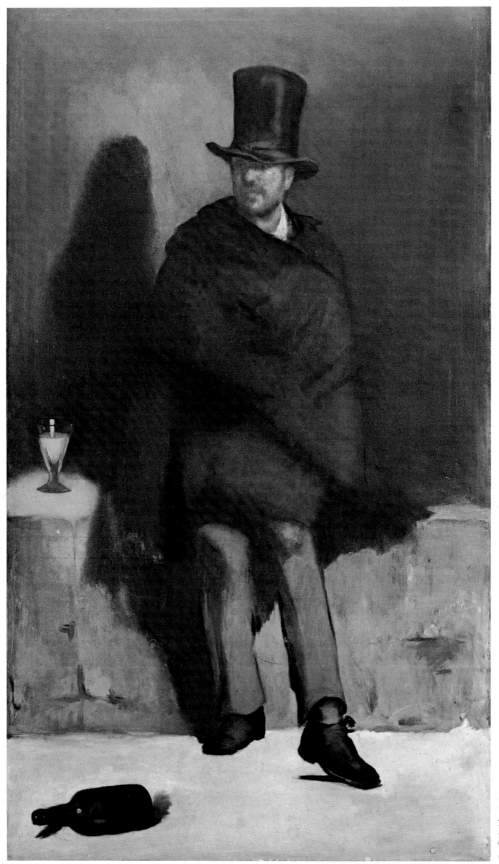

II. *The Absinthe Drinker*.
Ny Carlsberg
Glyptotek,
Copenhagen.

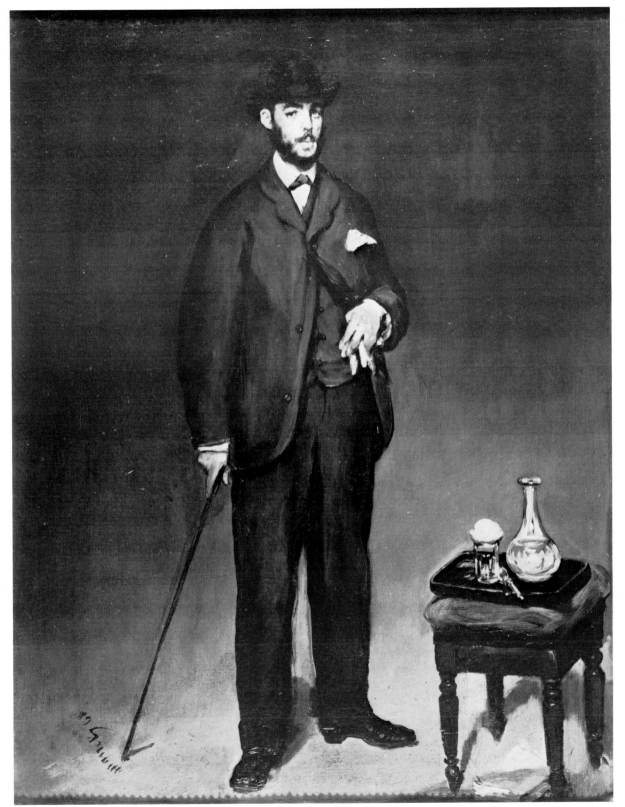

19. *Portrait of Duret*. Musée du Petit Palais, Paris.

21. *L'Ami de l'artiste*, by Monnier, from *Les Français peints par eux-mêmes*,
II, 157.

20. *La Modiste*, by Lami, from *Les Français peints par eux-mêmes*, IV, 349.

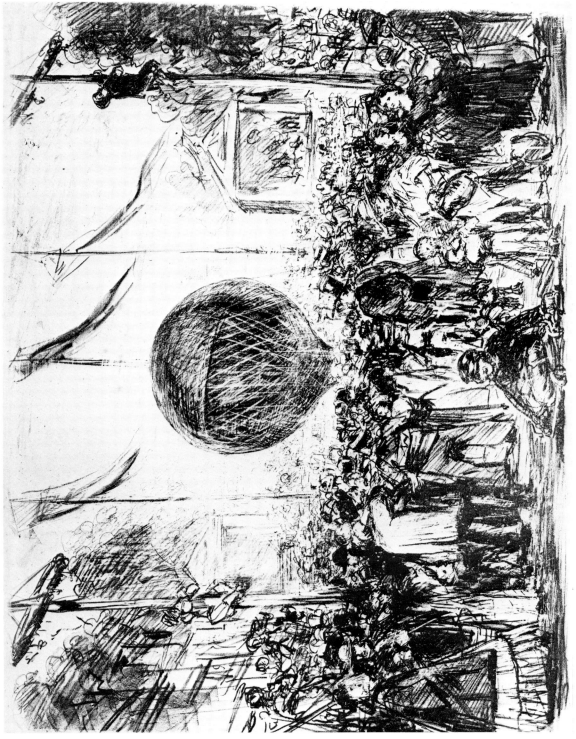

22. *The Balloon*, lithograph. Prints Division, New York Public Library. Astor, Lenox and Tilden Foundations.

23. *Les Joueurs de l'hotel d'Angleterre*, from Pierre Zaccone, *Les Rues de Paris*, Paris [1859], 216

25. *Le Café-concert*, from Émile de Labédollière, *Le Nouveau Paris*, Paris [1860], 113.

24. *At the Cafe*, drawing. Fogg Art Museum, Cambridge, Massachusetts. Bequest of Meta and Paul J. Sachs.

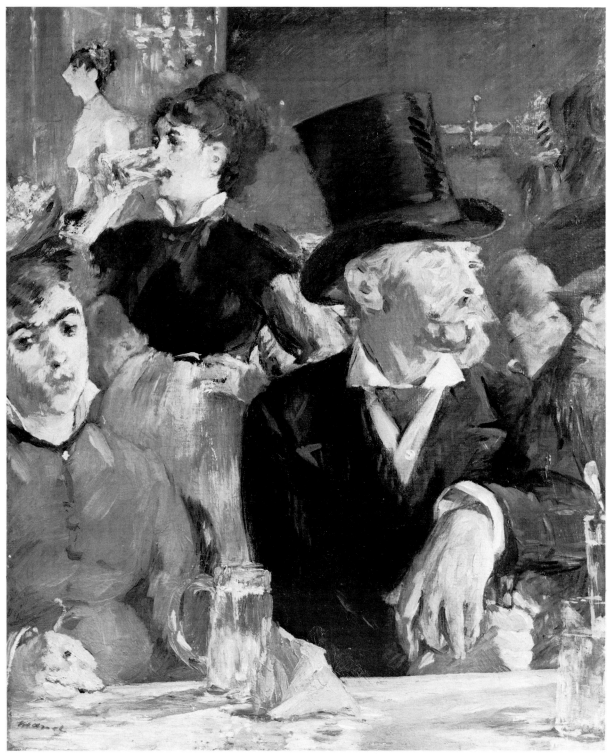

26. *At the Cafe*. The Walters Art Gallery, Baltimore.

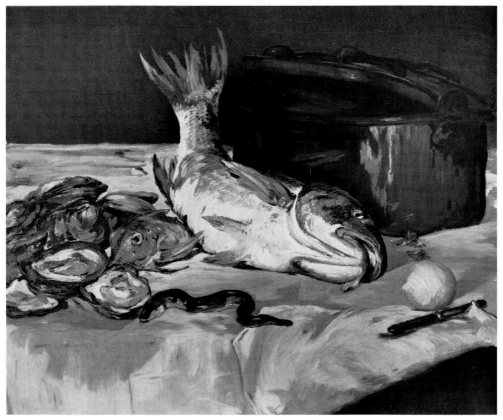

27. *Still Life with Carp*. The Art Institute of Chicago. Mr and Mrs Lewis L. Coburn Memorial Collection.

28. *Still Life with Salmon and Pike*. Private Collection, U.S.A.

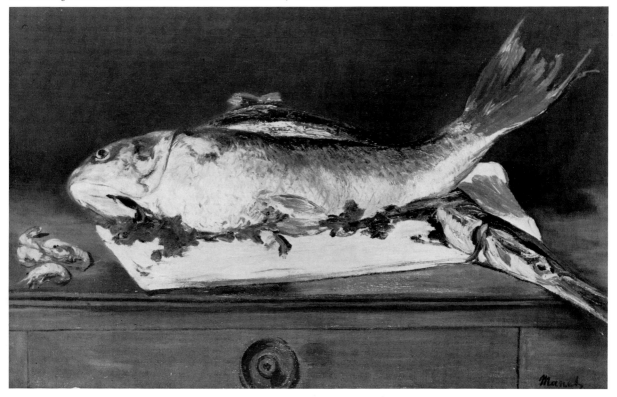

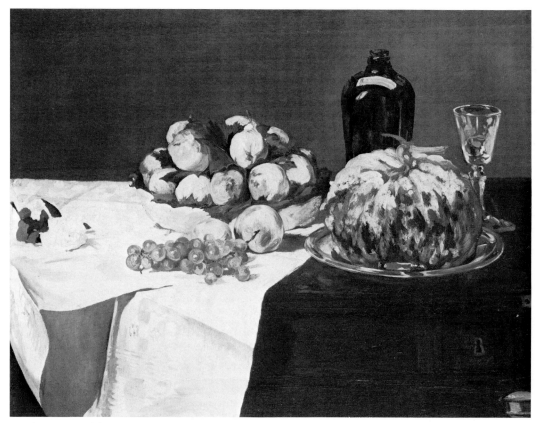

29. *Still Life with Melon and Peaches*, National Gallery of Art, Washington. Gift of Eugene and Agnes Meyer.

30. *Still Life with a Hat*. Musée Calvet, Avignon.

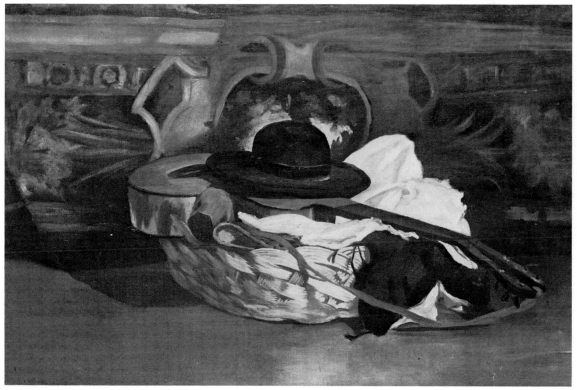

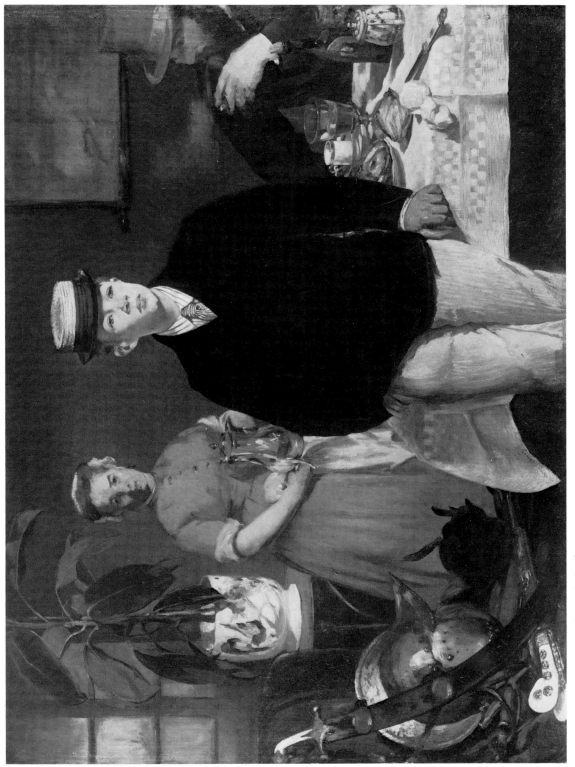

31. *Luncheon in the Studio*. Bayerische Staatsgemäldesammlungen, Munich.

33. *Frontispiece*, etching. Prints Division, New York Public Library. Astor, Lenox and Tilden Foundations.

32. *Frontispiece*, watercolor. Prints Division, New York Public Library. Astor, Lenox and Tilden Foundations.

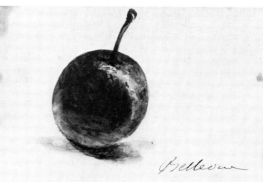

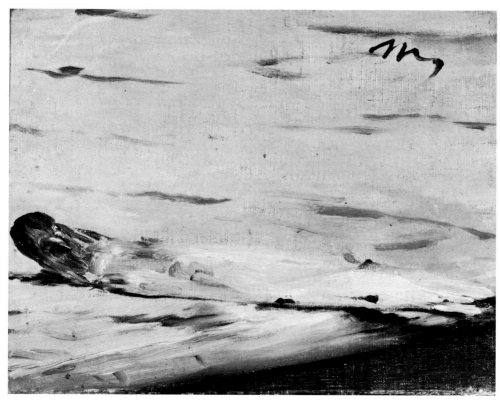

34. (above left)
Letter with a Snail on a Leaf, ink and watercolor. Collection of Mr and Mrs Alexander M. Lewyt, New York.

35. (above right)
Letter with a Plum, ink and watercolor. Museum Boymans-van Beuningen, Rotterdam.

36. (left)
Stalk of Asparagus. Musée du Louvre, Paris.

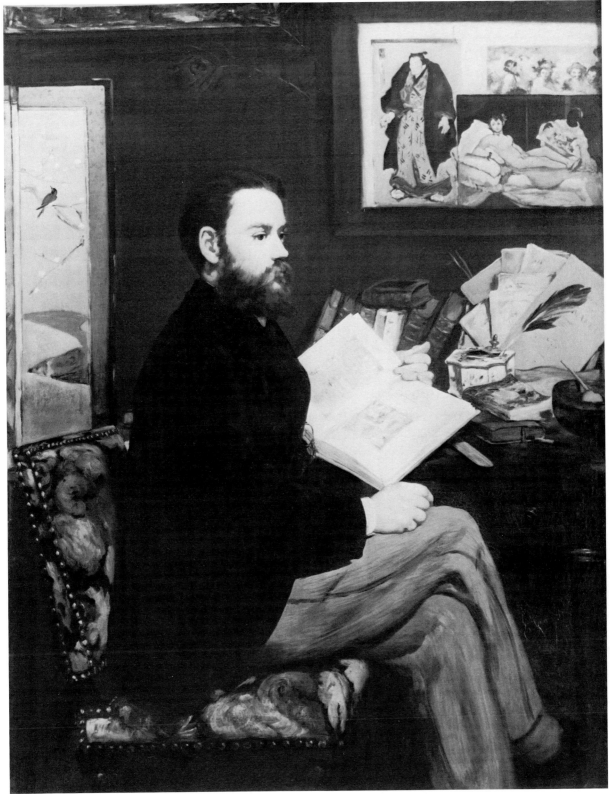

37. *Portrait of Zola*. Musée du Louvre, Paris.

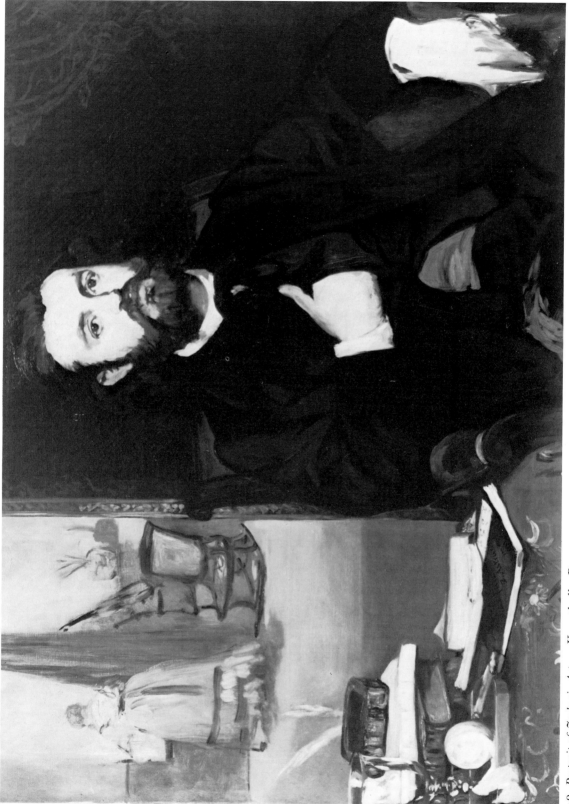

38. *Portrait of Zacharie Astruc.* Kunsthalle, Bremen.

40. *Portrait of the Artist's Parents*. Private Collection, Paris.

39. Copy after Titian, *Venus of Urbino*. Private Collection, Paris.

41. *Portrait of the Artist's Parents*, sanguine drawing. Private Collection, Paris.

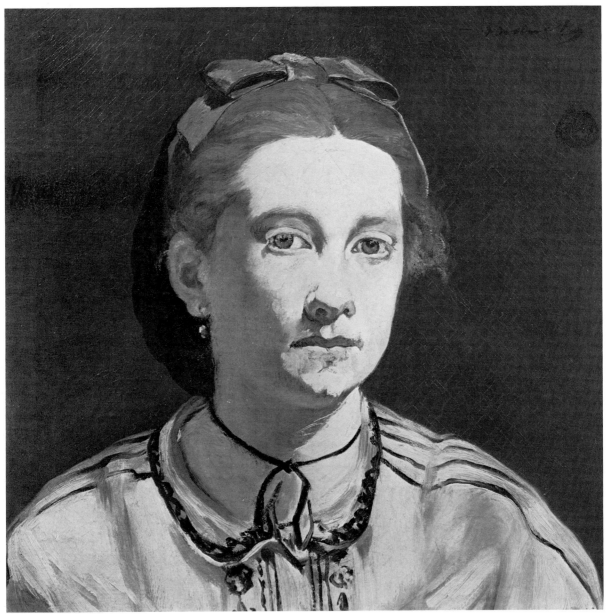

42. *Portrait of Victorine Meurand*. Museum of Fine Arts, Boston. Gift of Richard C. Paine in memory of his father, Robert Treat Paine II.

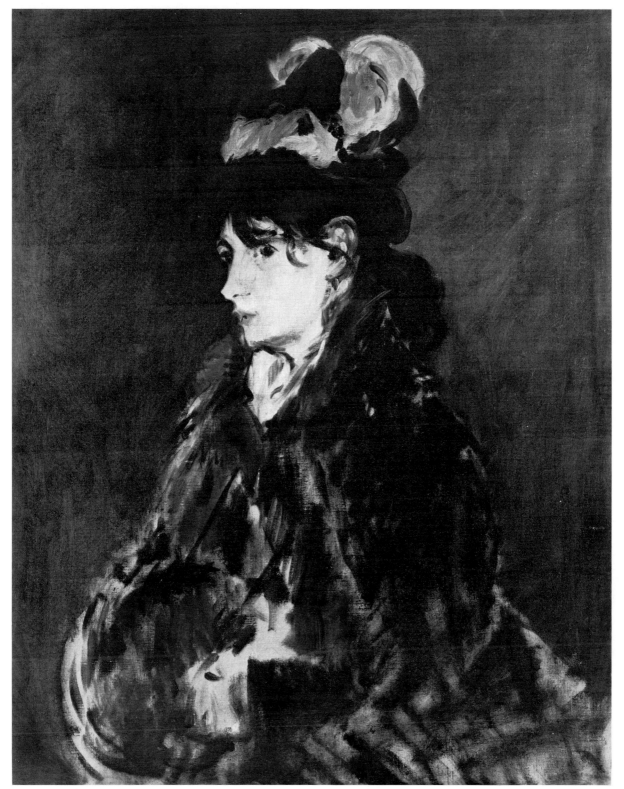

43. *Portrait of Berthe Morisot with a Muff*. The Cleveland Museum of Art. Leonard C. Hanna Jr. Collection.

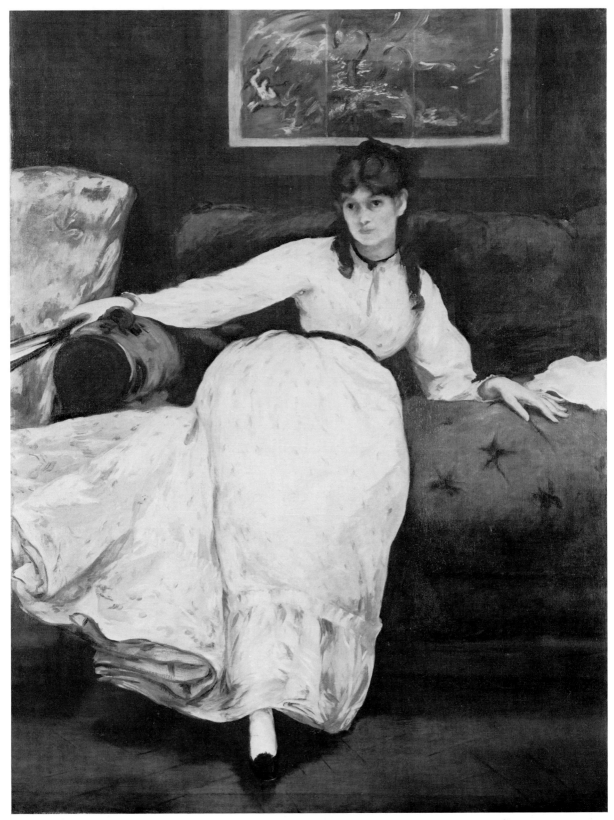

44. *Le Repos*. Museum of Art, Rhode Island School of Design, Providence. Bequest of the estate of Mrs Edith S. Gerry.

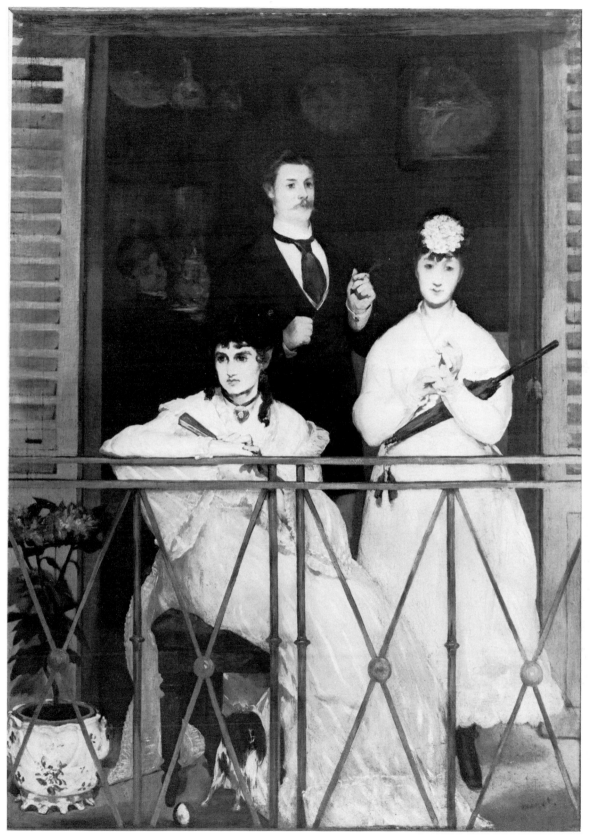

45. *The Balcony*. Musée du Louvre, Paris.

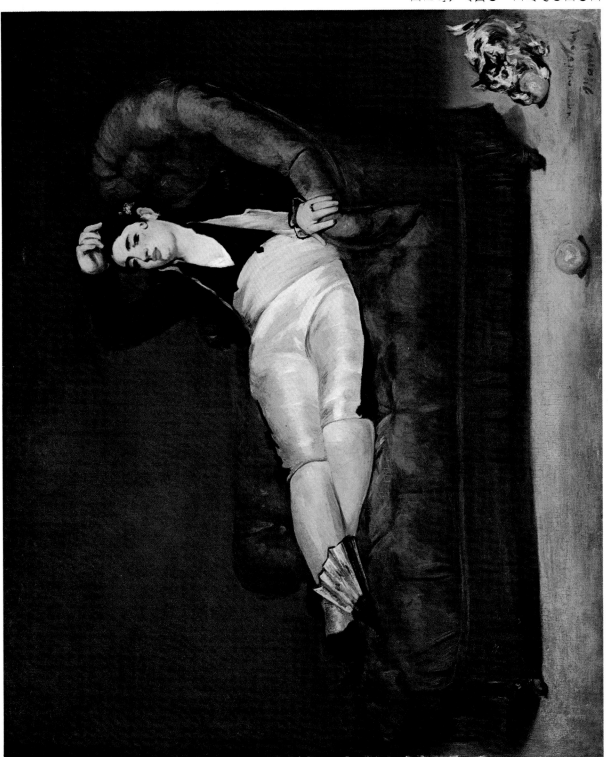

III. (left) *Young Woman Reclining in Spanish Costume.* Yale University Art Gallery, New Haven, Connecticut.

IV. (below) *The Painter Guillaudin on Horseback.* Collection of Mr Henry Ford II, Grosse Point Farms, Michigan.

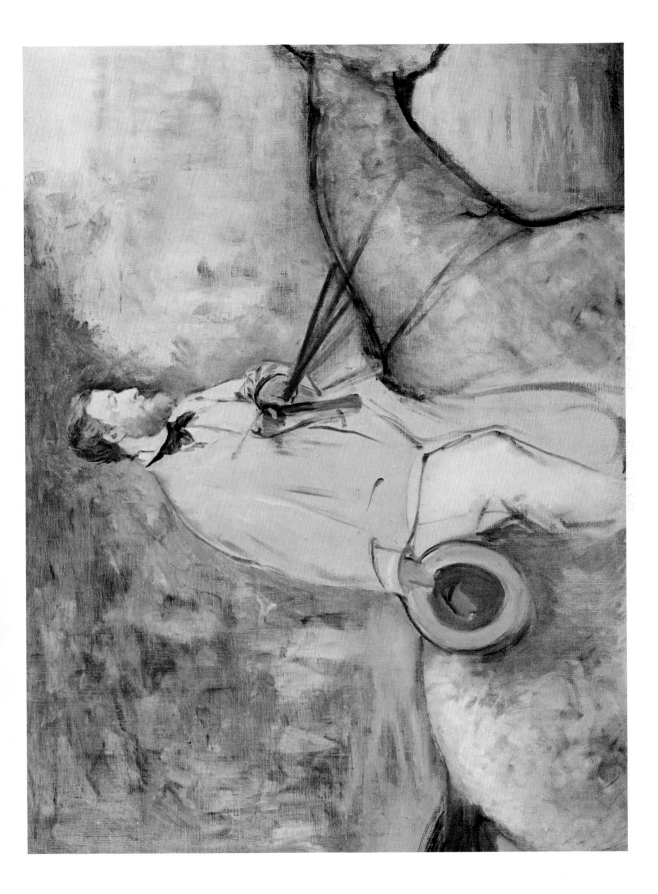

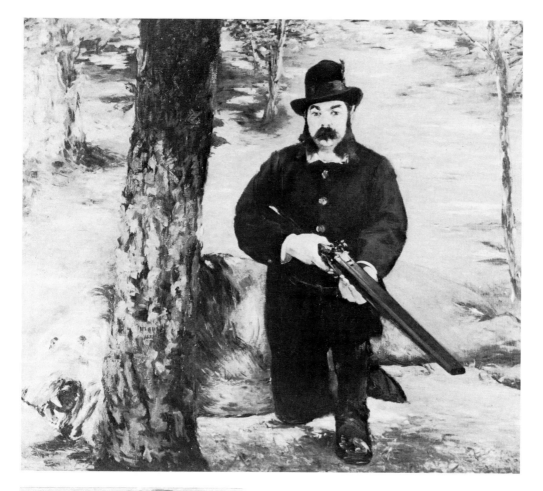

46. (above) *Portrait of Pertuiset as a Lion Hunter*.
Museu de Arte, São Paolo.

47. (left) *Le Tueur des lions*, from Pierre Dupont,
Chants et chansons, Paris, 1855, IV, 125.

48. (right) *The Boy with the Sword*. Metropolitan
Museum of Art, New York. Gift of Erwin
Davis, 1889.

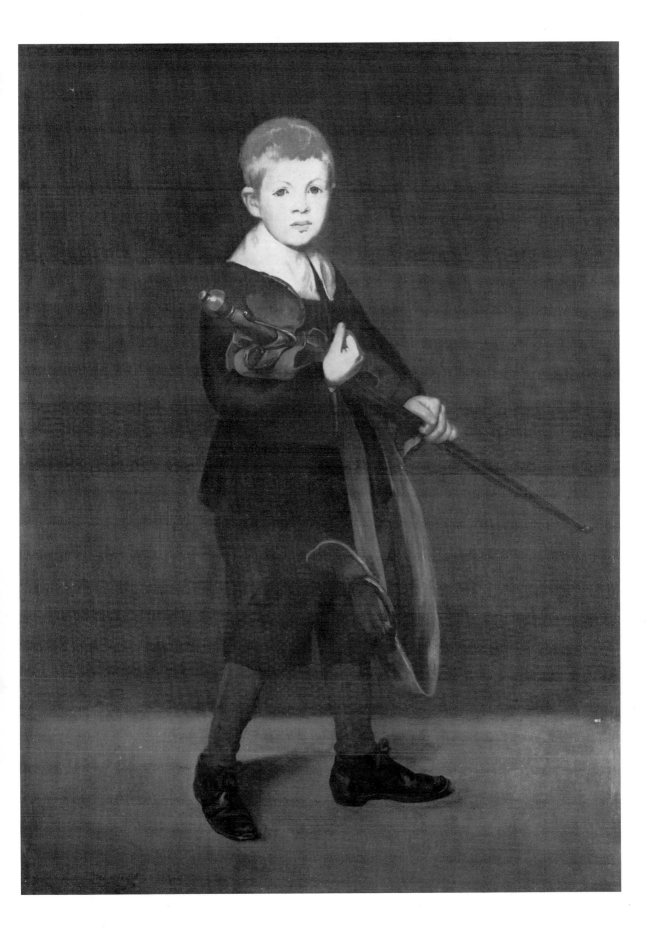

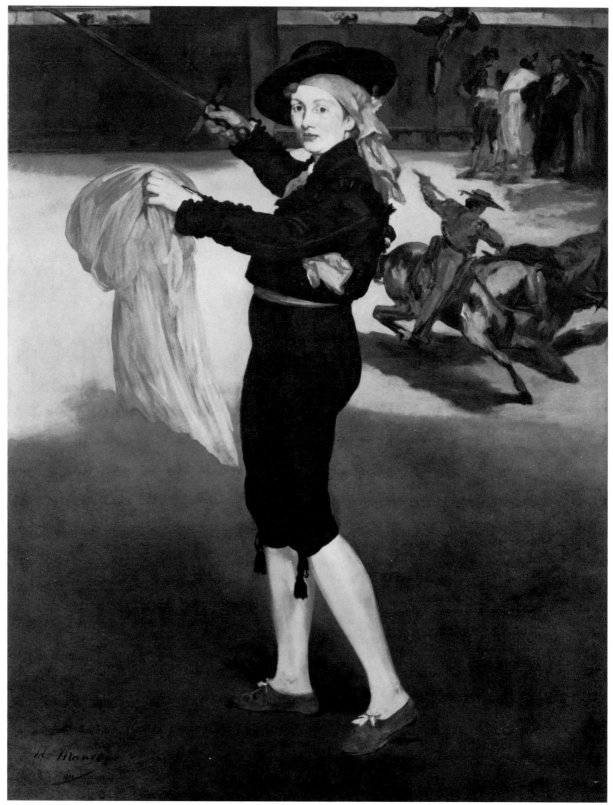

49. *Mademoiselle Victorine as an Espada*. Metropolitan Museum of Art, New York. The H. O. Havemeyer Collection. Bequest of Mrs H. O. Havemeyer, 1929.

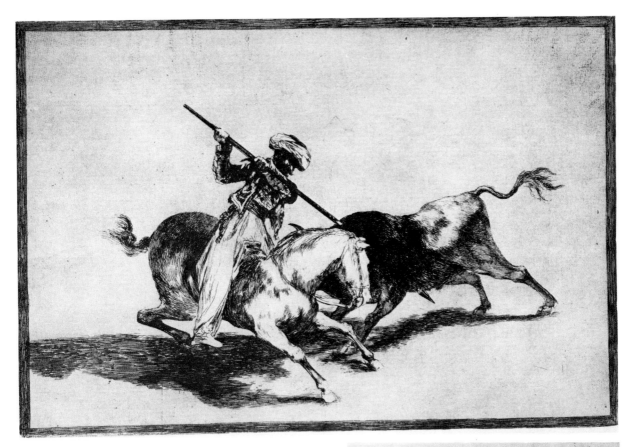

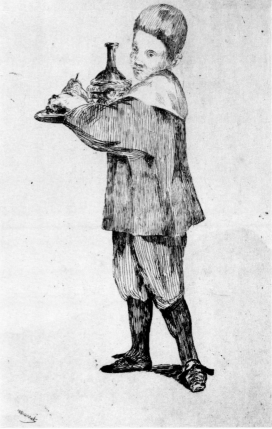

50. (above) *Tauromaquia*, no. 5., etching, by Goya.

51. (right) *The Boy with a Tray*, etching. The Art
Institute of Chicago. John H. Wrenn Memorial
Collection.

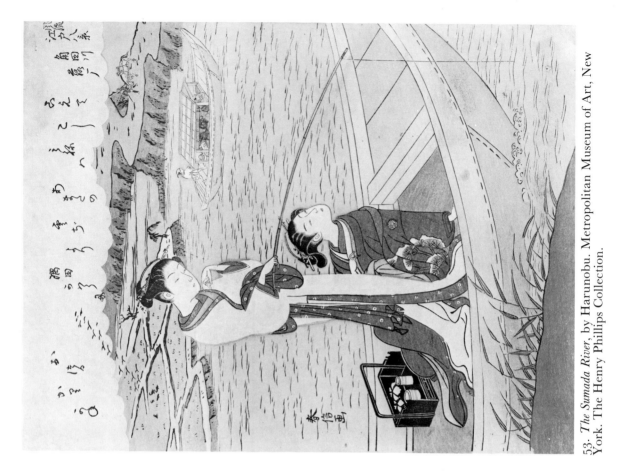

53. *The Sumada River*, by Harunobu. Metropolitan Museum of Art, New York. The Henry Phillips Collection.

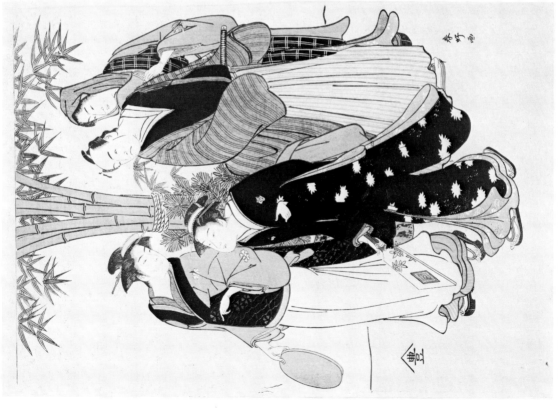

52. *New Year Scene*, by Shunko I. Metropolitan Museum of Art, New York. The Henry L. Phillips Collection.

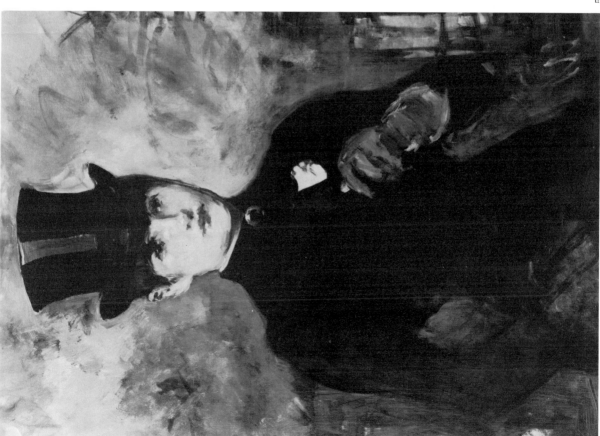

54. *Amazon.* Collection of Mrs Henry Pearlman, New York.

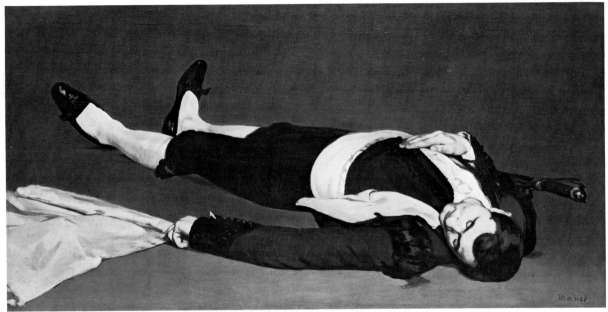

55. *The Dead Toreador*. National Gallery of Art, Washington. Widener Collection, 1942.

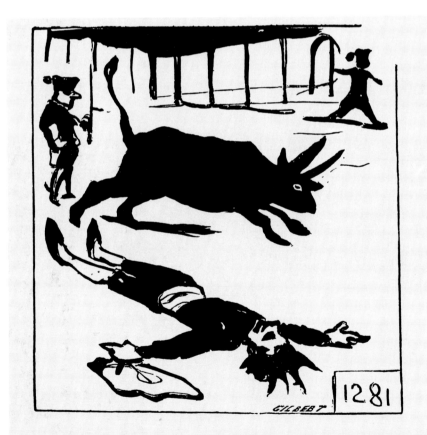

56. Cartoon of *The Dead Toreador*, by Cham, from *Charivari*, 22 May 1864.

MANET.

Ayant eu à se plaindre de son marchand de couleurs, M. Manet prend le parti de ne plus se servir que de son encrier.

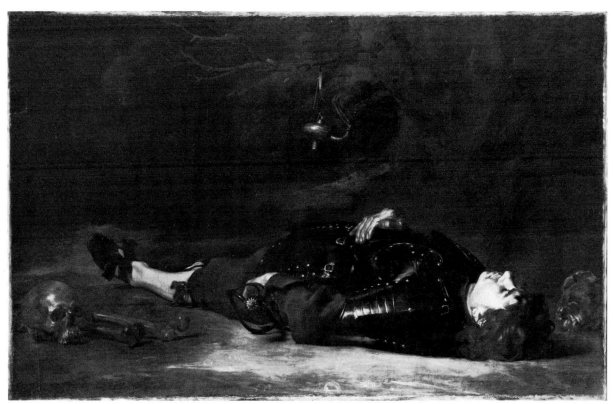

57. *Dead Soldier*, Italian School, Seventeenth Century. The National Gallery, London.

58. *The Death of Caesar*, by Gérôme. The Walters Art Gallery, Baltimore.

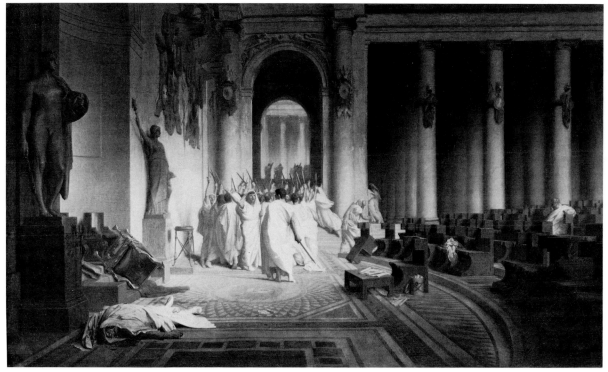

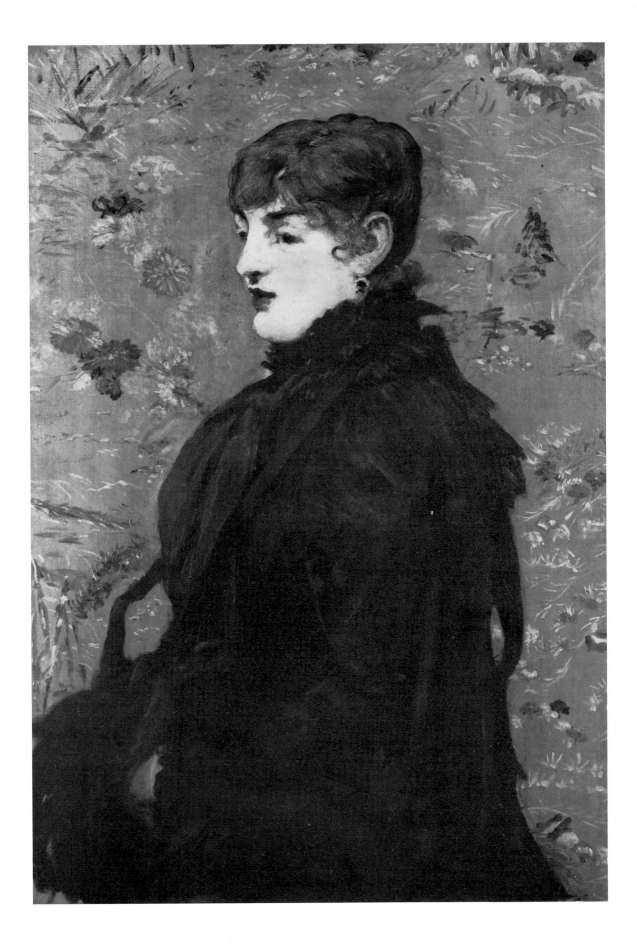

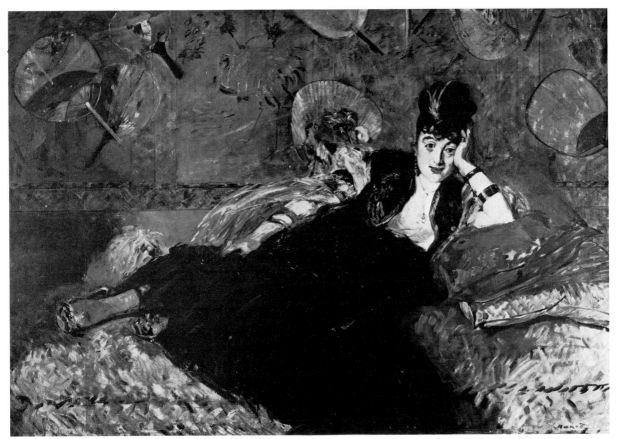

60. *Portrait of Nina de Callias: The Woman with the Fans.* Musée du Louvre, Paris.

59. (left)
Autumn. Musée
des Beaux-Arts,
Nancy.

61. (right)
Odalisque,
etching.
George A. Lucas
Collection, on
indefinite loan
from The Mary-
land Institute.
Courtesy of
The Baltimore
Museum of Art.

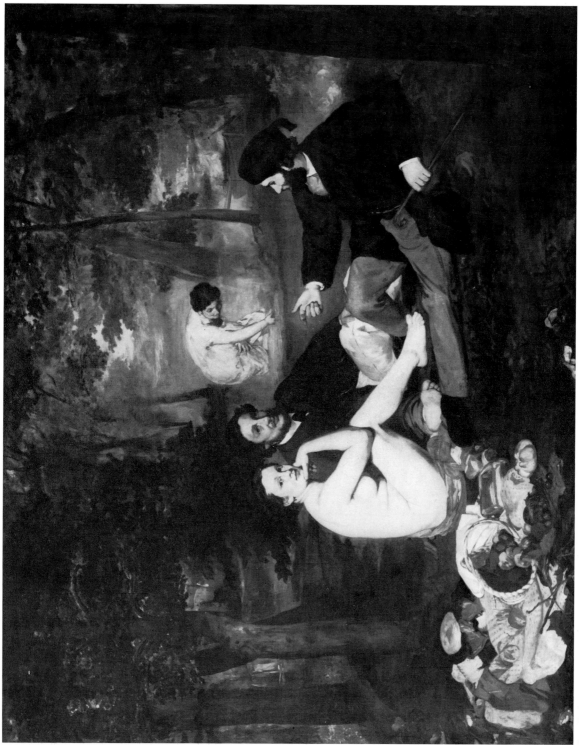

62. *Déjeuner sur l'herbe*. Musée du Louvre, Paris.

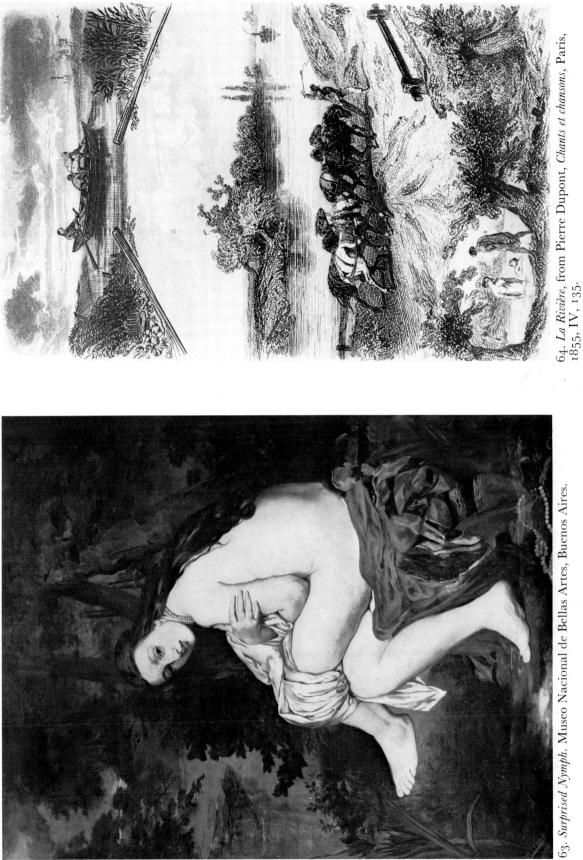

64. *La Rivière*, from Pierre Dupont, *Chants et chansons*, Paris, 1855, IV, 135.

63. *Surprised Nymph*. Museo Nacional de Bellas Artes, Buenos Aires.

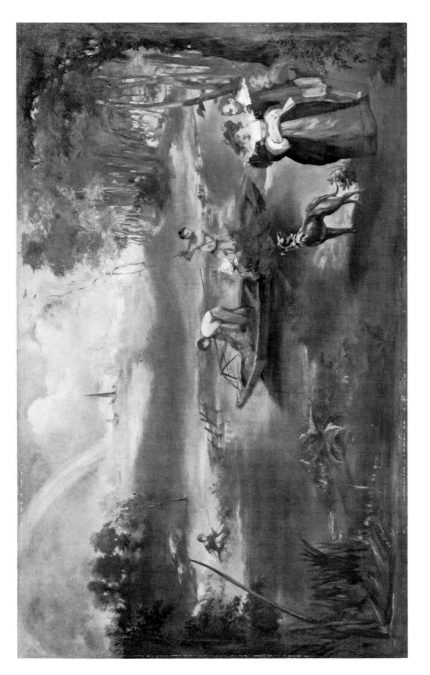

65. (above) *Fishing*. Metropolitan Museum of Art, New York. Purchase Mr and Mrs Richard Bernhard Fund, 1957.

66. (right) Illustration by Gavarni from Paul Huart, *Physiologie de la grisette*, Paris [1841], 86.

68. *Ma nacelle*, by A. Lemud, from P. J. Béranger, *Oeuvres complètes*, Paris, 1856, I, 250.

67. *Le Sauvage*, from Pierre Dupont, *Chants et chansons*, Paris, 1855, I, 101.

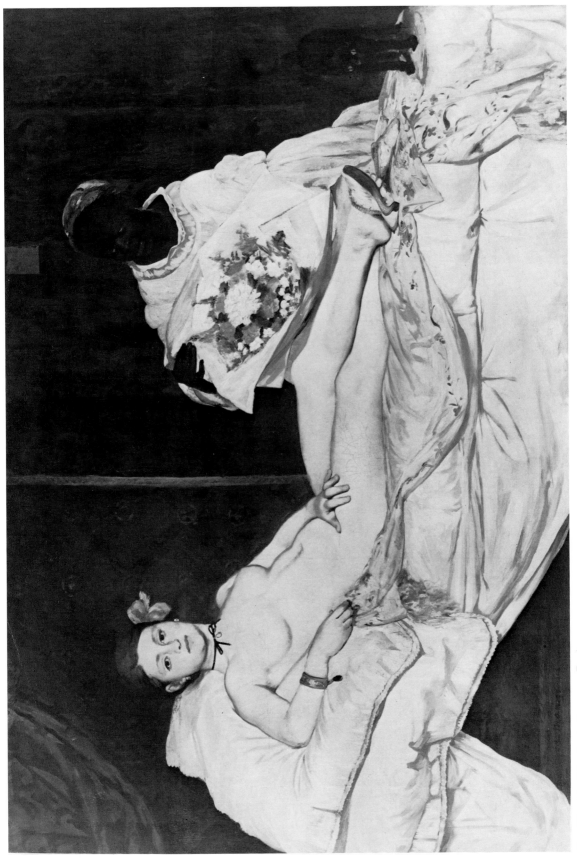

69. *Olympia*. Musée du Louvre, Paris.

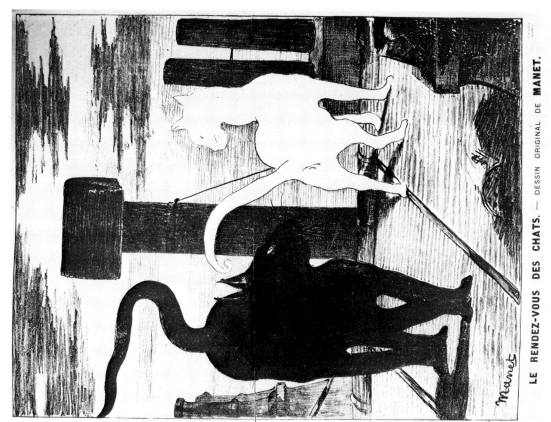

70. *Sujet gracieux*, by Achille Devéria, from Maximilien Gauthier, *Achille et Eugène Devéria*, Paris, 1925, opp. p. 80.

71. *Cats Meeting*, lithograph. Prints Division, New York Public Library. Astor, Lenox and Tilden Foundations.

72. *The Cookoo's Verse*, by Shunshō, from Philip Stanley Rawson, *Erotic Art of the East*, G. P. Putnam, Sons, New York, 1968, Plate XXIV.

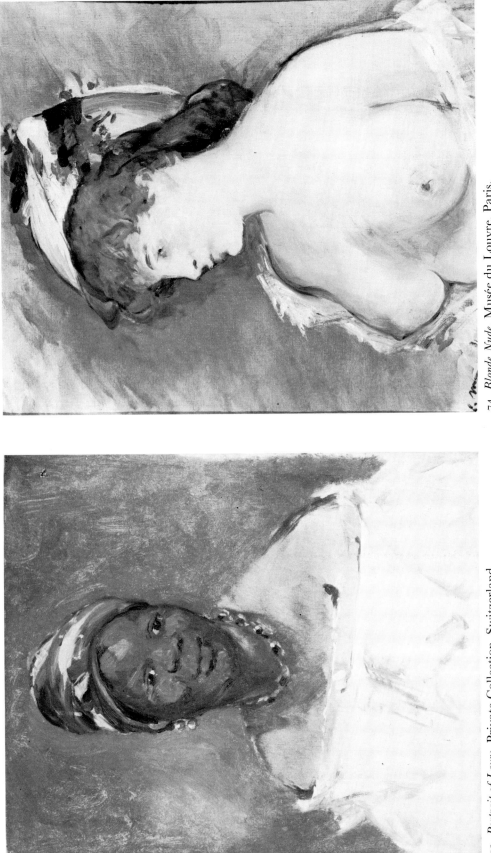

73. *Portrait of Laure.* Private Collection, Switzerland.

74. *Blonde Nude.* Musée du Louvre, Paris.

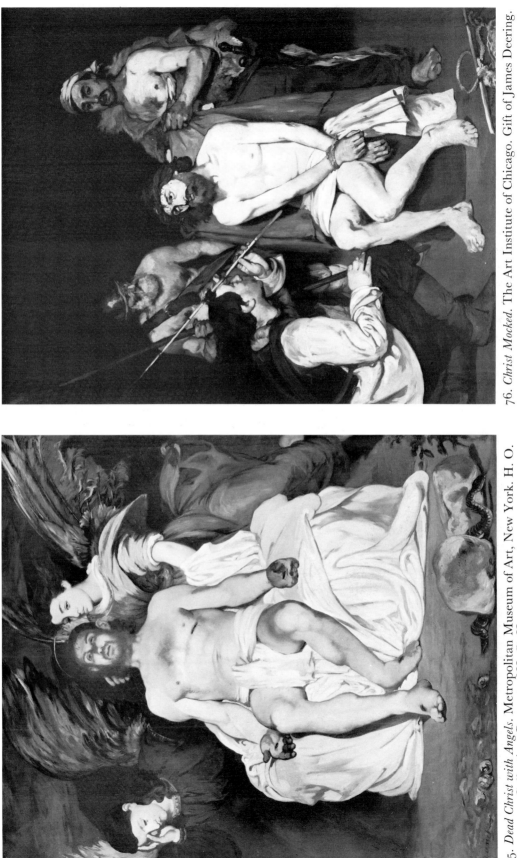

76. *Christ Mocked*. The Art Institute of Chicago. Gift of James Deering.

75. *Dead Christ with Angels*. Metropolitan Museum of Art, New York. H. O. Havemeyer Collection. Bequest of H. O. Havemeyer, 1929.

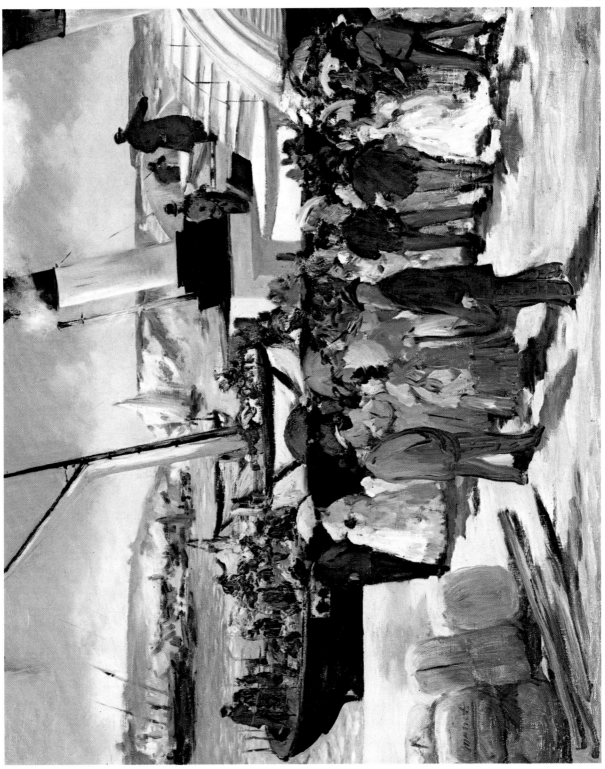

V. (left) *The Departure of the Folkestone Boat.* Philadelphia Museum of Art, Mr and Mrs Carroll S. Tyson Collection.

VI. (below) *The Conservatory.* Nationalgalerie, Berlin.

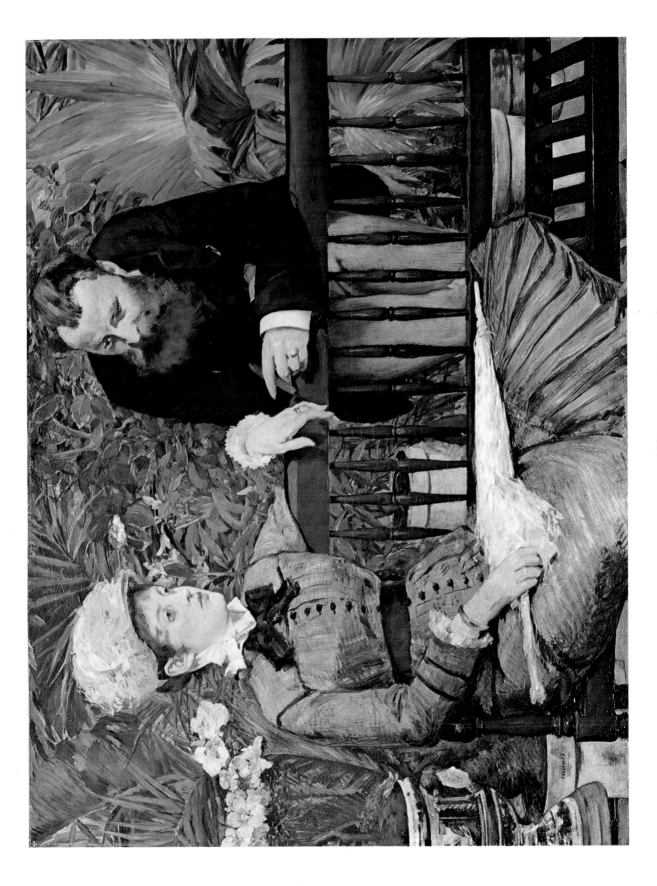

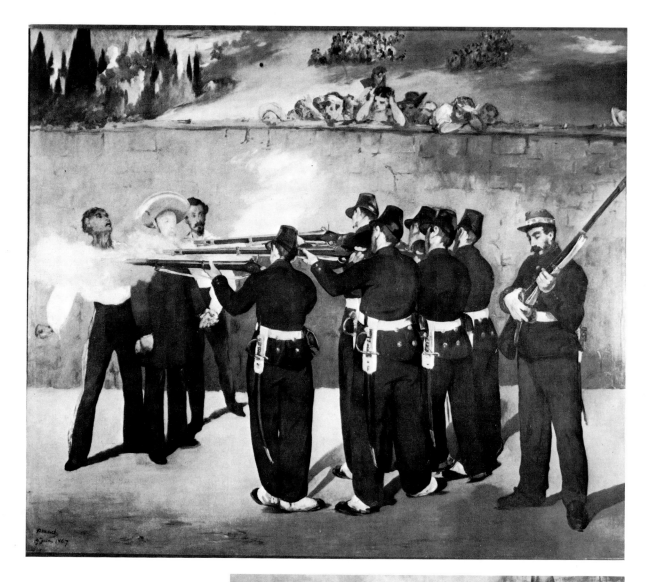

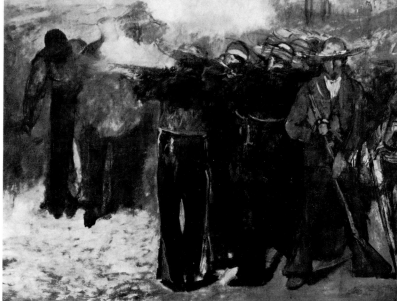

77. (above) *The Execution of the Emperor Maximilian*. Städtische Kunsthalle, Mannheim.

78. (right) *The Execution of the Emperor Maximilian*. Museum of Fine Arts, Boston. Gift of Mr and Mrs Frank Gair Macomber.

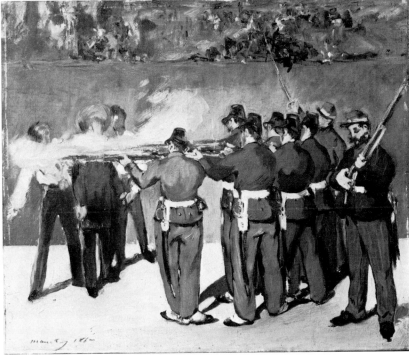

79. (above) Detail of *The Execution of the Emperor Maximilian*. Museum of Fine Arts, Boston.

80. (left) *The Execution of the Emperor Maximilian*. Ny Carlsberg Glyptotek, Copenhagen.

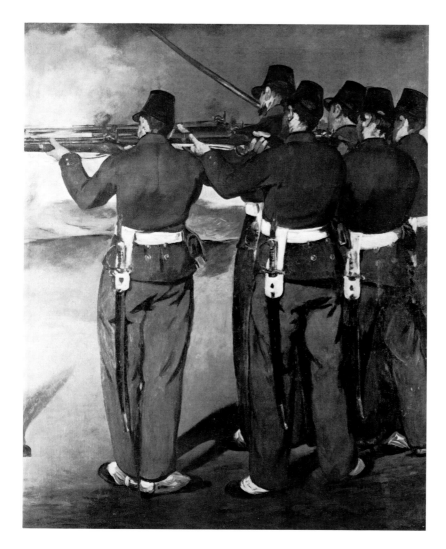

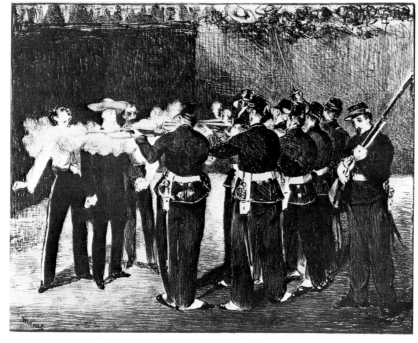

81. (above left) Fragment from *The Execution of the Emperor Maximilian*, National Gallery, London.

82. (left) *The Execution of the Emperor Maximilian*, lithograph. National Gallery of Art, Washington. Rosenwald Collection.

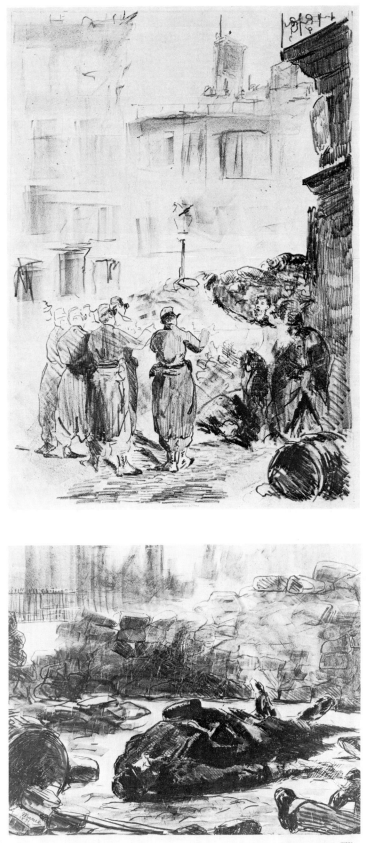

83. (above right) *The Barricade*, lithograph.
The Art Institute of Chicago. Gift of The
Print and Drawing Club.

84. (right) *Civil War*, lithograph. Collection
of Robert Walker, Swarthmore,
Pennsylvania.

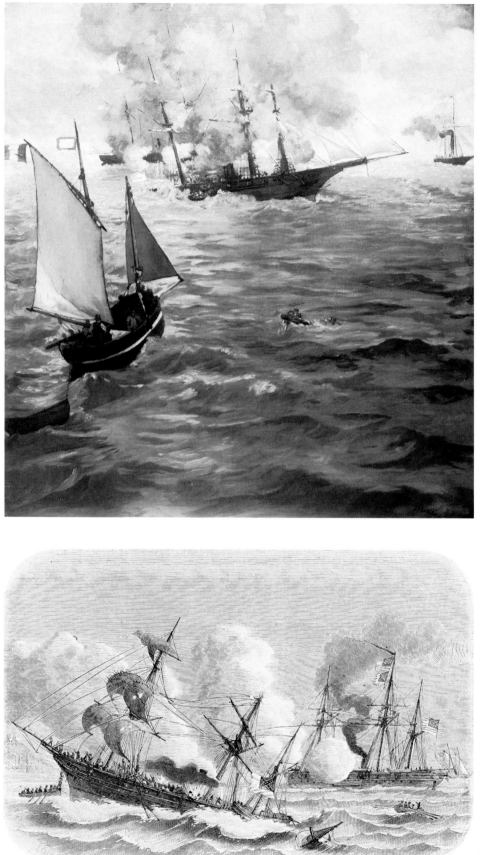

85. (above left) *The Battle of the Kearsarge and the Alabama*. The Philadelphia Museum of Art. John G. Johnson Collection.

86. (left) *The Battle of the Kearsarge and the Alabama*, from *Almanach: Magasin pittoresque*, XV (1865), 55.

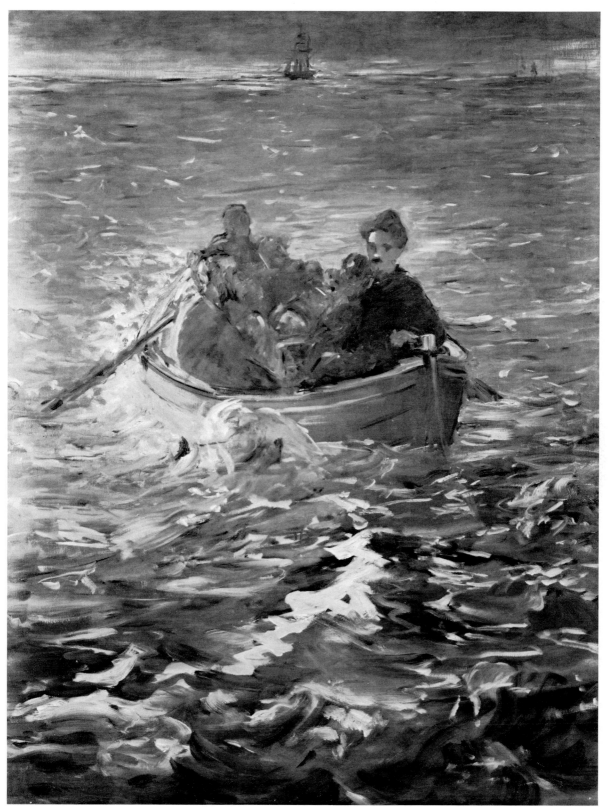

87. *The Escape of Rochefort*. Kunsthaus, Zurich.

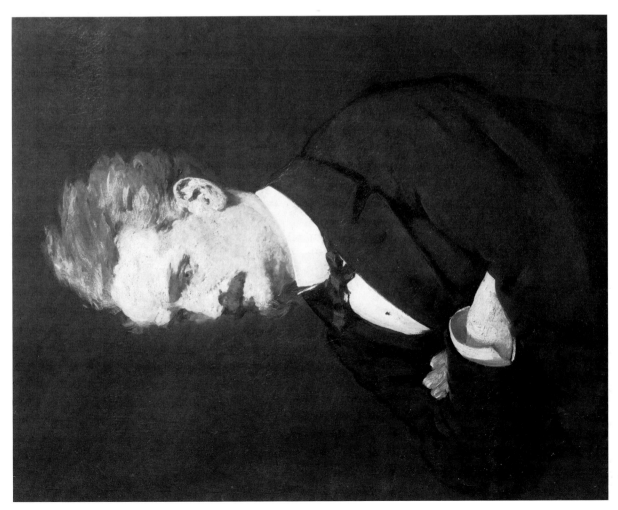

88. (left) *Portrait of Henri Rochefort*. Kunsthalle, Hamburg.

89. (above) Cartoon by G. Darre, *Le Carillon*, 16 July 1881.

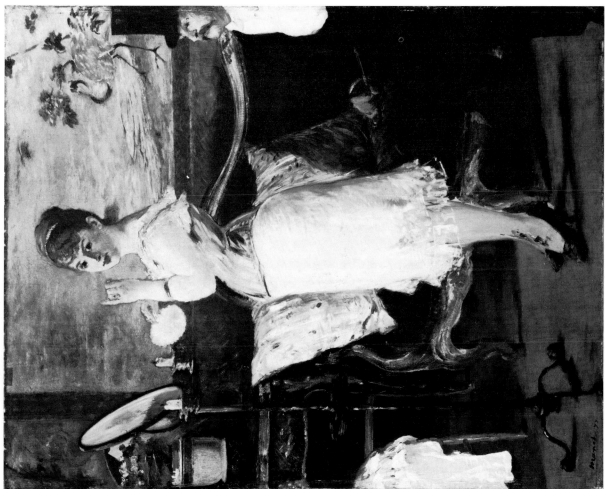

90. *Nana*. Kunsthalle, Hamburg.

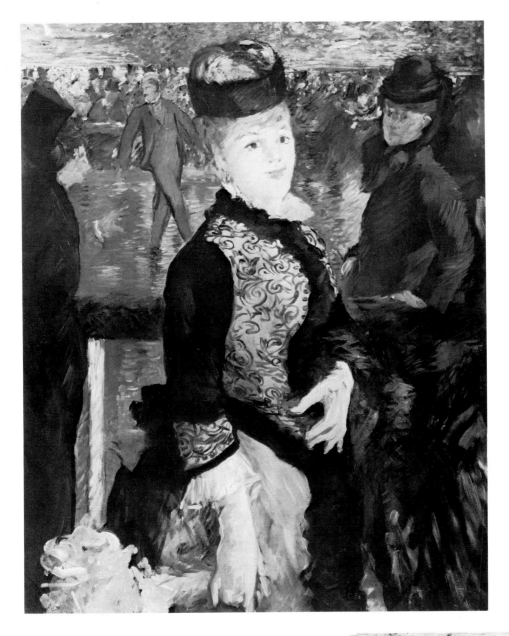

91. (above) *Skating*. The Fogg Art Museum,
Cambridge, Massachusetts. Collection of Maurice
Wertheim, Class of 1906.

92. (right) *Les Patineurs de la glacière*, from Émile de
Labédollière, *Le Nouveau Paris*, Paris [1860], 201.

93. (right) Illustration for *Le Fleuve* by Charles Cros, etching. Library of Congress, Washington. Rosenwald Collection.

94. (below left) Illustrations for *L'Après-midi d'un faune* by Stéphane Mallarmé, wood engraving. George A. Lucas Collection, on indefinite loan from The Maryland Institute. Courtesy of The Baltimore Museum of Art.

95. (below right) *The Raven on the Bust of Pallas*, illustration for *Le Corbeau*, translated by Stéphane Mallarmé from Poe, *The Raven*, transfer lithograph. Philadelphia Museum of Art. The Print Club of Philadelphia, Permanent Collection.

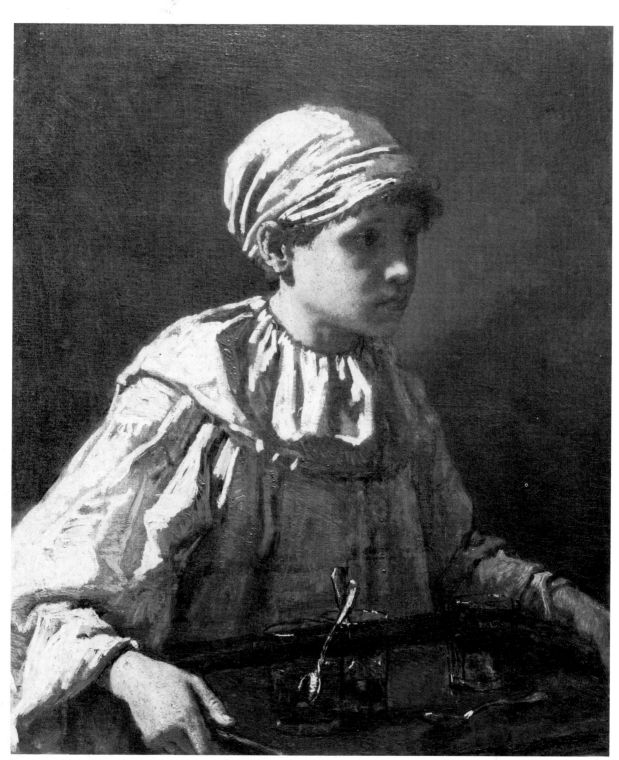

96. *Little Gilles*, by Thomas Couture. The Philadelphia Museum of Art. The William L. Elkins Collection.

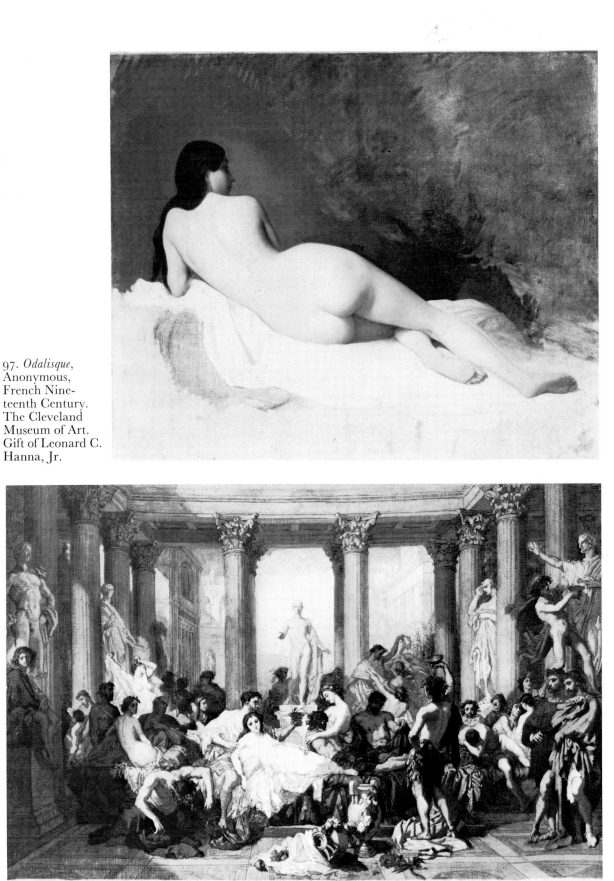

97. *Odalisque*, Anonymous, French Nineteenth Century. The Cleveland Museum of Art. Gift of Leonard C. Hanna, Jr.

98. *Study for* The Romans of the Decadance, by Thomas Couture. Museum of Art, Rhode Island School of Design, Providence. Mary B. Jackson Fund.

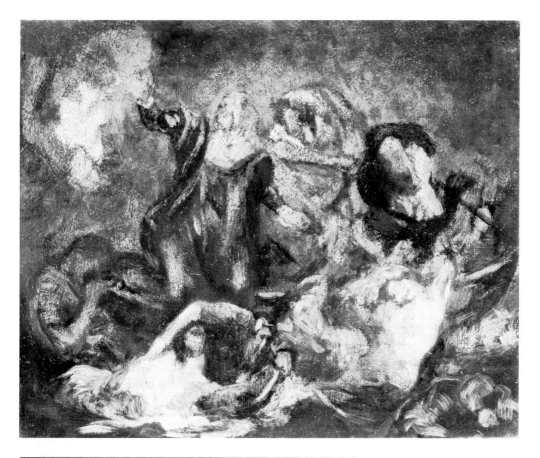

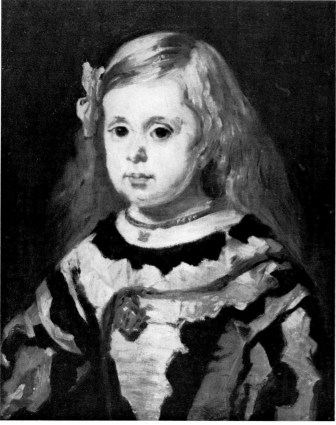

99. (above) Copy after Delacroix, *Barque of Dante*. Metropolitan Museum of Art, New York. The H. O. Havemeyer Collection. Bequest of Mrs H. O. Havemeyer, 1929.

100. (left) Copy after Velasquez, *Infanta Margarita*, artist unknown. Private Collection, United States.

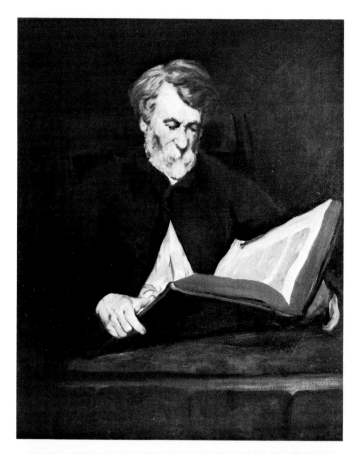

101. (right) *The Reader*. The St. Louis Art Museum.

102. (below) *The Spanish Ballet*. The Phillips Collection, Washington.

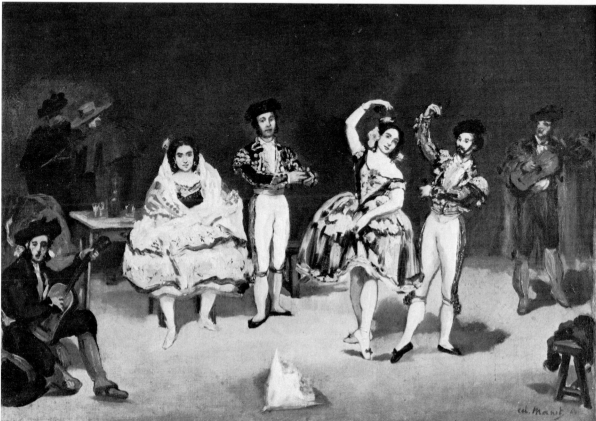

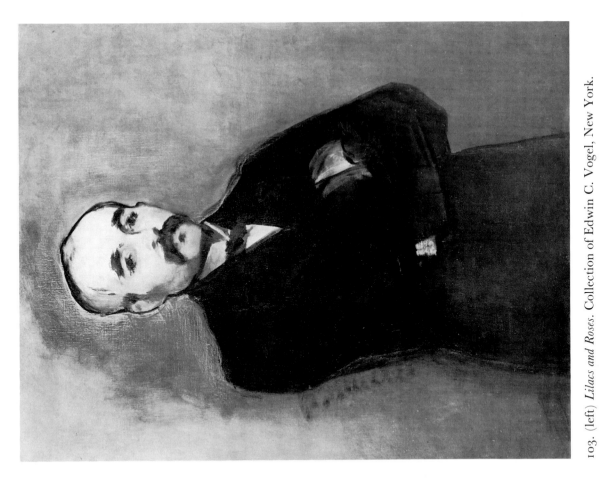

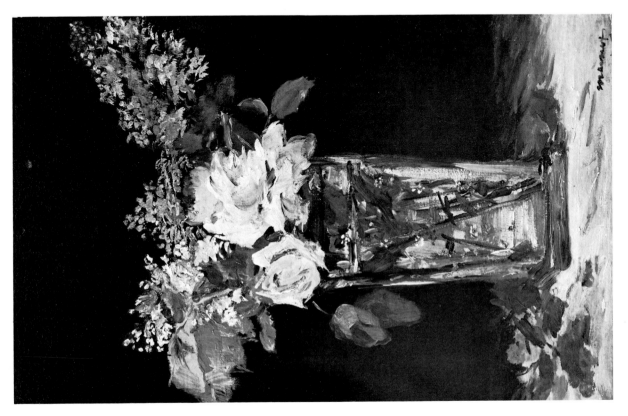

103. (left) *Lilacs and Roses*. Collection of Edwin C. Vogel, New York.

104. (above) *Portrait of Clemenceau*. Musée du Louvre, Paris.

105. (left) *Portrait of Vigneau*, ink drawing. The Baltimore Museum of Art. The Cone Collection.

106. (below) *Portrait of George Moore in a Café*. Metropolitan Museum of Art, New York. Gift of Mrs Ralph J. Hines, 1955.

107. (right) *Young Woman*. The Art Institute of Chicago. The Joseph Winterbotham Collection.

108. *Claude Monet in his Floating Studio. Staatsgalerie, Stuttgart.*

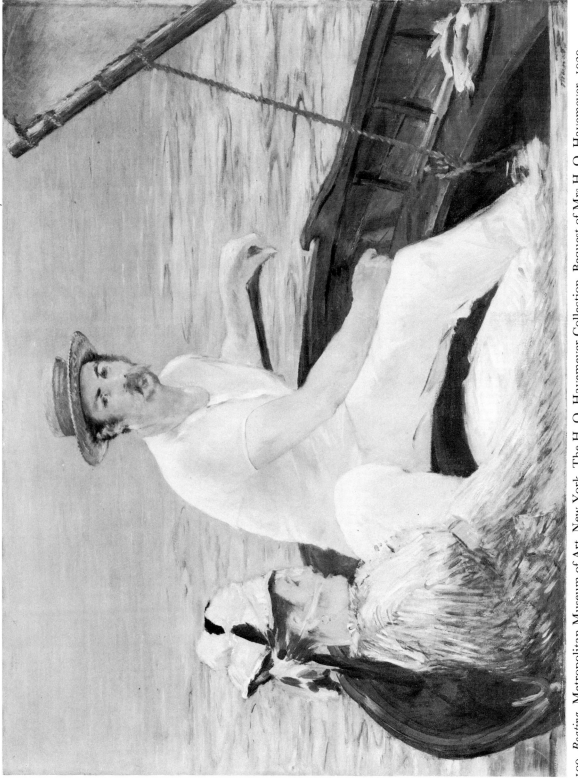

109. *Boating*. Metropolitan Museum of Art, New York. The H. O. Havemeyer Collection. Bequest of Mrs H. O. Havemeyer, 1929.

VII. (far left)
Detail of
The Conservatory.

VIII. (left)
Detail of
Le Journal illustré.

IX. (below) *The
Bar at the Folies
Bergère*. Courtauld
Institute Galleries,
University of
London.

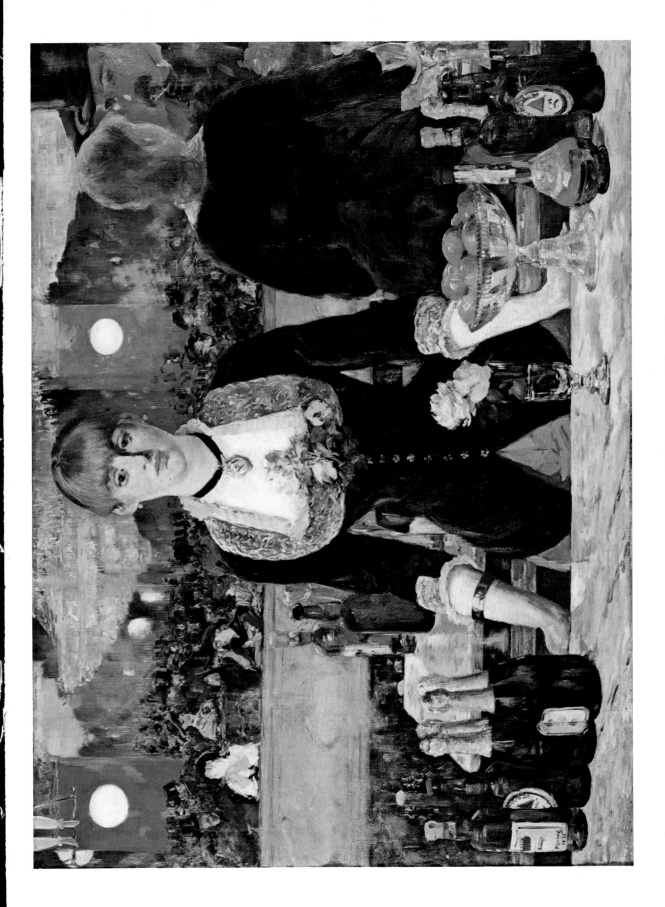

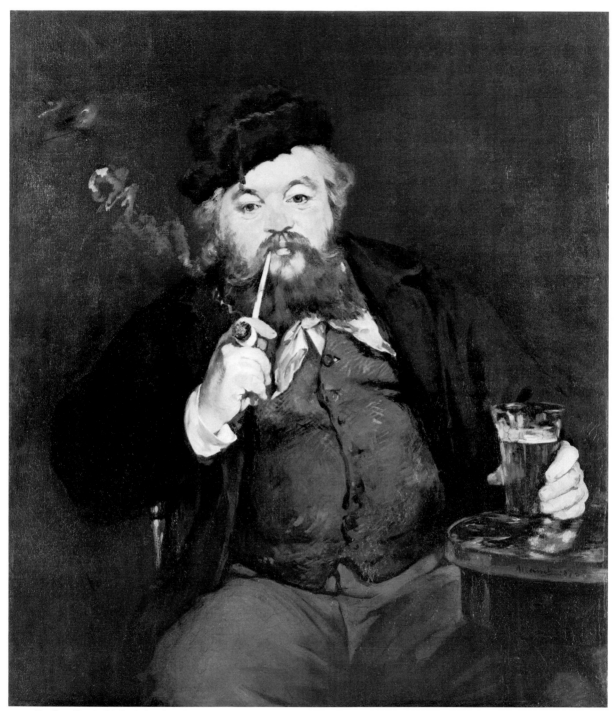

110. *Le Bon Bock*. Philadelphia Museum of Art. The Mr and Mrs Carroll S. Tyson Collection.

111. *Portrait of Stéphane Mallarmé*. Musée du Louvre, Paris.

112. *On the Banks of the Seine at Argenteuil*. From the Collection of the late Samuel Courtauld, London.

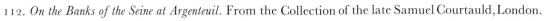

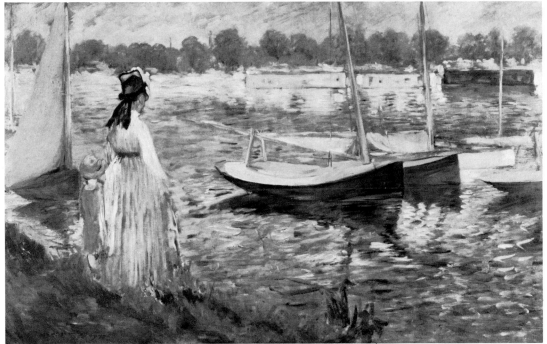

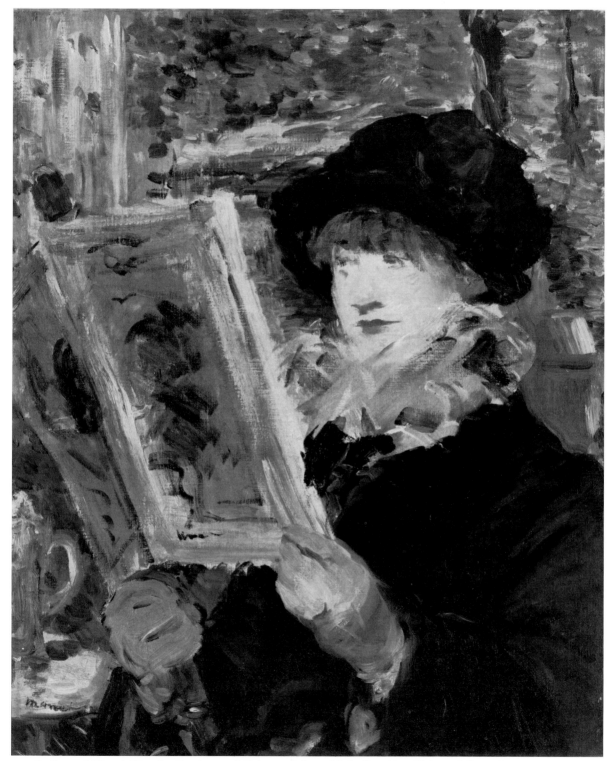

113. *Le Journal illustré*. The Art Institute of Chicago. Mr and Mrs Lewis L. Coburn Memorial Collection.

114. (right) *Lola de Valence*. Musée du Louvre, Paris.

115. (below) *The Little Cavaliers*, etching. Bryn Mawr College, Pennsylvania.

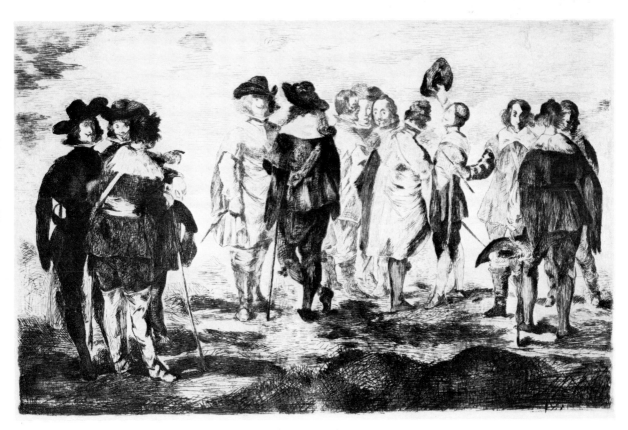

116. (top left) Page of sketches from Hokusai *Mangwa*, Volume I.

117. (top right) Page of sketches from Hokusai, *Mangwa*, Volume I.

118. (above) *Salamander*, wash drawing. Cabinet des dessins, Musée du Louvre, Paris.

119. (right) *Fishermen off the Coast of the Province of Nizan*, by Hiroshige II. Yale University Art Gallery, New Haven.

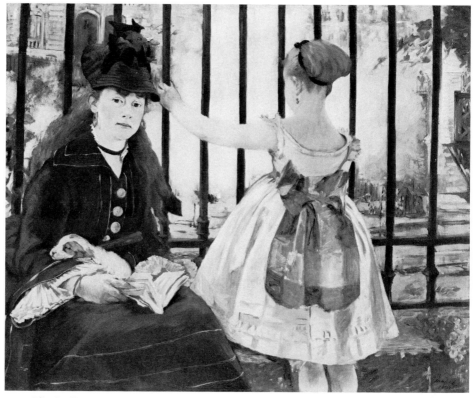

120. *The Railroad*. National Gallery of Art, Washington. Gift of Horace Havemeyer in memory of his mother Louisine W. Havemeyer.

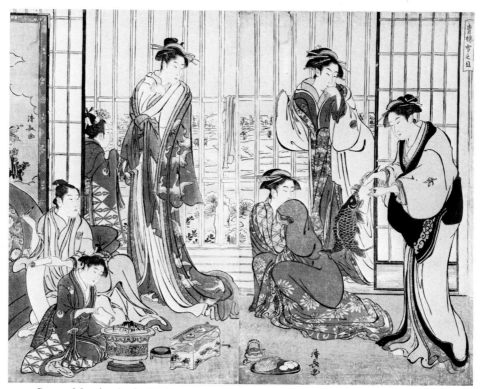

121. *Snowy Morning in the Yoshiwara*, by Torii Kiyonaga. Honolulu Academy of Arts. The James A. Michener Collection.

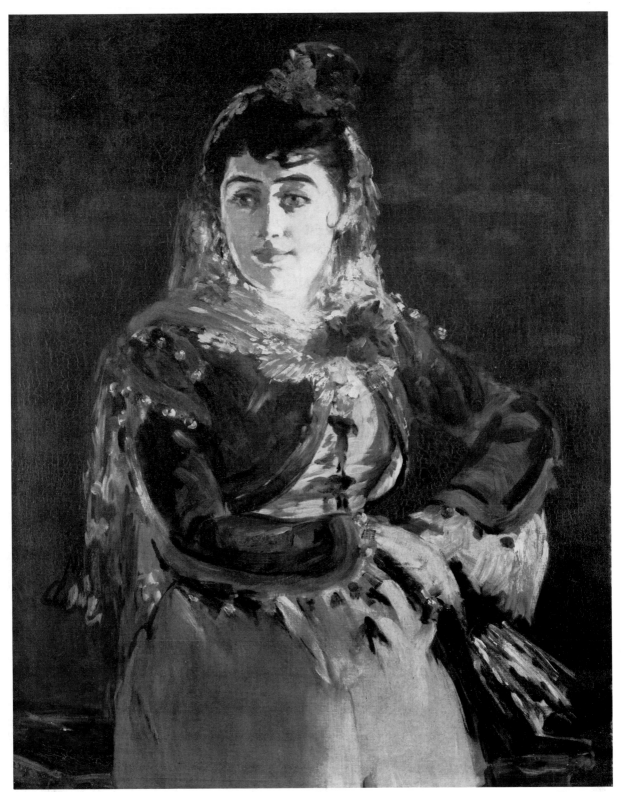

122. *Portrait of Emilie Ambre as Carmen*. Philadelphia Museum of Art. Gift of Mr and Mrs Edgar Scott (Reserving Life Interest).

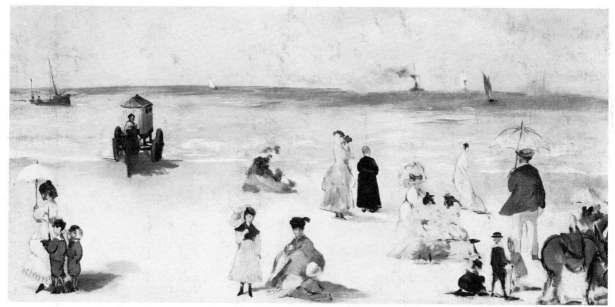

123. *On the Beach at Boulogne*. Collection of Mr and Mrs Paul Mellon, Upperville, Virginia.

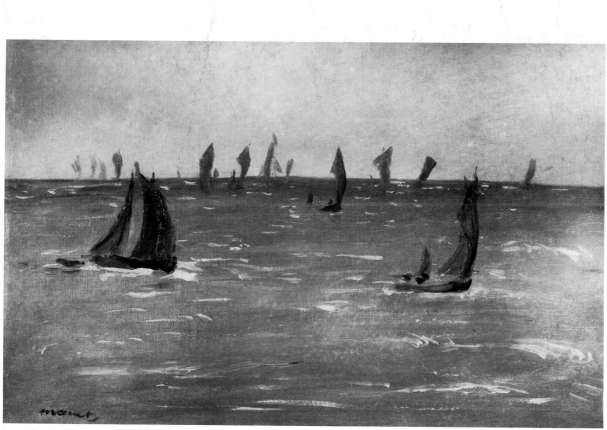

124. *Boats*. The Cleveland Museum of Art. Gift of J. H. Wade.

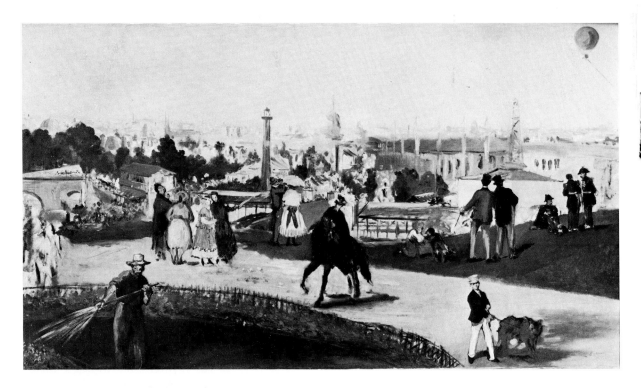

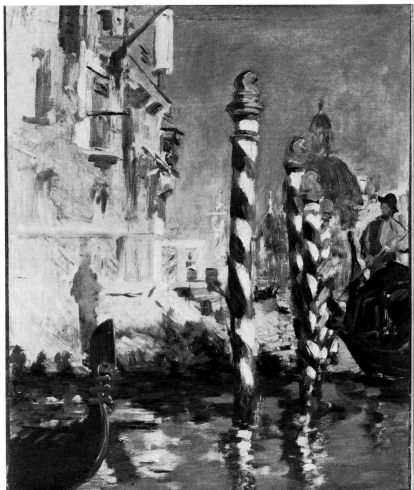

125. (above) *View of the Universal Exhibition of 1867*. Nasjanalgalleriet, Oslo.

126. (left) *Blue Venice*. Provident Securities Company, San Francisco.